Landscapes of the Itza

UNIVERSITY PRESS OF FLORIDA

Florida A&M University, Tallahassee
Florida Atlantic University, Boca Raton
Florida Gulf Coast University, Ft. Myers
Florida International University, Miami
Florida State University, Tallahassee
New College of Florida, Sarasota
University of Central Florida, Orlando
University of Florida, Gainesville
University of North Florida, Jacksonville
University of South Florida, Tampa
University of West Florida, Pensacola

Landscapes of the Itza

Archaeology and Art History
at Chichen Itza and Neighboring Sites

EDITED BY LINNEA WREN,
CYNTHIA KRISTAN-GRAHAM,
TRAVIS NYGARD,
AND KAYLEE SPENCER

UNIVERSITY PRESS OF FLORIDA
Gainesville / Tallahassee / Tampa / Boca Raton
Pensacola / Orlando / Miami / Jacksonville / Ft. Myers / Sarasota

23 22 21 20 19 18 6 5 4 3 2 1

Library of Congress Cataloging-in-Publication Data
Names: Wren, Linnea Holmer, editor. | Kristan-Graham, Cynthia, editor. |
 Nygard, Travis, editor. | Spencer, Kaylee R., 1975– editor.
Title: Landscapes of the Itza : archaeology and art history at Chichen Itza
 and neighboring sites / edited by Linnea Wren, Cynthia Kristan-Graham,
 Travis Nygard, and Kaylee Spencer.
Description: Gainesville : University Press of Florida, 2018. | Includes index.
Identifiers: LCCN 2017018509 | ISBN 9780813054964 (cloth)
Subjects: LCSH: Chichén Itzá Site (Mexico)—Antiquities. | Mayas—Mexico—
 Yucatán (State)—Antiquities. | Indians of Mexico—Antiquities. | Excavations
 (Archaeology)—Mexico—Chichén Itzá Site.
Classification: LCC F1435.1.C5 L36 2017 | DDC 972/.65—dc23
LC record available at https://lccn.loc.gov/2017018509

The University Press of Florida is the scholarly publishing agency for the State
University System of Florida, comprising Florida A&M University, Florida Atlantic
University, Florida Gulf Coast University, Florida International University, Florida
State University, New College of Florida, University of Central Florida, University
of Florida, University of North Florida, University of South Florida, and University
of West Florida.

University Press of Florida
15 Northwest 15th Street
Gainesville, FL 32611-2079
http://upress.ufl.edu

Contents

Figures

Tables

Preface and Acknowledgments

The site of Chichen Itza has fascinated intellectuals for over a century, and this is not the first book to be published on the ancient Maya center. The volume of essays assembled here is thus an attempt to update, complicate, and strengthen our understanding of the great ancient site. While doing so, we have chosen to emphasize the theme of landscapes, in the hope that it will enrich our understanding of how Maya people lived in and viewed the natural world.

The genesis of this book was "What's Up, Chaak," a symposium that addressed recent work at Chichen Itza, at the meeting of the Society for American Archaeology (SAA) in Memphis in 2012. Annabeth Headrick and Cynthia Kristan-Graham organized and chaired the symposium. Originally art historians and archaeologists were invited to participate, but due to prior commitments at SAA only art historians presented papers, and archaeologists Geoffrey Braswell and John Pohl served as discussants.

Before the conference, Meredith Babb of the University Press of Florida contacted the organizers to inquire if they were interested in publishing the symposium papers. Although Headrick and Kristan-Graham were eager to publish, they were committed to other projects and could not serve as editors. They invited Linnea Wren, a speaker in the symposium, to serve as editor, and she agreed to do so along with Travis Nygard and Kaylee Spencer. As work began sending letters to contributors and inviting archaeologists to contribute to the volume, Wren asked Kristan-Graham if she would share her advice about editing books, and eventually she was invited to be a coeditor. We four coeditors distributed the workload.

We are grateful that Geoffrey Braswell, Beniamino Volta, Nancy Peniche May (Chapter 1), Eduardo Pérez de Heredia, Péter Bíró (Chapter 3), Scott Johnson (Chapter 4), and J. Gregory Smith and Tara Bond-Freeman (Chapter 5) agreed to contribute chapters that complement the original symposium with archaeological approaches to Chichen Itza. Several speakers at the symposium, Laura Amrhein, Jeff Kowalski, and Victoria Lyall, did not contribute chapters due to other commitments.

We thank two anonymous readers for their comments. Meredith Babb was

supportive and accommodating throughout the editing process, as was the staff of the University Press of Florida. Geoffrey Braswell and Beniamino Volta answered many questions for us about archaeology at Chichen Itza. Some academic institutions have supported the editing process, particularly the sabbatical leave that Gustavus Adolphus College granted Linnea Wren; Auburn University for supporting Cynthia Kristan-Graham's participation in the SAA session; Ripon College provided funding to support Travis Nygard's work; the University of Wisconsin–River Falls supported portions of Kaylee Spencer's participation in several SAA meetings, which allowed for further development of the topics considered in this volume.

1

Introduction

Looking Backward, Looking Forward at Chichen Itza

CYNTHIA KRISTAN-GRAHAM AND LINNEA WREN

For nearly 500 years Chichen Itza in Yucatan, Mexico, has fascinated explorers, scholars, and visitors. Its large area, compelling visual culture, and many references in ethnohistory have secured it a central place in Mesoamerican studies. The written corpus about Chichen Itza is talmudic in breadth, and would fill a small library. *Landscapes of the Itza: Archaeology and Art History at Chichen Itza and Neighboring Sites* adds to this corpus. The chapters address archaeology, social interaction, visual art, epigraphy, and historiography, and all add to the Western dialog about Chichen Itza that began in the sixteenth century.

The centrality of Chichen Itza in Mesoamerican studies parallels its place in archaeology and popular culture. In 1998 UNESCO named it a World Heritage site, and 11 years later a global Internet vote declared Chichen Itza one of the "new seven wonders of the world," the only Mesoamerican site to have this distinction (Conlin 2007). Both helped to make the site a magnet for the thousands of tourists who visit it annually; it is second in popularity as a tourist attraction in Mexico after the Classic-period archaeological site of Teotihuacan in Central Mexico (see Castañeda 2009 regarding the politics of tourism). Chichen Itza also has been the subject of many popular books, articles, and television documentaries.

Coming to Terms with Chichen Itza

Landscapes of the Itza is one of the few edited books explicitly devoted to Chichen Itza, one that purposely includes a spectrum of archaeological and art historical approaches to the site's development and its relationship with surrounding settlements. Before proceeding, some words in the book's title deserve attention. The English word "landscape" derives from the late sixteenth-

century Dutch word *landschap*, which refers to landscape painting, and today landscape is a key concept related to the habitation, alteration, use, and views of land. Philosophy, archaeology, art history, architectural and urban history, memory studies, and literature in particular recognize the import of landscape as both physical and ideological milieus. Inhabiting the land—including space and structures—is a formative experience that tempers deep memories about identity, family, and social relations. Related to this is place memory wherein place inculcates and sparks memories that powerfully evoke the past (Hayden 1995: 9).

Landscape as merged natural and cultural features need not match what actually exists, because vision, memory, and mutations of place alter perceptions of the totality that is landscape. Raymond Williams demonstrates this in *The Country and the City*, his analysis of British literature from the sixteenth through nineteenth centuries. Of the transformation from an agrarian to urban economy and concomitant rural-to-urban settlements, Williams (1973: 180) notes that recollections of the lost countryside are "a condition imagined out of a landscape and selective observation and memory." Thus, the idealized British past as landscape that never quite existed is a surrogate for the nostalgia of rapidly waning rural culture.

In *Landscapes of the Itza* the authors engage landscape in many ways, from direct discussions of the plan and areal evolution of Chichen Itza and its environs to explorations of the site's interaction with other settlements in Yucatan. Some authors explore the significance of individual buildings and associated embellishment that represents landscape elements such as hills and vegetation (for landscape and landscape archaeology, see Ashmore and Knapp 1999; Basso 1996; Bender 1993; Cosgrove 1998; Hendon 2010; Parker Pearson 2012; Tilley 1994). Other authors discuss landscape in metaphorical terms. One example is the historiographical background, or "intellectual landscape" of Chichen Itza, which is one of the concerns of Chapter 2. In such cases, or in discussions about a part of the site such as Chapter 3's focus on early Chichen Itza, authors may not even mention landscape per se. Yet all chapters do reference landscape in some way(s).

Itza is another problematic word. Since the sixteenth century it has been recognized as part of the name of Chichen Itza, which is usually translated as "at the mouth of the well of the Itza" in reference to the Sacred Cenote, the largest sinkhole there (Figure 1.1). Sixteenth-century Spanish sources are the earliest European accounts about the Maya of Yucatan, and although Chichen Itza then was sparsely populated, the Yucatec Maya remembered it as a large, prominent city. The population of the site was called "Itza," yet it

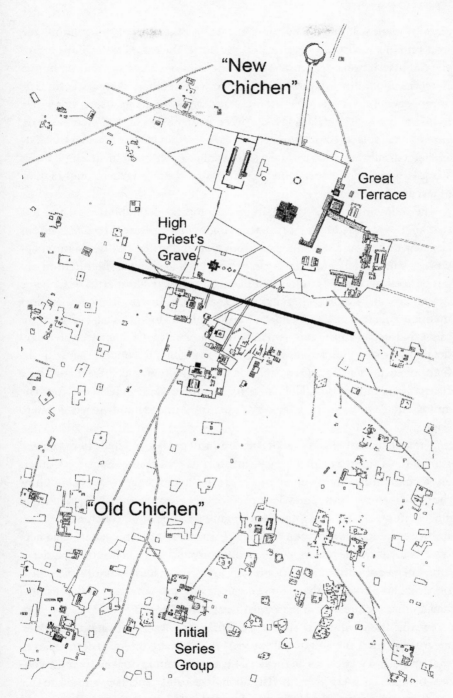

Figure 1.1. Plan of the Great Terrace, the site center of Early Postclassic Chichen Itza. By Beniamino Volta and Geoffrey Braswell, by permission of Routledge.

remains unclear if this is a cultural, ethnic, or other sort of designation, and so it remains a sort of default category.[1] Nevertheless, Classic Maya hiero-glyphic inscriptions demonstrate how the root of Itza (*its* or *itz*) embodies concerns vital to the Maya. *Itz* can refer to water, rain, milk, tears, resin, sap, or more generally a "sacred substance," and can even mean sorcerer or witch. In his study of the Late Postclassic–early colonial Maya in the Peten Lakes region of Guatemala, Grant Jones (1998: 428–429) notes that Itza can translate as "Sacred-Substance Water" (see sources that Jones uses, including Barrera Vásquez and Rendón 1948, and Freidel et al. 1993; more recent ones include Macri and Looper 2003).

The following chapters contain archaeological data about Chichen Itza that are the foundation for new chronologies and historical reconstructions and new understandings of social interaction and visual culture. Many chapters consider Chichen Itza in the wider contexts of Yucatan, highlighting interconnections and offering broad historiographical summaries of Chichen Itza and its place more generally in Mesoamerica. Interestingly, few authors mention Tula or a possible Central Mexican intrusion into Yucatan, an argument that began in the mid-nineteenth century (see Chapter 2 for relevant details). Perhaps that issue is too complex to discuss in conjunction with the focus of each chapter. Or, perhaps it is time to let that issue hibernate after a recent flurry of attention (Cobos 2006; Coggins 2002; L. Jones 1995; Kowalski and Kristan-Graham 2011; Slusser 2008; Sodi Miranda and Aceves Romero 2006).

The archaeology chapters at the beginning of the book include new data and ruminations about data that have been available for decades. Each has a different focus, and reading them all presents a spectrum of fresh ideas about how the city developed, how elites used parts of the city, and how Chichen Itza and a network of smaller sites interacted (Figure 1.2). The book concludes with art history chapters that analyze a building or part thereof at Chichen Itza and necessarily focus on the materiality of architecture and its embellishment and use. This intersects with art history's recent focus on material culture, especially on visual art as objects that people created and used, contra two-dimensional images that require decoding (Prown 2002; Yonan 2011).[2]

Finally, the chapters in *Landscapes of the Itza* move between micro- and macroanalyses that result in shifting views of Chichen Itza and Yucatan. Given the variety and intricacies of Yucatec Maya history and visual culture, the content of some chapters overlaps. The approaches and conclusions indicate that the animated debates about Chichen Itza that have persisted for over a century are sure to continue.

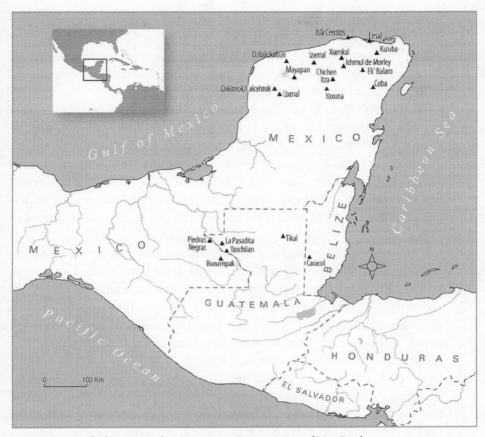

Figure 1.2. Map of select sites in the Maya region. By permission of Matt Dooley.

Archaeology at Chichen Itza and Neighboring Sites

Chapter 2, "The Archaeology of Chichen Itza: Its History, What We Like to Argue About, and What We Think We Know," by Beniamino Volta, Nancy Peniche May, and Geoffrey Braswell summarizes work at Chichen Itza and analyzes salient scholarly debates. Because it serves as a general introduction to Chichen Itza and related historiographical issues, Chapter 2 is discussed in more detail than others here. The jocular-sounding title actually embodies many vital concerns about Chichen Itza, including epistemology, disputes about previous and current scholarship that range from elfin to gargantuan scales, and general approaches to the archaeology and art of the site and its environs. The chapter also discusses plans, decipherment of hieroglyphic texts, and archaeological work by the Carnegie Institution of Washington and the

Mexican government that commenced in the 1920s. While the entire chapter is invaluable for anyone interested in historiography, the section about chronology is essential for specialists and nonspecialists alike due to explanations of *how* chronologies were created, *why* some differ, and *how* data and their analyses affect conclusions.

Nearly two centuries ago, French explorer Désiré Charnay's (1885) observation of a "Mexican" influence in Chichen Itza's art and architecture was a catalyst for debates about chronology and possible foreign intrusions into Yucatan, some of which continue today. Since Charnay's time there has been no real consensus about chronology at Chichen Itza. The authors of Chapter 2 add new data and update some of their previously published ideas while considering other chronological work (Braswell and Peniche 2012; Volta and Braswell 2014).

Chichen Itza chronology is based on ceramics, stratigraphy, and hieroglyphic and radiocarbon dates (there are few of the latter).[3] All contribute to an understanding of the site's urban development and interactions with surrounding sites. Volta et al. present a Chichen Itza chronology that divides the site into two major periods. Terminal Classic correlates with Yabnal and small amounts of Cehpech ceramics and Early Postclassic with Sotuta ceramics (Figure 1.3).

Cehpech and related ceramics have a long and complex history.[4] Pottery related to the Cehpech ceramic complex first appeared in the Puuc region at the Early-Late Classic transition. According to Joseph Ball (1979) and others, the slate wares of this complex initially formed an elite subcomplex within an older and broader Copo tradition. Volta and Braswell (2014) argue that the spread of the earliest elite Cehpech pottery is analogous and parallel to Tzakol pottery in the Peten during the Early Classic. By about 700, the full Cehpech ceramic complex and sphere coalesced in much of the Northern Lowlands and continued for at least 200 years, through the Terminal Classic period as defined here. The Late and Terminal Classic Yabnal ceramics of Chichen Itza may be considered local variants on this theme, and some Cehpech pottery (such as Thin Slate) appears alongside Yabnal types. The apogee of Cehpech and related pottery of circa 700–900 frames the Late Classic–Terminal Classic; its tenth-century decline affected regions and sites differently, and Cehpech ceramics disappear by about 950/1050 (Braswell 2016).

Sotuta ceramics began to be produced at Chichen Itza circa 900–950 and characterize the Early Postclassic city. The Sotuta ceramic complex embodies a local tradition, new imported wares, and foreign ideas. Volta et al. wonder if the Sotuta complex might be considered a local Cehpech variety, with differ-

Figure 1.3. Chronological chart. By permission of Beniamino Volta.

	Brainerd (1958)	R.E. Smith (1971)	Cobos (2004)	Pérez de Heredia (2010)	Architectural Styles	Lowland Maya Periods	Central Mexico Periods
A.D. 1400	LATE MEXICAN	TASES	TASES	CHENKU-TASES		Late Postclassic	Aztec
A.D. 1300							Middle Postclassic
A.D. 1200	MIDDLE MEXICAN	HOCABA	HOCABA	KULUB-HOCABA			
A.D. 1100	EARLY MEXICAN	SOTUTA	LATE SOTUTA	SOTUTA-SOTUTA	International	Early Postclassic	Epiclassic
A.D. 1000			EARLY SOTUTA	HUUNTUN-CEHPECH	Maya/Puuc	Terminal Classic	Late Classic
A.D. 900	FLORESCENT	CEHPECH		YABNAL-MOTUL		Late Classic	Middle Classic
A.D. 800		MOTUL	MOTUL				
A.D. 700				COCHUAH		Early Classic	Early Classic
A.D. 600	REGIONAL	COCHUAH	?				
A.D. 500							
A.D. 400		?		?		Protoclassic	Terminal Formative
A.D. 300							
A.D. 200							
A.D. 100	FORMATIVE	TIHOSUCO		TIHOSUCO		Late Preclassic	Late Formative
100 B.C.							
200 B.C.							
300 B.C.							
400 B.C.						Middle Preclassic	Middle Formative
500 B.C.							
600 B.C.							
700 B.C.							
800 B.C.							

ences due to local clay and firing techniques, and most important, the addition of foreign influence.

Recent work has toppled the old chestnut about the futility of finding meaningful stratigraphy at Chichen Itza because of the region's thin layer of soil above limestone. For example, based upon architectural and sculptural style the Great Ball Court was previously dated very early among the structures on the Great Terrace (Cohodas 1978), but recently examined floor layers on the terrace indicate that this was one of the very last structures to be built there (Braswell and Peniche 2012) (Figure 1.1). Stratigraphy also indicates that most construction on the Great Terrace ended by the late tenth or early eleventh centuries, and major construction at the site ended by circa 1100 of the Early Postclassic period.

Recent climatological evidence also has entered chronological debates. A severe drought is thought to have affected the entire Yucatan Peninsula circa 900–950. Along with intersecting social, economic, and political stresses, this may have caused population decline in the region (Kennett et al. 2012; Middleton 2012: 275–276).[5] At the center of the peninsula, Chichen Itza suffered population loss, yet the continued occupation of its coastal towns Emal and Isla Cerritos may have been crucial in the eventual repopulation of Chichen Itza beginning circa 950 in the Early Postclassic in the northern part of the site.

The historical reconstruction that Volta et al. suggest for Chichen Itza includes two major occupations. They cite Eduardo Pérez de Heredia's (2010, 2012) recent ceramic and settlement data. As the ceramicist on recent projects with the Instituto Nacional de Antropología e Historia (INAH), he found that settlement at Late Classic Chichen Itza was gradual, with two subsequent periods of rapid growth.[6] In the Terminal Classic period the site had a north-south axis and clustered in a zone from the Monjas in the north to the Temples of the Three and Four Lintels in the south. Most of the buildings had Puuc-style core-veneer masonry, mosaic facades, and hieroglyphic inscriptions that cite K'ak'upakal as a ruler. This part of the site has traditionally has been called "Old Chichen," "Maya," or "Pure Florescent." The absence of Sotuta materials in sealed construction fill clearly indicates that ninth-century Puuc-style architecture was built before International style construction. However, the architectural style–ceramic complex link is less straightforward in other ways, as some sealed fill contexts of Puuc-style structures had both Yabnal and Cehpech materials.

Subsequently, the tenth-century drought precipitated a chain of events that affected population decline. Intermittent construction in this half century was followed by a postdrought, Early Postclassic "golden age" typified by new building types and sculpture, including colonnaded halls and warrior columns, that

radiated from the Great Terrace, the new site center (Figure 1.1). Volta et al. call Early Postclassic architecture at Chichen Itza "International" because it embodies what was once thought to be "Mexican" or "Toltec" influence. Although most facades lacked Puuc-style mosaics, the core-veneer masonry technique continued, indicating that the population and/or the construction technology were local. Local pottery continued to be made and used, but elites also used new types inspired by foreign wares. The appearance of new materials, including turquoise and copper, is the result of long-distance trade.

At present it is not possible to interpolate the above ceramic data with many surrounding areas because of the dearth of systematic ceramic data for the entire Yucatan Peninsula. The result of this severe limitation is, according to Volta et al., a "Franken-sequence, sewn together using complexes defined for distinct sites." Complicating the understanding of chronology is the fact that some scholars use terminology inconsistently. Some use "Cehpech" broadly as a category that incorporates many ceramic complexes, including Sotuta. Others use a more circumscribed definition for "Cehpech" as a local Puuc phenomenon of the eighth through early tenth centuries (R. Smith 1971).

New chronologies engender debates, and no doubt the chronology that Volta et al. present will meet with queries and disagreements. William Ringle (2017) questions some of the radiocarbon, ceramic, and stratigraphic analyses in Chapter 2 and argues for a compressed and continuous florescence in the ninth and early tenth centuries. He doubts whether Chichen Itza experienced a hiatus or had any monumental construction after 1000. These substantial disparities signal that Chichen Itza's chronological issues are far from settled.

Some lingering discrepancies exist regarding other issues. An inclusive settlement pattern study has not been conducted at Chichen Itza, and a comprehensive published site plan does not exist. As this went to press in 2017 the standard plan remains the 1952 Carnegie Institution map, which displays about 5 km² of the site core; this map was compiled from Carnegie Institution surveys that J. O. Kilmartin made in 1924 and 1929, and J. P. O'Neill made in 1932, and centered on the Great Terrace (Ruppert 1952: fig. 151). This map, though, covers only about one-fifth of the entire site and omits the areas where most of the population was concentrated. Newer data from INAH and other projects that augment this map and would contribute to an up-to-date site plan have not been integrated into the aforementioned site plan; this includes Peter Schmidt's work on the Initial Series Group, Rafael Cobos' work on the Chultun Group, Charles Lincoln's (1990) remapped part of southern Chichen Itza, and surveys of the site that are outside the archaeological park.

Likewise, scholars use diverse terms to describe chronology, areas of the site, and the ancient populace. Sometimes terms are used not just because they are familiar, but also because they express a very particular idea. It is not always obvious when this is the case, however, and this is the situation at Chichen Itza, which has both the asset of much scholarship and the tribulations of near constant controversy. Some continue to use the traditional labels "Maya" and "Toltec." As stated earlier, an emergent majority opinion holds that peoples from Tula in Central Mexico *did not* conquer Chichen Itza; hence the most common term for people from Tula, "Toltec," is outdated in this context. We do not expect that a specialized Chichen Itza argot be developed, only that clear terminology reign, as Volta et al. demonstrate.

Volta et al. acknowledge that there is still much to learn, particularly about Chichen Itza's Late Classic occupation and the nature of its political organization. We add a caveat about ethnohistory. While ethnohistoric sources are mentioned, they do not discuss *how* such sources are to be used. Perhaps this is self-evident, but we would be remiss if we did not discuss the potential abuses of texts. If Chichen Itza began its decline circa 1100, then roughly 450 years separate the earliest ethnohistoric documents from Chichen Itza's apogee. Such temporal distance creates potential pitfalls. How were memories of informants, especially about Chichen Itza, affected by the specter of time? Sixteenth-century sources, such as Diego de Landa's *Relación de las Cosas de Yucatán* (in Tozzer 1941) and the *Relaciones histórico-geográficas de Yucatán* (de la Garza 1983) were written for the Spanish crown or the Church—it is vital to consider in what ways they might have been shaded regarding the authors' duties in Yucatan.

For example, Landa wrote his *Relación* in Spain in the 1560s, where he was remanded for exceeding the bounds of the Inquisition. He was not convicted and eventually returned to Yucatan as its second bishop. Landa remains a primary source for Yucatec Maya society, but must be read cautiously. His *Relación* explained his methods for erasing idolatry and providing salvation for the Maya, and is imbued with millennial language; one passage compares Yucatan with Jerusalem: "its enemies would encircle it and encompass it and press so hard upon it that they would tumble it to the ground" (Landa in Timmer 1997: 488). One oft-repeated phrase, "They say that . . . ," expresses the memories of Landa's informants. Because memories are fluctuating creations, Landa's reliability about Terminal Classic–Early Postclassic Chichen Itza is questionable. However, its prominence in the minds of contact-period Maya cannot be disputed.

Landa also introduced subjects that continue to be points of discussion and

frustration, especially the issue of possible contact with Mexico and individuals that may be quasi-historical: "They [Yucatec Maya] say that he [Kukulcan] arrived from the west; but they differ among themselves as to whether he arrived [at Chichen Itza] before or after the Itzas or with them. They say that he was favorably disposed, and had no wife or children, and that after his return he was regarded in Mexico as one of their gods and called Quetzalcouatl" (Landa in Tozzer 1941: 22–26). Later writers, including the chronicler Antonio de Herrera, repeated the above passage in 1601 almost verbatim (Tozzer 1941: 215). The practice of quoting earlier writers ultimately expressed more about the practices of contact-period writers than about Kukulcan (also spelled elsewhere in this volume as K'uk'ulkan) or the Itza.

Despite this limited caveat, Chapter 2 summarizes much of Chichen Itza scholarship and introduces some crucial concepts discussed in *Landscapes of the Itza*. The following archaeology chapters focus on more specific issues, ranging from the nature of the social, political, and economic relationships between Chichen Itza and sites within its sphere of influence, to rulership at Chichen Itza. Authors use different data sets, terminology, spelling, and dates, all of which illustrate what Volta et al. convey about arguments that do not meet on the same level playing field due to a disparity of equipment. With variable data, few issues enjoy consensus and ideas are somewhat in flux.

Chapter 3, "K'ak' Upakal K'inich K'awil and the Lords of the Fire: Chichen Itza during the Ninth Century" by Eduardo Pérez de Heredia and Péter Bíró integrates ceramics, stratigraphy, epigraphy, and cautious readings of ethnohistoric sources to propose a historical reconstruction of early Chichen Itza. Despite the title the authors discuss a longer time period spanned by several ceramic complexes and chronological periods: Yabnal (600–800/850, which is roughly coeval with the authors' dates for Late Classic Chichen Itza, 600–800/830); Huuntun-Cehpech (Terminal Classic), and Sotuta (Early Postclassic). As mentioned earlier, the lead author was a ceramicist for the recent INAH Proyecto Arqueológico Chichén Itzá. Like Volta et al., Pérez de Heredia and Bíró reject the partial and total overlap models for Chichen Itza construction and settlement. Evidence for the sequential construction of architecture in Late Classic, Puuc, and International styles includes the three ceramic complexes in sequence at the Initial Series Group and the Great Terrace and the presence of Sotuta ceramics inside structures. Yet Chapters 2 and 3 do not agree in lockstep, as Pérez de Heredia and Bíró consider the relatively few Huuntun-Cehpech ceramics found together with Puuc-style architecture to signal a phase of construction distinct from and after the Yabnal ceramic phase. They explain the larger quantity of Yabnal-Motul sherds found in sealed

contexts of Puuc-style buildings to reflect the time length required for ceramics to enter the waste stream.

Chapter 3 focuses on the Late and Terminal Classic periods. In the former, construction was concentrated near the Xtoloc Cenote, south of the later Great Terrace, and included early stages of the Caracol, Monjas, and architectural terraces that supported the Initial Series Group and other buildings (Ruppert 1952: fig. 151). The authors propose that the Late Classic site center around the Caracol was named Tzaj or Tza' and associated with a noble "divine speaker." This is an early indication for a title of office and/or an individual who seems to have been integral to Chichen Itza's development (see also Boot 2005; Voss and Eberl 2001). The subsequent Terminal Classic is typified by the name K'ak' Upakal K'inich K'awil (hereafter the shorter K'ak'upakal is used) that is carved in many hieroglyphic inscriptions. The name clusters within a 30-year period from 860 to 890, which may be related to part of a human lifespan, and plausibly refers to a ruler. "K'ak'upakal" appears in inscriptions that record his family (Grube and Krochock 2011; Krochock 1988, 2002), activities, and court. These issues are indicative of Terminal Classic sociocultural realignments, when inscriptions focused on ruler-performed rituals rather than on life-events.

In Chapter 4, "Rulers without Borders: The Difficulty of Identifying Polity Boundaries in Terminal Classic Yucatan and Beyond," Scott A. J. Johnson discusses the nature and expression of hegemonic political authority evident in borders. He analyzes Chichen Itza and nearby sites within the context of tangible and invisible borders and queries whether boundary types correlate with social rank (Figure 1.2).

Johnson focuses on two major boundary types: closed political borders are associated with elites, especially rulers that exerted control via social constraints, while open frontiers tend to correlate with commoners and are dynamic, flexible, and are normally controlled. He utilizes J. Gregory Smith's (2000, Smith et al. 2006) analysis of Ek Balam and Chichen Itza wherein influence tends to weaken with increasing distance from the center. Evidence for political domination extends to material culture. At Chichen Itza and its allied sites, elite manifestations of culture include foreign items such as Fine Orange and Plumbate ceramics and Pachuca obsidian. Ichmul de Morley and Popola are exceptions. At Ichmul de Morley, obsidian, architecture, and ceramics are related to both Ek Balam and Chichen Itza. "Hybrid" ceramics—with Sotuta forms made with Cehpech paste and slip—may be explained by the site's general autonomous nature, little elite control of utilitarian ceramic production (in contrast to Volta et al.), and the presence of a social border between the two larger sites. Popola, located 5 km from Yaxuna and 13 km from Chichen Itza,

was the subject of Johnson's 2012 dissertation; he explains the hybrid ceramics there via the open frontier between larger "framing" sites.

Johnson's regional analysis demonstrates new ways to conceptualize the Chichen Itza region as a landscape of boundaries that exerts strong social and political power and expands and contracts according to realpolitik. Political power here need not be understood as totalizing and regulatory, because commoners apparently took advantage of open frontiers for trade.

Another regional analysis is Chapter 5, "In the Shadow of Quetzalcoatl: How Small Communities in Northern Yucatan Responded to the Chichen Itza Phenomenon" by J. Gregory Smith and Tara M. Bond-Freeman. The authors test the arguments of William Ringle et al. (1998) about the Feathered Serpent cult. Ringle et al. argue that a widespread Epiclassic Mesoamerican cult focused on a ruler-priest-deity called the Feathered Serpent (Quetzalcoatl in Nahuatl and K'uk'ulkan in Yucatec Maya).[7] Specific forms of religion, long-distance trade, and military and political leadership typify the cult, as do Feathered Serpent imagery and other elements of visual culture.[8] Smith and Bond-Freeman analyze the Feathered Serpent phenomena within a world-system economic framework and replace "cult" with "political ideology" to clarify that they deal with overarching ideas about political, social, economic, and cultural systems rather than the idea of religion that "cult" might evoke.

A spectrum of small Epiclassic sites that Chichen Itza may have affected is ranked 1 through 4 (Garza and Kurjack 1980) in order of descending size (Figure 1.2). The smaller sites demonstrate a variety of associations with the politically independent Chichen Itza. Ichmul de Morley, a Rank 3 site located between Xuenkal and Chichen Itza, was a convenient place for traders traveling to and from the latter to spend the night (Ardren and Lowry 2011). In Chapter 4 Johnson describes the site as autonomous and forming a social border between Ek Balam and Chichen Itza. While Ichmul de Morley exhibits few material associations with Chichen Itza, some artifacts related to food preparation suggest it served as a way station: *Molcajetes* associated with the Feathered Serpent cult are present, and one habitation has sixfold more *metates* than the usual three in other abodes.

In contrast, among the scattering of domestic and civic buildings at the small Rank 4 site of Yaxkukul is a large I-shaped ballcourt that follows the design of Chichen Itza's Great Ballcourt. As the sole indication that links the two sites, Smith and Bond-Freeman follow Ringle et al. (1998) to suggest that the ballcourt was an outlying noble house used for Feathered Serpent rituals. As the closest Feathered Serpent architecture to Ek Balam, it may be a "formal boundary statement" that Chichen Itza conveyed to that site.[9]

Chapters 4 and 5 approach Chichen Itza and its environs from a wide-angle viewpoint. While both chapters evaluate sites and their interrelationship from different methodological bases, they concur that it is not possible to predict the political and cultural affiliations of sites in the fluid environment of Chichen Itza hegemony.

Visual Culture

Most chapters deal with visual culture in addition to social interaction and chronology, and tend to adopt all or part of the new chronology that Volta et al. present in Chapter 2. Of the archaeology chapters, Chapters 2 and 3 concern imagery and embellishment in historiographical terms while the latter also presents new analyses of epigraphy, imagery, and building use for Terminal Classic Chichen Itza. Chapters also discuss Maya and foreign objects, especially obsidian, and ceramics, regarding chronology, status, trade, and social interaction. Another issue addressed is Chichen Itza's plan (Chapters 2–5), primarily as it relates to chronology or ideology. It is also possible to discuss buildings and their arrangements as imagery, as symbolic and astronomical analyses of site plans demonstrate (Dowd 2015; Schele and Mathews 1998: 42–48). Specific types of imagery are examined, such as the Feathered Serpent (Chapter 5). Literally hundreds appear on portable objects and in painting and two- and three-dimensional sculpture at Chichen Itza, and thousands more are seen throughout Mesoamerica. A close look, especially at feathers and rattles, shows that the same type of serpent is not always represented. This important issue requires further analysis.

The archaeology and art history chapters differ regarding how visual culture is conceived. Except for parts of Chapter 3 that analyze epigraphy, imagery, and plan, the archaeology chapters tend to treat visual culture as data or as support for arguments about material culture, religion, and social organization, and this demonstrates how the two academic disciplines differ. The art history chapters are less concerned with visual culture as evidence for chronology or a Mexican presence at Chichen Itza, for example. Rather, the Castillo, the Osario, the Mercado, and the Upper Temple of the Jaguars are investigated as physical realms that invite inquiry about subject matter, symbolism, interaction, and more (Figure 1.1). In a turn away from an earlier art historical approach, the authors do not view buildings and their embellishment as "reflections" of society, but rather as edifices with agency that participated in social and ritual life.

Art History at Chichen Itza

Of the art historians, Virginia Miller analyzes the earliest building in Chapter 6, "The Castillo-sub at Chichen Itza: A Reconsideration." Ironically, although it is an icon for Chichen Itza, the Castillo is the least-studied major building there. Miller focuses on the least-familiar part of the pyramid.

According to recent Great Terrace chronology, the Castillo-sub was built after 900, with the later Castillo constructed later in the tenth century (Volta and Braswell 2014). It probably was the sole structure on the Great Terrace for several decades. The Castillo-sub is built in the Puuc style, unlike the "Mexican-style" Castillo. A carved reed glyph on the Castillo could reference Tollan, perhaps marking Chichen Itza as a reed-place or capital associated with ancestral legitimacy and/or a place of political investiture.

Sculpture in the two-chambered temple atop the Castillo-sub supports these ideas. Political and ritual aspects of the temple include the chacmool "buried" by the later Castillo, which Miller identifies as an Itza warrior rather than a prisoner (compare M. Miller 1985). The receptacle on the abdomen could have been used to drill fires, a rite that abounds in earlier hieroglyphic inscriptions. The fire theme continues with the jaguar throne that holds a wooden disk; its mosaic depicts fire serpents and bears evidence of burning. The inner temple chamber included human femurs embedded into a wall, which may relate to captives given the other contexts for this bone in Maya art; this "bone-wall" would have been suitable for bloodletting or human sacrifice. Miller suggests that a ruling council could have met in the Castillo-sub temple. Given Chichen Itza's hieroglyphic record that includes many references to fire rituals and rulership (see Chapter 3), the temple seems a likely locus for rites of rulership.

The other chapter that analyzes an entire building is Chapter 7, "The Osario of Chichen Itza: Where Warriors Danced in Paradise" by Annabeth Headrick, who revisits the topic of her master's thesis (Headrick 1991). Utilizing INAH excavation data and analyzing all parts of the building, Headrick proposes that the Osario (also called the High Priest's Grave) was a burial and commemoration for the afterlife of warriors, including those involved in long-distance trade.

Headrick's detailed analysis of the Osario exterior includes balustrades embellished with carved feathered and cloud serpents and interlaced serpents adorned with carved jade and turquoise that seem to slither along the cornice. Both materials were found at Chichen Itza and symbolize fertility, life, and water; the depiction of turquoise may have resulted from new long-distance trade routes. Combined with quetzal feathers and cloud serpents, which symbolize rain, the Osario's carved serpents evoke a verdant, sumptuous vision.

The stacked masks carved at the temple corners in the past have been associated with the deity Chaak (also spelled elsewhere in this volume as Chahk), but following Karl Taube (2004), Headrick interprets them as *witz* or mountain heads. Taube identifies headbands on the witz masks as flowers, and interprets the Osario as a representation of Flower Mountain, a place of abundance, home of gods and ancestors, and an entry point to the Edenic realm of the Sun. (In Chapter 6 Miller also reads the long-nosed masks on the Castillo as witz, or a sacred mountain and door to a solar paradise; in the next chapter Kristan-Graham reads the dais/throne in the Mercado as *k'an witz*, an ancestral origin place.) Flower Mountain is also considered to be an afterlife abode where warriors were rewarded for their heroic lives. In support of this, Headrick interprets carved panels on the pyramid exterior as warriors dancing, and avian traits characterize the warriors in transition to the afterlife, as ethnohistoric sources state that deceased warriors ascended to the afterlife as birds or butterflies.

The Flower Mountain reading is enhanced by burials inside the pyramid, which give the building its Spanish name for ossuary. The opening to the natural cave below the pyramid contained charred human bones and stone points, the latter expressing martial interests. Elite grave goods, including copper bells and turquoise, attest to Chichen Itza's participation in some form of long-distance trade. In a diachronic view, Headrick sees a turn to more formal burials, which coincides with a Chichen Itza whose trading prowess made it wealthy.

The two remaining art history chapters concern specific parts of buildings from the Great Terrace (Figure 1.1). In Chapter 8, "The Least Earth: Curated Landscapes at Chichen Itza," Cynthia Kristan-Graham analyzes the Mercado. This building is a gallery-patio rather than a market, and such edifices served as lineage or council houses. On the basis of the Mercado's location in the Group of the Thousand Columns, an elite walled compound, Kristan-Graham suggests that it was a royal structure dedicated to political theater. Her discussion of rulership relative to architecture shares some similarities with how Pérez de Heredia and Bíró (Chapter 3) and Miller (Chapter 6) consider rulers and associated rituals.

Of the many architectural elements in the Mercado that suggest a performative function, Kristan-Graham concentrates on the dais, a platform that projects from the gallery wall. Its central placement and bright palette arguably made it the focal point of the gallery and the Group of the Thousand Columns plaza, which is second in size to the Great Terrace. The dais-form parallels many Classic Maya thrones, and its silhouette and imagery express an array of symbolism. The *talud-tablero* architectural profile can be read as a

landscape, with the *talud* simulating a mountain or pyramid and the *tablero*, which includes a skyband, symbolizing the firmament. In Maya dialects, "sky-mountain" is k'an witz, an ancestral place of creation. If the dais functioned as a seat, then elites or rulers would be placed in an enviable locale associated with the beginning of time and the fertile caves within mountains. In addition, the talud is embellished with a narrative scene of bound prisoners and sacrifice and the skyband features Feathered Serpent imagery. Kristan-Graham does not associate these serpents with a cult as do Smith and Bond-Freeman. Instead, she concentrates on Maya associations, including the Venus cycle and agricultural fertility. This rereading may suggest that other daises and benches, particularly at Chichen Itza and Tula, may merit new readings.

Chapter 8 also draws parallels between the dais/throne, the Yucatecan Maya language, and landscape. Human movement is implicit in the carved narrative, and more broadly throughout Chichen Itza as causeways and colonnades seem to invite walking. This intersects with Yucatec words for "road" that signify morality and a basic state of being. Linguistic and cognitive emphasis on space therefore seems to warrant, and even require, that space be part of analyses of Chichen Itza. Kristan-Graham also highlights the critical role of landscape in the process of "becoming" in the Deleuzian sense.[10] While space is not neutral or knowable in any sort of normative manner, people who are "becoming" in space reify that architecture can have agency (Buchanan and Lambert 2005; Getch Clarke 2005).

The final art history chapter explores the representation of gender at Chichen Itza. While hieroglyphic inscriptions feature women in prominent filial and ritual roles, this importance is not evident in the site's visual record. In Chapter 9, "To Face or to Flee from the Foe: Women in Warfare at Chichen Itza," Linnea Wren, Kaylee Spencer, and Travis Nygard characterize much of the Great Terrace's imagery as martial, including a paradigm of militarism and "hegemonic forms of masculinity" in much the same manner that gender roles were fashioned.[11]

Chapter 9 adds to the voluminous literature about Maya warfare and the Upper Temple of the Jaguars, and to the smaller but no less important dialogue about women at Chichen Itza, which largely focuses on the hieroglyphic record (Grube and Krochock 2011; Krochock 1988, 2002; Pérez de Heredia and Bíró, Chapter 3) and several women that are represented elsewhere at the site (Stone 1999). The authors probe deeper than previous analyses, which tended to classify figures into categories such as "warrior," or attempted to identify the location of some narratives (Charlot 1931; A. Miller 1977). Attention to gender extends beyond feminist approaches to art history, which include correctives to

the art history canon to include female artists, subjects, and patrons, attention to the role of women in society (Broude and Garrard 1982; Nochlin 1971), and feminist theory (Drucker 1992). Instead, gendered approaches concern the roles of males, females, and others as socially rather than biologically determined. The authors assert that social organization, political structure, ritual, and language have power to create and reinforce ideas, appearances, and stereotypes.

Wren et al. focus on the enigmatic Upper Temple of the Jaguars murals and propose that the murals probably were created for selected Itza audiences, with the battle scenes plausibly reinforcing semimythologized historical events. They observe that in battle scenes women are represented as targets of state-sanctioned violence, and they respond in strategic ways. The Itza women wear similar costumes, share a similar palette, lack trappings of individual identity, and are depicted near or inside buildings, perhaps paralleling domestic roles of women during peacetime. The variety of scenes include women acting together while other women seem tempted to flee during battle. Some Itza warriors assert their physical power over escaping women via pose, weapons, and even the suggestion of rape.

Because previous attention focused on identifying locales and ethnicities, these disturbing images have been overlooked. What may the images ultimately express about relations between the Itza and their vanquished enemies? The authors suggest that attaining female labor was one benefit of Itza conquest, and this may be implied in murals that show an Itza camp in which women prepare food and serve it to men.

The art history chapters look anew at well-known buildings and artistic programs at Chichen Itza. Some of the most familiar buildings are not necessarily well understood, as Miller's discussion of the Castillo-sub demonstrates. The authors moreover approach their subjects as structures that people both inhabited and viewed rather than as static, empty spaces—this is vital in order to understand Chichen Itza as a functioning city.

Summary

The following chapters engage with the current state of Chichen Itza scholarship, as the book went to press in 2017. Each year new findings, hieroglyphic decipherments, and readings of visual culture provide further knowledge of northern Yucatan. The chapters exhibit diverse scholarly interests and flexibility in investigating and crafting questions about material and visual culture and looking anew at familiar and new sites, buildings, and imagery. The landscapes analyzed, at Chichen Itza and surrounding sites, are considered as loci for habita-

tion, exchange, transformation, ritual, interaction, commemoration, and more. The varied terminology, use of data sets, questions pursued and answered, and theoretical approaches epitomize the breadth of Chichen Itza scholarship.

Acknowledgments

Two anonymous reviewers and Mark Graham provided valuable feedback. Ben Volta and Geoff Braswell provided assistance regarding the nuances of chronology. Thank you to Matt Dooley for making the map that is Figure 1.2 and to Ben Volta for making the chronological chart that is Figure 1.3.

Notes

1. This situation is parallel to the Toltecs, another enigmatic Postclassic Mesoamerican group. In addition to inhabitants of the mythic Tollan and the geographic Tula in Hidalgo, Mexico, the Toltecs have been identified as historical inventions of the Aztecs in sources that range from histrionic (Brinton 1887) to nuanced regarding Aztec rhetorical use of history (Carrasco 2001; Florescano 1999; Gillespie 2011), and a point of confusion regarding mythic and actual geography (Kristan-Graham 2011).

2. In a corrective to museums of Euro-American art that has ramifications for material culture and art history, Kurt Forster (1972) suggests that holdings be expanded to include everyday objects in addition to the so-called fine arts. This would lead to a fuller understanding of how objects were created, used, and perceived.

Pre-Columbian and other branches of art history that study the non-West approached the visual arts as material culture prior to the discipline's recent interest in material culture. Art that archaeologists and anthropologists recovered lent itself to analyses of material form, use, and aesthetics. George Kubler, the founder of Pre-Columbian art history in the U.S., wrote in 1962 that archaeology and ethnology examine material culture and suggested that a "history of things" replace the "bristling ugliness of material culture" and intended this history to "reunite ideas and objects under the rubric of visual forms so that the term includes both artifacts and works of art" (Kubler 1962: 9). In the 1980s, Cecelia Klein (1982: 5–6) argued that the "new archaeology" offered an inroad for art historians to broaden their approach to visual culture by demystifying religious explanations and adding materialist analyses to understand fully the conditions and contexts of art creation, use, and understanding.

Some 60 years after Kubler, material culture studies help to define art history (Morphy 2010: 266–267). Dissertations, articles, and books that treat art as material culture have multiplied, and some graduate programs in art history stress their material culture foundations (Berlo 2005: 182–186; Cummins 2012; examples of Mesoamerican art history that incorporate approaches to material culture include Brittenham 2009; Guernsey 2010; Mollenhauer 2014; O'Neil 2010; Reese-Taylor and Koontz 2001). More recently, Mary Miller (2006: 375) has called for "relatedness" among the disciplines that examine Pre-Columbian cultures.

3. In the past, ethnohistory contributed to this chronological framework. However, few sources agree about supposed historical events at Chichen Itza or interaction between Yucatan and Central Mexico, and textual studies question if instead the sources have rhetorical

import for the times of their authorship in the sixteenth century, *after* the Spanish Conquest (see Carrasco 2001; Florescano 1999; Gillespie 2011). Too, architectural style was used to date buildings and associated art. Because art can intentionally have an archaizing appearance and dating by style is notoriously difficult, the authors here tend to support style with stratigraphic and ceramic dates.

4. Volta's chronological chart (Figure 1.3) incorporates previous chronologies for Chichen Itza. For the sake of continuity, authors were asked to use the Volta et al. chronology, which incorporates some data from Pérez de Heredia (2012, Pérez de Heredia and Bíró, Chapter 3). The authors, though, were able to use alternative chronologies if they wished. Because Chichen Itza is relatively late in Mesoamerican prehistory (Late Classic–Early Postclassic), dates for it and contemporaneous sites mentioned in this book do not use CE.

5. Thus, it now seems likely that climate rather than foreign invasion may have divided Chichen Itza's occupation, the earlier one coinciding with Terminal Classic southern Chichen Itza and the later one with Early Postclassic northern Chichen Itza. This is vital not only for grasping how environmental conditions affected settlement but also for appreciating some older chronologies. For example, A. M. Tozzer's posthumous 1957 *Chichen Itza and Its Cenote of Sacrifice* was for many years the most complete discussion of Chichen Itza. It included a baroque chronology with five stages—including many subdivisions and Maya and Mexican groups arriving and leaving the site—for which Tozzer has been credited (or blamed). The recent climatological data suggest that while he was essentially correct about one episode of depopulation and resettlement at Chichen Itza, it was for an erroneous reason.

6. Volta et al. essentially agree with Pérez de Heredia's discussion of a linked settlement-ceramic development, yet disagree with his phase names. According to Pérez de Heredia, initial spatial patterns developed in the Yabnal-Motul ceramic phases of the seventh and eighth centuries, followed by a Terminal Classic Huuntun-Cehpech phase settlement, and subsequently an Early Postclassic Sotuta phase settlement.

7. Epiclassic is a term used in Central Mexico for a period that is generally equivalent to the Terminal Classic, which Smith and Bond-Freeman date to 700–1100.

8. At Chichen Itza evidence for the cult includes I-shaped ballcourts, radial pyramids, colonnaded halls, gallery-patios, large civic plazas, molcajetes, and pilgrimages that spread the Feathered Serpent ideology. Pachuca obsidian and Fine Orange and Plumbate evince long-distance trade.

9. Although this does not fit into Johnson's taxonomy of borders in Chapter 4, it can be considered a symbolic or ideological boundary.

10. According to Giles Deleuze's geophilosophy, perception lies at the intersection of matter and space, or at an "in-between" where space is an active agent (Deleuze 1993; Deleuze and Guattari 1987). The junction of people, culture, and architecture can thus be understood as a nexus that has the potential for social formation. Hence, space is not an empty stage set to be occupied, but rather a highly charged arena of social formation where people and space in dialog create relations and meaning (see Normark 2006 for a Deleuzian approach to Maya archaeology.).

11. A word of caution: several hundred of the figures implied in discussions about warfare are males carved on pillars in the Temples of the Chacmool and Warriors and nearby colonnades. While this multitude dons armor and weapons they also wear elite regalia and headdresses, just as rulers did. Maya rulers fused political and military roles and dressed accordingly, and an individual bearing weapons may not solely be a warrior.

References Cited

Ardren, Traci, and Justin Lowry
2011 The Travels of Maya Merchants in the Ninth and Tenth centuries AD: Investigations at Xuenkal and the Greater Cupul Province, Yucatán, Mexico. *World Archaeology* 43: 428–443.

Ashmore, Wendy, and A. Bernard Knapp (editors)
1999 *Archaeologies of Landscape: Contemporary Perspectives.* Blackwell, Malden, Mass.

Ball, Joseph W.
1979 Ceramics, Culture History, and the Puuc Tradition: Some Alternative Possibilities. In *The Puuc: New Perspectives. Papers Presented at the Puuc Symposium, Central College, May, 1977,* edited by Lawrence Mills, pp. 18–35. Scholarly Studies in the Liberal Arts 1. Central College, Pella, Iowa.

Barrera Vásquez, Alfredo, and Silvia Rendón (editors)
1948 *El libro de los libros de Chilam Balam.* Fondo de Cultura Económica, Mexico City.

Basso, Keith H.
1996 *Wisdom Sits in Places: Landscape and Language among the Western Apache.* University of New Mexico Press, Albuquerque.

Bender, Barbara (editor)
1993 *Landscape: Politics and Perspectives.* Berg, Providence, R.I.

Berlo, Janet Catherine
2005 Anthropologies and Histories of Art: A View from the Terrain of Native North American Art History. In *Anthropologies of Art,* edited by Mariët Westermann, pp. 178–192. Sterling and Francine Clark Art Institute, Williamstown, Mass.

Boot, Erik
2005 *Continuity and Change in Text and Image at Chichén Itzá, Yucatan, Mexico: A Study of the Inscriptions, Iconography, and Architecture of a Late Classic to Early Postclassic Site.* Centre for Non-Western Studies Publications no. 135. Research School Centre for Non-Western Studies, Leiden, Netherlands.

Braswell, Geoffrey
2016 Personal e-mail to author, June 8.

Braswell, Geoffrey E., and Nancy Peniche May
2012 In the Shadow of the Pyramid. Excavations of the Great Platform of Chichen Itza. In *The Ancient Maya of Mexico: Reinterpreting the Past of the Northern Maya Lowlands,* edited by Geoffrey E. Braswell, pp. 229–258. Equinox, Sheffield, England.

Brinton, Daniel Garrison
1887 Were the Toltecs an Historic Nationality? *Proceedings of the American Philosophical Society* 24: 229–241. Philadelphia.

Brittenham, Claudia
2009 Style and Substance, or why the Cacaxtla paintings were buried. *RES: Anthropology and Aesthetics* 55/56: 135–155.

Broude, Norman, and Mary D. Garrard (editors)
1982 *Feminism and Art History: Questioning the Litany.* Harper and Row, New York.

Buchanan, Ian, and Gregg Lambert
2005 Introduction. In *Deleuze and Space,* edited by Ian Buchanan and Gregg Lambert, pp. 1–15. University of Toronto Press, Toronto.

Carrasco, Davíd

2001 *Quetzalcoatl and the Irony of Empire: Myths and Prophecies in the Aztec Tradition*, rev. ed. University Press of Colorado, Boulder.

Castañeda, Quetzil E.

2009 Heritage and Indigeneity: Transformations in the Politics of Tourism. In *Cultural Tourism in Latin America: The Politics of Space and Imagery*, edited by Michiel Baud and Annelou Ypeij, pp. 263–296. Koninklijke Brill NV, Leiden.

Charlot, Jean

1931 Bas-Reliefs from the Temple of the Warriors Cluster. In *The Temple of the Warriors at Chichen Itza, Yucatan* by Earl H. Morris, Jean Charlot, and Ann Axtell Morris. Publication 406. Carnegie Institution of Washington, Washington, D.C.

Charnay, Désiré

1885 *Les anciennes villes du Nouveau Monde*. Paris.

Cobos Palma, Rafael

2006 The Relationship Between Tula and Chichén Itzá: Influences or Interaction? In *Lifeways in the Northern Maya Lowlands: New Approaches to Archaeology in the Yucatan Peninsula*, edited by Jennifer P. Mathews and Bethany A. Morrison, pp. 173–183. University of Arizona Press, Tucson.

Coggins, Clemency C.

2002 Toltec. *RES: Anthropology and Aesthetics* 42: 34–85.

Cohodas, Marvin

1978 *The Great Ball Court of Chichen Itza, Yucatan, Mexico*. Garland, New York.

Conlin, Jennifer

2007 Newest Wonders of the World Prompt More than Wonder. *New York Times,* July 22: TR2. New York.

Cosgrove, Denis E.

1998 *Social Formation and Symbolic Landscape*. University of Wisconsin Press, Madison.

Cummins, Tom

2012 Looking Back at the Future of Pre-Columbian Art History. Theory, Method, & the Future of Pre-Columbian Art History, edited by Cecelia F. Klein. 100th Annual Conference of the College Art Association, Los Angeles, California, February 24, 2010. *Journal of Art Historiography* 7 (December): 19–25.

de la Garza Camino, Mercedes (editor)

1983 *Relaciones histórico-geográficas de la Gobernación de Yucatán*. 2 vols. Instituto de Investigaciones Filológicas, Centro de Estudios Mayas. Universidad Nacional Autónoma de México, Mexico City.

Deleuze, Gilles

1993 *The Fold: Leibniz and the Baroque*, translated by Tom Conley. University of Minnesota Press, Minneapolis.

Deleuze, Gilles, and Felix Guattari

1987 *A Thousand Plateaus: Capitalism and Schizophrenia*, translated by Brian Massumi. University of Minnesota Press, Minneapolis.

Dowd, Anne S.

2015 Maya Architectural Hierophanies. In *Cosmology, Calendars, and Horizon-Based Astronomy in Ancient Mesoamerica*, edited by Anne S. Dowd and Susan Milbrath, pp. 37–75. University Press of Colorado, Boulder.

Drucker, Johanna
1992 Visual Pleasure: A Feminist Perspective. *M/E/A/N/I/N/G*, no. ll: 3–11.
Florescano, Enrique
1999 *The Myth of Quetzalcoatl*, translated by Lisa Hochroth. Johns Hopkins University Press, Baltimore.
Forster, Kurt
1972 Critical History of Art, or Transfiguration of Values? *New Literary History* 3: 459–470.
Freidel, David A., Linda Schele, and Joy Parker
1993 *Maya Cosmos: Three Thousand Years on the Shaman's Path*. William Morrow, New York.
Garza Tarazona de González, Silvia, and Edward B. Kurjack
1980 *Atlas Arqueológico del estado de Yucatan*. 2 vols. Instituto Nacional de Antropología e Historia, Mexico City.
Getch Clarke, Holly A.
2005 Land-scopic Regimes: Exploring Perspectival Representation beyond the "Pictorial" Project. *Landscape Journal* 24: 50–68.
Gillespie, Susan D.
2011 Toltecs, Tula, and Chichén Itzá: The Development of an Archaeological Myth. In *Twin Tollans: Chichén Itzá, Tula, and the Epiclassic to Early Postclassic Mesoamerican World*, rev. ed., edited by Jeff Karl Kowalski and Cynthia Kristan-Graham, pp. 61–92. Dumbarton Oaks, Washington, D.C.
Grube, Nikolai, and Ruth J. Krochock
2011 Reading between the Lines: Hieroglyphic Texts from Chichén Itzá and Its Neighbors. In *Twin Tollans: Chichén Itzá, Tula, and the Epiclassic to Early Postclassic Mesoamerican World*, rev. ed., edited by Jeff Karl Kowalski and Cynthia Kristan-Graham, pp. 157–193. Dumbarton Oaks, Washington, D.C.
Guernsey, Julia
2010 *Ritual and Power in Stone: The Performance of Rulership in Mesoamerican Izapa Style Art*. University of Texas Press, Austin.
Hayden, Dolores
1995 *The Power of Place: Urban Landscapes as Public History*. MIT Press, Cambridge.
Headrick, Annabeth
1991 The Chicomoztoc of Chichen Itza. M.A. thesis, Department of Art History, University of Texas Press, Austin.
Hendon, Julia A.
2010 *Houses in a Landscape: Memory and Everyday Life in Mesoamerica*. Duke University Press, Durham, N.C.
Johnson, Scott A. J.
2012 *Late and Terminal Classic Power Shifts in Yucatan: The View from Popola*. PhD diss., Department of Anthropology, Tulane University, New Orleans. University Microfilms, Ann Arbor, Mich.
Jones, Grant D.
1998 *The Conquest of the Last Maya Kingdom*. Stanford University Press, Stanford.
Jones, Lindsay
1995 *Twin City Tales: A Hermeneutical Reassessment of Tula and Chichen Itza*. University of Oklahoma Press, Norman.

Kennett, Douglas J., Sebastian F. M. Breitenbach, Valorie V. Aquino, Yemane Asmerom, Jaime Awe, James U. L. Baldini, Patrick Bartlein, Brendan J. Culleton, Claire Ebert, Christopher Jawza, Martha J. Macri, Norbert Marwan, Victor Polyak, Keith M. Prufer, Harriet E. Ridley, Harald Sodemann, Bruce Winterhalder, and Gerald H. Haug
 2012 Development and Disintegration of Maya Political Systems in Response to Climate Change. *Science* 338: 788–791.

Klein, Cecelia F.
 1982 The Relation of Mesoamerican Art History to Archaeology in the United States. In *Pre-Columbian Art History: Selected Readings*, edited by Alana Cordy-Collins, pp. 1–6. Peek Publications, Palo Alto.

Kowalski, Jeff K., and Cynthia Kristan-Graham (editors)
 2011 *Twin Tollans: Chichén Itzá, Tula, and the Epiclassic to Early Postclassic Mesoamerican World*, rev. ed. Dumbarton Oaks, Washington, D.C.

Kristan-Graham, Cynthia
 2011 Structuring Identity at Tula: The Design and Symbolism of Colonnaded Halls and Sunken Spaces. In *Twin Tollans: Chichén Itzá, Tula, and the Epiclassic to Early Postclassic Mesoamerican World*, rev. ed., edited by Jeff Karl Kowalski and Cynthia Kristan-Graham, 429–467. Dumbarton Oaks, Washington, D.C.

Krochock, Ruth J.
 1988 The Hieroglyphic Inscriptions and Iconography of the Temple of the Four Lintels and Related Monuments, Chichen Itza. Yucatan, Mexico. M.A. thesis. University of Texas, Austin.
 2002 Women in the Hieroglyphic Inscriptions of Chichén Itzá. In *Ancient Maya Women*, edited by Traci Ardren, pp. 152–170. AltaMira Press, Walnut Creek, Calif.

Kubler, George
 1962 *The Shape of Time: Remarks on the History of Things*. Yale University Press, New Haven.

Lincoln, Charles E.
 1990 *Ethnicity and Social Organization at Chichen Itza, Yucatan, Mexico*. PhD diss., Department of Anthropology, Harvard University, Cambridge. University Microfilms, Ann Arbor, Mich.

Macri, Martha, J., and Matthew George Looper
 2003 *The New Catalog of Maya Hieroglyphs: The Classic Period Inscriptions*. University of Oklahoma Press, Norman.

Middleton, Guy D.
 2012 Nothing Lasts Forever: Environmental Discourses on the Collapse of Past Societies. *Journal of Archaeological Research* 20: 257–307.

Miller, Arthur G.
 1977 "Captains of the Itza": Unpublished Mural Evidence from Chichén Itzá. In *Social Process in Maya Prehistory: Studies in Honour of Sir Eric Thompson*, edited by Norman Hammond, pp. 197–225. Academic Press, New York.

Miller, Mary Ellen
 1985 A Re-examination of the Mesoamerican Chacmool. *Art Bulletin* 67: 7–17.
 2006 The Study of the Pre-Columbian World. In *A Pre-Columbian World*, edited by Jeffrey Quilter and Mary Miller, pp. 363–375. Dumbarton Oaks, Washington, D.C.

Mollenhauer, Jillian
 2014 Sculpting the Past in Preclassic Mesoamerica: Olmec Stone Monuments and the Production of Social Memory. *Ancient Mesoamerica* 25: 11–27.

Morphy, Howard

2010 Art as Action, Art as Evidence. In *The Oxford Handbook to Material Culture Studies*, edited by Dan Hicks and Mary C. Beaudry, pp. 265–290. Oxford University Press, Oxford.

Nochlin, Linda

1971 Why Have There Been No Great Women Artists? *ARTnews* 69 (January): 22–39.

Normark, Johann

2006 Ethnicity and the Shared Quasi-Objects: Issues of Becoming Relating to Two Open-fronted Structures at Nohcacab, Quintana Roo, Mexico. In *Maya Ethnicity: The Construction of Ethnic Identity from the Preclassic to Modern Times*, edited by Frauke Sasche, pp. 61–81. *Acta Mesoamericana*, vol. 19. Verlag Anton Saurwein, Markt Schwaben.

O'Neil, Megan E.

2010 The Material Evidence of Ancient Maya Sculpture. *Journal of Visual Culture* 9: 316–328.

Parker Pearson, Michael

2012 Stonehenge and the Beginning of the British Neolithic. In *Image, Memory and Monumentality: Archaeological Engagements with the Material World*, edited by Andrew M. Jones, Joshua Pollard, Michael J. Allen, and Julie Gardiner, pp. 18–28. Prehistoric Society Research Paper no. 5. Oxbow, Oxford.

Pérez de Heredia Puente, Eduardo J.

2010 Ceramic Contexts and Chronology at Chichen Itza, Yucatan, Mexico. Unpublished PhD diss., Faculty of Humanities and Social Sciences, School of Historical and European Studies, Archaeology Program, La Trobe University, Melbourne, Australia.

2012 The Yabnal-Motul Complex of the Late Classic Period at Chichen Itza. *Ancient Mesoamerica* 23: 379–402.

Prown, Jules

2002 *Art as Evidence: Writings on Art and Material Culture*. Yale University Press, New Haven.

Reese-Taylor, Kathryn, and Rex Koontz

2001 The Culture Poetics of Power and Space in Ancient Mesoamerica. In *Landscape and Power in Ancient Mesoamerica*, edited by Rex Koontz, Kathryn Reese-Taylor, and Annabeth Headrick, pp. 1–27. Westview Press, Boulder, Colo.

Reese-Taylor, Kathryn, Peter Mathews, Julia Guernsey, and Marlene Fritzler

2009 Warrior Queens among the Ancient Maya. In *Blood and Beauty: Organized Violence in the Art and Archaeology of Mesoamerica and Central America*, edited by Heather Orr and Rex Koontz, pp. 39–72. Cotsen Institute of Archaeology Press, Los Angeles.

Ringle, William M.

2017 Debating Chichen Itza. *Ancient Mesoamerica*, 1–18. doi:10.1017/S0956536116000481

Ringle, William M., Tomás Gallareta Negrón, and George J. Bey III

1998 The Return of Quetzalcoatl: Evidence for the Spread of a World Religion during the Epiclassic Period. *Ancient Mesoamerica* 9: 183–232.

Ruppert, Karl

1952 *Chichen Itza: Architectural Notes and Plans*. Publication 595. Carnegie Institution of Washington, Washington, D.C.

Schele, Linda, and Peter Mathews

1998 *The Code of Kings: The Language of Seven Sacred Maya Temples and Tombs*. Scribner's, New York.

Slusser, Andrea B.

2008 Discerning Migration in the Archaeological Record: A Case Study at Chichén Itzá. M.A. thesis, Department of Anthropology. University of Central Florida, Orlando.

Smith, J. Gregory

2000 *The Chichen Itza-Ek Balam Transect Project: An Intersite Perspective on the Political Organization of the Ancient Maya.* PhD diss., Department of Anthropology, University of Pittsburgh. University Microfilms, Ann Arbor, Mich.

Smith, J. Gregory, William M. Ringle, and Tara M. Bond-Freeman

2006 Ichmul de Morley and Northern Maya Political Dynamics. In *Lifeways in the Northern Maya Lowlands: New Approaches to Archaeology in the Yucatan Peninsula*, edited by Jennifer P. Mathews and Bethany A. Morrison, pp. 155–172. University of Arizona Press, Tucson.

Smith, Robert E.

1971 *The Pottery of Mayapan, including Studies of Ceramic Material from Uxmal, Kabah, and Chichen Itza.* 2 vols. Papers of the Peabody Museum of Archaeology and Ethnology, vol. 66. Harvard University, Cambridge.

Sodi Miranda, Federica, and David Aceves Romero

2006 Chichen Itza, Tula y su impacto en la gran Tenochtitlan, a través de la complejidad cultural en el arte y sus implicaciones en la sociedad. In *XIX Simposio de Investigaciones Arqueológicas en Guatemala, 2005*, edited by Juan P. Laporte, Beatriz Arroyo, and Hector E. Mejía, pp. 463–474. Museo Nacional de Arqueología y Etnología, Guatemala City.

Stone, Andrea

1999 Architectural Innovation in the Temple of the Warriors at Chichén Itzá. In *Mesoamerican Architecture as a Cultural Symbol*, edited by Jeff Karl Kowalski, pp. 298–319. Oxford University Press, New York.

Taube, Karl A.

2004 Flower Mountain: Concepts of Life, Beauty, and Paradise among the Classic Maya. *RES: Anthropology and Aesthetics* 45: 69–98.

Tilley, Christopher

1994 *A Phenomenology of Landscape: Places, Paths, and Monuments.* Berg, Oxford.

Timmer, David E.

1997 Providence and Perdition: Fray Diego de Landa Justifies His Inquisition against the Yucatecan Maya. *Church History* 66: 477–488.

Tozzer, Alfred M.

1957 *Chichen Itza and Its Cenote of Sacrifice: A Comparative Study of Contemporaneous Maya and Toltec.* Memoirs of the Peabody Museum of Archaeology and Ethnology, vols. 11–12. Harvard University, Cambridge.

Tozzer, Alfred M. (editor and translator)

1941 *Landa's Relación de las cosas de Yucatán: A Translation.* Papers of the Peabody Museum of American Archaeology and Ethnology, vol. 18. Harvard University, Cambridge.

Volta, Beniamino, and Geoffrey E. Braswell

2014 Alternative Narratives and Missing Data: Refining the Chronology of Chichen Itza. In *The Maya and Their Central American Neighbors: Settlement Patterns, Architecture, Hieroglyphic Texts, and Ceramics*, edited by Geoffrey E. Braswell, pp. 356–402. Routledge, London.

Voss, Alexander, and Markus Eberl

2001 Los Itzaes en Chichen Itza: los datos epigráficos. In *Los Investigadores de Cultura Maya* 9, Tomo I: 152–173. Universidad Autónoma de Campeche, Campeche, Mexico.

Williams, Raymond

1973 *The Country and the City*. Chatto and Windus, London.

Yonan, Michael

2011 Toward a Fusion of Art History and Material Culture Studies. *West 86th: A Journal of Decorative Arts, Design History, and Material Culture* 18: 232–248.

2

The Archaeology of Chichen Itza

Its History, What We Like to Argue About,
and What We Think We Know

BENIAMINO VOLTA, NANCY PENICHE MAY,
AND GEOFFREY E. BRASWELL

Chichen Itza is one of the best-known yet most enigmatic cities of the ancient Maya. Important scholarly debates still surround its basic chronology and the people who built and lived in the city. These academic discussions are complemented by a colorful background of popular speculation. Early explorers, such as Augustus Le Plongeon, merged the two and sometimes created wild tales involving lost continents, unrequited love, sacrificial virgins, and ancient Egypt. These narratives still fuel contemporary interest in Chichen Itza, as do the more recently developed tenets of New Age spirituality.

Although there is no reason to think that Chichen Itza was built by aliens or Queen Moo of Atlantis, the city remains a focus of both scholarly and popular interest. In this introductory chapter, we hope to lift—or at least peek under—the veil of confusion surrounding Chichen Itza. Because we are archaeologists, we concentrate on the history of archaeological exploration and the interpretation of colonial and ancient texts concerning the site. Our goal here is to provide a background to "how we know what we know" about Chichen Itza and to hint at why we still do not know so many important things about this ancient Maya city.

Excavations at Chichen Itza

Early Explorers and Amateur Archaeologists

Chichen Itza stands alone among the hundreds of archaeological sites in the modern Mexican state of Yucatan. The ancient Maya city is now visited by more than a million people each year, with as many as 48,000 guests per day

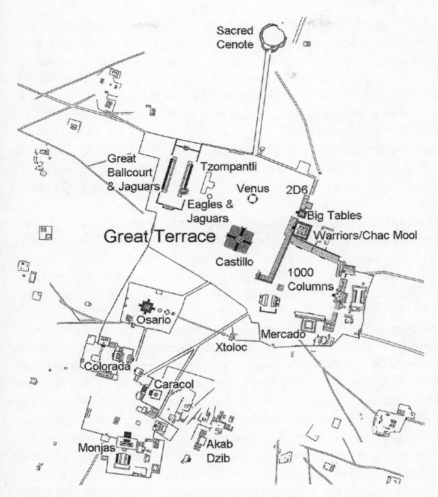

Figure 2.1. Major structures of Chichen Itza that can be visited by tourists. Image by
Beniamino Volta, Nancy Peniche May, and Geoffrey E. Braswell.

witnessing the moving shadows on the Castillo pyramid (Figure 2.1) during
the spring equinox. This fascination with Chichen Itza is not new.[1] During
colonial times, both Maya and Spaniards described Chichen Itza in their
chronicles and other documents, such as the *Relación de las cosas de Yucatán*
(Landa 1978 [1566]), the books of Chilam Balam (Barrera and Rendón 1948),
and the *Relaciones histórico-geográficas de la Gobernación de Yucatán* (de la
Garza 1983).

Throughout the nineteenth century, European travelers and antiquarians

visited the city leaving us important photographs, drawings, paintings, and written descriptions. Among the earliest travelers and antiquarians were John Burke, who visited Chichen Itza in 1838, and Emanuel von Friedrichsthal. The visit of von Friedrichsthal in 1840 was significant because he took the first daguerreotypes of important buildings at Chichen Itza. These photographs were later exhibited at the British Museum (Ewing 1972). In 1842, Benjamin Norman and John Lloyd Stephens separately visited Chichen Itza, but it was Stephens' (1843) vivid description of the site and its buildings that made the most impact. These accounts, along with illustrations created by Frederick Catherwood, are still of great value to archaeologists and tourists alike.

During the 1880s, explorers started using cameras with glass plates. Claude-Joseph Désiré Charnay, for example, took photographs and made a series of sculptural molds during his visit to Chichen Itza in 1882. Charnay (1887) is best known for having recognized architectural and sculptural similarities between Tula and Chichen Itza (see Miller, Chapter 6). Alice D. and Augustus Le Plongeon visited Chichen Itza several times during the last quarter of the nineteenth century. During that time they produced a series of photographs, plans, and drawings. The Le Plongeons also were the first to conduct excavations at the site, exploring the Platform of the Eagles and Jaguars and the Platform of Venus with the goal of proving that the Maya founded New World civilization. During their excavation of the Platform of the Eagles and Jaguars, the Le Plongeons discovered the first *chacmool* sculpture (Desmond and Messenger 1988). The Le Plongeons' excavations mark the transition between the era of exploration and the arrival of amateur archaeologists.

The next amateur archaeologist who investigated Chichen Itza was Alfred Percival Maudslay, who spent five months at the site in 1889. Although Maudslay did not excavate, he and Harold N. Sweet created an invaluable collection of descriptions, plans, sculptural drawings, and photographs (Maudslay 1889–1902). Teobert Maler (1932), under the auspices of the Peabody Museum of Harvard University, investigated Chichen Itza and explored the Temple of the Big Tables, where he found a chacmool and some Atlantean figures. Edward Herbert Thompson (1932, 1938), for many years the U.S. Consul in Yucatan, carried out excavations at several structures (for example, the Temple of the Small Tables, the Osario or High Priest's Grave, and the Monjas Complex). Thompson is best known for the dredging of the Sacred Cenote, which not only irreparably damaged it as an archaeological context, but also led to a great legal controversy between Mexico, the Peabody Museum of Harvard, and the Field Museum (Ewing 1972; Piña Chan 1970; Tozzer 1957).

The Carnegie Institute of Washington and the Era
of Professional Excavation

Chichen Itza also drew the attention of Sylvanus Griswold Morley, a profes-
sional archaeologist with an ambitious Maya research program. The great site
of Chichen Itza was to be his operational base. After submitting a proposal
to the Carnegie Institution of Washington (CIW), Morley was appointed Re-
search Associate in Middle American Archaeology and obtained the resources
to carry out his long-term program (Morley 1913). Mexican authorities agreed
to the CIW investigations. Manuel Gamio, then in charge of the Dirección de
Arqueología of the Mexican government, signed a contract authorizing the
CIW to conduct archaeological exploration, excavation, and restoration at
Chichen Itza for a term of ten years.

The archaeological activities of the CIW began with the excavation of the
Group of the Thousand Columns, work that was supervised by Earl H. Mor-
ris. Excavations conducted in 1924 were centered upon the extreme northeast
corner of the group designated the Northeast Colonnade (Morris 1924).

The following year, Morris (1925a, b) undertook the excavation and restora-
tion of the Temple of the Warriors, where he discovered the mural paintings
that once adorned this building as well as the substructure called the Temple of
the Chac Mool. Morris (1925c) also explored the Xtoloc Temple. In that same
year, Oliver G. Ricketson (1925a) worked on the Caracol, a building judged to
be in "urgent need of immediate repair." Ricketson restored the three remain-
ing windows and strengthened a section of the southeast outer wall and arch
that was in a state near to collapse. He conducted archaeo-astronomical obser-
vations in Window 1 and suggested that it functioned as a solar observatory
for determining the summer solstice and the equinoxes. Ricketson (1925b) also
was in charge of reintegrating the hieroglyphic lintels of the Temple of the Four
Lintels to their original positions on the doorjambs.

In 1926, George C. Vaillant and J. Eric Thompson investigated the Initial
Series Group, located in the area known as "Old Chichen" (see Figure 1.1). The
Temple of the Initial Series, the Temple of the Little Heads, and the Temple of
the Atlantean Columns were excavated and exploratory work was conducted
in the Temple of the Phalli (Strömsvik 1933).

From 1926 to 1928, Earl Morris (1926, 1927, 1928) focused his work on the
Temple of the Warriors, including the Northwest Colonnade and Temple of the
Chac Mool. By the end of the 1927 field season, Morris had obtained enough
data to establish a construction sequence for the Temple of the Warriors com-
plex. The sequence began with a terrace, on top of which the West Colonnade

of the Group of the Thousand Columns was erected. Later, the floor that lies between the West and Northwest Colonnades was constructed. On top of this was built the Temple of the Chac Mool, which later was completely covered by the Temple of the Warriors. Finally, the Northwest Colonnade was built. This stratigraphic analysis proved that both the Temple of the Chac Mool and the Temple of the Warriors were built after the Castillo pyramid. Morris was not the only scholar who worked at the Temple of the Warriors Complex. Jean Charlot (1927, 1928) illustrated the sculptures and paintings uncovered during the exploration of the North and Northwest Colonnades, as well as the low-relief figures on the columns of the Temple of the Chac Mool and the Temple of the Warriors. Ann Axtell Morris (1928) also studied the mural paintings and painted reliefs found in the Temple of the Chac Mool.

Paul S. Martin (1928) was in charge of excavating and restoring the Temple of the Three Lintels, an activity that he carried out during the 1927 and 1928 field seasons. The four exterior walls and the two interior partitions were reerected and the building was roofed over as part of the restoration work. This was one of the few buildings completely restored by the CIW project.

Karl Ruppert was a particularly important member of the CIW team at Chichen Itza. He excavated major buildings from 1926 to 1932. In 1927, Ruppert (1927) supervised the excavation and restoration of the Temple of the Wall Panels. From 1928 to 1931, he concentrated on excavating and restoring the Caracol, along with its West and South Annexes, the East Building, the Portal Vault, the Sweat House, and the Bench House (Ruppert 1929, 1931). Ruppert also contributed to the reconnaissance of the "outlying sections" of the settlement, exploring the territory east, southeast, south, and southwest of the Hacienda Chichen Itza (Ruppert 1928). Among the structures discovered during his reconnaissance was a circular building, named the Casa Redonda, thought to be similar to the Caracol. This building was partially excavated by H.E.D. Pollock (1929, 1936) in order to determine its function, but an astronomical purpose could not be proven through azimuth measurements. In 1932, after his work at the Caracol was over, Ruppert investigated and restored the Mercado, a structure that forms the southern section of the Group of the Thousand Columns (Kidder 1932).

In 1933, Gustav Strömsvik (1933) consolidated the Temple of the Phalli, in the Old Chichen area. The last major building to be investigated by the CIW archaeological team was the Monjas. John S. Bolles (1933, 1934, 1977) was in charge of this enterprise. Bolles spent three field seasons (1932–1934) excavating and consolidating the Monjas Complex and its two annexes, the Iglesia, and the neighboring ball court. The CIW Chichen Itza project continued until 1944, but project members conducted no major excavations after 1934.

Mexican Excavation and Reconstruction at Chichen Itza
during the Early and Middle Twentieth Century

The Mexican federal government also was interested in investigating Chichen
Itza and, through the Dirección de Arqueología, carried out professional ar-
chaeological research at the site. Details of this work are known today largely
because of Rubén Maldonado Cárdenas (1997), who has published descrip-
tions of excavations and restoration efforts.

José Reygadas Vértiz was the representative of the Mexican government and
the director of the Mexican team. The team focused its activities on the Cas-
tillo, the Great Ball Court, and minor buildings on the Great Terrace. Mexican
work at Chichen Itza started in 1920, when Miguel Angel Fernández was com-
missioned by the Director of Anthropology to produce models of the princi-
pal buildings. In 1923, Fernández was given the responsibility of clearing and
restoring the Great Ball Court Group, focusing on the Temple of the Jaguars
(Ewing 1972).

Mexican archaeological interventions at Chichen Itza continued in 1926,
when Eduardo Martínez Cantón began excavations of the Castillo. He would
spend a total of six years on this project, focusing on consolidating and re-
constructing the vault and upper rooms of the superstructure, the nine levels
of the pyramid, and three of the four staircases of the radial platform.

From 1930 to 1932, Martínez, assisted by Emilio Cuevas, consolidated the
Temple of the Jaguars under the direction of Juan Palacios. Cuevas invento-
ried the cut stones in order to reintegrate them, but realized that it was dif-
ficult to establish which stones were missing. They decided that only those
blocks found in situ and those that matched the reliefs would be incorpo-
rated into the consolidation. From 1931 to 1934, Martínez spent three seasons
exploring and consolidating the east and west structures of the Great Ball
Court, as well as its North and South Temples. Concurrent with this work,
he supervised the excavation of a tunnel into the Castillo, which led to the
discovery of the famous Castillo-sub (Maldonado 1997).

In 1935, Manuel Cirerol Sansores became the Inspector of the Archaeologi-
cal Zones of Yucatan. Under his direction, work continued in the tunnel with
the goal of exploring and consolidating the Castillo-sub (see Miller, Chapter
6). Cirerol also consolidated a section of the Great Ball Court and the final
portion of the Temple of the Jaguars, the west facade of the East Building of
the Monjas Complex, and conducted minor work at the Akab Dzib (Maldo-
nado 1997).

José Erosa Peniche was an important member of the Chichen Itza Project

beginning in 1929. From 1929 to 1932, Erosa undertook the job of excavating and restoring the Tzompantli and the Platform of the Eagles and Jaguars. In 1940, as an archaeologist of the newly formed Instituto Nacional de Antropología e Historia (INAH), Erosa returned to Chichen Itza to excavate the northeast and southeast sections of the Temple of the Jaguars. The following year, he dug a test pit at the base of the staircase of the Castillo-sub that is important to our understanding of the construction sequence of the Great Terrace. Later on, Erosa opened a tunnel to explore the interior of the Castillo-sub, where he discovered a second, even earlier, substructure. Unfortunately, he was unable to fully explore it because it was dangerous to continue with the excavation of the tunnel (Erosa 1948; Maldonado 1997).[2]

In 1951, Erosa returned to the Platform of the Eagles and Jaguars in order to continue its exploration and consolidation. Jorge R. Acosta also directed the consolidation of this platform and continued exploration of the Tzompantli. Likewise, Acosta conducted minor works at the Casa Colorada and the Caracol. In 1954, Alberto Ruz Lhuillier excavated and restored the sweat bath located by the Sacred Cenote (Maldonado 1997). Previously, during the 1940s, Ruz (1948) had excavated the West Gate of the wall surrounding the Great Terrace, a portion of the wall that no longer exists (Hahn and Braswell 2012).

During the 1960s, INAH undertook two subaquatic studies in the Sacred Cenote to recover artifacts and human bones. Román Piña Chan, Pablo Bush Romero, and Norman Scott directed the 1960–1961 exploration, while the 1967–1968 explorations were carried out under Piña's direction (Folan 1974; Piña Chan 1970).

Recent Excavations at Chichen Itza

INAH has continued to carry out excavation and consolidation at Chichen Itza since the 1960s. In 1980, for instance, an INAH team under the direction of Peter Schmidt consolidated the east and south sides of the rooms in the superstructure of the Castillo (Maldonado 1997). Agustín Peña Castillo excavated and consolidated the West Colonnade, including the entrance of the Group of the Thousand Columns. Schmidt also directed the excavation of test pits and trenches in the Great Terrace to install fixtures and electrical lines for the light-and-sound show (Schmidt and Pérez de Heredia 2006; see also Volta and Braswell 2014).

In 1993, INAH established a new excavation and consolidation program under the direction of Peter Schmidt (2011: 114–117). Eduardo Pérez de Heredia Puente, Rocío González de la Mata, Francisco Pérez Ruiz, Lilia Fernández

Souza, José Osorio León, Víctor Castillo Borges, and Geoffrey E. Braswell were among the many archaeologists who participated in the field and laboratory on Schmidt's Proyecto Arqueológico Chichén Itzá–Instituto Nacional de Antropología e Historia (INAH). The objective of the project was to work in areas where limited previous investigations had been conducted. Major excavations were carried out around Sacbe 1 (including Access 1 and Structure 2D13), the Temple of the Big Tables and the adjoining gallery-patio building (Structure 2D6), the architectural complex at the northeast and east end of the Group of the Thousand Columns, the Osario Plaza and Complex, the Xtoloc Temple, and in *chultuns* and *rejolladas* near the Temple of the Three Lintels. A few years later, Pérez Ruiz excavated and consolidated several structures on land belonging to the Hotel Mayaland. In a still later phase of Schmidt's extensive and important project, excavations and consolidation were conducted in the Group of the Initial Series. A long section of the wall surrounding the Great Terrace, including two of its gates, and an elevated colonnade and a round platform were excavated and consolidated (Castillo 1998; Osorio 2004, 2005; Pérez de Heredia 2001; Pérez Ruiz 2005; Schmidt 2011).

Under the same permit and in 1997, Rafael Cobos Palma (2003; see also Fernández 1999), a professor at the Universidad Autónoma de Yucatán (UADY), directed horizontal excavations at three structures in the Sacbe 61 Group as part of his doctoral dissertation research on settlement patterns at Chichen Itza. In this work, Cobos was assisted by Lilia Fernández Souza, Geoffrey E. Braswell, and Jennifer B. Braswell. Excavations were designed to answer questions related to the chronology of this small group that includes a temple (Structure 2A21), an altar (Structure 2A22), and a patio with a frontal gallery (Structure 2A17). Concurrent with this work, Geoffrey Braswell conducted a series of test pits in outlying groups of the site in order to gather more temporal information about the pattern of expansion of the city. It is noteworthy to mention that Charles Lincoln (1990) had previously conducted his dissertation research on the settlement pattern of Chichen Itza (see below) and, although he focused on surveying the site, also placed 21 test pits in several platforms located in Old Chichen.

In 2009, Cobos began the archaeological project *Chichén Itzá: estudio de la comunidad del Clásico Tardío*. Braswell and a team of graduate students from the University of California–San Diego (UCSD) were invited to conduct research parallel to the UADY team. The UADY team was supervised by Fernández and focused on excavating and restoring the gallery-patio building (Structure 2D6) adjacent to the Temple of the Big Tables. The UCSD team concentrated on excavating test pits east of the Castillo and excavat-

ing the wall of the Great Terrace between the Great Ball Court and the site entrance (Braswell and Peniche 2012; Hahn and Braswell 2012; Peniche et al. 2009; Volta and Braswell 2014). Cobos later began reconsolidation of a small section of the northwest portion of the Great Ball Court, work that was concluded by José Huchim Herrera. Also beginning in 2009, José Osorio León and Francisco Pérez Ruiz conducted excavations in the Casa Colorada Group, south of the Osario. Although consolidation and maintenance continue, there has been little archaeological field research conducted at Chichen Itza since 2010.

Settlement Pattern Studies

Just as the history of excavations at Chichen Itza can be described in terms of different periods and goals, so too can settlement pattern research. Broadly speaking, these periods are: (1) early explorations and sketch maps; (2) the CIW mapping project; and (3) modern settlement pattern studies. Nineteenth-century explorers produced a series of more or less impressionistic plans and descriptions of the central area of Chichen Itza, culminating in the highly accurate site map, ground plans, photographs, and illustrations that resulted from Maudslay's (1889–1902: vol. 3, plates 2–65) fieldwork. The massive Carnegie project carried out in the 1920s and 1930s generated a wealth of data on the ancient city, including a detailed map covering the central 5 km of the settlement. CIW researchers also were the first to apply an explicitly scientific approach at Chichen Itza, including investigations on the form and function of buildings, as well as studies of commoner households. Starting in the late 1970s, Mexican and foreign archaeologists have attempted to define the full spatial extent of the settlement and to explain its chronological development in relation to the sociopolitical organization of the city. Specifically, Lincoln (1990) and Cobos (2003) have focused on special-function architectural arrangements and on the spatial layout of the great causeway system of the site. Nonetheless, despite more than a century of fieldwork, very large areas of the site remain unmapped. Systematic data about the chronology and layout of the settlement are lacking, as are accurate estimations of the population of the city at different periods.

Nineteenth-Century Explorations and Sketch Maps

About three centuries after Friar Diego de Landa (1978 [1566]) first visited Chichen Itza and drew a sketch map of the Castillo pyramid, a succession of

travelers from Europe and North America began exploring the ruins of the ancient Maya city. The earliest published plan was drafted by Norman (1843), who visited the site in 1842, about a month before Stephens and Catherwood's arrival. The importance of Catherwood's map and drawings and Stephens' (1843) descriptions has already been discussed.

In 1889, Maudslay (1889–1902) and Sweet photographed, excavated, and surveyed in an area encompassing about "a thousand yards square" between the Sacred Cenote and the Monjas Complex. Like previous explorers, they focused on the standing monumental architecture in their survey, but also noted "small raised foundations, stone-faced terraces, heaps of squared stones, and fragments of columns [extending] a mile or more in each direction" (Maudslay 1889–1902: vol. 5, text vol. 3: 10). Employing villagers from Pisté to clear and burn the vegetation covering the site center, Maudslay recorded about 55 structures, two causeways (Sacbes 1 and 4), portions of the walls enclosing the Great Terrace and the platform of the Osario, and the two central cenotes of the site.

William Holmes (1895), an archaeologist from the Field Columbian Museum of Chicago (now Field Museum of Natural History), spent a week at Chichen Itza in 1895. His report includes a site plan and a perspective drawing of the site center. Although Holmes' plan is similar in extent and overall layout to Maudslay's, it is inferior in both quality and level of detail.

Survey during the Carnegie Years (1924–1954)

Morley's proposal to the Carnegie Institution of Washington for a project at Chichen Itza was conceived to include "a map of the entire city, with detailed ground plans of its individual structures" (Morley 1913: 80). Research under Morley's direction began in 1924 and ended in 1936, and the project was officially closed in 1940. Nonetheless, Carnegie members continued surveying as late as April 1954 (Ruppert and Smith 1955: 59).

The CIW project published four successive versions of the site map of Chichen Itza. The first is included by Morris et al. in their report (1931) on the excavations at the Temple of the Warriors. It covers an area of approximately 2.6 km of the site center surveyed by topographer Jerome Kilmartin in 1924. Ruppert's (1935) report on the excavation and consolidation of the Caracol includes the second map, which incorporates the results of Kilmartin's 1929 survey of an area of about 2.4 km to the south of the Monjas, as well as a smaller section of about half a square kilometer to the west of the 1924 map, recorded by John O'Neill in 1932. The spatial extent of this map—approximately 5 km—

was not further enlarged by following Carnegie work, although members of the project did record structures beyond these limits.

Ruppert's (1952) publication of *Chichen Itza: Architectural Notes and Plans* contains a revised version of the 1935 map (Figure 2.2) and detailed plans and descriptions of most of the numbered structures at the site. Following the publication of this third Carnegie site plan, Ruppert and Ledyard Smith (1957) set out to record low house mounds at the site. They determined that the two most common types of house are single-room structures with a doorway on either side, and adjacent single rooms each with its own doorway. They also noted that, unlike at Puuc sites, most rooms at Chichen Itza appear to have had benches in their interior. It is also important that, unlike commoner houses found in many other parts of the peninsula, those at Chichen Itza (with only one or two exceptions) are rectangular rather than apsidal in plan. The house mounds recorded by Ruppert and Smith were included in the final site map produced by the CIW project, which accompanies Alfred Tozzer's (1957) grand synthesis of the archaeology of Chichen Itza.

The CIW plan of the site center forms the heart of all subsequent maps. Nonetheless, it has been difficult to rectify distances and angles between the site center—roughly the area open to tourists—and outlying groups. Therefore, although the site core map is quite accurate, as are individual sections of the map beyond the core, the relationship between the architecture of the core and the settlement zone is slightly inaccurate in all large-scale maps of Chichen Itza.

Recent Settlement Pattern Studies

Settlement pattern studies at Chichen Itza continued with the establishment of the archaeological zone boundaries, carried out in 1978 under the direction of INAH archaeologist Peter Schmidt. The survey covered 15 km, roughly three times the extent of the final Carnegie map. Nonetheless, it should be noted that the ancient settlement extends beyond the *poligonal de delimitación del sitio* (that is, the boundaries of the archaeological zone) established by Schmidt (Figure 2.3). For instance, Sacbe 3 runs to the northwest for at least 6 km from the site center to the Cumtun Group, well outside the limits of the archaeological zone, and may continue beyond that group (Schmidt 2011: 116).

In 1983–1986, Charles Lincoln of Harvard University remapped a portion of the area commonly known as "Old Chichen," located between the Monjas Complex and the Group of the Three Lintels. Lincoln's research focused on architectural arrangements formed by a "Maya" range structure, a "Toltec"

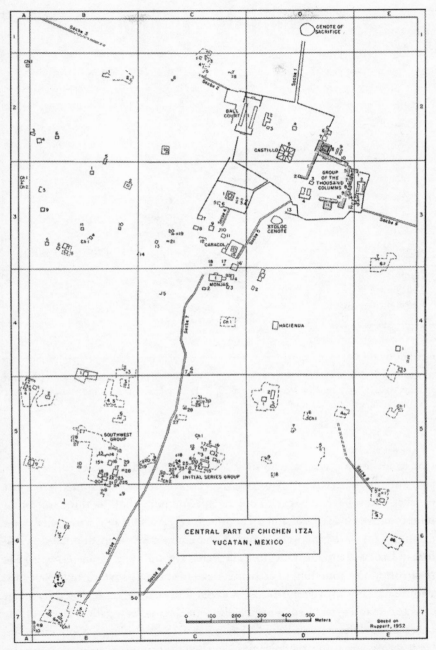

Figure 2.2. Map of the Central Part of Chichen Itza, Yucatan, Mexico (Alfred M. Tozzer, *Chichen Itza and Its Cenote of Sacrifice: A Comparative Study of Contemporaneous Maya and Toltec*. Memoirs of the Peabody Museum of Archaeology and Ethnology, 1957: vol. 12, fig. 1). Copyright 1957 by the President and Fellows of Harvard College.

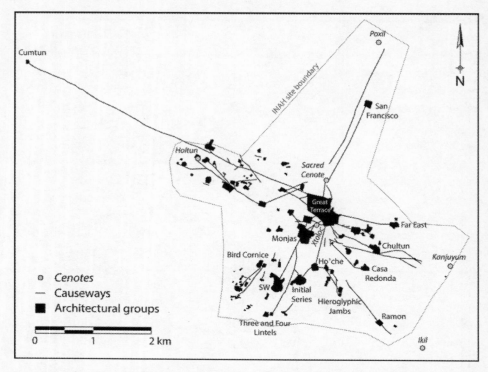

Figure 2.3. Schematic map of Chichen Itza showing cenotes, causeways, and major architectural groups. By Beniamino Volta, Nancy Peniche May, and Geoffrey E. Braswell, after Cobos and Winemiller 2001: fig. 5; Cobos et al. 2008: 72; García Moll and Cobos 2009: 49.

two-room temple with a twin-column entrance, and an "Itzá" gallery-patio structure. Whereas Tozzer (1957) assigned each of these structure types to a distinct chronological period, Lincoln (1986) argued that the three were contemporaneous (see discussion on architectural styles below). He labeled these arrangements "tri-functional groups" and considered them the defining features of the settlement. Lincoln interpreted the building types in relation to the institutional functions of archaic states: (1) a priestly sovereignty, associated with temples; (2) a warrior-based nobility and royalty, represented by range structures; and (3) a class of producers, linked to gallery-patio structures. He characterized the settlement of Chichen Itza as "a single, large, population center which came into existence and developed an internal hierarchy rapidly, changing its internal structure little as it grew" (Lincoln 1990: 579).

Starting in 1993, members of the Proyecto Arqueológico Chichén Itzá–INAH, directed by Schmidt, carried out large-scale excavation and consolida-

tion both in the site center and in the Initial Series group (see above), which they remapped. Project members also conducted survey, surface collection, test pitting, and consolidation at various other locations throughout the site. Schmidt (2011: 116) reported that the extent of the area mapped up to 2003 was more than double that surveyed by Carnegie archaeologists. Much of this mapping was accomplished by Pérez Ruiz, especially in areas southeast of the Great Terrace and even beyond the boundaries of the park, particularly to the east. Figure 2.3 shows only a small amount of the survey accomplished by INAH.

Cobos, who had participated in Lincoln's survey efforts during the 1980s, ran a parallel mapping project in collaboration with the INAH investigations directed by Schmidt. In 1993–1997, he carried out surveys and excavations in groups outside the site center, mapping a 1.2-km-wide transect that extended 2.5 km to the northwest of the Castillo and 1.5 km to the southeast of it. Cobos (2003: 201–206) rejected Lincoln's arguments about tri-functional groups and instead proposed that the defining architectural arrangements of Chichen Itza are composed of temples, altars, and gallery-patio or patio structures. These compounds do not include range structures, which were built at Chichen Itza only until the end of the "Late Classic" (defined by Cobos as 700–900), and especially during the last 50 years of that span, when "Puuc" or "Maya" or "Florescent" architecture was built (see Volta and Braswell 2014). In what Cobos considers the "Terminal Classic" (900–1050), arrangements composed of a gallery-patio structure, a temple, and an altar became the defining architectural unit of the site, and occurred in both the center and the periphery. This order of construction is correct, and essentially states that Puuc-style architecture precedes rather than is coeval with International- or "Toltec"-style architecture.

Cobos and Terance Winemiller (2001) also identified two networks of causeways at Chichen Itza. Cobos (2003: 462) argued that the "Early Sotuta" system of the Late Classic functioned to integrate a settlement composed of "families or other socially homogenous groups who chose to associate to form a community." The radical change of the social, political, and economic organization of the site after 900 is reflected in the dendritic arrangement of the "Late Sotuta" causeway system of the Terminal Classic. This form indicates a more centralized or hierarchical type of community arrangement, which Cobos associated with the transition of Chichen Itza to an administrative city and regional capital functioning as part of a market economy (see Braswell 2010; Braswell and Glascock 2002).

An alternative interpretation of the growth trajectory of the settlement of Chichen Itza was proposed by Eduardo Pérez de Heredia Puente (2010, 2012; hereinafter referred to as Pérez de Heredia), ceramicist for the Proyecto Ar-

queológico Chichén Itzá–INAH. In his model, the spatial patterns for the settlement were laid out in the Yabnal-Motul phase of the seventh and eighth centuries. A period of rapid growth in the Terminal Classic Huuntun-Cehpech phase was followed by additional growth and reorganization of the site center in the Early Postclassic Sotuta phase (see Pérez de Heredia and Bíró, Chapter 3). Pérez de Heredia did not find support for Cobos' identification of an "Early" and "Late" facet for the Sotuta phase, nor for its chronological placement in the Terminal Classic. For Pérez de Heredia, gradual settlement growth in the early part of the Late Classic was followed by two intense building episodes in the ninth (Terminal Classic) and tenth to eleventh centuries (Early Postclassic). This difference in interpretation has more to do with ceramics and terminology than with architectural chronology.

We concur with Pérez de Heredia's description of site growth, his conclusion that the Sotuta phase did not begin until sometime during (perhaps even the middle of) the tenth century, and his use of the phrase "Early Postclassic" for Chichen Itza during the Sotuta phase (Volta and Braswell 2014: 392–393). Nonetheless, we agree with Cobos that there was a distinct break that occurred at about 900. Cobos argues that this break, which we date to roughly 900–950/980, was the result of profound political and economic transformations at the site. We concur, but also see a strong link between the break and a regional drought that led to the collapse and abandonment of the Puuc and most major inland sites of the Northern Maya Lowlands during the first half of the tenth century (Volta and Braswell 2014: 387–388).

These two models for settlement growth—and the competing chronologies on which they rely—illustrate a basic lack of agreement on the ceramic sequence of Chichen Itza and unevenness in coverage of settlement data. Historically, research has focused disproportionately on the site center, leaving large gaps in our knowledge of the outlying areas of Chichen Itza. A systematic mapping project of the site area enclosed by the INAH boundary line has yet to be completed, and each year more areas of the site periphery are lost to urban growth and to the expansion of tourism infrastructure. A more recent mapping project led by Cobos in 2008 and 2009 covered more than 70 hectares in the southwestern portion of the site, with additional reconnaissance carried out in the area to the east of the Chultun Group. The results of this project await publication. Detailed survey—not only of large, architecturally complex groups, but also of low platforms and small house mounds—is fundamental in order to address questions about the structure and chronology of the settlement.

Perhaps the most persistent question in the settlement archaeology of Chichen

Itza concerns demography. How many people lived in the city? We cannot yet answer this securely for any period of its history. Although pottery assigned to the Preclassic through Early Classic periods has been recovered from the site, there is no known architecture at Chichen Itza that old. We suspect that structures dating to this time were torn down in later periods. Only a few Late Classic structures are known, and these are buried or encased within later platforms and structures. Such Late Classic buildings include the House of the Stuccos (within the Temple of the Initial Series; Osorio 2004), Platforms AC3 and AC16 of the Great Terrace (Braswell and Peniche 2012; Volta and Braswell 2014: 368), and probably Erosa Peniche's second substructure of the Castillo (see note 2) and the earliest substructure of the Monjas (Bolles 1977: 86).

For later periods when the site was at its peak (specifically 870–900 and 950/980–1050/1100), we have only the partial map. Population estimates for Chichen Itza vary widely, but 30,000–50,000 seems reasonable for a maximum in the late tenth century. It is important to stress, however, that this range is not based on systematic calculations but instead on guesses and gross comparisons with other large Maya cities. Chichen Itza probably was not as populous as Late Classic Tikal (for which we also still lack a complete map) or Calakmul, but it does seem larger than Classic Dzibilchaltun, Late Classic Copan (including the entire pocket), Late Preclassic Seibal, and Late to Terminal Classic Sayil (see Rice and Culbert 1990: table 1.3).

Ethnohistorical Sources

Archaeological fieldwork at Chichen Itza has been complemented by laboratory analyses of materials and by the study of texts, including early colonial documents and hieroglyphic inscriptions from Chichen Itza and related sites. Until the late twentieth century, ethnohistorical documents were the most important sources of information used to understand the history of Chichen Itza. Scholars have turned to three types of ethnohistorical texts for information about the chronology, political organization, and cultural affiliations of Chichen Itza. These are: (1) the books of Chilam Balam; (2) sixteenth-century Spanish chronicles from Yucatan; and (3) Aztec and highland Maya histories and legends. The Yucatecan sources directly mention Chichen Itza and individuals associated with it. From early on, this information was combined with narratives from Central Mexico and Guatemala to create what Susan Gillespie (2011: 63) has called "the modern 'archaeological myth' of the Toltecs."

The *k'atun* chronicles and prophecies contained in the books of Chilam

Balam, especially those of Chumayel and Tizimin, served during the first half of the twentieth century as the main source of chronological information about Chichen Itza. The dominant historical framework championed by J. Eric Thompson (1937, 1970), Morley (1946), and Tozzer (1957) was built upon Ralph Roys' (1933) correlation of the *k'atun-ajaw* dates for events in the book of Chilam Balam of Chumayel with the Gregorian calendar. These events are: the establishment of Chichen Itza in K'atun 6 Ajaw; its abandonment in K'atun 8 Ajaw; its invasion by Kukulcan (we use here the original spelling, K'uk'ulkan in the new orthography) and the Itza in K'atun 4 Ajaw; and its conquest by Hunac Ceel (Junak Keel) of Mayapan during another K'atun 8 Ajaw.

Landa's (1978 [1566]) *Relación de las cosas de Yucatán* reported that Chichen Itza was ruled by a lord named Kukulcan, who arrived from the west at about the same time as the Itza, and who gave Mayapan its name. Landa also related the story of three brothers who governed Chichen Itza, described the Castillo, and discussed pilgrimages to the Sacred Cenote and the human sacrifices that took place there. The *Relaciones histórico-geográficas de la Gobernación de Yucatán* (de la Garza 1983) describe Chichen Itza as a powerful place whose rulers received tribute or tax from far-flung locations. They also contain references to both a ruler named Kakupacal (K'ak'upakal) and the previously mentioned Kukulcan. In the *Relación de Izamal y Santa María*, the former is identified as a brave Itza captain who founded Mayapan, while the latter was "a Mexican captain . . . who taught idolatry [to the people of Chichen Itza]" (de la Garza 1983: 303–306; trans. by Volta).

Ever since the Conquest, the links in ethnohistorical sources between the feathered serpent figure Kukulcan/Quetzalcoatl, Tollan, and Chichen Itza have provided much ground for speculation. Gillespie (1989) has argued that early Spanish attempts to identify this personage had an important influence on the development of early colonial narratives about him. Starting in the late nineteenth century, scholars—struck by the architectural and iconographic similarities between Tula and Chichen Itza—searched for chronological information in central Mexican and highland Maya documents that could be correlated with existing data about the great Maya city (for example, Jiménez 1941; Kirchhoff 1955; Tozzer 1927). The *Florentine Codex*, the *Anales de Cuauhtitlan*, the *Popol Vuh*, and the *Annals of the Cakchiquels*, among other sources, provide often conflicting evidence that was interpreted, accommodated, and reassessed. The resulting chronological model situated the Toltecs of Tula and the "Toltec-Maya" at Chichen Itza in the Early Postclassic period, after the fall of Classic-period Teotihuacan and before the Aztecs of the Late Postclassic.

Hieroglyphic Research

The history of hieroglyphic research at Chichen Itza began with Morley's (1920, 1925) and J. Eric Thompson's (1927) attempts to identify chronological information that could be correlated with ethnohistorical sources. Hermann Beyer's (1937) structural analysis of the inscriptions of Chichen Itza—for which he infamously cut into individual glyph blocks the rubbings made by John Denison and Conrad Kratz, much to Morley's dismay—was the first comprehensive study of the hieroglyphic record of the site. Beyer's focus on repeating glyph clusters was a major advancement for the analysis of linguistic patterns and equivalencies in ancient Mayan texts, but did little to aid in their interpretation. J. Eric Thompson's (1937) method for reading Short Count dates at Chichen Itza, which made ample use of Beyer's study, also constituted a major breakthrough for the study of the chronology of the Northern Maya Lowlands.

One of the first attempts to extract noncalendrical meaning from the inscriptions of the site was Thomas Barthel's (1955) study of glyphs related to fire drilling in the texts of the Casa Colorada. His reading was confirmed by David Kelley's (1968) landmark phonetic decipherment of the name Kakupacal, a name also mentioned in conquest-period historical documents. Kelley's pioneering study was followed by others identifying the names of individuals, both historical and mythological, in the texts of Chichen Itza (Boot 2005; Davoust 1980; García Campillo 2001; Krochock 1998; Ringle 1990; Wren and Schmidt 1991). Along with these new decipherments came the suggestion that, during its tenth-century apogee, Chichen Itza was ruled by dual leaders or by a council government known as *multepal* (Grube 1994; Krochock and Freidel 1994; Schele and Freidel 1990). Although popular in the 1990s, this proposal has fallen out of favor (Cobos 2011; Grube and Krochock 2011).

Recent studies have attempted to situate the hieroglyphic record of Chichen Itza within the broader political context of the Northern Lowlands, integrating it with data from nearby sites such as Halakal, Yula (Love 1989), and especially Ek Balam (Voss and Eberl 1999). Addressing the political organization of the region in the Late Classic, Grube and Krochock (2011) have argued that, early in its history, Chichen Itza was a secondary site under the control of Ek Balam. During the latter half of the ninth century, this relationship reversed (see Pérez de Heredia and Bíró, Chapter 3). Detailed philological analysis also has revealed important differences—in addition to the use of the Short Count date format—between the hieroglyphic record of Terminal Classic (that is, 832?–897) Chichen Itza and that of Late Classic Ek Balam, which more closely follows the conventions of Southern Lowland

centers. As Pérez de Heredia and Péter Bíró discuss in Chapter 3, these differences include the introduction of Yucatecan linguistic forms at Chichen Itza, as well as an emphasis on the maternal descent of important individuals like Kakupacal and his brother Kinil Copol (K'inil Kopol; Grube and Krochock 2011; Krochock 2002).

One noteworthy aspect about the Mayan hieroglyphic texts of Chichen Itza is the limited period to which almost all of them can be assigned. Of the 51 examples of hieroglyphic dates, just two (from the Temple of the Hieroglyphic Jambs) may date to before 864 and only four (three from the Osario and the circular stone of the Caracol) possibly date to after 897 (Volta and Braswell 2014: table 13.1, fig. 13.10). In fact, the dates of all texts that fall outside of the range 867–897 have been questioned and are subject to debate. Thus, the Mayan hieroglyphic texts at Chichen Itza are mostly limited to the Terminal Classic period, especially the lifetime of the ruler Kakupacal. A poorly understood corpus of non-Mayan, "foreign," or International-style hieroglyphic texts at Chichen Itza is limited to architecture that dates to the Early Postclassic period (Love and Schmidt 2011), 50 to 150 years after the erection of most monuments containing Mayan glyphs.[3]

Points of Contention in Chichen Itza Archaeology

Despite the fact that Chichen Itza has seen more than a century of archaeological, epigraphical, and ethnohistorical research—or perhaps because of this fact—there are many scholarly debates concerning the site. We know far too little concerning the early occupation of the city and the organization of the Itza state. The most important questions have to do with chronology and the nature of relations between the Itza and their counterparts elsewhere in Mesoamerica, especially the Toltecs of Tula and so-called "Mexicanized Maya" living on the Gulf Coast of southern Campeche and Tabasco. This latter topic was the focus of a recent book (Kowalski and Kristan-Graham 2011) and a very thorough and important article (Ringle et al. 1998), and hence will not be addressed in detail in this chapter. Like Ringle (2012), we consider the word "Toltec" to apply to many urban and civilized peoples of Mesoamerica who practiced arts and crafts at a high level and who worshiped the Feathered Serpent. For Postclassic Mesoamerica, the concept of "Toltec" was paired with its wild, nomadic, yet powerful opposite "Chichimec" (amaq' in Kaqchikel Mayan). The mythical struggles between Quetzalcoatl and Tezcatlipoca reflect this duality of enlightened civilization versus the powerful yet untamed wild. Thus, the Itza of late tenth-century Chichen Itza, the Toltecs of Tula, and many other Postclassic city dwellers were all "Toltecs."

Chronological questions concern the relationships between the pottery of Chichen Itza and other regions of the Northern Maya Lowlands (especially the Puuc region), the issue of the potential temporal overlap of specific architectural and ceramic styles, the chronometric placement of the end of major construction at the city and its demographic collapse, and the use of the phrases "Terminal Classic" and "Early Postclassic" as descriptions for the timing and nature of occupation at Chichen Itza. At first glance, this set of questions does not seem to hold much anthropological or historical interest. Nonetheless, how we choose to answer them greatly impacts our overall interpretations of the great city and its role in the Mesoamerican world.

The Ceramic Sequence of Chichen Itza and the Cehpech-Sotuta Problem

We have recently discussed alternative perspectives on the pottery of Chichen Itza (Volta and Braswell 2014: 362–368, 383–385). Problems in the chronology of Chichen Itza can be traced to attempts to create a single, unifying ceramic sequence for the Northern Maya Lowlands. Regional ceramic sequences define major variation in pottery as temporal in nature. In contrast, spatial variation—that is, the difference in pottery among contemporary sites—is often overlooked. Put another way, distinct pottery types found at different sites are often assigned to separate temporal phases even though they may date to the same time. Thus, while individual sequences for distinct sites can allow for significant temporal "overlap" of different types or complexes, pan-regional sequences tend to create "no overlap" models. Contexts containing what are in reality contemporary pottery types that are thought to be temporally distinct are therefore dismissed as chronologically mixed.

Smith (1971), building on earlier and in some ways more useful analyses by Vaillant (1961) and Brainerd (1958), created a unified ceramic chronology for the Northern Maya Lowlands consisting of seven phases from the Middle Preclassic to the Late Postclassic period. The latest complexes (Tases and Hocaba) were established largely from pottery collected at Mayapan. An older complex (Sotuta) was defined principally using collections from Chichen Itza. A still earlier complex (Cehpech) was defined for Uxmal and Kabah and then extended to Mayapan, Chichen Itza, and beyond. Before this is a very problematic complex/phase (Motul) defined at Mayapan from just 357 sherds (Smith 1971: vol. 1: 142), and still earlier complexes/phases defined mostly from small, mixed, and scattered collections. This Franken-sequence, sewn together using complexes defined for distinct sites, works best for the particular periods and sites where each complex was defined. Following Smith (1971), Motul is

traditionally assigned to the Late Classic (600–800), Cehpech to the Terminal Classic (800–1000), Sotuta to the Early Postclassic (1000–1200), Hocaba to the Middle Postclassic (1200–1300), and Tases to the Late Postclassic period (1300–1540). At Chichen Itza, Smith (1971: table 1b) classified the vast majority of the pottery he studied as belonging to the Sotuta complex, only a small number of sherds to the Cehpech complex, none whatsoever to Motul, and just a handful to the earlier Cochuah complex.

By the 1970s, ceramicists began to question if the Cehpech and Sotuta complexes were temporally distinct (Ball 1976, 1979; Lincoln 1986). Specifically, Ball (1976: 328) noted that Cehpech really began as an elite subcomplex within Copo (first defined at Dzibilchaltun, and a much more useful construct than Motul) and spread by merging with other preexisting complexes. Lincoln (1986) discussed "partial" and "total" overlap models. The partial overlap model is characterized first by the appearance of Cehpech pottery in the Puuc, somewhat later the production of Sotuta at Chichen Itza, and finally the disappearance of Cehpech and continuation of Sotuta. Lincoln, however, favored a total overlap model, in which Cehpech and Sotuta were completely coeval. Today, we understand that much of what we call Sotuta, especially the more quotidian groups and types, can be considered as local variants of Cehpech pottery that differ from their Puuc counterparts in the kinds of clay available at Chichen Itza and the firing conditions employed at the site (see Johnson [2012] for a discussion of how Dzitas Slate at Chichen Itza should be considered as a local variant of Muna Slate). Thus, much of what we call Sotuta and Cehpech are regional variants of the same ceramic ideas. The local utilitarian pottery of the Cehpech and Sotuta complexes belong to the same Northern Lowland tradition.

Nonetheless, the Sotuta complex—as defined by Smith—also includes decorative modes, forms, and even types that are clearly of foreign inspiration or origin. What chiefly differentiates Sotuta from Cehpech—and what makes Sotuta useful as a construct—is not the local, everyday pottery belonging to a long-standing Yucatan tradition shared by the two complexes. Instead, it is the elite wares that were either imported or inspired by foreign influence. This "full" Sotuta complex, containing foreign ideas and actual imports, does not overlap to any great extent with the Cehpech pottery of the Puuc region. We now know that the Puuc was largely abandoned sometime during the first half of the tenth century (Braswell et al. 2011; Dunning and Kowalski 1994). At roughly the same time—or perhaps slightly later—the earliest Sotuta pottery appeared at Chichen Itza. "Full" Sotuta as defined by Smith (1971) truly *is* later than Cehpech, and any potential overlap is minimal and limited to the period after the collapse of most Terminal Classic cities.

Eduardo Pérez de Heredia (2010, 2012; Pérez de Heredia and Bíró, Chapter 3) has made great breakthroughs in understanding the ceramics of the Late Classic period. Unfortunately, he employs a binomial nomenclature that in-cludes new local phase names and Smith's ceramic complexes/spheres. Thus, the Late Classic phase is called "Yabnal-Motul" even though Smith found *no* Motul sherds at Chichen Itza. The Yabnal-Motul complex defined by Pérez de Heredia is therefore completely different from Smith's Motul complex. This is followed at Chichen Itza by the Huuntun-Cehpech complex (Pérez de Heredia and Bíró, Chapter 3). It is important to stress that Pérez de Heredia found very few to no Cehpech sherds in the fill of most of the Puuc-style structures that he dates to this phase, although he reports some sherds (58 of a total of 172) for the Akab Dzib (Pérez de Heredia 2010: charts 15 and 16). He also found more Cehpech sherds in a test pit off the "Motul" Terrace of the Initial Series Group (Test Pit F399, especially Layers II–IV) and in the fill of Structure 5C2-sub (Pérez de Heredia 2010: charts 17 and 18). Nonetheless, he documents *only one* pure Cehpech context, containing just 27 sherds (Test Pit 21, Layer III, in Terrace 4D6; Pérez de Heredia 2010: chart 20). This dearth of Cehpech ceramics in Puuc-style structures is explained in terms of the time lag for pottery to enter the waste stream (Pérez de Heredia 2010: 128).

The paucity of diagnostic pottery assigned to a given complex seems to us to be a weak reason to propose a discrete ceramic phase named for that complex, let alone a construction episode dating to that phase. We therefore are not yet convinced that a stand-alone Cehpech phase exists at Chichen Itza, and at the moment prefer to place the construction of Puuc-style structures during Kaku-pacal's reign toward the end of the Yabnal phase (the name we advocate for Pérez de Heredia's Late Classic complex). Although there certainly is some Cehpech pottery at Chichen Itza, we currently favor considering Huuntun as a subcom-plex or facet within late Yabnal. Most contexts where Cehpech pottery has been found contain much more Yabnal or Sotuta pottery. Moreover, there just are not enough "pure" Cehpech contexts (so far, just one) with a significant number of sherds to view Huuntun as a stand-alone complex representing a distinct phase.

What Pérez de Heredia makes absolutely clear is that the Puuc-style archi-tecture of the late ninth century was built *before* the Sotuta phase. This is a critical and very important correction to earlier misstatements (Braswell and Peniche 2012: 230; Cobos 2004, 2011; Grube and Krochock 2011: 176).

Pérez de Heredia (2010: 182) calls the next phase Sotuta-Sotuta and cor-rectly notes that all "International-style" architecture dates to this time. He follows this with the Kulub-Hocaba phase, during which no major buildings were constructed, and the Late Postclassic Chenku-Tases phase. Like other

scholars (Ringle et al. 1998: 189–190), we do not consider Hocaba to be a complete complex. Rather, Hocaba pottery dates to the rather long period of 900/1050–1250/1300 (Ochoa Rodriguez 1999).

The Architectural Sequence of Chichen Itza
and the Maya-"Toltec" Overlap Problem

A similar problem of stylistic overlap has confused understanding of the architecture of Chichen Itza. Early scholars noted two architectural styles at the site and argued they were sequential. First came a "Maya," "Puuc," or "Florescent" architectural style related to (but not precisely the same as) the Classic Puuc Mosaic style. Many of the buildings found south of the Great Terrace—including the Casa Colorada, the Monjas, the Iglesia, the Temple of the Three Lintels, and the Akab Dzib—are built in this style. Most of the hieroglyphic inscriptions with dates are found on these structures, implying they were built during the reign of Kakupacal in the late ninth century. This flurry of construction activity, therefore, took place a few decades before that of Lord Chaak at Uxmal.

According to this traditional (and we argue, correct) perspective, so-called "Old Chichen" was followed by "New Chichen," with the many "Mexican-," "Maya-Toltec-," "Modified Florescent-," or "International-" style structures of the Great Terrace. With the exception of the Osario, which contains two dates corresponding to 998 and possibly a third of 1007, we do not have hieroglyphic dates for International-style structures.

Some scholars have claimed that these two architectural styles overlap in time in a manner similar to that proposed for Cehpech and Sotuta pottery (Cohodas 1978; Lincoln 1986, 1990; Schele and Freidel 1990; Schele and Mathews 1998). But like those ceramic complexes, any overlap in architectural styles is minimal at Chichen Itza. Recent stratigraphic research demonstrates, for example, that the Great Ball Court—one of the International-style monuments claimed to be early—actually was one of the last structures built on the Great Terrace (Braswell and Peniche 2012). Recent radiocarbon assays also place a lower bound on the International style at about 900, and suggest the Castillo—one of the oldest known International-style structures—probably dates to 950 or even slightly later (Volta and Braswell 2014; see also Schmidt 2011). This is in relatively close accord with Thompson's (1970) placement of the beginning of "Toltec" architecture at about 10.8.0.0.0 or 987. The era of greatest building activity on the Great Terrace was the end of the tenth century and, probably, the early eleventh. The Puuc and International architectural styles are *not* contemporary.

The End of Construction and the Collapse of Chichen Itza

Chichen Itza was never truly abandoned and, in fact, was still an important place when the first *Ciudad Real* in Yucatan was established there by Francisco de Montejo in the early 1530s. CIW researchers noted that the Temple of the Warriors was restuccoed more than 100 times, and Tases-complex pottery was found beneath the final floor of the Caracol. Nonetheless, very little of consequence was built at Chichen Itza after the great construction boom of International-style architecture. Hocaba pottery, principally types called Peto Cream, Kukula Cream, or Coarse Slate Ware, is found in very minor structural alterations and generally in above-floor contexts. We cannot precisely date the appearance of this pottery at Chichen Itza, but much seems to be found in contexts dating after 1000. The end of major construction at Chichen Itza could have occurred that early. A more likely date is sometime during the eleventh century. The year 1200 now seems far too late on ceramic grounds. Recent high-resolution paleoenvironmental data from Yok Balum Cave, Belize, place the most severe drought seen in that region at about 1000–1100 (Kennett et al. 2012). Archaeological evidence from the Holtun Cenote at Chichen Itza (Figure 3.4) also indicates particularly dry conditions in the eleventh century (Cobos et al. 2014). Taken together, these data suggest that the ultimate collapse of Chichen Itza may have been tied to environmental factors.

The Terminal Classic versus the Early Postclassic

For most of the twentieth century, Chichen Itza and its counterpart, Tula, were viewed as the defining sites of the Early Postclassic period. Because of lingering questions regarding the ceramics of Chichen Itza—especially the Cehpech-Sotuta overlap debate—in the 1980s scholars began to push back the chronology of the site. By the 1990s, art historians and epigraphers, most notably Linda Schele (in Schele and Freidel 1990; Schele and Mathews 1998), began to reinterpret hieroglyphic dates at Chichen Itza and see more ties with the artistic programs of the Classic Maya than with broader Postclassic Mesoamerica. Many scholars began openly to call Chichen Itza a Terminal Classic or even an Epiclassic site, rather than describe it as Early Postclassic in character.

Most North American archaeologists working in Yucatan have adopted this position, as a survey of many of the chapters in *Twin Tollans: Chichén Itzá, Tula, and the Epiclassic to Early Postclassic Mesoamerican World* (Kowalski and Kristan-Graham 2011) reveals. Nonetheless, there is something fundamentally flawed with this viewpoint. Chichen Itza has *both* Terminal Classic and Early

Postclassic components. They are distinct and separated by the turbulent years of the early tenth century.

The late ninth century saw the first great period in the history of Chichen Itza. Kakupacal became the ruler of the Itza and the dominance of Ek Balam (or, as we are now thinking, Yaxuna) over the site ended. Many great structures were built in the Puuc style as Chichen Itza asserted its independence. The pottery belonged either to the Yabnal complex (preferred by us) or the Cehpech complex (preferred by Pérez), and was closely related to—but distinct from—the ceramics produced in the Puuc region. Over a period of about 30 years, many monuments containing Mayan hieroglyphic texts were carved. All of this was in the decades immediately before the final, great florescence of Uxmal. It makes complete sense to call this the Terminal Classic period.

The first half of the tenth century, however, was a period of great decline across the Northern Maya Lowlands (for a summary, see Braswell [2012: 19–21]). The Puuc and many other inland regions were largely abandoned. Population levels plummeted throughout the Northern Lowlands. It seems likely that a major subsistence failure, driven by drought, occurred across the region. Most great sites fell, but some of those with close ties to the coast—where alternative subsistence strategies were developed and new trade routes flourished—continued to be occupied. Chichen Itza was one of the few large cities that survived the collapse of the early tenth century. In part, this may have been due to its coastal connections with Isla Cerritos and Emal. Its survival might also reflect the singular importance of Chichen Itza as a pilgrimage and elite inauguration center in the cult of Quetzalcoatl/Kukulcan (Ringle 2004; Ringle et al. 1998).

There is very little evidence for construction during the first half of the tenth century at Chichen Itza, although the Castillo-sub and the Castillo Viejo of Old Chichen probably were built then. Ignacio Marquina (1951: 852) describes the architecture of this time as "Transitional," a word we have adopted (Braswell and Peniche 2012). Nonetheless, this style could just as easily be called "Early International" because it shows familiarity with some of the elements incorporated in later architecture (Volta and Braswell 2014: 370). Despite a great slowdown in construction activity, Chichen Itza weathered this storm.

By the second half of the tenth century, the city entered a second golden age. Most of the pottery still belonged to a long-standing local tradition with roots going back to the Late Classic period. Nonetheless, new foreign-inspired pottery and actual imports were consumed by the elites of the site during the Sotuta phase. New and foreign-inspired architectural forms—the gallery-patio, radial pyramid, and colonnaded hall—were built. But these International-style

buildings were constructed using the older and local Terminal Classic technique of (modified) core-veneer masonry. New artistic forms, such as warrior columns and chacmools, were introduced. A new and simpler writing system, one that may not be closely tied phonetically to Mayan languages, was introduced. Metal objects were imported for the first time and turquoise came to replace jade as the most desired sacred stone. Metal and turquoise, as Karl Taube has emphasized many times, are diagnostic not of Epiclassic Central Mexico but of the Postclassic period.

Thus, although late-tenth– and (at least) early-eleventh–century Chichen Itza demonstrated many ties to the past—especially in utilitarian pottery and building techniques—there also were significant changes in elite culture. By 1000, Chichen Itza looked less like the Terminal Classic city of Kakupacal and more like the Late Postclassic city of Mayapan (compare Andrews and Sabloff 1986: 452–453). It therefore makes perfect sense to call this second great period in the history of Chichen Itza the Early Postclassic.

Conclusions

What do we know about Chichen Itza? To begin with, the site was occupied during the Late Preclassic period, if not before. Pottery dating to this time and the Early Classic is known particularly from the Sacred Cenote and from "Old Chichen." Unfortunately, we do not have any structures dating to this period. Perhaps they all were razed, or perhaps some are still to be found deeply buried beneath later buildings. Chichen Itza as we know it began to take shape in the Late Classic period. We have a few structures, not only in "Old Chichen" but also within the Great Terrace, that date to this time. They are crudely built and covered with very thick layers of painted stucco. They are not built using a version of the core-veneer technique. Chichen Itza likely was a secondary or tertiary site under the political control of Ek Balam or Yaxuna for at least part of this period.[4] The ceramics of the Late Classic period were closely related to those of other sites in Yucatan, but local clays created some notable differences. Firing technology was inferior to that of important Puuc cities, perhaps indicating the lack of elite sponsorship of production at Chichen Itza.

By the Terminal Classic period, the political fortunes of Chichen Itza improved and population levels grew dramatically. The ruler Kakupacal oversaw the first great period of architectural expansion and urban growth. Notable too are the many hieroglyphic monuments carved at Chichen Itza during his reign. The ceramics of this period became more diverse, firing techniques improved, and some of the finer Cehpech groups and types were produced at Chichen

Itza or imported from elsewhere for local consumption. In many ways, Terminal Classic Chichen Itza resembled contemporary cities and towns in the Puuc region. The center of the site was defined along a roughly north-to-south axis linked by several causeways, with the Monjas to Casa Colorada groups in the north and the Temples of the Three and Four Lintels to the south—a pattern of palaces somewhat reminiscent of Sayil. Chichen Itza was a wholly Maya city of the Northern Lowlands. Evidence for interaction with other regions of the Maya area is somewhat limited and trade with greater Mesoamerica was negligible. After this brief florescence, the early tenth century saw a great reduction of construction activity and perhaps even demographic contraction. Nonetheless, Chichen Itza survived the much more general collapse that affected many large cities of the interior.

The late tenth century, what we consider the Early Postclassic, saw a dramatic reorganization of the site and its renaissance. The city expanded outward along the radial spokes of its many causeways. Many of these converged on the Great Terrace, the new hub of Chichen Itza. Although we do not have reliable calculations, a population of something on the order of 30,000 to 50,000 is reasonable for this time period. A string of related sites linked the city to several coastal ports, which in turn connected Chichen Itza to great cities of Mesoamerica outside of the Maya region. For the first time in its history, Chichen Itza became a truly international city. Obsidian, turquoise, metal, and foreign pottery flowed into Early Postclassic Chichen Itza, as did numerous foreign ideas. These ideas were manifest in new architectural forms, new ceramic modes and imports, new styles of artistic expression, a new form of writing, and especially in the greatly heightened importance of the cult of Quetzalcoatl/Kukulcan, who epitomized the pan-Mesoamerican idea of elite, urban civilization. Chichen Itza became the most important southern center of this cult, the Maya counterpart of Tula and Cholula. No doubt the much older importance of the Sacred Cenote, which gave the city its name, also played a part in the continued role of Chichen Itza as a great pilgrimage city. There also may have been migrations from other parts of Mesoamerica—as would be expected in any cosmopolitan city—but continuity in utilitarian ceramics and construction techniques suggests that most people of Early Postclassic Chichen Itza were Maya with deep roots in the Northern Lowlands.

The dearth of Mayan hieroglyphic texts carrying dates for this period makes it difficult to precisely place the end of major construction at Chichen Itza. The renaissance of the site could have been as brief as a few decades or as long as 150 years. It seems likely, however, that decline began sometime in the eleventh century. Paleoclimate data indicate an increase in aridity throughout

that period and the offerings in Balankanche Cave suggest that the inhabitants of Chichen Itza were deeply concerned with drought and soil fertility. By 1100 or so, population levels were quite low. Chichen Itza, however, was never completely abandoned or unoccupied. It remained an important place for pilgrims throughout the Late Postclassic and even during the colonial period. As Morley (1925) long ago noted, Chichen Itza was an American Mecca. Today, it sees more visitors than ever before.

Notes

1. Our historical review is necessarily brief. We refer readers to Chapter 6 of this volume for additional details, especially concerning explorations of the Castillo.

2. In November 2016, a team from UNAM and INAH presented the results of a 3D electrical resistivity tomography study and announced the discovery by remote sensing of a second, earlier substructure of the Castillo that is approximately 10 m in height. One very likely possibility is that they have simply detected the substructure partially exposed by Erosa Peniche in the early 1940s. Denisse Argote, a member of the new team of explorers, is quoted as stating: "With the discovery of this structure we're talking about something from the pure Mayans...." (Roberts and Said-Moorhouse 2016). By this, she means the Late Classic (ca. 600–800), within what Pérez de Heredia (2010, 2012) calls the Yabnal phase.

Our own work at Chichen Itza strongly suggests that Erosa Peniche's structure was built on top of either the Stage I Platform Feature AC16 or the Stage II Platform Feature AC3 (Braswell and Peniche May 2012: 241–243), both of which are constructed in what we call the Early Chichen style (Volta and Braswell 2014: 368). These platforms date to the Yabnal phase, and were built before about 860. Early Chichen-style architecture is characterized by roughly faced stones covered with a thick layer of painted stucco, and predates the Puuc-related architecture (which is also "pure Mayan") of about 860–900.

3. See, however, a discussion of Nawa-language elements in two Terminal Classic inscriptions from Chichen Itza in Chapter 3 of this volume.

4. As this volume comes into print, we are more convinced that in the ninth century, the local center of power moved from Yaxuna to Chichen Itza. This may have occurred as a result of the decline of Coba (linked to Yaxuna by a 100-km causeway) or because of the growing importance of Chichen Itza during the reign of Kakupacal. We urge a re-evaluation of the Late Classic ceramics of Yaxuna (which, concurring with Pérez de Heredia in chapter 3, we strongly suspect are under recognized) and advocate for the consideration of Yaxuna and Chichen Itza as sequential regional capitals.

References Cited

Andrews, E. Wyllys, V, and Jeremy A. Sabloff
 1986 Classic to Postclassic: A Summary Discussion. In *Late Lowland Maya Civilization: Classic to Postclassic*, edited by Jeremy A. Sabloff and E. Wyllys Andrews V, pp. 433–456. School of American Research and University of New Mexico Press, Albuquerque.

Ball, Joseph W.

1976 Ceramic Sphere Affiliations of the Barton Ramie Ceramic Complexes. In *Prehistoric Pottery Analysis and the Ceramics of Barton Ramie in the Belize Valley*, by James C. Gifford, pp. 323–330. Memoirs of the Peabody Museum of Archaeology and Ethnology, vol. 18. Harvard University, Cambridge.

1979 Ceramics, Culture History, and the Puuc Tradition: Some Alternative Possibilities. In *The Puuc: New Perspectives: Papers Presented at the Puuc Symposium, Central College, May 1977*, edited by Lawrence Mills, pp. 18–35. Scholarly Studies in the Liberal Arts 1. Central College, Pella, Iowa.

Barrera Vásquez, Alfredo, and Silvia Rendón (editors)

1948 *El libro de los libros de Chilam Balam*. Fondo de Cultura Económica, Mexico City.

Barthel, Thomas S.

1955 Versuch über die Inschriften von Chich'en Itzá Viejo. *Baessler-Archiv* n.s. 3: 5–33.

Beyer, Hermann

1937 *Studies on the Inscriptions of Chichén Itzá*. Contributions to American Archaeology, no. 21. Publication 483: 29–175. Carnegie Institution of Washington, Washington, D.C.

Bolles, John S.

1933 Excavation at the Monjas. *Year Book 32*, pp. 84–86. Carnegie Institution of Washington. Washington, D.C.

1934 Monjas. *Year Book 33*, pp. 90–91. Carnegie Institution of Washington. Washington, D.C.

1977 *Las Monjas: A Major Pre-Mexican Architectural Complex at Chichén Itzá*. University of Oklahoma Press, Norman.

Boot, Erik

2005 *Continuity and Change in Text and Image at Chichén Itzá, Yucatan, Mexico: A Study of the Inscriptions, Iconography, and Architecture of a Late Classic to Early Postclassic Site*. Centre for Non-Western Studies Publications, no. 135. Research School Centre for Non-Western Studies, Leiden, Netherlands.

Brainerd, George W.

1958 *The Archaeological Ceramics of Yucatan*. Anthropological Records, no. 19. University of California Press, Berkeley.

Braswell, Geoffrey E.

2010 The Rise and Fall of Market Exchange: A Dynamic Approach to Ancient Maya Economy. In *Archaeological Approaches to Market Exchange in Ancient Societies*, edited by Christopher P. Garraty and Barbara L. Stark, pp. 127–140. University Press of Colorado, Boulder.

2012 The Ancient Maya of Mexico: Reinterpreting the Past of the Northern Maya Lowlands. In *The Ancient Maya of Mexico: Reinterpreting the Past of the Northern Maya Lowlands*, edited by Geoffrey E. Braswell, pp. 1–40. Equinox, Sheffield, England.

Braswell, Geoffrey E., and Michael D. Glascock

2002 The Emergence of Market Economies in the Ancient Maya World: Obsidian Exchange in Terminal Classic Yucatán, Mexico. In *Geochemical Evidence for Long Distance Exchange*, edited by Michael D. Glascock, pp. 33–52. Bergin and Garvey, Westport, Conn.

Braswell, Geoffrey E., Iken Paap, and Michael D. Glascock

2011 The Obsidian and Ceramics of the Puuc Region: Chronology, Lithic Procurement, and Production at Xkipche, Yucatan, Mexico. *Ancient Mesoamerica* 21: 135–154.

Braswell, Geoffrey E., and Nancy Peniche May

2012 In the Shadow of the Pyramid: Excavations of the Great Platform of Chichen Itza. In *The Ancient Maya of Mexico: Reinterpreting the Past of the Northern Maya Lowlands*, edited by Geoffrey E. Braswell, pp. 227–258. Equinox, Sheffield, England.

Castillo Borges, Víctor R.

1998 Liberación y restauración de la Estructura 2D7 o Templo de las Grandes Mesas de Chichén Itzá. Licenciatura thesis, Universidad Autónoma de Yucatán, Merida, Mexico.

Charlot, Jean

1927 Report on the Sculptures and Paintings in the North and Northwest Colonnades (Station 8 and 10). *Year Book 26*, pp. 246–249. Carnegie Institution of Washington, Washington, D.C.

1928 Report on the Sculptures of the Temple of the Warriors and the Temple of the Chac Mool. *Year Book 27*, pp. 300–302. Carnegie Institution of Washington, Washington, D.C.

Charnay, Désiré

1887 *Ancient Cities of the New World: Being Voyages and Explorations in Mexico and Central America from 1857–1882*. Translated by J. Gonino and Helen S. Conant. Harper & Brothers, New York.

Cobos Palma, Rafael

2003 *The Settlement Patterns of Chichén Itzá, Yucatán, Mexico*. PhD diss., Department of Anthropology, Tulane University, New Orleans. University Microfilms, Ann Arbor, Mich.

2004 Chichén Itzá: Settlement and Hegemony during the Terminal Classic Period. In *The Terminal Classic in the Maya Lowlands: Collapse, Transition, and Transformation*, edited by Arthur A. Demarest, Prudence M. Rice, and Don S. Rice, pp. 517–544. University Press of Colorado, Boulder.

2011 Multepal or Centralized Kingship? New Evidence on Governmental Organization at Chichén Itzá. In *Twin Tollans: Chichén Itzá, Tula, and the Epiclassic to Early Postclassic Mesoamerican World*, rev. ed., edited by Jeff Karl Kowalski and Cynthia Kristan-Graham, pp. 249–271. Dumbarton Oaks, Washington, D.C.

Cobos Palma, Rafael, Guillermo de Anda Alanís, and Roberto García Moll

2014 Ancient Climate and Archaeology: Uxmal, Chichén Itzá, and Their Collapse at the End of the Terminal Classic Period. *Archaeological Papers of the American Anthropological Association* 24: 56–71.

Cobos Palma, Rafael, Armando Inurreta Díaz, and Rodolfo Canto Carrillo

2008 Informe del recorrido de superficie y mapeo realizado entre abril y julio de 2008 en el sitio arqueológico de Chichén Itzá. Manuscript on file, Instituto Nacional de Antropología e Historia, Mexico City.

Cobos Palma, Rafael, and Terance L. Winemiller

2001 The Late and Terminal Classic-Period Causeway Systems of Chichén Itzá, Yucatán, Mexico. *Ancient Mesoamerica* 12: 283–291.

Cohodas, Marvin

1978 *The Great Ball Court of Chichen Itza, Yucatan, Mexico*. Garland, New York.

Davoust, Michel

1980 Les premiers chefs Mayas de Chichen Itza. *Mexicon* 2: 25–29.

de la Garza Camino, Mercedes (editor)

1983 *Relaciones histórico-geográficas de la Gobernación de Yucatán*. 2 vols. Instituto de Inves-

tigaciones Filológicas, Centro de Estudios Mayas. Universidad Nacional Autónoma de México, Mexico City.

Desmond, Lawrence Gustave, and Phyllis Mausch Messenger
1988 *A Dream of Maya: Augustus and Alice Le Plongeon in Nineteenth Century Yucatan*. University of New Mexico Press, Albuquerque.

Dunning, Nicholas P., and Jeff Karl Kowalski
1994 Lords of the Hills: Classic Maya Settlement Patterns and Political Iconography in the Puuc Region, Mexico. *Ancient Mesoamerica* 5: 63–95.

Erosa Peniche, José A.
1948 *Guía para visitar las ruinas de Chichén-Itzá*. Editorial Maya Than, Merida, Yucatan, Mexico.

Ewing, Robert M.
1972 *A History of the Archaeological Activity at Chichen Itza, Yucatan, Mexico*. PhD diss., Department of History, Kent State University, Ohio. University Microfilms, Ann Arbor, Mich.

Fernández Souza, Lilia
1999 Análisis de una unidad habitacional de alto status: Estructura 2A17 de Chichén Itzá, Yucatán. M.A. thesis, Universidad Autónoma de Yucatán, Merida, Mexico.

Folan, Willliam J.
1974 The Cenote Sagrado of Chichén Itzá, Yucatán, México, 1967–68: The Excavation, Plans, and Preparations. *International Journal of Nautical Archaeology and Underwater Explorations* 3: 283–293.

García Campillo, José Miguel
2001 Santuarios urbanos. Casas para los antepasados en Chichén Itzá. In *Reconstruyendo la ciudad Maya: el urbanismo en las sociedades antiguas*, edited by Andrés Ciudad Ruiz, María Josefa Iglesias Ponce de León, and María del Carmen Martínez Martínez, pp. 403–423. Publicaciones de la Sociedad Española de Estudios Mayas, no. 6, Madrid.

García Moll, Roberto, and Rafael Cobos Palma
2009 *Chichén Itzá: Patrimonio de la humanidad*. Grupo Azabache, Mexico City.

Gillespie, Susan D.
1989 *The Aztec Kings: The Construction of Rulership in Mexica History*. University of Arizona Press, Tucson.
2011 Toltecs, Tula, and Chichén Itzá: The Development of an Archaeological Myth. In *Twin Tollans: Chichén Itzá, Tula, and the Epiclassic to Early Postclassic Mesoamerican World*, rev. ed., edited by Jeff Karl Kowalski and Cynthia Kristan-Graham, pp. 61–92. Dumbarton Oaks, Washington, D.C.

Grube, Nikolai
1994 Hieroglyphic Sources for the History of Northwest Yucatan. In *Hidden among the Hills: Maya Archaeology of the Northwest Yucatan Peninsula*, edited by Hanns J. Prem, pp. 316–358. Acta Mesoamericana, no. 7. Verlag von Flemming, Möckmühl, Germany.

Grube, Nikolai, and Ruth J. Krochock
2011 Reading Between the Lines: Hieroglyphic Texts from Chichén Itzá and Its Neighbors. In *Twin Tollans: Chichén Itzá, Tula, and the Epiclassic to Early Postclassic Mesoamerican World*, rev. ed., edited by Jeff Karl Kowalski and Cynthia Kristan-Graham, pp. 157–193. Dumbarton Oaks, Washington, D.C.

Hahn, Lauren D., and Geoffrey E. Braswell
 2012 Divide and Rule: Interpreting Site Perimeter Walls in the Northern Maya Lowlands and Beyond. In *The Ancient Maya of Mexico: Reinterpreting the Past of the Northern Maya Lowlands,* edited by Geoffrey E. Braswell, pp. 264–281. Equinox, Sheffield, England.

Holmes, William H.
 1895 *Archaeological Studies Among the Ancient Cities of Mexico: Part 1, Monuments of Yucatan.* Publication 8, Anthropological Series, vol. 1, no.1. Field Columbian Museum, Chicago.

Jiménez Moreno, Wigberto
 1941 Tula y los Toltecas según las fuentes históricas. *Revista Mexicana de Estudios Antropológicos* 5: 79–85.

Johnson, Scott A. J.
 2012 *Late and Terminal Classic Power Shifts in Yucatan: The View from Popola.* PhD diss., Department of Anthropology, Tulane University, New Orleans. University Microfilms, Ann Arbor, Mich.

Kelley, David H.
 1968 Kakupakal and the Itzás. *Estudios de Cultura Maya* 7: 255–268.

Kennett, Douglas J., Sebastian F. M. Breitenbach, Valorie V. Aquino, Yemane Asmerom, Jaime Awe, James U. L. Baldini, Patrick Bartlein, Brendan J. Culleton, Claire Ebert, Christopher Jawza, Martha J. Macri, Norbert Marwan, Victor Polyak, Keith M. Prufer, Harriet E. Ridley, Harald Sodemann, Bruce Winterhalder, and Gerald H. Haug
 2012 Development and Disintegration of Maya Political Systems in Response to Climate Change. *Science* 338: 788–791.

Kidder, Alfred V.
 1932 Chichen Itza. *Year Book 31,* pp. 92–95. Carnegie Institution of Washington. Washington, D.C.

Kirchhoff, Paul
 1955 Quetzalcoatl, Huemac y el fin de Tula. *Cuadernos Americanos* 84: 163–196.

Kowalski, Jeff Karl, and Cynthia Kristan-Graham (editors)
 2011 *Twin Tollans: Chichén Itzá, Tula, and the Epiclassic to Early Postclassic Mesoamerican World,* rev. ed. Dumbarton Oaks, Washington, D.C.

Krochock, Ruth J.
 1998 The Development of Political Rhetoric at Chichén Itzá, Yucatan, Mexico. Unpublished PhD diss., Department of Anthropology, Southern Methodist University, Dallas, Texas.
 2002 Women in the Hieroglyphic Inscriptions of Chichén Itzá. In *Ancient Maya Women*, edited by Traci Ardren, pp. 152–170. AltaMira Press, Walnut Creek, Calif.

Krochock, Ruth, and David A. Freidel
 1994 Ballcourts and the Evolution of Political Rhetoric at Chichén Itzá, Yucatan, Mexico. In *Hidden among the Hills: Maya Archaeology of the Northwest Yucatan Peninsula*, edited by Hanns J. Prem, pp. 359–375. Acta Mesoamericana, vol. 7. Verlag von Flemming, Möckmühl, Germany.

Landa, Diego de
 1978 [1566] *Relación de las cosas de Yucatán.* 11th ed. Porrúa, Mexico City.

Lincoln, Charles E.
 1986 The Chronology of Chichen Itza: A Review of the Literature. In *Late Lowland Maya*

Civilization: Classic to Postclassic, edited by Jeremy A. Sabloff and E. Wyllys Andrews V, pp. 141–196. University of New Mexico Press, Albuquerque.

1990 *Ethnicity and Social Organization at Chichen Itza, Yucatan, Mexico*. PhD diss., Department of Anthropology, Harvard University, Cambridge. University Microfilms, Ann Arbor, Mich.

Love, Bruce

1989 *The Hieroglyphic Lintels of Yulá, Yucatán, México*. Research Reports on Ancient Maya Writing, no. 24. Center for Maya Research, Washington, D.C.

Love, Bruce, and Peter J. Schmidt

2011 Catálogo preliminar de glifos ajenos de la tradición maya en Chichén Itzá. Unpublished manuscript in possession of the authors. Proyecto Arqueológico Chichén Itzá, Merida, Yucatan, Mexico.

Maldonado Cárdenas, Rubén

1997 Las intervenciones de restauración arqueológica en Chichén Itzá (1926–1980). In *Homenaje al profesor César A. Sáenz*, coordinated by Angel García Cook, Alba Guadalupe Mastache, Leonor Merino, and Sonia Rivero Torres, pp. 103–132. Serie Arqueología, vol. 351. Instituto Nacional de Antropología e Historia, Mexico City.

Maler, Teobert

1932 *Impresiones de viaje a las ruinas de Cobá y Chichén Itzá*. Editorial José Rosado E., Merida, Yucatan, Mexico.

Marquina, Ignacio

1951 *Arquitectura prehispánica*. Memorias del Instituto Nacional de Antropología e Historia I: Instituto Nacional de Antropología e Historia and Secretaría de Educación Pública, Mexico City.

Martin, Paul S.

1928 Report on the Temple of the Two Lintels (Station 7). *Year Book 27*, pp. 302–305. Carnegie Institution of Washington. Washington, D.C.

Maudslay, Alfred P.

1889–1902 *Archaeology*. 6 vols. In *Biologia Centrali-Americana*, edited by F. Ducane Godman and Osbert Salvin. Porter and Dulau, London.

Morley, Sylvanus G.

1913 Archaeological Research at the Ruins of Chichen Itza, Yucatan. In *Reports upon the Present Condition and Future Needs of the Science of Anthropology, presented by W.H.R. Rivers, A. E. Jenks, and S. G. Morley at the Request of the Carnegie Institution of Washington*, pp. 61–91. Publication 200. Carnegie Institution of Washington, Washington, D.C.

1920 *The Inscriptions at Copan*. Publication 219. Carnegie Institution of Washington, Washington, D.C.

1925 Chichen Itzá, an American Mecca. *National Geographic Magazine* 47: 63–95.

1946 *The Ancient Maya*. 1st edition. Stanford University Press, Stanford, Calif.

Morris, Ann Axtell

1928 Report on the Mural Paintings and Painted Reliefs in the Temple of the Chac Mool. *Year Book 27*, pp. 297–300. Carnegie Institution of Washington. Washington, D.C.

Morris, Earl H.

1924 Report on the Excavations at Chichen Itza, Mexico. *Year Book 23*, pp. 211–213. Carnegie Institution of Washington. Washington, D.C.

1925a Report on the Temple of the Warriors (Station 4). *Year Book 24,* pp. 252–259. Carnegie Institution of Washington. Washington, D.C.

1925b Report on the Mural Paintings of the Temple of the Warriors (Station 4). *Year Book 24,* pp. 260–262. Carnegie Institution of Washington. Washington, D.C.

1925c Report on the Temple on the Northeast Bank of the Xtoloc Cenote (Station 3). *Year Book 24,* pp. 263–265. Carnegie Institution of Washington. Washington, D.C.

1926 Report on the Excavation of the Temple of the Warriors and the Northwest Colonnade (Stations 4 and 10). *Year Book 25,* pp. 282–286. Carnegie Institution of Washington. Washington, D.C.

1927 Report on the Temple of the Warriors and the Northwest Colonnade (Stations 4 and 10). *Year Book 26,* pp. 240–246. Carnegie Institution of Washington. Washington, D.C.

1928 Report on the Excavation and Repair of the Temple of the Warriors (Station 4). *Year Book 27,* pp. 293–297. Carnegie Institution of Washington. Washington, D.C.

Morris, Earl H., Jean Charlot, and Ann Axtell Morris

1931 *The Temple of the Warriors at Chichen Itzá, Yucatan.* 2 vols. Publication 406. Carnegie Institution of Washington, Washington, D.C.

Norman, Benjamin M.

1843 *Rambles in Yucatan.* 2nd ed. Langley, New York.

Ochoa Rodriguez, Virginia Josefina

1999 Spatial Distribution of Peto Cream Ware in the Yucatan Peninsula. Unpublished M.A. thesis, Department of Geography and Anthropology, Louisiana State University, Baton Rouge.

Osorio León, José F.

2004 La Estructura 5C4 (Templo de la Serie Inicial): Un edificio clave para la cronología de Chichén Itzá. Licenciatura thesis, Universidad Autónoma de Yucatán, Merida, Yucatan, Mexico.

2005 La Sub-estructura de los Estucos (5C-4I): Un ejemplo de arquitectura temprana en Chichen Itza. In *XVIII Simposio de Investigaciones Arqueológicas en Guatemala 2004,* edited by Juan Pedro Laporte, Bárbara Arroyo, and Héctor Mejía, pp. 836–846. Museo Nacional de Arqueología y Etnología, Guatemala City.

Peniche May, Nancy, Lauren D. Hahn, and Geoffrey E. Braswell

2009 *Excavaciones de la UCSD en Chichén Itzá: Informe de la temporada de campo 2009 al Proyecto Chichén Itzá.* Unpublished report on file at the Universidad Autónoma de Yucatán, Merida, and at the University of California, San Diego. http://pages.ucsd.edu/~gbraswel/docs/InformeChichenItza2009UCSD_opt.pdf

Pérez de Heredia Puente, Eduardo J.

2001 La arquitectura y la cerámica de Chichén Itzá. In *Los investigadores de la cultura Maya,* vol. 13, pp. 445–466. Universidad Autónoma de Campeche, Campeche, Mexico.

2010 Ceramic Contexts and Chronology at Chichen Itza, Yucatan, Mexico. Unpublished PhD diss., Faculty of Humanities and Social Sciences, School of Historical and European Studies, Archaeology Program, La Trobe University, Melbourne, Australia.

2012 The Yabnal-Motul Complex of the Late Classic Period at Chichen Itza. *Ancient Mesoamerica* 23: 379–402.

Pérez Ruiz, Francisco

2005 Recintos amurallados: Una interpretación sobre el sistema defensivo de Chichén Itzá,

Yucatán. In *XVIII Simposio de Investigaciones Arqueológicas en Guatemala 2004*, edited by Juan Pedro Laporte, Bárbara Arroyo, and Héctor Mejía, pp. 917–926. Museo Nacional de Arqueología y Etnología, Guatemala City.

Piña Chan, Román

1970 *Informe preliminar de la reciente exploración del Cenote Sagrado de Chichén Itzá.* Instituto Nacional de Antropología e Historia, Mexico City.

Pollock, H.E.D.

1929 Report on the Casa Redonda (Station 15). *Year Book 28*, pp. 310–312. Carnegie Institution of Washington. Washington, D.C.

1936 *The Casa Redonda at Chichen Itza, Yucatan.* Contributions to American Archaeology, no. 17. Publication 456, pp. 129–154. Carnegie Institution of Washington. Washington, D.C.

Rice, Don S., and T. Patrick Culbert

1990 Historical Contexts for Population Reconstruction in the Maya Lowlands. In *Precolumbian Population History in the Maya Lowlands*, edited by T. Patrick Culbert and Don S. Rice, pp. 1–36. University of New Mexico Press, Albuquerque.

Ricketson, Oliver G.

1925a Report on the Repair of the Caracol. *Year Book 24*, pp. 265–267. Carnegie Institution of Washington. Washington, D.C.

1925b Report on the Temple of the Four Lintels. *Year Book 24*, pp. 267–269. Carnegie Institution of Washington. Washington, D.C.

Ringle, William M.

1990 Who Was Who in Ninth-Century Chichen Itza. *Ancient Mesoamerica* 1: 233–243.

2004 On the Political Organization of Chichen Itza. *Ancient Mesoamerica* 15: 167–218.

2012 The Nunnery Quadrangle of Uxmal. In *The Ancient Maya of Mexico: Reinterpreting the Past of the Northern Maya Lowlands,* edited by Geoffrey E. Braswell, pp. 191–228. Equinox, Sheffield, England.

Ringle, William M., Tomás Gallareta Negrón, and George J. Bey III

1998 The Return of Quetzalcoatl: Evidence for the Spread of a World Religion during the Epiclassic Period. *Ancient Mesoamerica* 9: 183–232.

Roberts, Elizabeth, and Lauren Said-Moorhouse

2016 Second pyramid found inside Kukulkan at Chichen Itza in Mexico. *CNN*, November 18. www.cnn.com/2016/11/17/americas/chichen-itza-pyramid-discovery/.

Roys, Ralph L. (translator and editor)

1933 *The Book of Chilam Balam of Chumayel.* Carnegie Institution Publication. No. 438. Washington D.C.

Ruppert, Karl

1927 Report on the Caracol (Station 5). *Year Book 26*, pp. 249–252. Carnegie Institution of Washington. Washington, D.C.

1928 Report on the Outlying Sections of Chichen Itza. *Year Book 27*, pp. 305–307. Carnegie Institution of Washington. Washington, D.C.

1929 Report on the Excavation and Repair of the Caracol (Station 5). *Year Book 28*, pp. 303–310. Carnegie Institution of Washington. Washington, D.C.

1931 The Caracol. *Year Book 30*, pp. 108–109. Carnegie Institution of Washington. Washington, D.C.

1935 *The Caracol at Chichen Itza, Yucatan, Mexico.* Publication 454. Carnegie Institution of Washington, Washington, D.C.

1952 *Chichen Itza: Architectural Notes and Plans.* Publication 595. Carnegie Institution of Washington, Washington, D.C.

Ruppert, Karl, and A. Ledyard Smith

1955 Two New Gallery-Patio Type Structures at Chichen Itza. *Notes on Middle American Archaeology and Ethnology* 122: 59–62. Department of Archaeology, Carnegie Institution of Washington, Washington, D.C.

1957 *House Types in the Environs of Mayapan, and at Uxmal, Kabah, Sayil, Chichen Itza, and Chacchob.* Department of Archaeology Current Reports, no. 39. Carnegie Institution of Washington, Washington, D.C.

Ruz Lhuillier, Alberto

1948 *Puerta Occidental de la Muralla de Chichén-Itzá.* Instituto Nacional de Antropología e Historia, Secretaría de Educación Pública, Dirección de Monumentos Prehispánicos, Zona Maya, Merida, Yucatan, Mexico.

Schele, Linda, and David A. Freidel

1990 *A Forest of Kings: The Untold Story of the Ancient Maya.* William Morrow, New York.

Schele, Linda, and Peter Mathews

1998 *The Code of Kings: The Language of Seven Sacred Maya Temples and Tombs.* Scribner's, New York.

Schmidt, Peter J.

2011 Birds, Ceramics, and Cacao: New Excavations at Chichén Itzá, Yucatán. In *Twin Tollans: Chichén Itzá, Tula, and the Epiclassic to Early Postclassic Mesoamerican World*, rev. ed., edited by Jeff Karl Kowalski and Cynthia Kristan-Graham, pp. 113–155. Dumbarton Oaks, Washington, D.C.

Schmidt, Peter J., and Eduardo J. Pérez de Heredia Puente

2006 Fases de construcción de la Gran Nivelación de Chichén Itzá. Paper presented at the XVI Encuentro Internacional "Los Investigadores de la Cultura Maya," Campeche, Campeche, Mexico, November 2006.

Smith, Robert E.

1971 *The Pottery of Mayapan, Including Studies of Ceramic Material from Uxmal, Kabah, and Chichen Itza.* 2 vols. Papers of the Peabody Museum of Archaeology and Ethnology, Vol. 66. Harvard University, Cambridge.

Stephens, John L.

1843 *Incidents of Travel in Yucatan.* 2 vols. Harper & Brothers, New York.

Strömsvik, Gustav

1933 Temple of the Phalli. *Year Book 32*, pp. 86. Carnegie Institution of Washington. Washington, D.C.

Thompson, Edward Herbert

1932 *People of the Serpent.* Riverside Press, Cambridge, Mass.

1938 *The High Priest's Grave, Chichen Itza, Yucatan.* Anthropological Series, Pub. 412, vol. 27, no. 1, prepared for publication with notes and introduction by J. Eric Thompson. Field Museum of Natural History, Chicago.

Thompson, J. Eric S.

1927 *A Correlation of the Mayan and European Calendars.* Publication 241, Anthropological Series, vol. 17, no. 1. Field Museum of Natural History, Chicago.

1937 *A New Method of Deciphering Yucatecan Dates with Special Reference to Chichen Itza.* Contributions to American Archaeology and Ethnology no. 22. Publication 483. Carnegie Institution of Washington, Washington, D.C.

1970 *Maya History and Religion.* University of Oklahoma Press, Norman.

Tozzer, Alfred M.

1927 Time and American Archaeology. *Natural History* 27: 210–221.

1957 *Chichen Itza and Its Cenote of Sacrifice: A Comparative Study of Contemporaneous Maya and Toltec.* 2 vols. Memoirs of the Peabody Museum of Archaeology and Ethnology. Vols. 11 and 12. Harvard University, Cambridge.

Vaillant, George C.

1961 *The Chronological Significance of Maya Ceramics.* Archives of Archaeology 12. Society for American Archaeology and the University of Wisconsin Press, Washington, D.C. and Madison.

Volta, Beniamino, and Geoffrey E. Braswell

2014 Alternative Narratives and Missing Data: Refining the Chronology of Chichen Itza. In *The Maya and Their Central American Neighbors: Settlement Patterns, Architecture, Hieroglyphic Texts, and Ceramics,* edited by Geoffrey E. Braswell, pp. 356–402. Routledge Press, London.

Voss, Alexander, and Markus Eberl

1999 Ek Balam: A New Emblem Glyph from the Northeastern Yucatan. *Mexicon* 21: 124–131.

Wren, Linnea, and Peter J. Schmidt

1991 Elite Interaction during the Terminal Classic Period: New Evidence from Chichen Itza. In *Classic Maya Political History: Hieroglyphic and Archaeological Evidence,* edited by T. Patrick Culbert, pp. 199–225. Cambridge University Press, Cambridge.

3

K'ak' Upakal K'inich K'awil and the Lords of the Fire

Chichen Itza during the Ninth Century

EDUARDO PÉREZ DE HEREDIA AND PÉTER BÍRÓ

This chapter proposes a historical reconstruction of Chichen Itza during the Terminal Classic period that combines recent ceramic and archaeological data with contemporary epigraphic studies.[1] Through this reconstruction, we argue that we can clarify the understanding of the site's internal dynamics and of the chronological relationship between its Maya or "Puuc" and International-style constructions, as well as of the site's overall impact on northern Yucatan.[2] We recognize that multiple sets of evidence—ceramic, stratigraphic, stylistic, and ethnohistorical—have presented challenges to the development of a clear chronology for the site (see Volta et al., Chapter 2). We further recognize that the existence of two distinct architectural styles, the Maya "Puuc" and International style, has led to multiple interpretations regarding their relative temporal placement. These interpretations include the "no-overlap," "partial overlap," and "total overlap" models (Figure 3.1). We argue that the most current ceramic evidence and epigraphic analyses, combined with recent archaeological excavations and radiocarbon dating, support a no-overlap model.

We have benefited greatly from the research generated by the Proyecto Arqueológico Chichén Itzá–Instituto Nacional de Antropología e Historia (INAH), directed by Peter J. Schmidt. Begun in 1993, this project excavated several structures in the city core, including the Osario, the Temple of the Big Tables, Sacbe 1, the Northeast Colonnade, and most of the Initial Series Group (Schmidt 2000, 2003, 2011). The senior coauthor of this chapter analyzed the ceramics in the resultant large archaeological collection for more than a decade (Pérez de Heredia 1998, 2010) and produced a refined chronology summarized here.

The new collections demonstrate the presence of pure contexts of three different ceramic complexes: Yabnal (Motul), Huuntun (Cehpech), and Sotuta

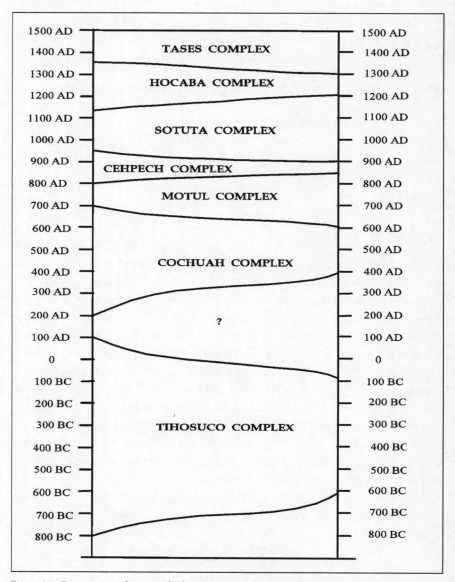

Figure 3.1. Ceramic complexes at Chichen Itza. Image by Eduardo Pérez de Heredia (2010).

(Pérez de Heredia 2010 [see Figure 3.2]).[3] A sequential order of the three ceramic complexes has been found at the Initial Series Group (Figure 3.3) and in the Great Terrace, the center of the "Toltec" city (Schmidt and Pérez 2005); moreover, a seriation of about 100 archaeological ceramic contexts confirms this sequential order (Pérez de Heredia 2010). Sotuta complex ceramics have

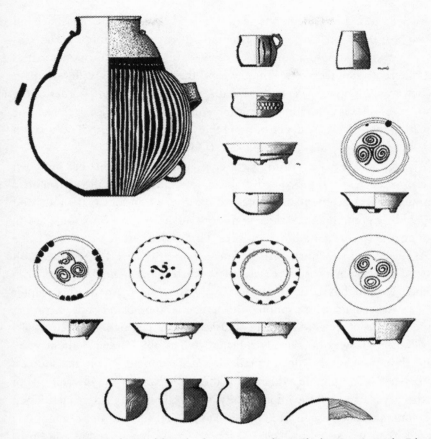

Figure 3.2. Diagnostic forms of the Yabnal ceramic complex at Chichen Itza. Image by Eduardo Pérez de Heredia (2010).

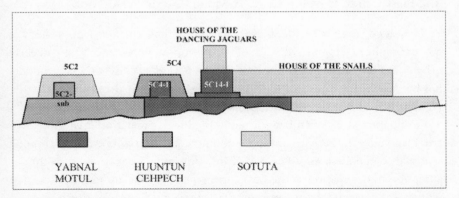

Figure 3.3. Schematic section of the ceramic periods of construction at the Initial Series Group. Image by Eduardo Pérez de Heredia (2010).

never been found in sealed construction fills of "Maya" Puuc buildings, but they appear inside all "Toltec" constructions. Slate ceramic groups of the Yabnal, Huuntun, and Sotuta complexes show distinctive modal characteristics and different manufacture techniques, and they appear with different diagnostic ceramic imports (Pérez de Heredia 2010). The sequential order of the ceramic complexes contradicts the argument that in the Classic to Postclassic transition there is no "evidence of more than one major period of occupation within the known limits of Chichén Itzá" (Lincoln 1990: 210).

We have also benefited from recent epigraphic research that has provided reexamined dates for some controversial monuments and has allowed scholars to understand the content and context of the inscriptions of Chichen Itza and neighboring contemporary cities in a more nuanced way (Bíró 2003, 2011b; Boot 2005; García Campillo 2000, 2001; Graña-Behrens 2002, 2006; Grube 2003; Grube and Krochock 2011; Lacadena 2004) (Table 3.1). The dates, with minor disagreements in some cases, follow the decipherment of the Yucatecan calendar system that J. Eric Thompson (1937) called "Tun-Ahau." This chapter analyzes the calendric inscriptions within their temporal landscape, including a mid-tenth-century gap. The date of Osario Pillar 4, which has been a matter of controversy, is now firmly substantiated as 998 (Graña-Behrens et al. 1999; Thompson 1937). Due to unreliable dates recorded in colonial sources, the absence of epigraphic evidence for the name Itza[4] in the inscriptions of northern Yucatan, and the impossibility of directly linking rulers mentioned in colonial sources—such as K'ak' Upakal or Kan Ek'—to their epigraphic counterparts, we do not use colonial sources in our reconstruction of ninth-century Chichen Itza.

The First Urban Development: The Late Classic Period 600–830

The results of the Proyecto Chichén Itzá show that Chichen Itza's history is more complicated than a sequence of two periods of florescence, since an early urban development dated to the Late Classic period, roughly 600–830, underlies the Maya "Puuc" city of K'ak' Upakal (Osorio 2004; Osorio and Pérez de Heredia 2001; Pérez de Heredia 2007, 2010, 2012).

Occupation at Chichen Itza started in the Preclassic period (Schmidt 2003, 2011), and after an Early Classic abandonment circa 250–600, Yabnal ceramic materials dated circa 600–800/830 (Pérez de Heredia 2010)[5] attest to the resumption of occupation in the Late Classic period; they are found associated with the first urban terraces and some masonry buildings (Osorio 2004; Osorio and Pérez de Heredia 2001; Pérez de Heredia 2010). At Chichen Itza the

Table 3.1. List of epigraphic dates at Chichen Itza

Maya Date	Christian Date	Monument
(Long Count/Short Count)	(585,285 corr.; Julian)	(building)
(MYTHICAL)		
13.0.0.0.0 4 Ajaw Kumk'u	September 8, 3114 BC	Caracol Panel
(EARLY)		
k'atun 7 Ajaw	AD 810–830	Water Trough Lintel
10.0.2.7.13 9 B'en 1 Sak	September 28, AD 832	Hieroglyphic Jambs
(MIDDLE)		
14th *tun* of *k'atun* 3 Ajaw	AD 862–863	Water Trough Lintel
17th *tun* of *k'atun* 3 Ajaw	AD 865–866	Water Trough Lintel
10.2.0.1.9 6 Muluk 12 Mak	September 11, AD 869	Casa Colorada Frieze
10.2.0.11.8 10 Lamat 6 Tzek	March 29, AD 869	Halakal Lintel
10.2.0.15.3 7 Ak'b'al 1 Ch'en	June 12, AD 870	Casa Colorada Frieze
10.2.0.17.7 12 Manik 5 Sak	July 26, 870	Stela 2
1st *tun* of *k'atun* 1 Ajaw	AD 869–870	Halakal Lintel, Akab Dzib Lintel
2nd *tun* of *k'atun* 1 Ajaw	AD 870–871	Casa Colorada Frieze
3rd *tun* of *k'atun* 1 Ajaw	AD 871–872	Casa Colorada Frieze
4th *tun* of *k'atun* 1 Ajaw	AD 872–873	Casa Coloroda Frieze
10.2.4.8.4 8 K'an 2 Pop	January 3, AD 874	Yula, Lintel 1
10.2.4.8.12 3 Eb' 10 Pop	January 11, AD 874	Yula, Lintel 2
10.2.9.1.9 9 Muluk 7 Sak	July 26, AD 878	Initial Series Lintel
10th *tun* of *k'atun* 1 Ajaw	AD 878–879	Three Lintels, Lintel 3
11th *tun* of *k'atun* 1 Ajaw	AD 879–880	Akab Dzib Lintel
10.2.10.11.7 8 Manik 15 Wo'	February 4, AD 880	Monjas, Lintels 2–6
10.2.11.14.1 6 Imix 4 Sek	March 22, 881	Yula, Lintel 2
10.2.12.1.8 9 Lamat 11 Yax	July 9, AD 881	Four Lintels, Lintel 1, 3–4
10.2.12.2.4 12 K'an 7 Sak	July 29, AD 881	Four Lintels, Lintel 2, 4
16th *tun* of *k'atun* 1 Ajaw	AD 884–885	Caracol Stela
17th *tun* of *k'atun* 1 Ajaw	AD 885–886	Caracol Stela
k'atun 1 Ajaw	AD 869–889	Capstone, Monjas
1st *tun* of *k'atun* 1 Ajaw	AD 889–890	Caracol Panel, Stela 2
(LATE)		
2nd *tun* of *k'atun* 8 Ajaw	AD 929–930	Caracol Circular Stone
10.8.10.6.4 10 K'an 2 Sotz	February 1, AD 998	Osario, Pillar 4
10.8.10.11.0 2 Ajaw 16 Mol	May 8, AD 998	Osario, Pillar 4
k'atun 1 Ajaw	AD 1125–1145	Capstone, Temple of the Owls
(MYTHICAL)		
1.13.0.0.0.0 10 Ajaw 8 Sip	December 14, AD 9897	Caracol Panel

Sources: Boot 2005; García Campillo 2000; Grube 1994; Voss 2001; Thompson 1937.

Yabnal ceramic complex is characterized by the use of Early (Say) Slate ceramics, which account for more than 40 percent of all ceramics of this complex. Unslipped ceramics are represented chiefly by water jars, which account for a percentage similar to that of the Slate ceramics. Also present are sherds of Thin Slate and Thin Red vessels and imported items such as Fine Gray ceramics and polychromes. A total of 34 different ceramic types have been identified for this complex. The high quantities of Yabnal complex ceramics and the widespread area in which they are found at Chichen Itza suggest a rather dense population, a long period of production, or a combination of both (Pérez de Heredia 2010).[6]

Terraces dated with ceramic materials from the Yabnal complex are concentrated around the Xtoloc Cenote, but this concentration may only reflect the fact that excavations have been more intense there. Nevertheless, considering that the Terminal Classic development of the administrative center of the city took place inside this same semicircle of *rejolladas* (see Figure 3.4), it is very possible that it was already favored during the Late Classic period. Indeed, the most remarkable buildings currently known to have been built during the Yabnal complex are located south of the Xtoloc Cenote.

The Yabnal ceramic complex is mainly associated at Chichen Itza with a massive terracing effort covering a great area from the Holtun Cenote to the Ikil Cenote. This area includes the terrace of the Temple of the Three Lintels where cist burials with Yabnal ceramics comparable to those published for Yaxuna (Freidel et al. 2002) have been found (Figure 3.5) (Pérez de Heredia 2010: 96–99), and also the early terrace of the Initial Series Group and terrace levels at the Great Terrace. Platform 1 of the Monjas, a special building with rounded corners and a stairway spanning most of the north façade, may possibly be attributed to this period (Bolles 1977: 86). Considering its size and orientation, this building may have been the focus of the Late Classic city.

To complete this picture of increasing urbanism, the recently found House of the Stuccoes (5C4-I) is of great interest. It shows an incipient form of architecture based on crude masonry combined with refined modeled and painted stucco decoration and is firmly dated to the Yabnal-Motul complex (Osorio 2004; Osorio and Pérez de Heredia 2001; Pérez de Heredia 2010: 107–108).

Because of the scarcity of monumental architecture and the apparent absence of monuments with hieroglyphic inscriptions dated within the Late Classic period, Chichen Itza can easily be imagined as a secondary site during this time period. Nevertheless, art and literature existed in other media. Some figurative sculpture of this period survives, such as the stucco modeled heads of the

Figure 3.4. Distribution of Yabnal ceramics and platform-building activity. Rectangles in gray show them clustered around cenotes and rejolladas in the landscape of Chichen Itza, suggesting that these first urbanization efforts took place close to the natural water sources and richer orchards. Firmly dated constructions of the Late Classic period are shown in black: Initial Series and Three Lintels platform. After Pérez de Heredia 2010: map 4, prepared by Pérez de Heredia and Francisco Pérez Ruiz.

House of the Stuccos (5C4-I). Some stuccoed and polychromed ceramic vessels recovered from the Sacred Cenote are painted with figurative scenes, architectural elements, and hieroglyphic inscriptions. The latter can be characterized stylistically as Late Classic, and one includes the name Ukit Koj, Ukit being a common name among rulers of Ek Balam (that is, Ukit Kan Lek Tok'; see Ediger 1971: ninth illustration in unnumbered series of color plates, pp. 96–97). In terms of external relations, imported ceramics of this period come from many places. Fine Orange, Fine Gray (Chablekal type), Fine Black Wares, and a few Late Classic polychromes (Kinich Group) have been found at Chichen Itza, as well as vessels of the Tinaja Group and even some Becanchen Brown–type sherds. Finally, some Late Classic jades have been found in the Sacred Cenote.

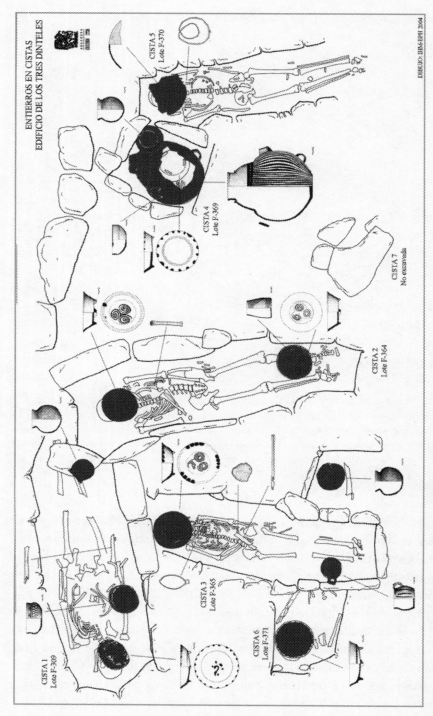

Figure 3.5. Yabnal burials under the Three Lintels building. Image by Eduardo Pérez de Heredia (2010: fig. 43).

Although the dates of their importation to Chichen Itza and their deposition in the Cenote are uncertain, they bear inscriptions with dates and/or evincing stylistic qualities of the Late Classic period (Proskouriakoff 1974).[7]

Chichen Itza shows notable similarities during the Late Classic with Yaxuna, where the archaeological record reveals a bigger settlement. Here Late Classic (Motul Complex) ceramics are also associated with residential construction and burials in cists (Freidel et al. 2002). Published illustrations of Yaxuna's ceramics (Freidel et al. 2002; Johnstone 2001) are proof in terms of ceramic forms that most of the Early Slate ceramics pertaining to the Late Classic period were incorrectly identified as Muna Slate of the Eastern Sphere (as is the case with the classification of Slate ceramics at Coba [Pérez de Heredia and Bíró 2007, 2015]). Most of the complete and reconstructed vessels that David Freidel et al. (2002: figs. 62–100) illustrate as Terminal Classic are in fact diagnostic Late Classic vessels (Boucher 1992; Brainerd 1958, Pérez de Heredia 2010; Varela 1998).[8]

This may indicate that many of the residential structures and cist burials at Yaxuna which can only be dated by ceramic affiliation, and that have been attributed to the Terminal Classic period (Freidel et al. 2002), are better reclassified as Late Classic, 600–800/850, thus increasing the size and population estimates for the site at that time, and likewise decreasing those estimates for the Terminal Classic period. Furthermore, architecture at Yaxuna includes stucco buildings (Structures 6F-44 and 4E-4) (Freidel et al. 2002) comparable to Chichen Itza's House of the Stuccoes (5C4-I).

We find it reasonable that during the Late Classic period Chichen Itza may have been allied and subordinated to Yaxuna, a bigger urban development whose Late Classic constructions were built atop the Early Classic city. The construction of Sacbe 1, which links Yaxuna to Coba, apparently dates to the Late Classic period as well (Freidel et al. 2002) and may substantiate the hypothesis that Yaxuna was incorporated into Coba's sphere of influence (Ardren and Fowler 1998; Shaw 1998; Stanton 1999). If so, Chichen Itza, in close geographic proximity to Yaxuna, could have been drawn into the alliances of its more powerful neighbor and operated within the political and economic network dominated by Coba to the northeast.

Nevertheless, at the end of the Late Classic period, an event heralded new times to come. The first inscriptions of the dynasty of Ukit Kan Lek Tok' at Ek Balam were written circa 770. A few years later, in 779 and 780 at Coba, Stelae 16 and 20 were both dedicated by the ruler called Kalomte' Chan K'inich (Gronemeyer 2004) who acceded in 773 (Stuart 2010). Significantly, Stela 20 is the last firmly dated monument at Coba.

New Developments: Evidence of the Beginnings
of the Terminal Classic Period 830–860

Hieroglyphic inscriptions, stratigraphy, and ceramics can help to ascertain how some events, mainly the fall of Coba and Yaxuna and the rise of Ek Balam, relate to the Yabnal settlement of Chichen Itza. The first inscribed stone monument at Chichen Itza appears in 832, in the west jamb of the Temple of the Hieroglyphic Jambs (6E3). Graña-Behrens' (2002: 362) recent examination confirmed the date 10.0.2.7.13 9 Ben 1 Sak (832) first proposed by Ruth Krochock (1997), making it one of the earliest known dates from the site. We regard these jambs as a record of the first group of newcomers to arrive in the ninth century at Chichen Itza in the K'atun 5 Ajaw.

The west jamb describes an unknown event (the verb is eroded, but could have been "was finished" [see García Campillo 2000: 104]) possibly involving a god who came back to the dwelling of a Fiery Heart Chuk Lord. The east jamb again mentions the same god to whom the building was dedicated and possibly mentions another lord as parent of the Chuk Lord. The narrative of the east jamb ends with a verb translated as "then it came to an end" (*ka xupiy* [see Grube et al. 2003: 32]).

Clearly, the main character of the inscriptions is Fiery Heart Chuk Lord. Chuk is an Itza lineage in Colonial sources and also means "coal, charcoal" (Barrera Vásquez et al. 1980: 111; Bricker et al. 1998: 74 as *čúuk*). The other god is Atal Taway?, which may be also mentioned in the Water Trough Lintel (H) as we will see later. The owner of the dwelling, aside from the gods, is an individual whose name-phrase has not yet been deciphered (East Jamb C6-A7).

Independently of the content of the inscription, the location of the jambs is unusual in two ways. First, the jambs appear on the site periphery with respect to the later main development of the city. Second, the jambs were found attached to Structure 6E3, a gallery-patio construction of International (Toltec) architecture, and not in a Chichen Maya building, as should be expected. These circumstances have been used by some authors to substantiate a temporal overlap model (or the contemporaneity of Maya and Toltec traits [Lincoln 1990]). We do not see this as evidence of temporal overlap but rather as the reuse of inscribed stones, such as in the case of the Initial Series Lintel. Alternative possibilities are more difficult to explain.[9]

There are other very significant buildings possibly constructed between 830 and 860. The Iglesia has an early type of masonry in its lower walls, has an unusual vault, and once had a band of glyphs modeled in stucco (G. Andrews

n.d.). The House of the Phalli shows a similar early construction technique with the Iglesia, and its construction has been associated with very late Motul ceramics (see Pérez de Heredia 2010 for discussion of this context). Both also share a similar theme of iconography (Pawahtun) and were foundational landmarks of the newcomers.

On the other side, non-Maya traits are not as prominent in the newcomers' monuments, and the inception of the Ehecatl-Quetzalcoatl cult would have passed unnoticed if not for the construction of the First Circular Platform of the Caracol. With a diameter of 11 m and height of 3.7 m, the First Circular Platform of the Caracol is an impressive building with upper and lower moldings, but no stairs, rooms, or additional decoration. An unslipped jar was found as an offering (Ruppert 1935) that could be dated of the late Motul complex (Pérez de Heredia 2010). We propose here a date between 830 and 860 for this construction.

There is indirect epigraphic evidence that this first stage of the Caracol may have been built well before 860. Fragmented Stela 1 from the nearby site of Dzilam refers to at least four named captives. The leftmost person on the front of this monument may have come from Ichmul de Morley (aj mut), while on one side a Tzaj Ajaw is mentioned (Grube et al. 2003: 32–33).

We argue that the toponymic title Tzaj or Tza' was the name of the Caracol area. The same title appears in the later Caracol Panel (889–890) and the Circular Disk of the Caracol (929–930) (Figure 3.6). The former was associated with the noble Aj B'olon K'awil, who was a "divine speaker" (k'uhul aj kan) and "he of the fire" from Tza' . . . Tz'iknal (at) Wak[hab'?]nal (Caracol Panel N1–N4; Caracol Hieroglyphic Serpent Band Ashlars 7, 8, and 10) (Bíró and Pérez de Heredia 2016; Boot 2005: 354; Voss 2001). A second mention occurs on blocks Sb-T of the Caracol Circular Disk. In Maya texts a complex place name usually refers to a site area, a region, or even a particular building, such as Yehmal K'uk' Lakam Witz Lakam Ha' or "Descending Quetzal at the Big Hill at the Big River" (Palenque Temple 18: D17–19). When the Caracol texts were carved they mentioned for the first time the place Wak[hab'?]nal; this may have been an ancient form of the name of Chichen Itza (as it appears in the Books of Chilam Balam as Uachabnal or Uucyabnal) followed by two other toponymic titles, Tza' and Tz'iknal. We argue that Tza' was the city core, the Caracol vicinity, while Tz'iknal perhaps was the Tower proper, the circular building associated with astronomy (see Voss 2001), while Chichen Itza as a whole was named Wak[hab'?]nal.

Finally, Dzilam Stela 1 refers to the Tzaj Ajaw, maybe a captive. We know that the rulers of Ichmul de Morley had an alliance with, or were vassals of, the

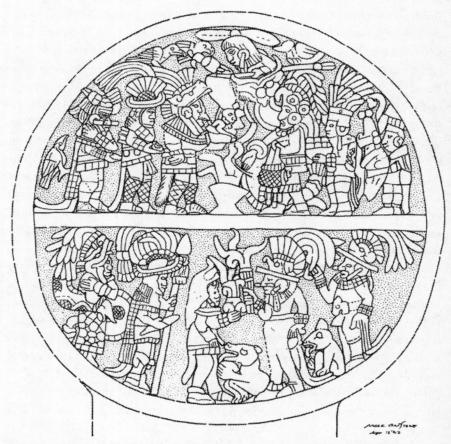

Figure 3.6. Circular Disk of the Caracol. Drawing by Mark van Stone for Linda Schele © David Schele, SD-5085, by permission of the Los Angeles County Museum of Art.

polity of Ek Balam, at least under the rule of Ukit Kan Lek Tok.' Perhaps the Dzilam king warred against the vassals of Ek Balam, which were at the time Chichen Itza and Ichmul de Morley. While we do not know the exact date of Stela 1, another captive, Uk'uw Chan, is mentioned, this being the first half of the coronation name of the Dzibilchaltun king before 840. If the captive represented and named on Stela 1 is the Dzibilchaltun king, then the Caracol captive was captured before 840, and therefore the first stage of the Caracol was possibly built before that date, as the ceramics suggest.

We also include in this group of early Puuc constructions the central part of the Akab Dzib (or First Akab Dzib), since this part of the building clearly

predates the lintel dedicated in 870/880. Construction has been dated by ceramics to the early facet of the Huuntun (Cehpech) complex (Pérez de Heredia 2010: 144).

Platform 2 of the Monjas Complex can also be reasonably assigned to these dates, relative to its stratigraphic position in relation to the later construction of the House of the Seven Lintels at the Monjas, dated 880 (Pérez de Heredia 2010: 114). Therefore, there are several buildings that can be dated before the inscriptions that mention K'ak' Upakal and that were constructed by a previous generation of rulers, possibly his father and his grandfather (Figure 3.7).

These episodes of construction are related in time with the destruction of the House of the Stuccoes (5C4-I), dated circa 800–830. This Yabnal building was partially razed, and the polychrome stucco decoration of the façade was smashed into small pieces and used as construction fill for a new building, Structure 5C4-II (Osorio and Pérez de Heredia 2001; Osorio 2004; Pérez de Heredia 2010: 109–110).

Therefore the date 832 for the beginning of the "Maya Puuc" city of Chichen Itza is suggested by the epigraphic record and supported by the ceramic chronology. Pérez de Heredia (2010: 178) proposes 830 for the beginning of production of the Huuntun ceramic complex, based on the presence of pure contexts of Huuntun ceramics inside "Maya" style constructions. Some of the Puuc

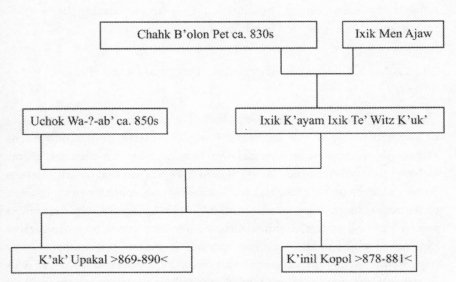

Figure 3.7. The family of K'ak' Upakal (see Boot 2005; García Campillo 2001: 405, 362; Grube and Krochock 2011: 171). Diagram by Eduardo Pérez de Heredia and Peter Bíró.

buildings, such as the Akab Dzib, show significant percentages of Huuntun ceramics in their construction fill, but in other cases, such as the Temple of the Three Lintels, the latest ceramics found in the construction fill still date to the previous Yabnal complex (Pérez de Heredia 2010: 178). These differences could be the result of the unequal contents of the available refuse deposits in the vicinity of each of these buildings, but in general they suggest that production of the Huuntun complex ceramics at Chichen Itza started shortly before the construction of the "Maya" style buildings of K'ak' Upakal, which cluster in the second half of the ninth century.[10]

Some minor similarities between the Yabnal and Huuntun complexes have been detected, but we clearly see a substitution of a ceramic tradition in terms of form, technology, and decorative treatment, while there is a continuity in the production of the paste, including ash tempers (for a description of Huuntun complex ceramics see Pérez de Heredia 2010: 134–137, 173–180). Only 18 types of ceramics have been identified so far at Chichen Itza for this period, a low number when compared to the 34 types of the previous complex, echoing the remarks of Volta et al. (Chapter 2) about uneven data sets for Chichen Itza.

Nevertheless, pure Huuntun ceramic contexts definitively exist at Chichen Itza, and they are associated with the construction and use of Puuc-style buildings. The main reason why they are so difficult to find is that most often these pure Huuntun contexts were covered by later Sotuta terrace constructions. We must remember that for every building constructed during the Huuntun ceramic complex duration, ten buildings were constructed during the next Sotuta ceramic complex period (Andrews n.d.; Ruppert 1952).

The City of K'ak' Upakal: The Middle Terminal Classic Period 860–890

During the Terminal Classic period Chichen Itza witnessed intense construction activity on top of existing Yabnal Complex terraces, or atop new extensions of those terraces, in what has been termed "Maya Chichen" or "Puuc" architectural style. Some clarifications need to be made. We agree with George Andrews' (n.d: 159) assessment that it consists of "buildings in which an early construction technology (semi-veneer block walls and slab-type, corbelled vaults) is combined with Terminal Classic Puuc-like decorative forms such as long-nosed masks and large G-frets, executed in a mosaic technique. Most of these buildings are only vaguely similar to Puuc Mosaic style buildings, with the exception of one building (Temple of the Three Lintels) which might pass for a real Puuc Mosaic-style structure."[11]

Independently of how we call this style, in a short period of time many buildings were constructed in close proximity to the Xtoloc Cenote, creating a large plaza dominated by the Monjas, the most impressive and the tallest building of its time. Several ninth-century buildings have inscriptions with inaugural dates, which are the most reliably absolute dated features that we have. They evince a short but intense period of dedications, clustering between 860 and 890.

The Casa Colorada was dedicated in 869, and its inscriptions mention K'ak' Upakal and his noble Yajawal Chow. No other building was dedicated until 878, when the lintel of the Initial Series was inscribed, announcing the great urban effort that would take place during the 880s including the House of the Seven Lintels at the Monjas; the extension of the Akab Dzib, near the Xtoloc Cenote; and in more southerly locations the Temple of the Three Lintels (dedicated 879), the Temple of the Four Lintels (dedicated 881), and possibly also the Temple of One Lintel. The most glorious decade in K'ak' Upakal's reign, the 880s, ends with dedications at the Caracol Tower. The Caracol Panel bears a date of 890, and in the same year Stela 1 was erected on the Stela Platform of the Casa Colorada (Schmidt 2011). Outlying groups such as Yula and Halakal mark the extension of the city, and we think it is very possible that K'ak' Upakal's rule extended at least as far as Yaxuna, Xtelhu, and Popola.

Chahk god masks,[12] Pawahtun figures, and geometric motifs adorn Puuc buildings at Chichen Itza. In addition, several portraits of rulers have escaped destruction. These include the portrait of Yajawal in the lintel of the Akab Dzib (Figure 3.8a) and the portrait of K'ak' Upakal in the Halakal lintel (Figure 3.8b). Painted capstones and one stela platform were also commissioned during the rule of K'ak' Upakal.

The absence of a ballcourt associated with K'ak' Upakal's reign is curious. According to inscriptions at Yula (Yula Lintel 1: C3–F2), K'ak' Upakal arrived at the Yula ballcourt and performed a ritual at that site (García Campillo 2000: 142–143), yet no records of the ruler and ballcourt activity at Chichen Itza are extant.[13] This could mean either that K'ak' Upakal never constructed a ballcourt there, or that one of the 14 ballcourts at the site could date to the late ninth century. If the latter, a likely candidate is the ballcourt annex in the north of the Monjas (Bolles 1977), but the ceramic dating for this construction still remains problematic.

The contents of Chichen Itza texts during the reign of K'ak' Upakal (>864–890<) have counterparts in some southern Maya lowland texts. According to his title of k'uh[ul] ajaw, K'ak' Upakal was a paramount ruler there, being the only Chichen Itza noble to be mentioned on hieroglyphic inscriptions outside

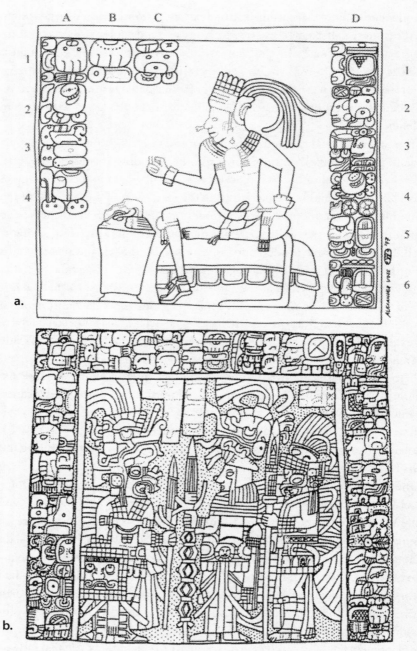

Figure 3.8. Portraits of rulers: *a*, the Second Akab Dzib Lintel. Drawing by Alexander Voss in Grube et al. 2003: part 2: 66; *b*, the Halakal Lintel, representing kings K'ak' Upakal and Jun Pik Tok'. Drawing by Alexander Voss in Grube et al. 2003: 43. Courtesy of Alexander W. Voß (Voss).

the site. For example, according to the texts he went to Halakal, about 4 km northeast of the present Chichen site center where he conducted rituals with the Halakal leader and with Ek Balam's king. He also went to Yula, 5.5 km south and somewhat east of Chichen, and with the domestic lord (*ajaw*) and his priests (*yajaw k'a[h]k'*) he conjured gods and performed a ballgame ritual, as mentioned above. When outside his kingdom, he was the representative of Chichen Itza in the manner of southern Maya lowland rulers.

The discourse of the Chichen Itza hieroglyphic texts is similar to counterparts in the Puuc in the eighth and ninth centuries. There are no accession, birth, or death statements; instead the inscriptions recorded the dedication of dwellings of gods and nobles. The languages of the texts are Proto-Yucatecan and Proto-Ch'olan, with phonological, morphological, and syntactical features mixed together in the same inscription (García Campillo 2000; Lacadena 2000; Lacadena and Wichmann 2002). This, again, is, similar to inscriptions at Puuc sites that include Xcalumkin, Xcocha, Xcombec, and Xculoc.

Many Chichen Itza inscriptions mention K'ak' Upakal's relatives and court functionaries as well as his genealogy. His grandparents, father, mother, and brother are named in some texts. The mother of K'ak' Upakal was Ixik K'ayam, "Lady Singer," who appears in several inscriptions. One of her titles was "Lady of Tree-Hill-Quetzal," a toponym which is not yet identified. Her mother and therefore K'ak' Upakal's grandmother, Ixik Men Ajaw, possibly was a female "shaman" (modern Yucateco *š mèen* [Bricker et al. 1998: 183]; *men* [Barrera Vásquez et al. 1980: 520]).

The texts state that some nobles had the roles of priests (*yajaw k'a[h]k'*), warriors (*ch'ako[h]l, b'a[h] te' ajaw, b'a[h] pakal*), and possibly a judge (*k'uh[ul] kokom*). During K'ak' Upakal's reign, gods owned dwellings (*otot*) on behalf of themselves or their relatives.

An important figure in Chichen Itza's history was Uchok Wa-?-ab'. Casa Colorada texts record that K'ak' Upakal was an *ajaw* of Wa-?-ab' (*ha'i tzakaj tu kin tu b'a[h] tu . . . [i]l k'ak' upakal k'uh[u]l a[j] mel waj yajaw wa-?-ab'*—"it was who conjured in the sun, in the water, in the . . . of K'ak' Upakal, the divine who distributes/orders the food, the subject of Wa-?-ab'"). Uchok Wa-?-ab' had a *k'uh[ul] ajaw* title, as did K'ak' Upakal, and is cited as the father of K'inil Kopol who was K'ak' Upakal's brother (text in the Temple of the Three Lintels). According to Shannon Plank, Uchok Wa-?-ab' was a deified ancestor, an apotheosized "historical" person, and perhaps the father of K'ak' Upakal. She has proposed the name as Uchokow Tab, "he scatters the salt." She also affirms that Uchok Wa-?-ab' "plays a role in two rooms of the Monjas, one of them as a dwelling owner, and he also 'owns' a dwelling in the Initial Series lintel and a

dwelling in the Three Lintel structure" (Plank 2003: 428–433). Erik Boot (2005: 358) and Miguel García Campillo (2000, 2001) concur that Uchok Wa-?-ab' was the father of K'ak' Upakal and that he may have ruled at Chichen Itza as a k'uhul ajaw before his son. However, there is no proof that he was already dead or still alive in the era of K'ak' Upakal.

According to inscriptions, K'ak' Upakal had the titles k'uh[ul] ajaw, k'uh[ul] aj mel waj,[14] k'uh[ul] aj k'a[h]k', unu'nalk'a[h]k'nal, ch'ajom, ba[h] te' and aj k'a[h] k' bi[h]tun ("divine lord," "the divine who distributes/orders the food," "divine of the fire," "the prophet of the fire place," "incense-caster," "first staff," and "the fire of the causeway") (Boot 2005: 356). His brother K'inil Kopol had the titles k'uh[ul] aj mel waj, yajaw k'a[h]k', ch'ako[h]l and ba[h] te' ajaw ("the divine who distributes/orders the food," "the lord of the fire," "decapitator," and "first staff lord"). The latter title was held by rulers in the Southern Lowlands but the yajaw k'a[h]k' title was used by subordinate priests (Zender 2004).

One of the most important buildings at Chichen Itza, the Akab Dzib, was owned by the noble Yajawal Cho who held the titles: k'uh[ul] kokom, ch'ako[h] l, ba[h] te' ajaw, and b'a[h] pakal. K'uh[ul] kokom is unique among the titles. It has been deciphered as oidor or "judge" (Grube 1994). B'a[h] pakal, "first shield," was a subordinate warrior.

Other nobles, such as Ak'e Tok' and Kalaj Kaw, had a yajaw k'a[h]k' title. Lords or ajaws from other sites are mentioned as well, such as Tok'yas ajaw and Kalkej Tok'ajaw of Yula (Boot 2005: 361). In sum, we see a political system with semi-independent settlements such as Yula or Halakal that their own ajaw ruled, but also were bound to and under the superior rule of the k'uh[ul] ajaw K'ak' Upakal at Chichen Itza.

The owner of the biggest architectural complex at that time, the Monjas, was naturally K'ak' Upakal himself, as this building functioned as the administrative center of Chichen Itza (Plank 2003: 444). The owner of the three buildings with inscribed lintels in the 7B area (as at the Temple of the Three Lintels) was a single person: K'inil Kopol, K'ak' Upakal's brother. The Initial Series Lintel records that this building was the dwelling of Uchok Wa-?-ab'. Charles Lincoln (1990: 439, 445–6) proposed that it pertained originally to the House of the Phalli. However, the volume of the lintel and the area that the inscription occupies on the stone do not fit any of the doors at the House of the Phalli.

A multitude of gods are mentioned in the Chichen Itza texts, and many are also cited in Southern Lowlands inscriptions. The most important is Yax Pech Kan depicted at Yula, the Four Lintels Temple, and Stela 1 of Casa Colorada and which we propose can be identified with the Wind God Ehecatl, a known aspect of Quetzalcoatl. Yax Pech Kan means "First Duck Snake," which relates

to the duck mask of Ehecatl. The birdlike figure in the three representations at Chichen Itza shows a duck beak and wings of knives. The same creature (without the avian form but with the duck-beak mask) is present on Seibal Stelae 3 and 19, and Uxmal Stela 14, while the wings of knives are represented on Seibal Stela 1 and Ucanal Stela 4. Coeval to these representations is the use of non-Maya graphemes. One text from Seibal Stela 13 records the Nawatl expression **t'o-t'o-ma e-je-ke****totōm ehecatl* "the hot wind" (Whittaker 2015). Another supernatural figure is Yayax Uk'uk'um K'awil, who represents lordship and aspects of K'awil associated with lightning and fertility. Yax Hal Chahk seems to be a specific manifestation of Chahk, the rain, and also the war god. Other gods, for instance, Puj Mahk Nah and Uchok Yok Puy, are unique to Chichen Itza. Other groups of gods unique to some sites are known in the Maya area, for example, at Copan, Palenque, Tikal, and Caracol (Boot 2008: 11).

In addition, some verbs in the Chichen Itza texts show similarities with the Southern Lowlands. These include *tzak-k'a[h]k,' hoch'-k'a[h]k,'pul ti k'a[h]k,'tap-al k'a[h]k,'k'al-*, *huli-* or *ul-*, *il-* , and *uxul-n-ah-* ("to conjure the fire," "to drill the fire," "to throw the fire," "to extinguish the fire," "to present," "to come," "to see," and "to carve") (Boot 2005: 375). Verbs unique to Chichen Itza include *k'uchi, hol-, xup-*, and *k'ul-ew-* ("to come," "to leave," "to end," and "to worship") (García Campillo 1996, 2000).

It is well known that the Chichen Itza texts are concerned with rituals, especially verbs about fire. In other Maya inscriptions of the area, there are one or two roughly coeval events where the main event was the "entering-the-fire" ritual. The first mention of a fire ritual is Pusilha Stela O in 573, spreading later into the Petexbatun area, the Western Region, the Eastern Region around Caracol-Naranjo, and even later into the Puuc region (Grube 2000). It is interesting that this is the same time that the name of Kan Ek' appears in Pusilha. The title of *yajaw k'ahk'* is only referenced in the inscriptions of Comalcalco, Palenque, and Tonina, apart from Chichen Itza (Jackson 2013). The spread of the fire ritual and the *yajaw k'ahk'* title, with the parallel Kan Ek' and the 9-Hab'tal titles, has led to the suggestion that there is an intimate connection between northern Yucatan and the western regions, especially the fringe area in Tabasco (Boot 2005; Pallán 2009).

What is the significance of the verbs and royal and noble titles that invoke fire in the hieroglyphic inscriptions at Chichen Itza? As noted above, the name and actions of K'ak' Upakal are related to many instances of fire rituals in Chichen Itza buildings, and one even appears at the nearby site of Halakal. The concern with fire seems to follow that of the Classic Maya, as hieroglyphic texts and imagery concerning fire rituals occur at Palenque, Piedras Negras,

Yaxchilan, Tonina, Copan, Naranjo, Kaminaljuyu, Zaculeu, Becan, and in Central Mexico at Teotihuacan, Xochicalco, and Tula (Coggins 1987; Plank 2003; Stuart 1998). David Stuart (1998: 402–403) notes the close link between fire, incense, and architectural ritual. He further notes that "the inscriptions and art of the Classic period are in fact replete with records of ceremonial burning and that these are, not surprisingly, intimately tied to sacrificial rites and other ceremonies associated with dedication." Most inscriptions involved building dedication; kindling fire in a new structure symbolically creates a home with a hearth, and thus heat and power (Stuart 1998: 417; see also Grube 2000). These ideas are applicable to Chichen Itza. Moreover, hieroglyphic inscriptions in the Casa Colorada include four fire rituals that occurred in a span of 822 days between 869 and 871; the distance between each date equals 274 days or one *tzolkin* (260-day ritual calendar) plus 14 days, with the likelihood that the four dates relate to equinoxes and solstices (Eberl and Voss 2006: 25).

The most recognizable fire ritual is New Fire, which was practiced throughout Mesoamerica. It was recorded in Maya texts as early as the sixth century. The later Mexica New Fire ceremony is the most fully documented, as Fray Bernardino de Sahagún's *Historia general* includes a detailed account. The ceremony occurred at New Year, or the transition to a new 52-year cycle, when the Pleiades crossed the solar zenith at midnight and divided the solar year into halves with a rainy and a dry season. The elaborate Mexica ceremony included episodes of dousing old fires, priests kindling new fires atop a sacrificial victim, and messengers delivering the new flames to city districts.

It is not easy to compare New Fire rituals of different sites and cultures given the type of evidence available from archaeology and hieroglyphic writing when compared with the acute level of detail that Sahagún provides. However, some scholars discuss New Fire rituals as far back as Early Classic Teotihuacan, where the Sun Pyramid was aligned to the eclipse cycle and sight lines are associated with the Pleiades and solar sightings. William Fash et al. (2009: 204–210) argue that Teotihuacanos visually labeled the Adosada, the "portal" attached to the pyramid's west façade facing the Street of the Dead, with reliefs of New Fire symbols. These include year bundles similar to the Mexica bundles of 52 canes/sticks that symbolized the 52-year cycle and censers marked with a twisted cord or fire-making sign indicating the place where fire was drilled and referencing child sacrificial victims buried at the pyramid's corners.[15]

Associated with this, Copan appropriated some Teotihuacan imagery, and Copan rulers made pilgrimages to that Mexican city to be invested in office (Fash et al. 2009: 211–213). For example, Temple 16's façade displays an image of the Teotihuacan Storm God with a corona of human skulls that suggests

human sacrifice. The temple is also adorned with T600 signs, which represent crossed bundles marked as *winte' nah*, "crossed bundle building" or "origin house" (see Estrada-Belli and Tokovinine 2016: 159–161 for the decipherment of *win*), linking them with the Adosada year bundles. At the center front of the temple is Altar Q, which portrays the Copan dynasty, including the dynasty founder K'inich Yax K'uk Mo' with goggle eyes, another Teotihuacan trait. These and other parallels led Fash et al. (2009: 213–214) to suggest that the Altar Q text records K'inich Yax K'uk Mo' traveling 153 days to Copan after receiving his charter of rulership from the *winte' nah* and identifies Teotihuacan as the locale of the Origin House.

New Fire was celebrated at other places, including Xochicalco, Tula, Kaminaljuyu, and Zaculeu (Coggins 1987). Clemency Coggins (1987) suggests that chacmools, pyrite mirrors and their depictions, and back shields worn by warrior figures at Tula and Chichen Itza may reference New Fire.

The Landscape of Chichen Itza in the Ninth Century

Several attempts have been made in recent decades to discern the sociopolitical organization from the map of Chichen Itza. Charles Lincoln (1990) and Rafael Cobos (2004) have proposed different explanations for the architectural arrangements and their relationships with the causeways in the settlement. Lincoln proposed a trifunctional group model reflecting different social classes of priests, warriors, and producers to explain the settlement as a single chronological entity, in which the Old (Maya) Chichen and the New (Toltec) Chichen parts of the city were totally contemporary. On the other hand, Cobos proposed another composition of architectural groups, noting changes in both architecture and causeway distribution. In addition, many authors have pointed out the relationship of the city with more than a dozen *cenotes* in the area as a prime factor for occupation, as well as the presence of coveted sinkholes called *rejolladas* (Gómez Pompa 1990; Kepecs and Boucher 1996). An integral part of the Proyecto Arqueológico Chichén Itzá has been the study of water resources as a primary factor for occupation (Schmidt 2000, 2003, 2011; González de la Mata 2006).

Our sequential chronological stand allows us to interpret the city in a new manner. In the first place, according to recent paleoclimate studies, it is becoming clear that the newcomers settled at an already existing Late Classic village in the middle of a period of drought and social changes when many cities were depopulated (Ebert et al. 2014; Guenter 2014). The Northern Plains, which usually receive less rainfall than the Southern Lowlands, were in this regard ap-

parently less affected by the drought than the southern regions (Dahlin 2002; Douglas et al. 2015). In such a scenario the population would have had a better chance of survival in the northern region, especially in an area of permanent water sources.

Figure 3.9 shows the known Terminal Classic buildings and the locations of the Cehpech ceramic complex collections in relation with the most important topographical changes in the plain landscape, which are represented by cenotes and sinkholes. Looking at the whole extension of the city (Figure 3.9), we first notice that there was not much construction built to the north of Xtoloc Cenote except for two stages of a platform currently buried under the Great Terrace (Schmidt and Perez de Heredia 2005).

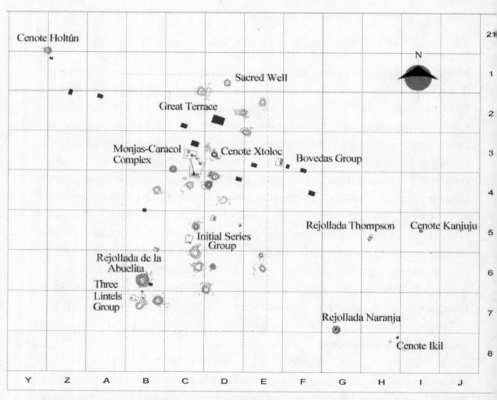

Figure 3.9. Chichen Itza at the end of the ninth century (Pérez de Heredia 2010) showing relations of architec tural groups and sinkholes (gray circles). Rectangles in gray indicate locations where Cehpech Complex ce ramics have been found. After Eduardo Pérez de Heredia 2010: map 5, prepared by Eduardo Pérez de Heredi and Francisco Pérez Ruiz.

The map shows that the Monjas Group is built inside a semicircle formed by several rejolladas and the Xtoloc Cenote, and that the main building efforts (Initial Series Group, the Temple of the Three Lintels) are close to other groups of rejolladas (Figure 3.9). Another tendency is that of placing the main buildings between pairs of rejolladas. In this respect we want to point to the name of the modern village of Xcalacoop, located about 8 km to the southeast of Chichen Itza, which means precisely "Between Two Rejolladas" and is an exact description of the location of the village between two sinkholes. We find that this "Xcalacoop" arrangement can be discerned in the settlement pattern of Terminal Classic Chichen Itza as well (Figure 3.9).

Colonial sources state clearly that, during the Late Postclassic period, the best rejolladas were owned by the noble families, and this may have been the case since Classic times (Roys 1957). Some interesting associations of architectural groups and known family groups at Chichen Itza point in that direction. Based on the inscriptions, it can be posited that the Kokom were associated with the pair of rejolladas of the Akab Dzib on the northeast, while K'inil Kopol was associated with the southwest area, since some groups of architecture were owned by K'inil Kopol in the area of rejolladas of the Three Lintels. Also it is clear that an association existed between K'ak' Upakal and the Monjas-Caracol complex on the northwest where the seating of power was situated. Moreover, K'ak' Upakal and his brothers owned the Initial Series Group located in the central position of our map. This was prime land positioned in close proximity to a group of three sinkholes. Finally, in the southeast the Chuk family was associated with the Hieroglyphic Jambs Group and possibly with the sinkholes of that area.

On a more abstract level, an overlying quadripartite/quincunx layout can be also argued, with its center at the Initial Series Group, representing the family shrine of the father of K'ak' Upakal while other groups each occupied one of the cardinal directions. The Caracol Tower represents an exception to the rest of the settlement, and may have been directly associated with the Xtoloc Cenote.

The Realm of Chichen Itza

The relations of Chichen Itza with Ek Balam and Yaxuna during the ninth century are relevant to our discussion and need some qualifications. We concur with George Andrews' opinion that "there is no known Modified Florescent architecture at Ek Balam" (Andrews n.d.: 156), while admitting that certain characteristics set it apart from the Late Classic tradition as exemplified by

Coba. According to George Bey and colleagues (1998), at Ek Balam a late Yum-cab ceramic complex can be dated 700–1000/1050 with a predominance of Muna Slate and Chum/Encanto Unslipped groups. This long Yumcab ceramic complex is associated with at least three different architectural styles; the first is a pre-Florescent style of monumental construction with relatively poor cut stone, slab vaults, and extensive use of modeled stucco; the second is a high-quality Florescent architecture characterized by buildings dressed with well-cut stone and specialized vault stones; and the third is "substantially lower-quality architecture that has similarities to that of the Postclassic" (Bey et al. 1998: 115). Changes also are apparent in the language used in the inscriptions. Eighth-century texts associated with the dynastic founder Ukit Kan Lek Tok' show Yucatecan phonology and morphological features (Grube et al. 2003). Yucatecan will become more frequent in the inscriptions under the subsequent ninth-century rulers.

At Chichen Itza two monuments connect the house of K'ak' Upakal with neighboring Ek Balam after the 860s. The Halakal Lintel has representations of the rulers of both cities. It has been suggested that Chichen Itza was under the patronage of Ek Balam until the 870s and later became an independent power (Grube and Krochock 2011). However, there is no lexeme in the text stating that the Chichen Itza ruler was a vassal of Ek Balam.

According to the Casa Colorada band, the Ek Balam ruler Jun Pik Tok' and K'ak' Upakal went to Halakal and as guests together conjured fire with the ruler there. This text first mentions K'ak' Upakal, then Jun Pik Tok', and then Yajawal Cho *k'uhul kokom*. Preceding the names, the lexeme (*ukab'an*) is a participle from the non-CVC transitive *kab(i)* "to watch, guard" and the transitive participle suffix *-an* with the third single/plural ergative *u*: *u-kab'-an* "watched it (they and the ritual)" (MacLeod 2004; Sanz González 2006). According to the discourse's protocol, the home ruler appears first, followed by the foreigner, and lastly a nonroyal noble. This suggests the possibility that Chichen Itza was a city independent of Ek Balam at this moment in time.

To the south, as stated above, we think that most ceramics and building constructions from Yaxuna that were previously thought to be Terminal Classic are instead of Late Classic times. This substantially diminishes the sample of Terminal Classic traits at the site, and only one building, Structure 6F–68, an addition to the North Acropolis, can be considered by its decoration as a Puuc construction (Freidel et al. 2002). The façade features groups of columns alternating with plain panels and 39 decorated panels that can be interpreted to identify the building as a council house or *popol nah*, while war-related symbols have also been noted (Freidel et al. 2002). In our opinion, the lack

of technical ability evident in the execution of the panels—possibly carved by artisans possessing limited skills—suggests an early date for this building, possibly in the first half of the ninth century.

Different types of evidence indicate that Yaxuna was not an independent city by 850: the earlier date of most of the Yaxuna Cehpech ceramics (Johnstone 2001) which we classify as Late Classic Slate ceramics, the fact that only one early Puuc building was ever constructed there, and finally the absence of extant hieroglyphic inscriptions for the entire ninth century. The dominion of Chichen Itza over the area seems reasonable especially given the advantage that would have resulted from control over the Yaxuna-Coba Sacbe. Later, during K'ak' Upakal's reign, apparently no new architecture was built at Yaxuna, and, as in the case of Coba, this ancient city would not be an important center in the times to come.

The End of the "Puuc" City: The Late Terminal Classic Period 890–930

The quantity of Huuntun ceramics found so far at Chichen Itza is not very abundant, suggesting a short period of production that matches the short period of construction of "Maya Puuc" style architecture (see Volta et al., Chapter 2, for alternative explanations). The end of production of Huuntun ceramics circa 930 is inferred from the beginning of production of Sotuta complex pottery which is placed at 920/950 at the Osario (Pérez de Heredia 2010).

During the last part of K'ak' Upakal's reign, Chichen Itza ruled almost alone in the northeastern plains. Coba and Yaxuna were surely defeated by 850, and, after 870, inscriptions at Ek Balam ended as well. We do not know the exact fate of the dynasties of these kingdoms. Many issues remain unresolved, especially regarding the role that Chichen Itza may have played in Ek Balam's downfall. Possible scenarios include a conquest or absorption of Ek Balam by Chichen Itza.

Although the last years of K'ak' Upakal's rule apparently included no nearby political competition, Uxmal was a powerful kingdom to the west. Under the ruler K'ak' Sip Chan Chahk k'a[h]k'nal ajaw (referred to as Lord Chaak in Chapter 2) it experienced an intense construction period of spectacular buildings, including the Monjas Quadrangle, in what is called the Late Uxmal architectural style (Andrews 1986). Carved dates associated with this ruler fall within a very short period (905–907) at the capstones of the East Building, Building Y, and South Building at the Monjas Quadrangle. K'ak' Sip Chan Chahk is portrayed in Stelae 11, 14, and 17, dated to 909 (Schele and Mathews 1998: 286–288).

K'ak' Upakal and K'ak' Sip Chan Chahk were the most powerful rulers of

northern Yucatan at the end of the ninth century, yet hieroglyphic inscriptions reveal nothing about any interaction between both realms. Likewise, we understand little about Chichen Itza and plausible relationships with other cities in the northern plains including Izamal, which is almost as close to Chichen Itza as Ek Balam, and Dzibilchaltun further to the west.

Because we are not sure when K'ak' Upakal died, some speculation is necessary. If he was at least 20 years old when he performed rituals in Halakal in 869, he must have been born by 849, and by 900 he would have been about 51 years old. We think it is possible, in the vacuum of inscriptions, that he may have died by 910 at age 60. We do know that in the years after K'ak' Upakal's death, at the beginning of the tenth century, a new linguistic discourse developed at Chichen Itza. This had its origins in the older Puuc discourse but also included a transformation of the graphemes, as can be seen in the texts of the Caracol Disk (Bíró and Pérez de Heredia 2016; Figure 3.6).

Locals or Foreigners?

There is substantial evidence that the Terminal Classic period, especially the ninth century, was a period of reorganization in the Southern Lowlands. Seibal and surrounding sites, as well as selected cities in the northeast Peten and El Mirador Basin, resumed dedication of monuments circa 860–900 using Classic-period iconographic motifs but in a different style (Just 2006). Several visual motifs such as the depictions of darts and *atlatls*, identical slipper-like footgear, and the "Knife-Wing" bird were used concurrently in such faraway places as Seibal and Chichen Itza (Kowalski 1989).

A discursive change is also found throughout the Maya Lowlands during the ninth century. Fewer hieroglyphic inscriptions are carved, and their texts are shorter. In contrast to those of the Early and Late Classic periods, inscriptions no longer include the life events of rulers, focusing instead on the performance of rituals, especially building dedications for supernatural beings, which had many participants. At Chichen Itza inscriptions have a local emphasis on specific themes, such as fire rituals, but do not differ from the main lowland discursive framework beginning circa 820/830 (Boot 2005; Grube and Krochock 2011).

On a regional level, this period saw the reorganization of the lowlands after the first wave of political collapse (Houston and Inomata 2009). A new artistic style developed, which often combines elements of the Classic period Southern Lowlands with foreign iconographic motifs. A new discourse pattern and new formats of inscriptions were in fashion, along with a growing Yucatecan vernacularization in the texts of the Northern Lowlands (Grube 2003; Patrois

2008). After a period of silence, the rulers of Edzna and Oxkintok resumed commissioning monuments but displayed a new style. The ninth century was also the time when the great centers of the eastern and the central Puuc region reached their heydays. Uxmal (819–928?), Kabah (849–911?), Sayil (862–928), Nohpat (858), and Labna (862) erected their first dated monuments (Graña-Behrens 2002) and undertook constructions in the Junquillo and Mosaic styles (Andrews 1986; Pollock 1980) coinciding with the production and use of Cehpech ceramics (Brainerd 1958; Smith 1971).

Admittedly, uncertainty surrounds the origins of the dynasties at both Ek Balam and Chichen Itza. We disagree with the proposal that the dynasties and/or populations of either site came from the Puuc region (Andrews and Robles Castellanos 1985). In our view, resemblances between northeastern cities such as Ek Balam, "Maya" Chichen Itza, and Kuluba, and western Puuc cities are difficult to find. The architecture of Ek Balam is dissimilar to that of Puuc sites, and its stucco technique has local roots in the Early Classic stuccoes of the northern plains. Sylviane Boucher points out that the Muna Slate ceramics of Ek Balam have particularities that distance them from Puuc Muna ceramics (2014). The same can be argued for Chichen Itza where the architecture has Puuc adornments yet differs technically from the Puuc cities (Andrews n.d.) and where particularities in the Muna Slate ceramics have also been noted (Pérez de Heredia 2010). Conversely, parallels between western and eastern sites in the northern plains can be found in iconography and epigraphy and in the use of Yucatecan words in the texts.

Rather than considering both dynasties of Ek Balam and Chichen Itza to have been similar in origin, we regard the former as having been a local development and the latter as having had a foreign source. At Ek Balam the dynasty of Ukit Kan Lek Tok' may have been local indeed, with roots since at least Late Classic times. Several types of evidence would support this. First, for the Early Yumcab ceramic complex, Fine Gray and polychromes have been reported (Bey et al. 1998), and published materials from the tomb of Ukit Kan Lek Tok' reveal that Early Slate ceramics also exist at the site. This shows that a population with access to polychromes and imported fine wares predated Ukit Kan Lek Tok'. Second, although stucco buildings at Ek Balam were constructed at the very end of the Late Classic, other buildings may underlie the visible structures in massive constructions such as the Acropolis. Third, epigraphy hints at the possible existence of a king who ruled before Ukit Kan Lek Tok' at Ek Balam. The Ikil lintels—mentioning Ukit Map of Ek Balam[16]—have been dated 650–750 (Andrews and Stuart 1968), prior to 770, the first date associated with Ukit Kan Lek Tok'.

Furthermore, the mother of Ukit Kan Lek Tok' could have been from Coba

or a site between Coba and Ek Balam, according to Alfonso Lacadena (2004). This offers an alternative explanation to population movements from the Puuc or elsewhere being responsible for the dynastic founding events of Ek Balam that occurred around 770. Ek Balam may have been a former Late Classic city that could have evolved into a more powerful capital, perhaps through a marriage alliance with Coba.

In any case, an interesting political circumstance, unprecedented in the Northern Lowlands, happened at the end of the eighth century when the supreme title of *kalomte'* was held simultaneously by two rulers, Ukit Kan Lek Tok' of Ek Balam and Kalomte' Chan Kinich of Coba.[17] A third ruler, located at an unidentified site, concurrently held the title of *xaman kalomte'* (northern *kalomte'*).[18] Apparently then, Ek Balam had the same rank as Coba, and this may have been the cause or product of a conflict between the two.

As stated earlier, Coba dedicated monuments until the 830s, according to the stylistic criteria that allow dating in the absence of recorded dates. This is roughly the same time that the first hieroglyphic inscription was recorded in 832 at Chichen Itza on the Temple of the Hieroglyphic Jambs. No more buildings were constructed at Coba until much later during the Late Postclassic occupation. The ultimate fate of the Coba dynasty remains unknown.

In contrast to Ek Balam, we think that at Chichen Itza there is compelling evidence that K'ak' Upakal's dynasty was foreign, without links to the previous Late Classic inhabitants. Two monuments show that the members of the ruling class in Chichen Itza already knew a Nahuan[19] language in the ninth century. One title in the inscription at Structure 6E1 is a lexeme originally coming from a Nahuan language (*tupi[l]*). It is usually explained as being derived from the Classic Nahuatl *topile* "alguacil" and ultimately from *topilli* "bastón." An alternative etymology for this title is YUC *tup* "tapar el fuego" (Barrera Vásquez et al. 1980). Since the name begins with "fire," the title may refer to the political officer who covered the fire during the ritual.

Other iconographic elements present on Column 6E1 (Figure 3.10) also are of foreign origins. The leftmost person with a possible Nahuan title (*tupil*) wears an eagle headdress that occurs on Edzna Stelae 15 and 16, Kabah Altar 3 (849), Sabana Piletas relief from the Sculpture Group (ca. 869) and Oxkintok Stela 12 (928) (Graña-Behrens 2002; Pallán 2009: 404). According to Carlos Pallán (2009, 2012), this eagle-headdress ultimately came from the Central Mexican Highlands via Chontalpa. This helmet may be named by the Nahua word **KOT/** *ko[h]t* "eagle" first mentioned in Etzna Stelae 5 and 9 between 790 and 810.

The helmet of the person named Jun Yajawal Winik is similar to that of the person on the north jamb of Structure 2C6 at Kabah. The remaining two

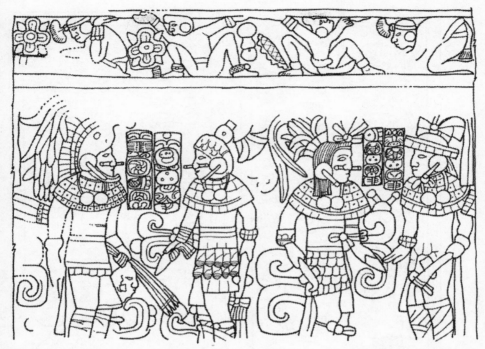

Figure 3.10. Column of Structure 6E1. Drawing by Linda Schele © David Schele, SD-5009, by permission of the Los Angeles County Museum of Art.

people show the hairstyle of Seibal Stela 13 and the wide cap of Itzimte Stelae 12 (869) and 6 (910) and Oxkintok Stela 12 (928). This wide cap is present in the Cacaxtla Red Temple Mural (ca. 750) associated with the Merchant God and in Postclassic Yucatecan codices with Ek' Chuwah, "the black scorpion."

Additional evidence can be seen in the inscription on the lintel of the East Wing of the Monjas in which four graphemes come from a Nahua idiom (Figure 3.11). In A3–B3 **yo-TOT**, the last grapheme is **TOT**/*totot(l)*, "bird." In A5-B5 there is a Central Mexican calendar glyph (Bricker and Bricker 1995) and in D1 is a grapheme **WATER** or **TLALOK** which occurs in the Central Mexican calendar system. While we have no date for its lintel, the architectural style of the East Annex is comparable with the Late Uxmal style dated circa 880–910. If the text was carved at the same date as the construction of the building, then the inclusion of these graphemes shows that the scribe explicitly used an idiom foreign to Yucatan. In the Southern Lowlands, Central Mexican graphemes and the Nahuan language appeared in the last quarter of the ninth century, usually in calendrical glyphs such as Jimbal Stelae 1 and 2 and Seibal Stelae 3

Figure 3.11. Inscription of the lintel at the East Annex of Monjas. Drawing by Travis Nygard, after Maudslay 1889–1902: vol. 3: plate 13c. By permission of Travis Nygard.

and 13 (Lacadena 2010; Pascual Soto and Velásquez García 2012). This Nahuan idiom possibly was close to the eastern Nahuan language spoken in the sixteenth century in the Gulf of Mexico (Isthmus Nahuan).

The graphemes and the Nahua idiom apparently are associated with the cult of the Venus God, or Tlahuizcalpantecuhtli (Pascual Soto and Velásquez García 2012). A Venus sign appears on the East Annex of the Monjas (in D4), and, according to Victoria Bricker and Harvey Bricker (1995), the date of the monument is 877 during K'ak' Upakal's reign.

In sum, we propose that a multiethnic foreign merchant-warrior group with cultural links to the Gulf Coast and Central Mexico settled at Chichen Itza after 800. They were most likely instrumental in the demise of Coba and Yaxuna.

By 832 the foreigners carved their first inscription (6E3). They may have married into the local noblesse with K'ak' Upakal possibly being the child of such a marriage.

At nearby Ek Balam, Ukit Jol Ahkul became ruler circa 830s and is represented as a ballplayer on Ichmul de Morley Panel 2. At this time Ek Balam would have been the mightiest city in northeast Yucatan. Possibly under the approval of Ukit Jol Ahkul, *k'uh[ul] ajaw* Uchok Wa . . . ab' expanded the foundations of Chichen Itza in preparation for the successful kingdom of his son K'ak' Upakal.

The Court of K'ak' Upakal

In the Postclassic and Colonial periods, the court of the ruler was transformed in many ways, and the names of officers changed from Yucatec to Spanish (Restall 2001). The *halach winik/yax batab* became *gobernador*; the *holpop* changed to *teniente*; the *aj tz'ib'hun* was named *escribano*, and so on. The Postclassic court perhaps had as many as 50 officers. Similarly, the ninth-century court of K'ak' Upakal had many political officers.

The most prominent member of the government during the early years of K'ak' Upakal's kingdom was Yajawal Cho. He may have acted as his first commander, *b'a[h] pakal* or "first shield," and also as a *k'uh[ul] kokom*. This title has been deciphered as *oidor, juez* (Grube 1994); in Spanish, *oidor* means *el que oye*, "he who hears." It refers to the first judges in the fourteenth-century kingdom of Castille, when the king appointed some advisers to hear the cases of the kingdom and delegated some of his powers to them so they could rule in his name. Therefore, in a military capacity, Yajawal Chow was a commander or "first shield" of K'ak' Upakal. In governmental affairs Yajawal Cho was one of K'ak' Upakal's closest advisers, acting as a judge and ruling in his name. Another important official was K'inil Kopol, K'ak' Upakal's brother who shared the title *k'uh[ul] aj mel waj*, "divine him who distributes the food" (Boot 2005).

Fire rituals were predominant political activities. The titles of the many participants show a hierarchy of practitioners, with the supreme actor being K'ak' Upakal K'inich K'awil. Apart from using the term *k'awil*, "fiery shield of the hot one," as part of his name, the king had the titles *k'uh[ul] aj k'a[h]k, unu'nal k'a[h]k'nal*, and *aj k'a[h]k' bi[ht]un* ("divine of the fire," "the prophet of the fire place," and "the fire of the causeway"). K'inil Kopol and other nobles like Ak'e Tok' and Kalaj Kaw used the title *yajaw k'a[h]k'*; they called themselves "the lords of the fire."[20] The importance of the fire rituals in northern Yucatan at this time is also evidenced in the name of the contemporaneous Uxmal king *k'a[h]*

Table 3.2. The court of K'ak' Upakal

PRIMARY LEVEL

k'uh[ul] ajaw	K'ak' Upakal K'inich K'awil
k'uh[ul] aj k'a[h]k'	
k'uh[ul] aj mel waj	
aj k'a[h]k' bi[h]tun	
unu'nal k'a[h]k'nal	

SECONDARY LEVEL

k'uh[ul] aj mel waj, ch'ako[h]l, b'a[h] te'	K'inil Kopol, brother of the ruler
yajaw k'a[h]k'	
k'uh[u]l kokom, b'a[h] pakal	Yajawal Cho
k'uh[ul] aj kan	Aj B'olon K'awil from Caracol area

TERTIARY LEVEL

yajaw k'a[h]k'	Kalaj Kaw, Ak'e Tok'
ajaw	Tok'yas, Kalkej Tok'

Source: Eduardo Pérez de Heredia and Péter Bíró.

k'nal ajaw K'ak' Sip Chan Chahk ("lord of the Fire Place, the fiery Sip, the Old Deer God, and Heavenly Chahk") (Grube 2012).

Later in our classification (Table 3.2) is Aj B'olon K'awil, who was a speaker (*aj kan*) of the Caracol. He was also mentioned in colonial sources, where his political office was on the tertiary level (Restall 2001). Exterior nobles from Halakal and Yula had the political title *ajaw*, and they possibly had their own court and priests.

Previous scholars have noted that the matrilineage of K'ak' Upakal is better recorded in hieroglyphic texts than his patrilineage (Grube 1994). The participation of women in the government is evidenced by their eminent position in the inscriptions of most eastern Puuc cities. Ukit Kan Lek Tok' recorded his mother's origin as from . . . Ho'-?, perhaps Coba or another site to the east or southeast of Ek Balam (Grube et al. 2003: 18). A noble lady who may have come from the Mirador Basin area is mentioned at Ikil. In addition to their role as close advisers to kings, these women also brought prestige to the lineage and reinforced the legitimacy of their sons (see also Wren et al., Chapter 9, for treatments accorded women in situations of conflict). K'ak' Upakal's mother, Ixik K'ayam or Lady Singer, traces her origins to a place called Tree-

Hill-Quetzal. In turn, she was the daughter of Ixik Men Ajaw, "Woman Shaman Lord" or "Queen Shaman." This name signals the participation of women in the religious and political activities of the ruling class and signals that acts of legitimization of foreign invading groups through marriage with local noble women are known in Mesoamerica as in the case of the Aztecs.

By 870 K'ak' Upakal was portrayed at Halakal in the company of the last known king of Ek Balam, Jun Pik Tok'. The Halakal inscriptions suggest good relations between the rulers and their cities. After this event Ek Balam ceased to be mentioned. In contrast to the silence at Ek Balam, for the next 20 years K'ak' Upakal was the only ruler recorded in northeastern inscriptions, which suggests that the power of Ek Balam passed to Chichen Itza.

K'ak' Upakal plausibly died at the end of the ninth or the beginning of the tenth century. Soon after his death, a new monument was carved: the Caracol Disk, dated 929–930, showing the arrival of the new cult of the Feathered Serpent, K'uk'ulkan, into Chichen Itza, an event that would change the fate of northern Yucatan forever. But that is another century.

Acknowledgments

We want to thank Sylviane Boucher, Peter Schmidt, Peter Mathews, and Tim Murray for reading different versions of this chapter and for their comments. In the section regarding the epigraphy we would like to thank Carlos Pallán Gayol and Guido Krempel for their insights. To the editors of this volume, Linnea Wren, Cynthia Kristan-Graham, Travis Nygard, and Kaylee Spencer, we express our appreciation for their patience and help.

Notes

1. There are multiple methods to transcribe and transliterate Maya script (Bíró 2011a: 4–8). In terms of the identity of the language, its phonological and morphological system, and inherently the discourse structure of the texts, we follow Wichmann (2006). In terms of the orthography we provide a full, broad transcription and a broad transliteration using the alphabet designed by the Guatemalan Academy of Mayan Languages.

2. When discussing Chichen Itza here we use the term "Maya" to refer to a configuration of particular "Puuc" architectural and Yucatec epigraphic styles in combination with the production/use of Cehpech ceramics. The "Toltec" term refers to another architectural and epigraphic style that clusters with Sotuta ceramics. We do not imply any ethnic component by the use of those two terms, as we are wary of assigning ethnic identities. At least we know from the inscriptions that the languages in use were Classic Ch'olan and Epigraphic Yucatec until 998, when the last inscription in Maya was carved in Chichen Itza. Later monuments will show the use of non-Maya graphemes, many still waiting decipherment.

3. This array has gathered some recent support, especially regarding the inception of the Sotuta ceramic complex at around 930, though some objections have been voiced, mostly focused in the case of the Huuntun complex (Schmidt 2005; see Volta et al., Chapter 2, this volume). Recently Scott Johnson (2015) has also agreed on the Sotuta dating, while expressing concerns about the chronological significance of the local wares for each complex. See Johnson, Chapter 4, this volume, for further discussion of this issue.

4. The [i]-tza-a spelling is found in the emblem glyph of Itzimte Sacluk, and in stone and ceramic inscriptions from the Lake Peten Itza area such as Motul de San José (Boot 2005, 2010). The main element of an emblem glyph, which was a title for the ruler and his family, was usually a toponym such as *itza'* or *itz ha'* (Bíró 2012; Mathews 1991; Stuart and Houston 1994; Tokovinine 2013). What was read as **hi-tza-a** from texts at Chichen Itza has turned out to be a local variant of the **tza** syllabic sign and therefore the intended collocation is simply **tza-a** (Grube 2003: 361–362). In combination with titles it expresses that a person is from such a site. Some epigraphers thought that *Tza'* has been interpreted as the emblem glyph of Dzilam González (Graña-Behrens 2006), but other authors have suggested a connection with Chichen Itza (Grube 2003; Grube et al. 2003; Grube and Krochock 2011).

5. It is very difficult to determine the date when production began for this complex because we lack absolute dates to fix the early contexts of this period at Chichen Itza. Robert Smith (1971) proposed the date 600, and, lacking better information, we accept it for the time being. Further excavations of early contexts of the Yabnal complex are vital to fine-tune this date.

6. The sample includes collections from the Ikil Group, the Sacred Cenote, the Great Terrace, the Osario Terrace, the Initial Series Group, the Temple of the Three Lintels, the Chultún Group, the Akab Dzib, the Plazas Group, the Group of the Alux, the East Group, the Groups of Sacbe 61 and 19, the "Rejollada de la Abuelita," Structures 3E19 and 4D6, the Casa Colorada, the Halakal Group, the tourist entrance area, and the Holtun Group.

7. Dates of the jades cluster between 682 and 706 and mention the kings of Piedras Negras, Palenque, and Calakmul (Grube et al. 2003: 7–8).

8. Here we agree with Brainerd's discussion about the collections of Yaxuna, where he detected an early development of slatewares: "The forms of slate ware found here differ in several respects from those of the Puuc sites. The jar forms, concave interior basin lips, and slab bowl legs all argue for an early Florescent dating for most of this assemblage" (Brainerd 1958: 128, fig. 39).

9. If the building pertains indeed to the 9th century, it would be the earliest gallery-patio building at Chichen Itza, with no known replication until at least a century later. However, in support of this alternative possibility, we note that the jambs mention a "first white plaza stone," "divine plaza," or just "plaza" (Plank 2003: 484) which may refer to the gallery-patio type of structure.

10. For context formations at Chichen Itza, see Pérez de Heredia 2010: 28–32.

11. According to G. Andrews (n.d.: 251), "The Maya-Chichen style is represented by some 16 buildings, including Structures 3C7 (Deer House), 3C9 (Red House), 3E3 (Sweat House), 4CI (Monjas proper. East Wing. Church, and East Annex), 4DI (Akab Dzib). 5C5 (House of the Shells), 7B3 (Temple of the Three Lintels), 7B4 (Temple of the Four Lintels), and Structures 5B3, 5B4, 5B7, 5B22, 5C14, 5D2, and 7B2. Possible additions to this list include Structures ID2, 3CII, 5A4, 5D4, and 7B1."

12. For alternative views of the god masks identified here as Chahk, see Miller (Chapter

6, this volume) and Headrick (Chapter 7, this volume), both of whom identify this motif as representative of the *witz* monster.

13. He was perhaps mentioned in the Great Ball Court Stone, but this is questionable. Earlier, scholars identified another record of a ballcourt at Lintel 1, the Temple of the Four Lintels (Voss and Kremer 2000: 172; Wren et al. 1989). However, we now know that the reading of the grapheme in C8 is "step" (*e[h]b'*) and not "ballcourt."

14. Grube (1994) deciphered the "Penis"-title as *aj achel waj* but Voss (in Voss and Kremer 2000: 153–156) later questioned it and proposed that the title was *aj tz'ul waj*. Recently, Dmitri Beliaev (2014) suggested that the unknown grapheme is *me* and the translation of the title "he who distributes/orders the food." Corresponding cognates are in Chol, Tzeltal, and Tzotzil (CHL *mel* "hacer; juzgar"; *melojel* "proceso") (Aulie and Aulie 1998: 57); TZE *melel* "explicar"; *meltsa'anel* "arreglar" (Slocum and Gerdel 1971: 161); TZO *meltsanel* "mejorar, componer"; and *melel* "cierto, acertado, verdadero" (Murley de Delgaty and Ruiz 1987: 82). Especially important is a gloss from Laughlin, -*mel* "distribute evenly /corn gruel or meat when offered communally" (Laughlin 1975: 234). He found an entry in Wisdom (1950), *mer chor* "one of five rain gods (special guardian of *milpas* located in southwest from whence rain bearing winds come)."

15. Fash et al. (2009) and Coggins (1987) present arguments that investigate New Fire on a large scale, while here only some of their ideas are discussed.

16. The emblem glyph that appears on the Ikil Lintel has been identified by some scholars with Ek Balam (Bíró 2003; Grube and Krochock 2011: 162; Zender 2003), while others have proposed that it was a different emblem glyph (Lacadena 2004; Graña-Behrens 2006: 113). The drawing clearly shows **ma-TAL-lo-AJAW-wa** spelling, meanwhile, in Ek Balam, the spelling of the emblem glyph is **TAL-lo AJAW-wa**. Recently, Stuart (2008) suggested that the sequence [**ma-TAL-nn**] is a composite sign (trigraph), and he proposed that its reading would be a Co grapheme. Such an interpretation seems valid to us as most of the time this trigraph is followed/preceded by a known Co syllabogram (**ko, lo, mo**). Indeed, the Ek Balam emblem glyph might be a spelling of this particular syllabic sign as indicated by a **lo** suffix. If this is true, then [**ma-TAL-nn**] in the Ek Balam emblem glyph would be covered by the upper and lower part of the trigraph (**ma** and **nn**) by the **AJAW** logogram and **lo**. However the sign **lo** would be enough to cue the appropriate reading. In this case all of the (**K'UH**) [(**ma**)-**TAL**]-**lo** (**AJAW**) spellings indicate the same emblem glyph (in Ek Balam and Ikil) and, if Stuart's suggestion is valid, then a possible **tz'o-lo**/*tz'ol* would be the reading of the Ek Balam emblem glyph.

17. Ukit Kan Lek Tok' and his successor K'an B'ob' Tok' were both connected to Chan Jutuw Chan Ek' who had an unidentified emblem glyph and also used the *xaman kalomte'* (northern *kalomte'*) title.

18. After the elite collapse of Coba, there were at least three *kalomte'* in northern Yucatan: Ek Balam, Dzibilchaltun, and the northern *kalomte'* ca. 830. The title is mentioned in two Ek Balam texts, both in the Acropolis Room Sub 29 (Mural A and B9), with an undeciphered main sign emblem glyph. The grapheme represents a rodent head with a black color around the eye, the mouth with two canine teeth, a tuft on the front, and an **AK'AB'** mark on the face. At the moment there are two graphemes that compare with it. One comparable grapheme is the raccoon logograph **EM** (Zender 2005), and the other is the weasel logograph **SAHB'IN** (Lopes 2005). However, while the **SAHB'IN** sign lacks the black color around the eye, it incorporates it above in two marks (both in sculpture and in painted ceramics such as in Palenque Temple 18 and in the vessels photographed by Kerr [n.d., K2067 and K4113]). The **EM** logograph is close to the

main sign in Ek Balam, especially to the painted ceramics (for example, in the vessel photographed by Kerr [n.d., K7821]). If the emblem glyph is *k'uhul em ajaw*, then it would be almost like the name of the colonial place Emal mentioned in the Chilam Balams of Chumayel and Tizimin and *Codex Peréz*. The first Emal was a Postclassic site close by the Isla Cerritos and the second one was the ancient name of Izamal (*etz emal* in Chumayel; see Mediz Bolio 1930: 34).

19. In linguistics, Proto-Nahuan language is composed of the Pochuteco and General Nahuan, and, within the latter, there are Eastern and Central-Western Nahuans. The Classic Nahuatl is Central Nahuan spoken in the Central Valleys of Mexico, Morelos, Puebla, Tlaxcala, and Guerrero (Kaufman 2001).

20. The rituals of fire, connected since early times in Mesoamerica with the Sun God cult (Old God of Fire in the Postclassic Nahuatl Huehueteotl-Xiuhtecuhtli) have precedents in the Maya region (the Jaguar God of the Underworld [see Stuart 1998; Taube 1992]), but the emphasis on fire rituals at Chichen Itza may have been motivated by the influx of New Fire ceremonies of Mexican origin attested to during the Epiclassic period.

References Cited

Andrews, Anthony P., and Fernando Robles Castellanos
1985 Chichén Itzá and Coba: An Itzá-Maya Standoff in Early Postclassic Yucatan. In *The Lowland Maya Postclassic*, edited by Arlen F. Chase and Prudence M. Rice, pp. 62–72. University of Texas Press, Austin.

Andrews, E. Wyllys, IV, and George E. Stuart
1968 The Ruins of Ikil, Yucatan, Mexico. Middle American Research Institute Publication 31: 69–80. Tulane University, New Orleans.

Andrews, George F.
1986 *Los estilos arquitectónicos del Puuc; una nueva apreciación*. Instituto Nacional de Antropología e Historia, Colección Científica, Mexico City.
n.d. *Architectural Survey of the Northern Plains: Chichen Itza*. Department of Architecture, University of Oregon.

Ardren, Traci, and William R. Fowler
1998 Introduction: Recent Chronological Research in Northern Yucatan. *Ancient Mesoamerica* 9: 99–100.

Aulie, H. Wilber, and Evelyn W. Aulie
1998 *Diccionario Ch'ol de Tumbalá, Chiapas, con variaciones dialectales de Tila y Sabanilla*. Instituto Lingüística de Verano, Coyoacán, Mexico City.

Barrera Vásquez, Alfredo, Juan Ramón Bastarrachea Manzano, William Brito Sansores, Refugio Vermont Salas, David Dzul Góngora, and Domingo Dzul Poot (editors)
1980 *Diccionario Maya Cordemex: Maya-Español, Español-Maya*. Ediciones Cordemex, Merida, Yucatan.

Beliaev, Dmitri
2014 Personal communication, February 14.

Bey, George J., III, Tara M. Bond, William M. Ringle, Craig A. Hanson, Charles W. Houck, and Carlos Peraza Lope
1998 The Ceramic Chronology of Ek Balam, Yucatan, Mexico. *Ancient Mesoamerica* 9: 101–120.

Bíró, Péter
2003 The Inscriptions on Two Lintels of Ikil and the Realm of Ek' B'ahlam. Mesoweb. www. mesoweb.com/features/Bíró/Ikil.pdf.
2011a The Classic Maya Western Region: A History. BAR International Series 2308. British Archaeological Reports, Oxford.
2011b Late and Terminal Classic Northern Maya Lowlands History: What if? Paper presented at the 76th Annual Meeting of the Society for American Archaeology, Sacramento.
2012 Politics in the Western Maya Region (II): The Emblem Glyphs. Estudios de Cultura Maya 39: 31–66.

Bíró, Péter, and Eduardo J. Pérez de Heredia Puente
2016 The Caracol Disk of Chichén Itzá (929–932 CE). Some Thoughts on Epigraphy and Iconography. Estudios de Cultura Maya 48: 129–162.

Bolles, John S.
1977 Las Monjas: A Major Pre-Mexican Architectural Complex at Chichén Itzá. University of Oklahoma Press, Norman.

Boot, Erik
2005 Continuity and Change in Text and Image at Chichén Itzá, Yucatan, Mexico: A Study of the Inscriptions, Iconography, and Architecture of a Late Classic to Early Postclassic Site. Centre for Non-Western Studies Publications, no. 135. Research School Centre for Non-Western Studies, Leiden.
2008 Amongst the Gods: Discourse and Performance in the Inscriptions at Chichen Itza, Yucatan, Mexico. Paper presented at the VI Mesa Redonda de Palenque, November. www. academia.edu/9282601, accessed on June 17, 2016.
2010 Chichen Itza in the Mesoamerican World: Some Old and New Perspectives. In The Maya and Their Neighbours: Internal and External Contacts through Time, edited by Laura van Broekhoven, Rogelio Valencia Rivera, Benjamin Vis, and Frauke Sachse, pp. 73–88. Acta Mesoamerica, vol. 22. Verlag Anton Sauerwein, Markt Schwaben.

Boucher, Sylviane
1992 Cerámica Pizarra Temprana: algunos precursores y variantes regionales. In Memorias del Primer Congreso Internacional de Mayistas, pp. 464–472. Universidad Nacional Autónoma de México, Mexico City.
2014 Personal communication, Jan. 10.

Brainerd, George W.
1958 The Archaeological Ceramics of Yucatan. Anthropological Records, no. 19. University of California Press, Berkeley.

Bricker, Victoria R., and Harvey M. Bricker
1995 An Astronomical Text from Chichen Itza, Yucatan, Mexico. Human Mosaic 28: 91–105.

Bricker, Victoria R., Eleuterio Po'ot Yah, and Ofelia Dzul de Po'ot
1998 A Dictionary of the Maya Language as Spoken in Hocabá, Yucatán. University of Utah Press, Salt Lake City.

Cobos Palma, Rafael
2004 Chichen Itza: Settlement and Hegemony during the Terminal Classic period. In The Terminal Classic in the Maya Lowlands: Collapse, Transition, and Transformation, edited by Arthur A. Demarest, Prudence M. Rice, and Don S. Rice, pp. 517–544. University Press of Colorado, Boulder.

Coggins, Clemency Chase

1987 New Fire at Chichen Itza. In *Memorias del Primer Coloquio Internacional de Mayístas 5–10 Agosto, 1985*, pp. 427–482. Centro de Estudíos Mayas, Universidad Nacional Autónoma de México, Mexico City.

Dahlin, Bruce H.

2002 Climate Change and the End of the Classic Period in Yucatan: Resolving a Paradox. *Ancient Mesoamerica* 13: 327–340.

Douglas, Peter M. J., Mark Pagani, Marcello A. Canuto, Mark Brenner, David A. Hodell, Timothy I. Eglinton, and Jason H. Curtis

2015 Drought, Agricultural Adaptation, and Sociopolitical Collapse in the Maya Lowlands. *PNAS: Proceedings of the National Academy of Sciences of the United States of America* 112: 5607–5612.

Eberl, Markus, and Alexander Voss

2006 New Fire Rituals at Chichén Itzá: The Casa Colorada Inscription. *Ketzalcalli* 2: 22–29.

Ebert, E. Claire, Keith M. Prufer, Martha J. Macri, Bruce Winterhalder, and Douglas J. Kennett

2014 Terminal Long Count Dates and the Disintegration of Classic Period Maya Polities. *Ancient Mesoamerica* 25: 337–356.

Ediger, Donald

1971 *The Well of Sacrifice*. Doubleday, Garden City, N.Y.

Estrada-Belli, Francisco, and Alexandre Tokovinine

2016 A King's Apotheosis: Iconography, Text, and Politics from a Classic Maya Temple at Holmul. *Latin American Antiquity* 27: 149–168.

Fash, William L., Alexandre Tokovinine, and Barbara W. Fash

2009 The House of New Fire at Teotihuacan and Its Legacy in Mesoamerica. In *The Art of Urbanism: How Mesoamerican Kingdoms Represented Themselves in Architecture and Imagery*, edited by William L. Fash and Leonardo López Luján, pp. 201–229. Dumbarton Oaks, Washington, D.C.

Freidel, David A., Travis W. Stanton, Charles K. Suhler, Traci Ardren, James N. Ambrosino, David Johnstone, Justine M. Shaw, and Sharon Bennett

2002 *Proyecto Yaxuna. Informe Final al Consejo de Arqueología del Temporadas 1986–1996*. Final report submitted to the Archaeology Council of the Instituto Nacional de Antropología e Historia. Mexico City.

García Campillo, José Miguel

1996 Sufijo verbal–ki# en las inscripciones de Chichén Itzá. *Mayab* 10: 50–58.

2000 *Estudio introductorio del léxico de las inscripciones de Chichén Itzá, Yucatán, México*. BAR International Series 831. British Archaeological Reports, Oxford.

2001 Santuarios urbanos. Casas para los antepasados en Chichén Itzá. In *Reconstruyendo la ciudad Maya: el urbanismo en las sociedades antiguas*, edited by Andrés Ciudad Ruiz, María Josefa Iglesias Ponce de León, and María del Carmen Martínez Martínez, pp. 403–423. Publicaciones de la Sociedad Española de Estudios Mayas no. 6, Madrid.

Gómez Pompa, Arturo

1990 The Sacred Cacao Groves of the Maya. *Latin American Antiquity* 1: 247–257.

González de la Mata, Rocío

2006 Agua, agricultura y mitos: El caso de tres rejolladas de Chichen Itza. In *XIX Simposio de Investigaciones Arqueológicas en Guatemala, 2005*, edited by Juan Pedro Laporte, Bárbara Arroyo, and Héctor E. Mejía, pp. 305–318. Museo Nacional de Arqueología y

Etnología, Guatemala City. http://docplayer.es/11403548-Agua-agricultura-y-mitos-el-caso-de-tres-rejolladas-de-chichen-itza.html.

Graña-Behrens, Daniel

2002 *Die Maya-Inschriften aus Nordwestyukatan, Mexico.* PhD diss., University of Bonn.

2006 Emblem Glyphs and Political Organization in Northwestern Yucatan in the Classic Period (A.D. 300–1000). *Ancient Mesoamerica* 17: 105–123.

Graña-Behrens, Daniel, Christian Prager, and Elisabeth Wagner

1999 The Hieroglyphic Inscription of the "High Priest Grave" at Chichén Itzá, Yucatán, México. *Mexicon* 21: 61–66.

Gronemeyer, Sven

2004 A Preliminary Ruling Sequence at Coba, Quintana Roo. *Wayeb Notes,* no. 14. http://www.wayeb.org/notes/wayeb_notes0014.pdf, accessed June 14, 2016.

Grube, Nikolai

1994 Hieroglyphic Sources for the History of Northwest Yucatan. In *Hidden among the Hills: Maya Archaeology of the Northwest Yucatan Peninsula*, edited by Hanns J. Prem, pp. 316–358. Acta Mesoamericana, vol. 7. Verlag von Flemming, Möckmühl, Germany.

2000 Fire Rituals in the Context of Classic Maya Initial Series. In *The Sacred and theProfane: Architecture and Identity in the Maya Lowlands*, edited by Pierre R. Colas, Kai Delvendahl, Marcus Kuhnert, and Annette Schubart, pp. 93–110. Acta Mesoamericana, vol. 10. Verlag Anton Saurwein, Markt Schwaben.

2003 Hieroglyphic inscriptions from Northwest Yucatan: An Update of Recent Research. In *Escondido en la selva: arqueologia en el norte de Yucatan,* edited by Hanns J. Prem, pp. 339–370. Instituto Nacional de Antropología e Historia, Mexico City and Universidad de Bonn, Bonn.

2012 A Logogram for **SIP**, "Lord of the Deer." *Mexicon* 34: 138–141.

Grube, Nikolai, and Ruth J. Krochock

2011 Reading between the Lines: Hieroglyphic Texts from Chichén Itzá and Its Neighbors. In *Twin Tollans: Chichén Itzá, Tula, and the Epiclassic to Early Postclassic Mesoamerican World*, rev. ed., edited by Jeff Karl Kowalski and Cynthia Kristan-Graham, pp. 157–193. Dumbarton Oaks, Washington, D.C.

Grube, Nikolai, Alfonso Lacadena, and Simon Martin

2003 Chichén Itzá and Ek Balam: Terminal Classic Inscriptions from Yucatan. In *Notebook for the 27th Maya Hieroglyphic Forum at Texas*, part 2, pp. 1–105. Maya Workshop Foundation, University of Texas at Austin.

Guenter, Stanley P.

2014 *The Classic Maya Collapse: Chronology and Causation.* PhD diss., Department of Anthropology, Southern Methodist University, Dallas, Texas. University Microfilms, Ann Arbor, Mich.

Houston, Stephen D., and Takeshi Inomata

2009 *The Classic Maya.* Cambridge University Press, Cambridge.

Jackson, Sarah E.

2013 *Politics of the Maya Court. Hierarchy and Change in the Late Classic Period.* University of Oklahoma Press, Norman.

Johnson, Scott A. J.

2015 The Roots of Sotuta: Dzitas Slate as a Yucatecan Tradition. *Ancient Mesoamerica* 26: 113–126.

Johnstone, David

2001 The Ceramics of Yaxuná, Yucatan. Unpublished PhD diss., Department of Anthropology, Southern Methodist University, Dallas.

Just, Brian B.

2006 *Visual Discourse of Ninth-Century Stelae at Machaquila and Seibal.* PhD diss., Department of Art History, Tulane University, New Orleans. University Microfilms, Ann Arbor, Mich.

Kaufman, Terrence S.

2001 The History of the Nawa Language Group from the Earliest Times to the Sixteenth Century: Some Initial Results. www.albany.edu/anthro/maldp/Nawa.pdf, accessed June 17, 2016.

Kaufman, Terrence S., and William M. Norman

1984 An Outline of proto-Cholan Onology, Morphology, and Vocabulary. In *Phoneticism in Mayan Hieroglyphic Writing*, edited by John S. Justeson and Lyle Campbell, pp. 77–166. Institute for American Studies, State University of New York at Albany.

Kepecs, Susan M., and Sylviane Boucher

1996 The Prehispanic Cultivation of Rejolladas and Stone Lands: New Evidence from Northeast Yucatan. In *The Managed Mosaic: Ancient Maya Agriculture and Resource Use*, edited by Scott L. Fedick, pp. 69–91. University of Utah Press, Salt Lake City.

Kerr, Justin

n.d. Maya Vase Database. Electronic database: http://www.mayavase.com, accessed June 19, 2016.

Kowalski, Jeff K.

1989 Who Am I among the Itza? Links between Northern Yucatan and the Western Maya Lowlands and Highlands. In *Mesoamerica after the Decline of Teotihuacan A.D. 700–900*, edited by Richard A. Diehl and Janet C. Berlo, pp. 173–185. Dumbarton Oaks, Washington, D.C.

Krochock, Ruth J.

1997 A New Interpretation of the Inscriptions on the Temple of the Hieroglyphic Jambs, Chichen Itza. *Texas Notes on Precolumbian Art, Writing, and Culture* 79. Center of the History and Art of Ancient American Culture, University of Texas at Austin.

Lacadena García-Gallo, Alfonso

2000 Nominal Syntax and Linguistic Affiliation of Classic Maya Texts. In *The Sacred and the Profane: Architecture and Identity in the Maya Lowlands*, edited by Pierre R. Colas, Kai Delvendahl, Marcus Kuhnert, and Annette Schubart, pp. 111–128. Acta Mesoamericana, vol. 10. Verlag Anton Saurwein, Markt Schwaben.

2004 El corpus glífico de Ek Balam, Yucatán, México. Foundation for the Advancement of Mesoamerican Studies. www.famsi.org/reports/01057es/index.html, accessed June 14, 2016.

2010 Highland Mexican and Maya Intellectual Exchange in the Late Postclassic: Some Thoughts on the Origin of Shared Elements and Methods of Interaction. In *Astronomers, Scribes, and Priests: Intellectual Interchange between the Northern Maya Lowlands and Highland Mexico in the Late Postclassic Period*, edited by Gabrielle Vail and Christine Hernández, pp. 383–406. Dumbarton Oaks, Washington, D.C.

Lacadena García-Gallo, Alfonso, and Søren Wichmann

2002 The Distribution of Lowland Maya Languages in the Classic Period. In *La organización*

social entre los Mayas prehispánicos, coloniales y modernos, edited by Vera Tiesler Blos, Rafael Cobos, and Merle Greene Robertson, pp. 275–320. Instituto Nacional de Antropología e Historia and Universidad Autónoma de Yucatán, Mexico City and Merida, Yucatan.

Laughlin, Robert M.
1975 Great Tzotzil Dictionary of San Lorenzo Zinacantán. *Smithsonian Contributions to Anthropology* 19. Smithsonian Institution Press, Washington, D.C.

Lincoln, Charles E.
1990 *Ethnicity and Social Organization at Chichen Itza, Yucatan, Mexico.* PhD diss., Department of Anthropology, Harvard University, Cambridge, Mass. University Microfilms, Ann Arbor, Mich.

Lopes, Luís
2005 A New Look at the Name Phrase of the "Snake Lady." *Wayeb Notes*, no. 19. http://www.wayeb.org/notes/wayeb_notes0019.pdf, accessed June 14, 2016.

MacLeod, Barbara
2004 A World in a Grain of Sand: Transitive Perfect Verbs in the Classic Maya Script. In *The Linguistics of Maya Writing*, edited by Søren Wichmann, pp. 291–326. University of Utah Press, Salt Lake City.

Mathews, Peter
1991 Classic Maya Emblem Glyphs. In *Classic Maya Political History: Epigraphic and Archaeological Evidence*, edited by T. Patrick Culbert, pp. 19–29. Cambridge University Press, Cambridge.

Maudslay, Alfred P.
1889–1902 *Archaeology.* 6 vols. In *Biologia Centrali-Americana*, edited by F. Ducane Godman and Osbert Salvin. Porter and Dulau, London.

Mediz Bolio, Antonio
1930 *Libro de Chilam Balam de Chumayel.* Repertorio Americano, San José, Costa Rica.

Murley de Delgaty, Alfa, and Agustín Ruiz
1987 *Diccionario tzotzil de San Andrés con variaciones dialectales y español.* Instituto Lingüístico de Verano, Mexico City.

Osorio León, José F.
2004 La estructura 5C4 (Templo de la Serie Inicial): un edificio clave para la cronología de Chichén Itzá. Licenciatura thesis, Universidad Autónoma de Yucatán, Mérida, Yucatán.

Osorio León, José F., and Eduardo Pérez de Heredia Puente
2001 La arquitectura y la cerámica del Clásico Tardío en Chichén Itzá. In *Los Investigadores de la Cultura Maya* 9: 327–334.

Pallán Gayol, Carlos
2009 *Secuencia dinástica, glifos-emblema y topónimos en las inscripciones jeroglíficas de Edzná, Campeche (600–900 d.C.): implicaciones históricas.* Unpublished M.A. thesis, FFyL, Universidad Nacional Autónoma de México, Mexico City.
2012 A Glimpse from Edzna's Hieroglyphics: Middle, Late, and Terminal Classic Processes of Cultural Interaction between the Southern, Northern, and Western Lowlands. In *Maya Political Relations and Strategies, Proceedings of the 14th European Maya Conference, Cracow, November 9–14, 2009*, edited by Jarosław Źrałka, Wiesław Koszkul, and Beata Golińska, pp. 91–112. Contributions in the New World Archaeology, vol. 4, Jagiellonian University, Cracow.

Pascual Soto, Arturo, and Erik Velásquez García

2012 Relaciones y estrategias políticas entre El Tajín y diversas entidades mayas durante el siglo IX d.C. In *Maya Political Relations and Strategies, Proceedings of the 14th European Maya Conference, Cracow, November 9–14, 2009,* edited by Jarosław Źrałka, Wiesław Koszkul, and Beata Golińska, pp. 205–227. Contributions in the New World Archaeology, vol. 4, Jagiellonian University, Cracow.

Patrois, Julie

2008 *Étude iconographique des sculptures du nord de la péninsule du Yucatán a l'époque classique.* BAR International Series 1779, Paris Monographs in American Archaeology 20. British Archaeological Reports, Oxford.

Pérez de Heredia Puente, Eduardo J.

1998 Datos recientes sobre la cerámica de Chichén Itzá. *Los Investigadores de la Cultura Maya* 6: 271–287.

2007 Chen K'u: La Cerámica del Cenote Sagrado de Chichén Itzá. Foundation for the Advancement of Mesoamerican Studies. www.famsi.org/reports, accessed June 18, 2016.

2010 Ceramic Contexts and Chronology at Chichen Itza, Yucatan, Mexico. Unpublished PhD diss., Faculty of Humanities and Social Sciences, School of Historical and European Studies, Archaeology Program, La Trobe University, Melbourne.

2012 The Yabnal-Motul Ceramic Complex of the Late Classic Period at Chichen Itza. *Ancient Mesoamerica* 23: 379–402.

Pérez de Heredia Puente, Eduardo J., and Péter Bíró

2007 Cerámica, arquitectura y epigrafía: Cobá en el Clásico Terminal. Paper presented at the 7th Congreso Internacional de Mayistas, Merida, Yucatan.

2015 Ceramics and Epigraphy: Coba and the History of Northern Yucatán A.D. 700–830. www.academia.edu/21906840, accessed April 16, 2016.

Plank, Shannon

2003 *Monumental Maya Dwellings in the Hieroglyphic and Archaeological Records: A Cognitive-Anthropological Approach to Classic Maya Architecture.* PhD diss., Boston University, Boston, Mass.

Pollock, H.E.D.

1980 *Puuc: An Architectural Survey of the Hill Country of Yucatan and Northern Campeche, Mexico.* Memoirs of the Peabody Museum of Archaeology and Ethnology, vol. 19, Harvard University, Cambridge.

Proskouriakoff, Tatiana

1974 *Jades from the Cenote of Sacrifice, Chichen Itza, Yucatan.* Memoirs of the Peabody Museum of Archaeology and Ethnology, vol. 10, no. 1. Harvard University Press, Cambridge.

Restall, Matthew

2001 The People of the Patio: Ethnohistorical Evidence of Yucatec Maya Royal Courts. In *Royal Courts of the Ancient Maya, Volume 2: Data and Case Studies,* edited by Takeshi Inomata and Stephen D. Houston, pp. 335–390. Westview Press, Colo.

Roys, Ralph L.

1957 *The Political Geography of the Yucatan Maya.* Publication 613, Carnegie Institution of Washington, Washington, D.C.

Ruppert, Karl

1935 *The Caracol at Chichen Itza, Yucatan, Mexico.* Publication 454. Carnegie Institution of Washington, Washington, D.C.

1952 *Chichen Itza: Architectural Notes and Plans.* Publication 595. Carnegie Institution of Washington, Washington, D.C.

Sanz González, Mariano

2006 La categoría del tiempo en las inscripciones mayas del período Clásico. PhD diss., Universidad Complutense, Madrid.

Schele, Linda, and Peter Mathews

1998 *The Code of Kings: The Language of Seven Sacred Maya Temples and Tombs.* Scribner's, New York.

Schmidt, Peter J.

2000 Nuevos datos sobre la arqueología e iconografía de Chichén Itzá. *Los Investigadores de la Cultura Maya* 8: 8–48.

2003 Siete años entre los Itza: Nuevas excavaciones en Chichén Itzá y sus resultados. In *Escondido en la selva: arqueologia en el norte de Yucatan,* edited by Hanns J. Prem, pp. 53–64. Instituto Nacional de Antropología e Historia, Mexico City and Universidad de Bonn, Bonn.

2005 Personal communication.

2011 Birds, Ceramics, and Cacao: New Excavations at Chichén Itzá, Yucatán. In *Twin Tollans: Chichén Itzá, Tula, and the Epiclassic to Early Postclassic Mesoamerican World,* rev. ed., edited by Jeff K. Kowalski and Cynthia Kristan-Graham, pp. 113–155. Dumbarton Oaks, Washington, D.C.

Schmidt, Peter J., and Eduardo J. Pérez de Heredia Puente

2005 Etapas de construcción de la Gran Nivelación. Paper presented at the 5th Congreso Internacional de Mayistas, Campeche, Mexico.

Shaw, Justine M.

1998 *The Community Settlement Patterns and Community Architecture of Yaxuna from A.D. 600–1400.* PhD diss., Department of Anthropology, Southern Methodist University, Dallas. University Microfilms, Ann Arbor, Mich.

Slocum, Marianna C., and Florencia L. Gerdel

1971 *Vocabulario tzeltal de Bachajon: castellano-tzeltal, tzeltal-castellano.* Instituto Lingüístico de Verano, Mexico City.

Smith, Robert E.

1971 *The Pottery of Mayapan, including Studies of Ceramic Material from Uxmal, Kabah, and Chichen Itza.* 2 vols. Papers of the Peabody Museum of Archaeology and Ethnography, vol. 66. Harvard University, Cambridge.

Stanton, Travis W.

1999 *From Cetelac to the Coast: The Archaeology of Itza Expansion.* Paper presented at the 64th Annual Meeting of the Society for American Archaeology, Chicago.

Stuart, David

1998 "The Fire Enters His House": Architecture and Ritual in Classic Maya Texts. In *Function and Meaning in Classic Maya Architecture,* edited by Stephen D. Houston, pp. 373–425. Dumbarton Oaks, Washington, D.C.

2008 Unusual Sign 1: A Possible Co Syllable. Electronic document: https://decipherment. wordpress.com/2008/09/13/unusual-signs-1-a-possible-co-syllable, accessed June 14, 2016.

2010 Notes on Accession Dates in the Inscriptions of Coba. *Mesoweb Report.* www.mesoweb. com/stuart/notes/Coba.pdf, accessed June 6, 2016.

Stuart, David, and Stephen D. Houston

1994 *Classic Maya Place Names.* Studies in Pre-Columbian Art and Archaeology, no. 33. Dumbarton Oaks, Washington, D.C.

Taube, Karl

1992 *The Major Gods of Ancient Yucatán.* Dumbarton Oaks, Washington, D.C.

Thompson, J. Eric S.

1937 *A New Method of Deciphering Yucatecan Dates with Special Reference to Chichen Itza.* Contributions to American Archaeology and Ethnology no. 22. Publication 483. Carnegie Institution of Washington, Washington, D.C.

Tokovinine, Alexandre

2013 *Place and Identity in Classic Maya Narratives.* Studies in Pre-Columbian Art and Archaeology, no. 37. Dumbarton Oaks, Washington, D.C.

Varela Torrecilla, Carmen

1998 *El Clásico Medio en el Noroccidente de Yucatán.* BAR International Series 739. British Archaeological Reports, Oxford.

Voss, Alexander

2001 Los Itzáes en Chichén Itzá: los datos epigráficos. *Los Investigadores de la Cultura Maya* 9: 152–173.

Voss, Alexander, and Jurgen Kremer

2000 K'ak'-u-pakal, Hun-pik-tok' and the Kokom: The Political Organization of Chichén Itzá. In *The Sacred and the Profane: Architecture and Identity in the Maya Lowlands,* edited by Pierre R. Colas, Kai Delvendahl, Marcus Kuhnert, and Annette Schubart, pp. 149–182. Acta Mesoamericana, vol. 10. Verlag Anton Saurwein, Markt Schwaben.

Whittaker, Gordon

2015 Personal communication, Feb. 9.

Wichmann, Søren

2006 Mayan Historical Linguistics and Epigraphy: A New Synthesis. *Annual Review of Anthropology* 35: 279–294.

Wisdom, Charles

1950 Materials on the Chorti Language. Microfilm Collection of Manuscripts on Middle American Cultural Anthropology, no. 28. Regenstein Library, University of Chicago, 3d Floor Microfilms. Microfilm F 241 Reel 14. Chicago.

Wren, Linnea, Peter Schmidt, and Ruth Krochock

1989 The Great Ball Court Stone of Chichen Itza. Center for Maya Research, *Research Reports in Ancient Maya Writing* 25. Center for Maya Research, Washington, D.C.

Zender, Marc

2003 Personal communication, July 6.

2004 *A Study of Classic Maya Priesthood.* PhD diss., Department of Anthropology and Archaeology, University of Calgary, Calgary. University Microfilms, Ann Arbor, Mich.

2005 The Raccoon Glyph in Classic Maya Writing. *The PARI Journal* 5(4): 6–16. www.mesoweb.com/pari/journal.html, accessed June 17, 2016.

4

Rulers without Borders

The Difficulty of Identifying Polity Boundaries in Terminal Classic Yucatan and Beyond

SCOTT A. J. JOHNSON

European tradition recognizes the possession of a landscape as the primary factor in determining dominance and political power. Territory is gained and lost through military conflict or diplomatic negotiations. People and resources within a territory are subject to the political body that controls the landscape. Borders are established and force is used at the edge of political and territorial power. Some archaeologists have sought to identify this style of borders in Mesoamerica, when a different type of political power was practiced. This chapter draws on data from across Mesoamerica to demonstrate that instead of the occupation of territory as the sine qua non of power, Mesoamerican rulers dominated social networks, practicing a hegemonic, not landscape-focused, type of power. I argue here that Chichen Itza wielded hegemonic power in Yucatan and support this argument with a growing body of data from the region.

Chichen Itza rose to dominate much of Yucatan during the Early Postclassic period (950–1100). Regional cities reacted in three ways: at least one collapsed (Yaxuna), others fell into Chichen Itza's sphere of influence (for example, Isla Cerritos, Xuenkal, Izamal, and Uxmal), and still others engaged in a standoff with the rising center (for example, Ek Balam and Coba). This chapter focuses on the hegemonic nature of Chichen Itza's domination and the political boundaries in Terminal Classic and Early Postclassic Yucatan. Although boundary zones must have existed between cities, they are notoriously difficult to identify. In this chapter, I will argue that Chichen Itza, like many other Mesoamerican powers, had open borders instead of finite ones. In particular, I will discuss the regions between Chichen Itza and Yaxuna, as well as Chichen Itza and Ek Balam, using data drawn from Yula, Popola, and Ichmul de Morley. The arguably bellicose relationship of these sites offers the best chance at identifying a finite boundary.

Border Studies

Definitions: Boundary, Border, Frontier, Closed, Open, Semipermeable

Scholars must use uniform and careful terms to describe social and territorial limits, as each has different cultural ramifications. Territory itself, and its theoretical and social definition, has become the focus of study and can be linked to social identity, conflict, and power (Elden 2013), but the term is used here in the colloquial sense to refer to a defined space. Bradley Parker (2006: 79–80) defined boundary terms for interdisciplinary studies, which I will use to discuss the interaction in the areas surrounding Chichen Itza. A *boundary* is a generic term that indicates the bounds of an entity, such as a polity or social group. A *border* is a static, linear boundary, fixed in space, and dividing political or administrative units. A *frontier* is a zone of interaction or space between two entities, which is fluid, dynamic, and not controlled by an authority. I characterize these boundaries on a continuum from open to closed. *Open boundaries* allow the unhindered passage of people, items, or ideas. They lack natural, constructed, institutional, or social barriers. *Closed boundaries* inhibit the passage of people, items, and ideas, often through the use of constructed, natural, institutional, or social barriers controlled by an authority. Between these extremes are various degrees of openness. *Semipermeable boundaries* allow certain people, items, and ideas to pass but not others. The gateways of constructed or natural barriers are controlled by an authority and reinforced through institutional and societal control. Boundaries from many cultures can be described using these terms. For example, most modern countries have semipermeable borders, while international waters are open frontiers. Using these definitions, we will be able to precisely discuss what types of boundaries may have existed between Chichen Itza and other regional powers and what archaeological correlates we would expect to see, which may give us an insight about how the inhabitants of this area viewed their physical world.

Recognized Borders in Archaeology

Greek archaeology benefits from a strong literary tradition that can supplement archaeological evidence with historic observation. The site of Eleutherai, for example, occupied the principal mountain pass between Athens and Boiotia (Camp 2001: 319–320). While the archaeological data are ambiguous, historical sources state that the site's allegiance fluctuated because of military conquest and political maneuvering (Camp 2001: 319). Although the town was fortified, it appears to have been an afterthought in the political and economic consider-

ations of both sides (Camp 2001: 319–320). Similarly, the site of Salamis, located on a small island that could control access to a major inlet, was taken over by Athens but never incorporated or used for its strategic value (Camp 2001: 325). Another site, Oropos, was located between three powers, Athens, Thebes, and Eretria. Although local authority changed hands 12 times in 600 years, the religious practices of the site's inhabitants appear to have remained unaltered (Camp 2001: 322). While these sites are culturally and physically separate from Mesoamerica, they are all small and located between antagonistic powers. The most germane aspect of this information is that even though these sites changed political affiliation, some of them repeatedly, they maintained local continuity of religious practice and often local political autonomy, suggesting that subjugation may not have been a major disruptive force. I will argue that this same pattern may be seen at sites in the frontier zones between Chichen Itza and other major cities: nonelite structure forms, utilitarian pottery, and subsistence practices appear to be stable throughout these periods.

In South America, the Inka empire was a well-organized imperial force. The southeastern Chiriguano boundary had been considered to be a closed perimeter against outside incursion, with fortified installations and imperial material culture within the border (Alconini 2004: 390–391). Sonia Alconini's (2004: 391) research suggests that Inka imperial "control" had little effect on the local settlement patterns, effected no agricultural intensification, and distributed no high-status imperial artifacts (Alconini 2004: 414). The boundary installations were not to create a linear border, but rather to occupy key topographic locations, in what Alconini characterized as a "soft military perimeter" (2004: 414). She argues that this perimeter was more efficient at defending the empire against sporadic external threats without disrupting cultural exchange in the area. Even the Inka, arguably the most imperial native New World civilization, created semipermeable boundaries, suggesting the possibility that such boundaries may have also existed in Mesoamerica.

Central and Western Mesoamerican cultures have shown material and linguistic connections with the American Southwest. In the Southwest, frontiers were marked by "no-man's-lands" between communities (LeBlanc 2003: 278). In comparing Southwest and Mesoamerican cultures, Steven LeBlanc argued that the type of warfare and local settlement distribution were correlated: "One would expect that if warfare included large groups of men, including nonelites, that signaling and empty zones would be more likely. If warfare was small scale between elites, the peasants may have been irrelevant, and no empty zones would form" (2003: 278).

As more intense regional surveys have been carried out across the North-

ern Lowlands (see A. P. Andrews et al. 1989; Glover and Rissolo 2010; Hutson 2014; Kepecs 1999; Robles Castellanos and Andrews 2001, 2002; Shaw 2008; J. G. Smith 2000; and Stanton and Magnoni 2009, 2010, 2013), the landscape has been shown to be packed with settlements, and although areas of high and low population density can be identified, no empty frontier zones between proposed polities have been found. This suggests, if LeBlanc was correct, that Late and Terminal Classic warfare was restricted to the elites, with minimal direct disruption to the nonelites (although, as discussed elsewhere, major political changes may have had indirect effects on the nonelite [Johnson 2012]). This may account for the fortifications and destruction at the (elite) North Acropolis at Yaxuna but not at subsidiary sites. It should be noted, however, that indirect evidence, such as murals at Chichen Itza, suggests warfare may have been taking place in commoner contexts, but without archaeological corroboration, it is hard to differentiate propaganda from historical fact (see also Chapter 9).

The Aztecs controlled an empire seated in central Mexico, dominating the region from approximately 1350 to 1520 (M. Smith 2003: 29). Today, we think of empires as territorial enterprises with strictly controlled borders and commerce. This modern, Western view of empires, however, is in direct contrast with the Mesoamerican system. Instead of controlling territory, Aztec political leaders controlled local elites, who in turn controlled commoners (M. Smith 2003: 151). As the Aztec empire absorbed neighboring polities, the leaders "tapped into the local commodity flow at the highest level, exercising very little administrative control" (Hassig 1985: 101–102). The Aztec empire controlled the flow of tribute, not territorial units. Most subject polities provided tribute, except for border polities, which were exempted because they defended the empire's border (M. Smith 2003: 158). Aztec borders had fortified outposts and manned garrisons (M. Smith 2003: 54, 164–165), which might suggest that they were only semipermeable or even closed. On the contrary, the "border" was moderately militarized and Aztec administrators did not restrict the passage of nonmilitary people or trade in and out of their empire. All segments of society were known to freely cross "borders" to shop at specialty markets (M. Smith 2003: 153). In fact, it appears the Aztecs maintained what was simultaneously a closed political-military border and open demographic frontier at the edges of their empire. Indeed, "closing roads to commerce was a frequently cited cause of war, as was killing merchants . . . a recognized casus belli extending through central Mexico . . . The effectiveness of a strictly political ban on trade appears questionable, given the numerous merchants and many markets in central Mexico, the fluidity of borders, and the virtual impossibility of rigorously controlling traffic over a wide area when neither roads nor vehicles were required" (Hassig 1985: 120–121).

Intriguingly, geographical proximity was not necessarily the major consideration in city affiliation, as colonial-period chroniclers documented cases of contact-period settlements that were closer to one center but allied with a more distant rival, creating an interdigitated political border (M. Smith 2003: 151). This observation may cause problems with spatial models often employed in archaeology, such as the Central Place and Thiessen models. We should not, though, simply import the Aztec boundary model into Terminal Classic Yucatan. The ethnohistoric Aztec model has correlates that should be tested for in other Mesoamerican hegemonic powers, such as the one centered at Chichen Itza (see Johnson 2013).

Charles Golden (2003, 2010) and Andrew Scherer (Golden and Scherer 2009; Golden et al. 2008, 2012) study the boundary between Yaxchilan and Piedras Negras along the Usumacinta River. Their research benefits from rich epigraphic, iconographic, architectural, and artifact data. They are able to connect these outposts with Yaxchilan through similarity of architecture, co-occurrence of local rulers on monuments, hieroglyphic texts, and elite token gifts, which memorialized and strengthened the superior-subordinate relationship between the sites' elites (Golden 2003: 41–43, 44, 2010: 379). Golden (2003: 46) argues that strong states have robust ties with their frontier subsidiaries and both sides benefit from this alliance. Yaxchilan's outposts were situated on high natural rises and fortified with palisade walls and watchtowers (Golden 2003: 35; Golden and Scherer 2009), suggesting the residents were concerned about warfare. Although costly in terms of people, matériel, and other resources, warfare can provide increased access to resources, subjects, alliances, and tribute (Golden 2003: 44). Golden and Scherer first identified fortified border outposts at sites such as La Pasadita and Tecolote, located at the overland passes between Yaxchilan and Piedras Negras (Golden 2003: 35; Golden and Scherer 2009). Recently, they have found a series of walls running between outposts and argue that they are tactical, strategic, and have "profound symbolic import as monumental border markers" (Golden and Scherer 2013). As this chapter demonstrates, these are unusual in Mesoamerica. Furthermore (as pointed out by Graham in response to Golden and Scherer 2013), these discontinuous walls do not preclude elite-versus-elite warfare. Finally, Golden points out that warfare may have been used not to create closed boundaries, but to keep trade routes open: "an embargo would have represented a threat to the authority of the k'uhul ajaw, and force may often have been required to ensure that traders and their wares could pass unhindered through areas accessible to the nobility" (Golden 2003: 44). Even with a series of border walls, it is highly likely that this was a permeable border, which allowed the free passage of commoners and

merchants. As with the Aztecs, the commoner's perception of the landscape was likely one of openness rather than discrete boundaries.

Borders in Yucatan

The sociopolitical history of the Yucatan Peninsula has been the focus of regional research projects. Instead of summarizing every debate, I will briefly lay out the most agreed-upon points and concentrate on the relationship between Chichen Itza and Yaxuna. This is not meant as a full discussion of the hypotheses but rather a short orientation. I will then move on to discuss regional studies of "border" sites before articulating the boundary model tested in this chapter.

Brief History of Scholarship

Anthony Andrews and Fernando Robles Castellanos (1985; Robles Castellanos and Andrews 1986) proposed a model of regional political history for the Late Classic through the Postclassic on the Yucatan Peninsula. This reconstruction has been most recently updated by Andrews (1990; Andrews et al. 2003), edited volumes (Demarest et al. 2004; Kowalski and Kristan-Graham 2011), and work at Chichen Itza, Yaxuna, Ek Balam, Xuenkal, Isla Cerritos, Coba, and many other sites (Ambrosino 2006; Andrews et al. 1986, 1988; Bey et al. 1998; Cobos 2004, 2011; Folan 1983; Folan et al. 1983; Freidel 2011; Freidel et al. 1998; Grube and Krochock 2011; Houck 2004; Johnson 2012; Johnstone 1998, 2001, Kowalski 2011; Manahan and Ardren 2006, 2010; Ringle et al. 2004; Robles Castellanos 1980, 1990; Schmidt 2011; J. G. Smith 2000, 2001; Stanton and Gallareta Negrón 2001; Stockton 2013; Suhler et al. 2004; Suhler et al. 1998; Toscano Hernandez and Ortegon Zapata 2003). Scholars have reached consensus on the general course of regional sociopolitical history, but continue to disagree on specific details. The historical narrative can be divided into three phases: before, during, and after Chichen Itza's hegemony. I will focus on the first two, as they are the most germane to this argument.

In the Late Classic (600–800), before Chichen Itza rose to regional dominance, Coba in the east and Puuc sites in the west (first Oxkintok and later Uxmal) were regional powers (A. Andrews and Robles Castellanos 1985: 64). Cehpech pottery was present across the entire peninsula, and Puuc-style architecture has been found practically everywhere except at Coba, which evinced "Classic" Peten-inspired architecture, as shown in Figure 4.1 (A. P. Andrews and Robles Castellanos 1985: 64–65; Robles Castellanos and Andrews 1986: 77). Coba was a powerful trade center and had strong ties with the Peten through

the middle of the Late Classic (evidenced by Peten-style polychrome pottery, architecture, and monumental traditions), but when sites in the Southern Lowlands declined, so did Coba's southward-focused trade (Robles Castellanos and Andrews 1986: 77). Yaxuna had been at the crossroads of Yucatan since the Middle Preclassic (1000–300 BCE) and had been influenced by a series of sites: Oxkintok (Early Classic), Coba (early Late Classic), Uxmal (late Late Classic), and, later, Chichen Itza (Terminal Classic) (Freidel 2011: 280–281; Suhler et al. 2004). Yaxuna was connected to Coba by a 100-km-long *sacbe*, or causeway, built in the early Late Classic, and the site may have been a garrison of the eastern power (Freidel 2011: 281–283; Suhler et al. 2004: 458, 462). By the end of the Late Classic, Puuc-style architecture and pottery were present at Yaxuna and its sociopolitical connection to Coba may have been severed (Freidel 2011: 284–286; Freidel et al. 1998; Suhler et al. 2004: 459–460). For most of the Late Classic, Chichen Itza also evinced Cehpech-sphere pottery and Puuc-style ar-

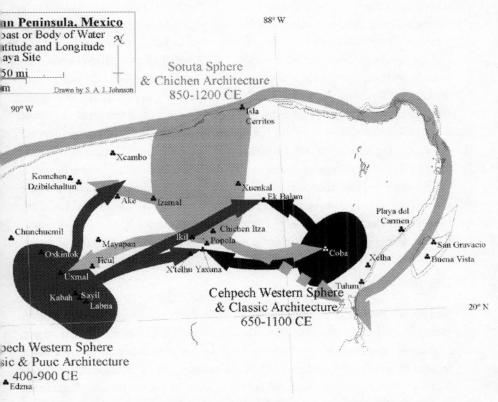

Figure 4.1. Yucatan's pottery and architecture before and during the rise of Chichen Itza. Map by Scott A. J. Johnson, base map drawn by author, after Google Earth satellite image.

chitecture (Pérez de Heredia 2010; Schmidt 2011: 117–118). At some point in the 800s, foreign people from the Gulf Coast arrived at Chichen Itza, bringing with them new architectural motifs and designs as well as trade goods (A. P. Andrews 1990: 259–260; A. P. Andrews and Robles Castellanos 1985: 67). A hybrid of local Maya and central Mexican architecture was created and Sotuta pottery types became prominent (Robles Castellanos and Andrews 1986: 89), as discussed in Chapter 2 (see also Johnson 2015).

During the Terminal Classic (800–950) and Early Postclassic (950–1100), Chichen Itza dominated much of the Yucatan Peninsula. Chichen Itza's hegemony was based on the control of terrestrial and coastal trade, military might, and the consolidation of regional political power, and, at its maximum, stretched from Tabasco and western Campeche to the eastern coast of Quintana Roo (Robles Castellanos and Andrews 1986: 69, 87). Coba's trade of southern goods had already declined and the site was now circumscribed and further isolated by Chichen Itza's trade routes (A. P. Andrews and Robles Castellanos 1985: 70–71). Around 900 Chichen Itza moved against Yaxuna, overwhelming the site's acropolis fortifications and destroying Puuc-related structures (Ambrosino 2006; Freidel 2011: 273; Suhler et al. 2004: 474–476; see Cobos 2004: 541 for an alternative scenario). A small Chichen Itza outpost may have been installed next to the now-defunct acropolis at Yaxuna (Suhler et al. 2004: 477; Toscano Hernandez and Ortegon Zapata 2003). Yaxuna's population quickly declined. Other sites, such as Coba and Ek Balam, suffered from a lack of monumental construction and decrease in population after 1100 CE (A. P. Andrews and Robles Castellanos 1985: 71; Ringle et al. 2004: 512). By the 1100s, Chichen Itza was in demographic decline (see discussion in Chapter 2) followed by the eventual collapse of the site and disorganization of the region (A. P. Andrews and Robles Castellanos 1985: 71–72). By the end of the Early Postclassic, there were new regional centers at Mayapan in the west and Ecab and Cozumel in the east (Robles Castellanos and Andrews 1986: 90–91, 93).

Regional Boundaries

The first in-depth discussion of boundaries in Yucatan comes from Ralph Roys' (1957) *The Political Geography of the Yucatan Maya*. He uses early colonial sources and observations to reconstruct a map of early-colonial-period political territories with distinct boundaries (Roys 1957: map 1), but it is unclear how much balkanization may have occurred after the fall of Mayapan (Robles Castellanos and Andrews 1986: 90–91), and Roys and his colonial sources may have been shoe-horning open boundaries into European-style territorial ideals with linear

and finite borders; the emic view of the landscape is unclear. Twenty years later, Edward Kurjack and E. Wyllys Andrews V (1976) tackled the assumption that the "limits of territories controlled by a community were situated approximately halfway between that site and its nearest neighbors of comparable size" (Kurjack and Andrews 1976: 319) and studied territorial markers such as causeways and defensive walls to refute this argument. They saw causeways as markers of positive relationships between dominant centers, but noted that other political, demographic, and environmental changes may have fueled an increase in boundary maintenance at the end of the Classic period (Kurjack and Andrews 1976: 324). They concluded that many social and historical factors may have affected the size and shape of any given territory, especially in Yucatan, where the landscape is generally homogeneous. Causeways and social factors confound the use of geometric territorial estimates, such as Thiessen polygons.

J. Gregory Smith (Chapter 5, this volume; 2000, 2001; Smith et al. 2006) surveyed a transect between Chichen Itza and Ek Balam to examine the dichotomy between "ambiguous" and "demarcated" boundaries (or what I would refer to as frontiers and borders, respectively) while testing three boundary models: Thiessen, boundary zone, and social linkage (J. G. Smith 2000: 35). Unlike Yaxuna, Ek Balam did not decline with the rise of Chichen Itza, and it was thought a boundary between these centers could be identified through surveying. Ek Balam was a major Late and Terminal Classic city with Cehpech-sphere pottery and a mix of Puuc- and Coba-inspired architecture, stela, and sculptures (Ringle et al. 2004: 490–491, 497–498). By the Early Postclassic, Ek Balam had declined, not as a casualty of Chichen Itza's trade dominance, but due to degradation of its local power base and wealth through overlarge construction projects (Ringle et al. 2004: 512). Xuenkal, Ek Balam's neighbor to the west, had had robust Terminal Classic occupation and construction with Puuc-style architecture and Cehpech pottery, but in the Early Postclassic, monumental construction ceased and Sotuta-sphere pottery became common (Manahan and Ardren 2010: 17, 20). Although over 50 sites were identified in Smith's survey area, Ichmul de Morley, which was approximately equidistant from Chichen Itza and Ek Balam, was the most likely boundary town because it combined material culture from both centers (Bey 2003; J. G. Smith 2000).

Patricia K. Anderson (1998a, 1998b) examined the small site of Yula, just 5 km south of Chichen Itza in an attempt to characterize the effect of the rise of Chichen Itza on a small community. Yula's elite contexts included a monumental center and carved lintels but none of the "eclectic style of monumental art that characterizes much of the monumental architecture of Chichen Itza" (Anderson 1998a: 158). As was the case at Ichmul de Morley, the local elite ap-

pear to have declined (or at least ceased monumental construction) with the rise of Chichen Itza.

Popola was a small site located on a direct line between Yaxuna and Chichen Itza; it was only 5 km north-northeast of the former and 13 km south-southwest of the latter, as shown in Figure 4.2. I directed four field seasons at this site (2008–2011) to collect data for my doctoral dissertation (Johnson 2012), which allowed me to reconstruct the occupational and sociopolitical history of Popola.

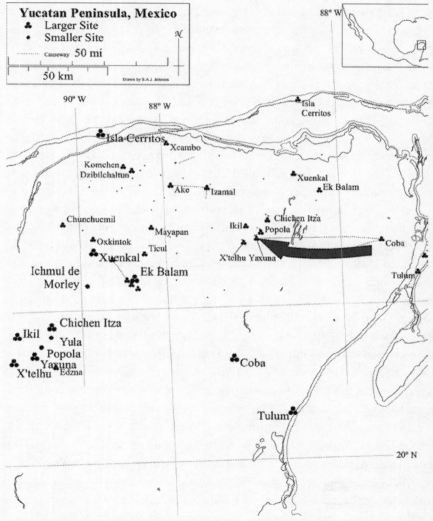

Figure 4.2. Map of central Yucatan showing primary sites discussed in this chapter. Map by Scott A. J. Johnson, base map drawn by author, after Google Earth satellite image.

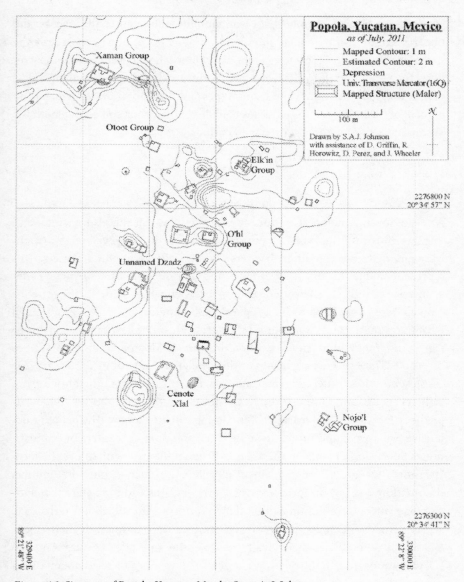

Figure 4.3. Site map of Popola, Yucatan. Map by Scott A. J. Johnson.

The site, shown in Figure 4.3, was occupied from as early as the Middle Preclassic (1000–300 BCE) to the Early Postclassic, but it was most heavily occupied during the Late and Terminal Classic periods. The local effects of the decline of Yaxuna and the rise of Chichen Itza were the primary research questions driving work at the site. Instead of being tied to the fate of Yaxuna, its former

ally (judging from the similarity of iconography, architectural alignments, and material culture), the nonelite population of Popola continued to occupy the site after Chichen Itza's rise to regional dominance. Local utilitarian pottery reflects the regional shift from Cehpech to Sotuta, with an intriguing hybrid slate variety that may link Muna and Dzitas types (Johnson 2015). Approximately 90 percent of the structures tested showed evidence of occupation during both the Terminal Classic and Early Postclassic periods.

Proposed Boundary Model

The previously discussed case studies from Greece, the American Southwest, Andean South America, Central Mexico, the banks of the Usumacinta, and Yucatan illustrate the type of boundaries I argue were prevalent in ancient Mesoamerica: closed political borders and open demographic frontiers. This represents a dual history: that of elites and that of commoners. Ancient Mesoamericans did not share our modern preoccupation with social equality. Nobles were considered to be a separate and superior class (M. Smith 2003: 132; Spores 1983: 228; Whitecotton 1977: 143, 146), and it is not unreasonable to expect different boundaries to exist on the same landscape for different classes of people. The expected correlates of this model are laid out in Table 4.1.

Mesoamerican rulers concentrated on protecting central locations from military incursions. Outposts did not delineate a finite linear border, but occupied key locations to guard against incoming military forces. The primary defensive walls are found protecting elite ritual and political centers or outposts, not as linear border walls in the areas between polities. We often use the term "territory" when describing a sphere of political influence, but elite political domination was not uniform across a "territory." Instead it appears that subordinate rulers were dominated by their overlords in a social, not territorial, sense. Perhaps members of the vassals' families were brought to their ruler's city as a way to ensure their loyalty, as was done in Andean South America (D'Altroy 2003: 184). Political power appears to have been focused not on direct control of areas, but on interaction with subordinates, such as through conquest or alliance (for example, marriage and reciprocity) (Hammond 1991: 277; Webster 1975, 1993). Political borders were elite social constructs that may have had no physical, identifiable geographical border in the Mesoamerican world, although they may have roughly coincided with open social frontiers. The evidence for these types of borders would come from political history (in the case of the Maya, this largely comes from hieroglyphic texts and oral histories) and stylistic similarities shared among elite architecture, iconography, and goods,

Table 4.1. Correlates of dual-boundary model

ELITE CONTEXTS

Hieroglyphic or oral history records indicating partners and enemies
 Architectural similarities among allies
 Iconographic similarities among allies
 Sumptuary goods from the same trade network and sources

COMMON CONTEXTS

Gradual change in utilitarian artifacts across space
 Exchange of utilitarian artifacts between areas of rival elites
 Continuity of architectural types regardless of elite affiliation
 Any similarity with local elite culture declines with increased distance from center
 Hybrid pottery found at frontier of contemporaneous utilitarian styles

FORTIFICATIONS

Center areas protected by walls and defensive structures
 No linear border walls between cities
 Outposts at strategic locations

ABSENCE OF COUNTER-CORRELATES

Contemporaneous commoner contexts with mutually exclusive but adjacent assemblages
 Linear, finite border fortifications in intermediate areas between sites

Source: Scott A. J. Johnson.

as well as connective infrastructure such as causeways. One obvious difficulty, however, is that while similarities in architectural style and iconography may signal alliances, it may also be the result of emulation in hopes of creating a social bond between groups or fictive relationships. Reconstructions, therefore, should depend on a variety of data. Archaeologists should not expect to see linear borders between sites because of the center-focused nature of the model, and evidence for passive or active aggression should be seen near the site's elite quarters. Furthermore, allies were not necessarily contiguous, as the elites were free to communicate through traders and emissaries across hostile territory.

The peasant majority appears to have been free to circulate between areas affiliated with rival political powers. In the cases cited above, civilians and traders were explicitly allowed to cross between these areas and blocking access was a casus belli. Instead of discussing linear borders for commoners, we should be able to identify open frontiers, where nonelite goods were traded freely. Although elites had social influence over their subjects, influence decreased as one moved farther from the center of power (Hammond 1972, 1974, 1991: 276). The archaeological pattern, then, would be of gradual

changes in artifact types over the landscape and even hybrids in the contact zone between different social groups.

Boundary Data from Late and Terminal Classic Central Yucatan

Although I argue that the above model was used across Mesoamerica, I want to turn now to Late and Terminal Classic Yucatan to test its validity using data drawn from Ichmul de Morley, Yula, and Popola. First, I will lay out the boundaries according to the proposed model and associated archaeological correlates. Next, I will present data from sites near Chichen Itza to evaluate whether or not a strong case can be made for the suggested boundaries.

Proposed Boundaries near Chichen Itza

I argue that two types of boundaries existed around Chichen Itza in the Early Postclassic: a closed political border (which may not have been contiguous) and an open demographic frontier. The political boundary would link the rulers of Chichen Itza and their allies. Hieroglyphic inscriptions from Chichen Itza and other regional sites, as well as oral histories, such as the books of Chilam Balam, may provide important, if biased, information about political alliances. Although they contain historical information, oral histories are essentially copies of copies, and with each generation, information can be lost or changed for reasons of propaganda, artistic license, or error. Luckily, the International architectural and stylistic canons are distinct, and allied elites from this period should also have C-shaped structures, column-supported roofs, and central Mexican iconographic motifs (such as feathered serpents, columned warriors, Atlanteans, *tzompantin* [skull-racks], jaguars, eagles, warrior processions, and chacmools). Centers not allied to Chichen Itza may have Puuc- and/or Peten-style architecture and iconography, including core-veneer masonry, corbel vaults with "boot" stones, decorated moldings and upper registers, modular cornices, mosaic stonework, and decorative columns. Careful attention must be paid to the date of each piece of evidence, because Puuc- and Peten-style architecture is common across the peninsula during the Late Classic, before the more International style in the Early Postclassic. If, however, the two different groups are found in the same period, it may be taken as evidence of elite social boundaries. Following the model above, one would expect that allied elites would possess similar sumptuary items because of linked trade systems and gift exchange among allies. Elite contexts of Chichen Itza's allies would likely contain imported Sotuta pottery such as Silho Fine Orange and Tohil Plumbate as well as green Pachuca obsidian. Those elites outside of Chichen Itza's sphere

would then have better access to nonutilitarian Cehpech pottery and Guatemalan obsidian sources instead. As I argue above, elites were center-focused and I do not expect to identify finite geographical political borders between Chichen Itza's allies and their rivals. A physical border is finite, linear, and exists across a landscape. Fortifications, if any, should be found around elite centers and outposts, but not in long, linear formations in the "no-man's land" between rival cities; finding the equivalent of Hadrian's Wall would disprove this model.

The demographic boundary would have been that of an open frontier between cities. Individuals could potentially travel and trade with those around them without being restricted by any potential political border. An open frontier is dynamic, fluid, and virtually uncontrolled. While the political division would be demonstrated through a sharp divide of elite architecture, iconography, and material culture, an open frontier would have a gradual change of nonelite architecture, iconography, and material remains. Thus, I expect to see overall similarities in domestic architecture (pole-and-thatch foundation braces, low platforms, C-shaped structures, patio-quads), unrestricted access to chert sources, and shared utilitarian pottery (both Cehpech and Sotuta types). Even if the elites were divided into identifiable social groups, as suggested above, I expect to see independent patterns in commoner contexts and zones of overlapping material culture. If, however, no transition areas could be identified, this model would be disproved. For example, if it was the case that commoners within a discrete area around Chichen Itza had uniform artifact assemblages and architectural styles, and neighbors in closely adjacent areas had completely different but internally uniform material culture, a closed or semipermeable border may have existed, not an open frontier as I argue. The expected local correlates of this model are laid out in Table 4.2.

It should also be said that change over time may be a confounding factor. Assemblages with mixed materials may be the result of bioturbation, not social mixing (see Johnson 2014 for a complete discussion). An ideal scenario would contain correlates indicating contemporaneity, demonstrating that mixing was the result of cultural, not taphonomic, factors. Correlates would include pottery that appears to have hybrid form and material combinations, sealed stratigraphic levels with no bioturbation, hybrid iconography on a single monument, "mismatched" architecture and material remains (that is, Chichen Itza architecture with only Puuc-style pottery), as well as "mismatched" artifacts of various types (only Yaxuna-sourced chert found with Chichen Itza–related pottery, for example). In most cases, however, we are forced to compare material culture from sites across a region that has a chronological framework that is still hotly debated.

Table 4.2. Correlates of proposed boundaries near Chichen Itza

ELITE CONTEXTS

Texts at Chichen Itza and books of Chilam Balam providing political alliance information
Central-Mexican architectural styles at allied centers
 C-shaped structures
 Column-supported roofs
Puuc-style architectural styles at contemporaneous nonallied centers
 Core-veneer masonry
 Corbel vaults with "boot" stones
 Decorated moldings and upper registers
 Modular cornices
 Mosaic stonework
 Decorative columns
Central Mexican iconographic motifs at allied centers
 Feathered serpents
 Columned warriors
 Atlanteans
 Tzompantin
 Jaguars
 Eagles
 Warrior Processions
 Chacmools
Goods imported through Chichen Itza's trade network
 Imported Sotuta types
 Silho Fine Orange
 Tohil Plumbate
 Pachuca obsidian

COMMON CONTEXTS

Similar or overlapping utilitarian pottery across space
 Mixed contemporaneous utilitarian Sotuta and Cehpech types
 Hybrid forms and/or pottery material
Similarity of domestic architecture across space
 Pole-and-thatch-house foundation braces
 Low platforms
 Patio-quads
Elite correlates mentioned above decline in frequency with increased distance from center
Uniform access to chert sources

FORTIFICATIONS

Fortifications around the central precincts of Chichen Itza, Ek Balam, Yaxuna, and others
Outposts protecting major centers in direction of perceived threats

ABSENCE OF COUNTER-CORRELATES

No exclusive Chichen Itza–related commoner assemblage as separate from neighbors
No border walls found between Chichen Itza and Ek Balam, Yaxuna, or other rival center

Source: Scott A. J. Johnson.

Evaluating the Proposed Model

Data from the region surrounding Chichen Itza support this model of elite political borders and commoner open frontiers. Elite data show alliances between major centers, suggesting strategic partnerships. Information from commoner contexts, though, indicates a free trade of goods across the region, regardless of nearby elite affiliation. Fortifications are near major centers, not demarcating borders between centers.

Hieroglyphic texts and native documents must be treated carefully, but current data and interpretations support the model proposed here. Northern inscriptions are less common and shorter than those of the Southern Lowlands. Nikolai Grube and Ruth Krochock's (2011) analysis suggests that Ek Balam was a dominant center of north-central Yucatan before the rise of Chichen Itza, and that it remained independent while Chichen Itza dominated most of the central and western peninsula. Grube and Krochock (2011: 185–186) and others (for example, Cobos 2011: 263; Kowalski 2011: 218) suggest that art and iconography replaced writing as the dominant form of public symbolic expression in Chichen Itza–affiliated centers by the Early Postclassic. The books of Chilam Balam chronicle the rise and fall of Chichen Itza. The most germane information for this study comes from the *Chilam Balam of Chumayel* (Roys 1933). It describes the Toltec's march around the peninsula and lists cities that began paying tribute to the new regional power (Roys 1933: 70–77). Although some have interpreted the passages literally (for example, A. P. Andrews and Robles Castellanos 1985: 69), Victoria Bricker (2011) pointed out that many of the short stanzas related to each city are puns related to the center's name. For example, at Yaxuna, where the Toltecs and the Yaxuneros "agreed in their opinions" (Roys 1933: 74–75), the Yucatec reads *cethi u thanobi*, or "their words became the same," which is a pun on *Cetelace*, the original name of Yaxuna. Other cities, such as Piste and Tichooh, also have name-based puns, something common in the books of Chilam Balam (Bricker 2002). The poetic basis for these passages cautions us not to read into the episodes literally. We can conclude, however, that the list of cities mentioned as tributaries is accurate, but not necessarily what took place when the newcomers arrived at these places.

Assessing architectural styles is complicated by questions of contemporaneity. Puuc-style architecture, dominated by core-veneer masonry, corbel vaults with "boot" stones, decorated moldings and upper registers, modular cornices, mosaic stonework, and decorative columns, was prevalent at elite centers such as Dzibilchaltun, Yaxuna, Chichen Itza, Ek Balam, and Culuba (but not Coba) in the Late and Early Terminal Classic (E. W. Andrews IV 1942, 1965; E. W.

Andrews V 1979; E. W. Andrews IV and E. W. Andrews V 1980; G. F. Andrews 1995: 225; Bey et al. 1998; Brainerd 1958; Thompson 1945: 6–8; Thompson et al. 1932: 20). After the rise of Chichen Itza, allied centers, such as Isla Cerritos, had International-style architectural construction, but many other centers that evinced coastal and central-Mexican trade goods, such as Uxmal and Xuenkal, lacked large International-style construction, and rivals, such as Ek Balam, continued to build more Puuc-style structures (A. P. Andrews et al. 1986, 1988; Bey et al. 1998; Manahan and Ardren 2010; Ringle et al. 2004; Stanton and Gallareta Negrón 2001: 238–239). Although a few centers demonstrate the International-style architecture expected in this model, it seems more common for subjugated sites to cease monumental construction.

Similar problems exist with demonstrating the proliferation of central-Mexican iconography at allied centers. While Late and Terminal Classic centers of power, such as Yaxuna, Ek Balam, and Coba, as well as the Puuc region, all have distinctive iconographic styles, smaller cities that fall under Chichen Itza's influence often cease monumental artistic expression, and even at the larger cities, International artistic motifs are uncommon. While it is clear that the occupation of these sites continues (with the exception of Yaxuna) after the rise of Chichen Itza, elite expressions of power decline, suggesting that instead of being seen as true allies, the local elites were seen as subjugated vassals.

Elite goods imported through the Chichen Itza–controlled trade network appear at vassal sites, and one may interpret their presence as having been given in exchange for the local elites' continued allegiance to Chichen Itza (that said, tertiary gifting or smuggling may also explain their presence). Although centers thought to be under the control of Chichen Itza do not all have International-style buildings or symbols, they often have Silho Fine Orange, Tohil Plumbate, and/or Pachuca obsidian in elite contexts. As a mercantile power, Chichen Itza may have emphasized goods over monumental architecture and iconography as rewards for their vassal rulers.

Other scholars and I have investigated a few small sites between rival centers looking for evidence of a socioeconomic border. Instead of finding a dividing line between sites such as Chichen Itza and Ek Balam or Chichen Itza and Yaxuna, we have found mixing and hybridization of pottery styles, continuity of household architecture, and no discernible pattern of trade restriction in commoner contexts (see Chapter 5 for Smith's description of similar contexts at Ichmul de San Jose, another site named Popola, and Chumul).

J. G. Smith (2000) assessed three boundary models (Thiessen, boundary zone, and social-linkage) when studying the Ek Balam–Chichen Itza transect. Both of the spatially defined models (Thiessen and boundary zone) were re-

jected, as they did not correspond to the Ek Balam– and Chichen Itza–related artifacts throughout his survey area: some sites closer to Ek Balam had Chichen Itza–style artifacts and vice versa (J. G. Smith 2000: 37, 39–40, 43, 45, 151). It may be difficult to trace social relationships from 1,000 years ago, but by using nondomestic and imported pottery, obsidian, elite architecture, and iconography, J. G. Smith (2000: 61–62) was able to argue for political linkages between sites within his transect area. Unfortunately, most sites had weak affiliations; only Ichmul de Morley had strong social linkages, but the connections were to both political centers (Chapter 5; J. G. Smith 2000: 62).

In the area surveyed between Chichen Itza and Ek Balam (J. G. Smith 2000, 2001; J. G. Smith et al. 2006), Bey (2003: 28) identified Sotuta forms made with Cehpech paste and slip, and interprets this hybridity as the local potters' effort to avoid conflict between two local powers. I argue that this hybridization was possible because the elites exerted little control over utilitarian pottery production (Ball 1979, 1993; Fry 1980: 10; Hassig 1985: 120–121; Johnson 2015; Rands 1967: 141; Ringle et al. 2004: 491; Roys 1943: 69; Stanton and Gallareta Negrón 2001: 232) and this exemplifies the gradual transition of utilitarian goods across the landscape expected in this model. Furthermore, if the sites in Smith's transect were contemporaneous, the dual political-demographic boundary model I have proposed explains the Ek Balam–Chichen Itza transect data. The elites of each large city may well have created a social border between them. The elites did not appear to interact in a significant way during the Early Postclassic (but see Grube and Krochock 2011 for evidence of Late and Terminal Classic interaction). The small sites between Ek Balam and Chichen Itza had weak links to the politically charged elite material culture of either center (J. G. Smith 2000: 62), except Ichmul de Morley, which had both Chichen Itza– and Ek Balam–related material culture. The nonelites appear to have been connected to utilitarian wares from both Sotuta and Cehpech spheres, perhaps even simultaneously as "hybrid" types are noted (Bey 2003: 28–29). Elite architecture shows early connections to Ek Balam, but no later International construction. More portable material culture, namely, pottery and obsidian, does show a less robust elite link to Chichen Itza, but overall elite activity at Ichmul de Morley seems to have declined in the Early Postclassic (J. G. Smith 2000: 66–67). In Chapter 6, Smith and Bond-Freeman attribute the presence of these Itza materials as evidence of trade passing through this site. Regardless of how the materials got there, however, data suggest that the site's nonelites enjoyed an open demographic frontier, in that the communities traded freely among themselves in terms of nonelite and nonpolitical goods. The mixing of Chichen Itza– and Ek Balam–related correlates in

Smith's transect were, if this model is correct, the result of free trade within an open demographic frontier, and the most significant elite correlates were chronologically segregated by a socially defined closed political border: first Ek Balam–related architecture and artifacts and later Chichen Itza–connected portable material culture.

In addition to examining the broader effects of the rise of Chichen Itza on surrounding communities at Yula, Anderson examined the chronological relationship of Sotuta and Cehpech pottery. During the Terminal Classic, the Sotuta-dominated utilitarian pottery assemblage was heavily mixed with contemporaneous Cehpech pottery, in almost all excavated contexts, including sealed stratigraphic layers (Anderson 1998a: 158). Even within a few hours' walk of Chichen Itza, the pottery at Yula was diverse, which suggests free trade among commoners.

At Popola, recent fieldwork has uncovered a similar pattern to that found at Ichmul de Morley and Yula: mixed utilitarian pottery and elites who declined with the rise of Chichen Itza (Johnson 2012). Popola is located 5 km north-northeast of Yaxuna and 8 km south-southwest of Yula. Its pottery assemblage was the inverse of the pattern found at Yula: Cehpech pottery dominated the local assemblage, but Sotuta types were a well-represented minority (unfortunately, all contexts were heavily mixed, and stratigraphic context was not preserved). Furthermore, the local pottery showed evidence of hybridization and stylistic transition of Cehpech and Sotuta slate wares. For example, a *molcajete*, a form associated with Sotuta-sphere pottery, was found with Cehpech paste and slip. Furthermore, I observed a continuum of rim types, paste, and slip between Sotuta and Cehpech archetypes (Johnson 2015). The local elite contexts had architectural, iconographic, and material remains similar to the nearby site of Yaxuna, yet no architecture or iconography resembling examples from Chichen Itza were observed and only one Pachuca obsidian blade was recovered (the dozens of others were gray or black and likely came from other sources). Again, the pattern at Popola speaks to an open demographic frontier between Chichen Itza and Yaxuna, while elites showed a distinct affiliation with a local power.

If Chichen Itza had controlled a territory by creating a finite and linear border between it and its rivals, I would not have expected to see mixed Cehpech and Sotuta contexts at Yula, Popola, or Ichmul de Morley. I would have expected to see pure Cehpech containing-layers underneath nearly pure Sotuta containing-layers, as each center's commoners would have only had access to markets controlled by their current overlords. Instead, I argue that as Chichen Itza rose to dominate much of the central peninsula, the commoners, even

those just a few kilometers away from Chichen Itza, were able to trade region-ally and independently of the elite political affiliation (Braswell 2010; Braswell and Glascock 2002).

Fortifications have not been found between rival centers, but instead they protect elite monumental areas. Recent excavations at Chichen Itza consol-idated a large wall around the site's central area (Hahn and Braswell 2012). The wall may have served to keep hostile invaders, commoners, or both from entering the central precinct. Ek Balam has a well-documented double wall ringing the site center, and Yaxuna's northern acropolis has the foundation of what may have been a palisade wall surrounding it, both of which appear to be single-purpose defensive walls. Instead of linear border fortifications between bellicose neighbors, researchers have found outposts, such as Xkanha, to the north of Yaxuna (Ardren 1997).

Summary and Conclusion

Scholars have recognized that social control was more important than terri-torial control in Mesoamerica for some time, yet archaeologists have sought to find territorial borders between rival cities. I have attempted to use the indigenous social division between elites and commoners to propose a dual boundary model for Mesoamerican polities and have attempted to use the Late and Terminal Classic rise of Chichen Itza in Yucatan to test this model. In short, elites created social borders between rivals. Because these are social, not physical, borders, defensive walls or territorial defenses may not have been constructed. Commoners likely saw their landscapes as borderless, as elite warfare was not aimed at conquering territory and defining boundaries, but rather at subjugating vassal polities by controlling their rulers. Archi-tecture, iconography, texts, and material culture may demonstrate the links between allies and the social distance between rivals. For the majority of society, however, these high-level divisions would have had less influence on day-to-day activities. Commoners would have been free to trade utilitarian goods across open frontiers, even between areas controlled by rival elites. Unlike elite goods, which would have had a more mutually exclusive distri-bution, utilitarian items change gradually across space and are not divided by borders. Elite contexts at sites such as Chichen Itza, Yaxuna, Ek Balam, Coba, Xuenkal, and Isla Cerritos demonstrate this pattern, as do the distribution of utilitarian items at smaller sites such as Ichmul de Morley, Yula, and Popola. It will be exciting to see if future data from this area will continue to conform to this pattern or overturn it.

References Cited

Alconini, Sonia

2004 The Southeastern Inka Frontier against the Chiriguanos: Structure and Dynamics of the Inka Imperial Borderlands. *Latin American Antiquity* 15: 389–418.

Ambrosino, James N.

2006 *Warfare and Destruction in the Maya Lowlands: Pattern and Process in the Archaeological Record of Yaxuna, Yucatan, Mexico.* PhD diss., Department of Anthropology, Southern Methodist University, Dallas. University Microfilms, Ann Arbor, Mich.

Anderson, Patricia K.

1998a Yula, Yucatan, Mexico: Terminal Classic Maya Ceramic Chronology for the Chichen Itza Area. *Ancient Mesoamerica* 9: 151–165.

1998b *Yula, Yucatan, Mexico: Terminal Classic Maya Settlement and Political Organization in the Chichen Itza Polity.* PhD diss., Department of Anthropology, University of Chicago, Chicago. University Microfilms, Ann Arbor, Mich.

Andrews, Anthony P.

1990 The Fall of Chichen Itza: A Preliminary Hypothesis. *Latin American Antiquity* 1: 258–267.

Andrews, Anthony P., E. Wyllys Andrews V, and Fernando Robles Castellanos

2003 The Northern Maya Collapse and Its Aftermath. *Ancient Mesoamerica* 14: 151–156.

Andrews, Anthony P., Tomás Gallareta Negrón, and Rafael Cobos Palma

1989 Preliminary Report of the Cupul Survey Project. *Mexicon* 11: 91–95.

Andrews, Anthony P., Tomás Gallareta Negrón, Fernando Robles Castellanos, Rafael Cobos Palma, and Pura Cervera Rivero

1986 *Isla Cerritos Archaeological Project: A Report of the 1985 Field Season.* Report to the Committee for Research and Exploration, National Geographic Society, Washington, D.C.

1988 Isla Cerritos: An Itzá Trading Port on the North Coast of Yucatan, Mexico. *National Geographic Research* 4: 196–207.

Andrews, Anthony P., and Fernando Robles Castellanos

1985 Chichén Itzá and Coba: An Itza-Maya Stand-off in Early Postclassic Yucatan. In *The Lowland Maya Postclassic,* edited by Arlen F. Chase and Prudence M. Rice, pp. 62–72. University of Texas Press, Austin.

Andrews, E. Wyllys, IV

1942 Yucatan Architecture. In *Carnegie Institution of Washington Yearbook* 41: 257–63.

1965 Archaeology and Prehistory in the Northern Maya Lowlands: An Introduction. In *Handbook of Middle American Indians,* vol. 2, edited by R. Wauchope and Gordon R. Willey, pp. 288–330. University of Texas Press, Austin.

Andrews, E. Wyllys, IV, and E. Wyllys Andrews V

1980 *Excavations at Dzibilchaltun, Yucatan, Mexico.* Middle American Research Institute, Publication 48. Tulane University, New Orleans.

Andrews, E. Wyllys, V

1979 Some Comments on Puuc Architecture of the Yucatán Peninsula. In *The Puuc: New Perspectives: Papers Presented at the Puuc Symposium, Central College, May 1977,* edited by Lawrence Mills, pp. 1–17. Scholarly Studies in the Liberal Arts, Publication no. 1. Central College, Pella, Iowa.

Andrews, George F.

1995 *Pyramids and Palaces, Monsters and Masks: The Golden Age of Maya Architecture,* vol. 1. Labyrinthos, Lancaster, Calif.

Ardren, Traci

1997 *The Politics of Place: Architecture and Cultural Change at the Xkanha Group, Yaxuná, Yucatán, Mexico.* PhD diss., Department of Anthropology, Yale University, New Haven, Conn. University Microfilms, Ann Arbor, Mich.

Ball, Joseph W.

1979 Ceramics, Culture History, and the Puuc Tradition: Some Alternative Possibilities. In *The Puuc: New Perspectives—Papers Presented at the Puuc Symposium, Central College, May, 1977,* edited by Lawrence Mills, pp. 18–35. Scholarly Studies in the Liberal Arts 1. Central College, Pella, Iowa.

1993 Pottery, Potters, Palaces, and Polities: Some Socioeconomic and Political Implications of Late Classic Maya Ceramic Industries. In *Lowland Maya Civilization in the Eighth Century A.D.,* edited by Jeremy A. Sabloff and John S. Henderson, pp. 243–272. Dumbarton Oaks, Washington, D.C.

Bey, George J., III

2003 The Role of Ceramics in the Study of Conflict in Maya Archaeology. In *Ancient Mesoamerican Warfare,* edited by M. Kathryn Brown and Travis W. Stanton, pp. 19–30. AltaMira Press, Walnut Creek, Calif.

Bey, George J., III, Tara M. Bond, William M. Ringle, Craig Hanson, Charles W. Houck, and Carlos Peraza Lope

1998 The Ceramic Chronology of Ek Balam, Yucatan, Mexico. *Ancient Mesoamerica* 9: 101–120.

Brainerd, George W.

1958 *The Archaeological Ceramics of Yucatan.* Anthropological Records, no. 19. University of California Press, Berkeley.

Braswell, Geoffrey E.

2010 The Rise and Fall of Market Exchange: A Dynamic Approach to Ancient Maya Economy. In *Archaeological Approaches to Market Exchange in Ancient Societies,* edited by Christopher P. Garraty and Barbara L. Stark, pp. 127–140. University Press of Colorado, Boulder.

Braswell, Geoffrey E., and Michael D. Glascock

2002 The Emergence of Market Economies in the Ancient Maya World: Obsidian Exchange in Terminal Classic Yucatan, Mexico. In *Geochemical Evidence for Long-Distance Exchange,* edited by Michael D. Glascock, pp. 33–52. Bergin and Garvey, Westport, Conn.

Bricker, Victoria R.

2002 The Mayan Uinal and the Garden of Eden. *Latin American Indian Literatures Journal* 18(1): 1–20.

2011 Personal e-mail communication.

Camp, John M.

2001 *The Archaeology of Athens.* Yale University Press, New Haven, Conn.

Cobos Palma, Rafael

2004 Chichén Itzá: Settlement and Hegemony during the Terminal Classic Period. In *The Terminal Classic in the Maya Lowlands: Collapse, Transition, and Transformation,* edited by

Arthur A. Demarest, Prudence M. Rice, and Don S. Rice, pp. 517–544. University Press of Colorado, Boulder.

2011 Multepal or Centralized Kingship? New Evidence on Governmental Organization at Chichén Itzá. In *Twin Tollans: Chichén Itzá, Tula, and the Epiclassic to Early Postclassic Mesoamerican World*, rev. ed., edited by Jeff Karl Kowalski and Cynthia Kristan-Graham, pp. 249–271. Dumbarton Oaks, Washington, D.C.

D'Altroy, Terence N.

2003 *The Incas.* 2d ed. Blackwell, Malden, Mass.

Demarest, Arthur A., Prudence M. Rice, and Don S. Rice (editors)

2004 *The Terminal Classic in the Maya Lowlands: Collapse, Transition, and Transformation.* University Press of Colorado, Boulder.

Elden, Stuart

2013 *The Birth of Territory.* University of Chicago Press, Chicago.

Folan, William J.

1983 The Ruins of Coba. In *Coba: A Classic Maya Metropolis*, edited by William J. Folan, Ellen R. Kintz, and Laraine A. Fletcher, pp. 65–87. Academic Press, New York.

Folan, William J., Ellen R. Kintz, and Laraine A. Fletcher (editors)

1983 *Coba: A Classic Maya Metropolis.* Academic Press, New York.

Freidel, David A.

2011 War and Statecraft in the Northern Maya Lowlands: Yaxuna and Chichén Itzá. In *Twin Tollans: Chichén Itzá, Tula, and the Epiclassic to Early Postclassic Mesoamerican World*, rev. ed., edited by Jeff K. Kowalski and Cynthia Kristan-Graham, pp. 273–298. Dumbarton Oaks, Washington, D.C.

Freidel, David A., Charles K. Suhler, and Rafael Cobos Palma

1998 Termination Ritual Deposits at Yaxuna: Detecting the Historical in Archaeological Contexts. In *The Sowing and the Dawning: Termination, Dedication, and Transformation in the Archaeological and Ethnographic Record of Mesoamerica*, edited by Shirley B. Mock, pp. 135–146. University of New Mexico Press, Albuquerque.

Fry, Robert E.

1980 Models of Exchange for Major Shape Classes of Lowland Maya Pottery. In *Models and Methods in Regional Exchange*, edited by Robert E. Fry, pp. 3–18. Society for American Archaeology, Papers, no. 1. Society for American Archaeology, Washington, D.C.

Glover, Jeffrey B., and Dominique Rissolo

2010 *La Costa Escondida: Una Investigación Arqueológica del Puerto Maya Vista Alegre, Quintana Roo, México.* Report prepared for the National Archaeological Counsel, Instituto Nacional de Antropología e Historia, Mexico City.

Golden, Charles

2003 The Politics of Warfare in the Usumacinta Basin: La Pasadita and the Realm of Bird Jaguar. In *Ancient Mesoamerican Warfare*, edited by Kathryn M. Brown and Travis W. Stanton, pp. 31–48. AltaMira Press, Walnut Creek, Calif.

2010 Frayed at the Edges: Collective Memory and History on the Borders of Classic Maya Polities. *Ancient Mesoamerica* 21: 373–384.

Golden, Charles, and Andrew K. Scherer

2009 Tecolote, Guatemala: Archaeological Evidence for a Fortified Late Classic Maya Political Border. *Journal of Field Archaeology* 34: 285–305.

2013 Territory, Trust, Growth, and Collapse in Classic Period Maya Kingdoms. *Current Anthropology* 54: 397–435.

Golden, Charles, Andrew K. Scherer, A. René Muñoz, and Zachary Hruby
2008 Piedras Negras and Yaxchilan: Divergent Political Trajectories in Adjacent Maya Polities. *Latin American Antiquity* 19: 249–274.
2012 Polities, Boundaries, and Trade in the Classic Period Usumacinta River Basin. *Mexicon* 34: 11–19.

Grube, Nikolai, and Ruth J. Krochock
2011 Reading between the Lines: Hieroglyphic Texts from Chichén Itzá and Its Neighbors. In *Twin Tollans: Chichén Itzá, Tula, and the Epiclassic to Early Postclassic Mesoamerican World*, rev. ed., edited by Jeff Karl Kowalski and Cynthia Kristan-Graham, pp. 157–193. Dumbarton Oaks, Washington, D.C.

Hahn, Lauren D., and Geoffrey Braswell
2012 Divide and Rule: Interpreting Site Perimeter Walls in the Northern Maya Lowlands and Beyond. In *The Ancient Maya of Mexico: Reinterpreting the Past of the Northern Maya Lowlands,* edited by Geoffrey E. Braswell, pp. 264–281. Equinox, Sheffield, England.

Hammond, Norman
1972 Locational Models and the Site of Lubaantun: A Classic Maya Centre. In *Models in Archaeology*, edited by David L. Clarke, pp. 757–800. Methuen Press, London.
1974 The Distribution of Late Classic Maya Major Ceremonial Centers in the Central Area. In *Mesoamerican Archaeology: New Approaches*, edited by Norman Hammond, pp. 313–334. University of Texas Press, Austin.
1991 Inside the Black Box: Defining Maya Polity. In *Classic Maya Political History: Hieroglyphic and Archaeological Evidence*, edited by T. Patrick Culbert, pp. 253–284. Cambridge University Press, Cambridge.

Hassig, Ross
1985 *Trade, Tribute, and Transportation: The Sixteenth-Century Political Economy of the Valley of Mexico*. University of Oklahoma Press, Norman.

Houck, Charles W., Jr.
2004 *The Rural Survey of Ek Balam, Yucatan, Mexico*. PhD diss., Department of Anthropology, Tulane University, New Orleans. University Microfilms, Ann Arbor, Mich.

Hutson, Scott R.
2014 Regional Interaction Involving Ucí and Its Causeway. In *The Archaeology of Yucatán: New Directions and Data*, edited by Travis W. Stanton, pp. 243–253. Archaeopress, Oxford.

Johnson, Scott A. J.
2012 *Late and Terminal Classic Power Shifts in Yucatan: The View from Popola*. PhD diss., Department of Anthropology, Tulane University, New Orleans. University Microfilms, Ann Arbor, Mich.
2013 The Transition Doesn't Hit Home: How an Elite Socioeconomic Change Did Not Affect Commoners at Popolá, Yucatán, México in the Late and Terminal Classic. *Chacmool Conference Proceedings*. University of Calgary, Calgary.
2014 Correlating Surface Collection and Excavation Results: A Test Case from Northern Yucatan, Mexico. *Journal of Field Archaeology* 39: 276–291.

2015 The Roots of Sotuta: Dzitas Slate as a Yucatecan Tradition. *Ancient Mesoamerica* 26: 113–126.

Johnstone, David

1998 Yaxuna Ceramics: Chronological and Spatial Relationships. In *Selz-Yaxuna, 1997 Season with Collected Papers,* edited by Justine M. Shaw and David A. Freidel, pp. 24–27.

2001 The Ceramics of Yaxuná, Yucatan. Unpublished PhD diss., Department of Anthropology, Southern Methodist University, Dallas.

Kepecs, Susan M.

1999 *The Political Economy of Chikinchel, Yucatán: A Diachronic Analysis from the Prehispanic Era through the Age of Spanish Administration.* PhD diss., Department of Anthropology, University of Wisconsin, Madison. University Microfilms, Ann Arbor, Mich.

Kowalski, Jeff Karl

2011 What's "Toltec" at Uxmal and Chichén Itzá? Merging Maya and Mesoamerican World Systems in Terminal Classic to Early Postclassic Yucatan. In *Twin Tollans: Chichén Itzá, Tula, and the Epiclassic to Early Postclassic Mesoamerican World,* rev. ed., edited by Jeff Karl Kowalski and Cynthia Kristan-Graham, pp. 195–248. Dumbarton Oaks, Washington, D.C.

Kowalski, Jeff Karl, and Cynthia Kristan-Graham (editors)

2011 *Twin Tollans: Chichén Itzá, Tula, and the Epiclassic to Early Postclassic Mesoamerican World,* rev. ed. Dumbarton Oaks, Washington, D.C.

Kurjack, Edward B., and E. Wyllys Andrews V

1976 Early Boundary Maintenance in Northwest Yucatan, Mexico. *American Antiquity* 41: 318–325.

LeBlanc, Steven A.

2003 Warfare in the American Southwest and Mesoamerica: Parallels and Contrasts. In *Ancient Mesoamerican Warfare,* edited by Kathryn M. Brown and Travis W. Stanton, pp. 265–286. AltaMira Press, Walnut Creek, Calif.

Manahan, Kam T., and Traci Ardren

2006 *Informe Final Proyecto Arqueológico Xuenkal Temporada Del Campo 2006: Recorrido Mapeo, y Excavación.* Report submitted to the Consejo de Arqueología del Instituto Nacional de Antropología e Historía, Mexico City.

2010 Transformación en el Tiempo: Definiendo el Sito de Xuenkal, Yucatán, durante el Periodo Clásico Terminal. *Estudios de Cultura Maya* 35: 11–32.

Parker, Bradley J.

2006 Toward an Understanding of the Borderland Process. *American Antiquity* 71: 77–100.

Pérez de Heredia Puente, Eduardo J.

2010 Ceramic Contexts and Chronology at Chichen Itza, Yucatan, Mexico. Unpublished PhD diss., Faculty of Humanities and Social Sciences, School of Historical and European Studies, Archaeology Program, La Trobe University, Melbourne.

Rands, Robert L.

1967 Ceramic Technology and Trade in the Palenque Region, Mexico. In *American Historical Anthropology: Essays in Honor of Leslie Spier,* edited by Leslie Spier, Carroll L. Riley, and Walter W. Taylor, pp. 137–151. Southern Illinois University Press, Carbondale.

Ringle, William M., George J. Bey III, Tara Bond-Freeman, Craig A. Hanson, Charles W. Houck, and J. Gregory Smith

2004 The Decline of the East: The Classic to the Postclassic Transition at Ek Balam, Yucatan. In *The Terminal Classic in the Maya Lowlands: Collapse, Transition, and Transformation*, edited by Arthur A. Demarest, Prudence M. Rice, and Don S. Rice, pp. 485–516. University Press of Colorado, Boulder.

Robles Castellanos, Fernando

1980 La secuencia cerámica de la región de Coba, Quintana Roo. M.A. thesis, Esquela Nacional de Antropología e Historia and Instituto Nacional de Antropología e Historia, Mexico City.

1990 *La secuencia cerámica de la región de Coba, Quintana Roo.* Serie Arqueología 184. Instituto Nacional de Antropología e Historia, Mexico City.

Robles Castellanos, Fernando, and Anthony P. Andrews

1986 A Review and Synthesis of Recent Postclassic Archaeology in Northern Yucatan. In *Late Lowland Maya Civilization*, edited by Jeremy A. Sabloff and E. Wyllys Andrews V, pp. 53–98. School of American Research, University of New Mexico Press, Albuquerque.

2001 *Proyecto Costa Maya: La interacción costa-interior entre de los mayas de Yucatán, México.* Report submitted to the Consejo Nacional de Arqueológia Instituto Nacional de Antropología e Historia, Mexico City.

2002 *Proyecto Costa Maya: Reconocimiento Arqueológico en el Noroeste de Yucatán, México.* Report submitted to the Consejo Nacional de Arqueológia Instituto Nacional de Antropología e Historia, Mexico City.

Roys, Ralph L.

1943 *The Indian Background of Colonial Yucatan.* Publication 548, Carnegie Institution of Washington, Washington D.C.

1957 *The Political Geography of the Yucatan Maya.* Publication 613, Carnegie Institution of Washington, Washington, D.C.

Roys, Ralph L. (translator and editor)

1933 *The Book of Chilam Balam of Chumayel.* Publication 438. Carnegie Institution of Washington. Washington, D.C.

Schmidt, Peter J.

2011 Birds, Ceramics, and Cacao: New Excavations at Chichén Itzá, Yucatan. In *Twin Tollans: Chichén Itzá, Tula, and the Epiclassic to Early Postclassic Mesoamerican World*, rev. ed., edited by Jeff K. Kowalski and Cynthia Kristan-Graham, pp. 113–155. Dumbarton Oaks, Washington, D.C.

Shaw, Justine M.

2008 *White Roads of the Yucatán: Changing Social Landscapes of the Yucatec Maya.* University of Arizona Press, Tucson.

Smith, J. Gregory

2000 *The Chichen Itza-Ek Balam Transect Project: An Intersite Perspective on the Political Organization of the Ancient Maya.* PhD diss., Department of Anthropology, University of Pittsburgh. University Microfilms, Ann Arbor, Mich.

2001 Preliminary Report of the Chichen Itza-Ek Balam Transect Project. *Mexicon* 23: 30–35.

Smith, J. Gregory, William M. Ringle, and Tara M. Bond-Freeman

2006 Ichmul de Morley and Northern Maya Political Dynamics. In *Lifeways in the Northern Maya Lowlands: New Approaches to Archaeology in the Yucatan Peninsula*, edited by Jennifer P. Mathews and Bethany A. Morrison, pp. 155–172. University of Arizona Press, Tucson.

Smith, Michael E.

2003 *The Aztecs*. 2d ed. Blackwell, Malden, Mass.

Spores, Ronald

1983 The Origin and Evolution of the Mixtec System of Social Stratification. In *The Cloud People: Divergent Evolution of the Zapotec and Mixtec Civilizations*, edited by Kent V. Flannery and Joyce Marcus, pp. 227–238. Academic Press, New York.

Stanton, Travis W., and Tomás Gallareta Negrón

2001 Warfare, Ceramic Economy, and the Itza: A Reconsideration of the Itza Polity in Ancient Yucatan. *Ancient Mesoamerica* 12: 229–245.

Stanton, Travis W., and Aline Magnoni

2009 *Proyecto de Interacción Politica del Centro de Yucatán: Segunda Temporada de Campo*. Report submitted to the Consejo de Arqueología del Instituto Nacional de Antropología e Historía, Mexico City.

2010 *Proyecto de Interacción Politica del Centro de Yucatán: Tercera Temporada de Campo*. Report submitted to Consejo de Arqueología del Instituto Nacional de Antropología e Historía, Mexico City.

2013 *Proyecto de Interacción Politica del Centro de Yucatán: Cuarto Temporada de Campo*. Report submitted to Consejo de Arqueología del Instituto Nacional de Antropología e Historía, Mexico City.

Stockton, Trent C.

2013 *An Archaeological Study of Peripheral Settlement and Domestic Economy at Ancient Xuenkal, Yucatan, Mexico*. PhD diss., Department of Anthropology, Tulane University. University Microfilms, Ann Arbor, Mich.

Suhler, Charles, Traci Arden, David Freidel, and David Johnstone

2004 The Rise and Fall of Terminal Classic Yaxuna, Yucatan, Mexico. In *The Terminal Classic in the Maya Lowlands: Collapse, Transition, and Transformation*, edited by Arthur A. Demarest, Prudence M. Rice, and Don S. Rice, pp. 450–484. University Press of Colorado, Boulder.

Suhler, Charles, Traci Ardren, and David Johnstone

1998 The Chronology of Yaxuna: Evidence from Excavation and Ceramics. *Ancient Mesoamerica* 9: 167–182.

Thompson, J. Eric S.

1945 A Survey of the Northern Maya Area. *American Antiquity* 11: 2–24.

Thompson, J. Eric S., H.E.D. Pollock, and Jean Charlot

1932 *A Preliminary Study of the Ruins of Coba, Quintana Roo, Mexico*. Publication 424. Carnegie Institution of Washington. Washington, D.C.

Toscano Hernandez, Lourdes, and David Ortegon Zapata

2003 Yaxuná, un Centro de Acropio del Tributo Itzá. In *Los Investigadores de la Cultura Maya*, 11: 439–445.

Webster, David L.

1975 Warfare and the Evolution of the State: A Reconsideration. *American Antiquity* 40: 464–470.

1993 The Study of Maya Warfare: What It Tells Us about the Maya and What It Tells Us about Maya Archaeology. In *Lowland Maya Civilization in the Eighth Century A.D.*, edited by Jeremy A. Sabloff and John S. Henderson, pp. 355–414. Dumbarton Oaks, Washington, D.C.

Whitecotton, Joseph W.

1977 *The Zapotecs: Princes, Priests, and Peasants.* University of Oklahoma Press, Norman.

5

In the Shadow of Quetzalcoatl

How Small Communities in Northern Yucatan Responded
to the Chichen Itza Phenomenon

J. GREGORY SMITH AND TARA M. BOND-FREEMAN

In the year 870, an Ek Balam king identified as Jun Pik Tok' (Pérez de Heredia
and Biro, Chapter 3) visited two lords of Chichen Itza, an event commemorated
on a stone lintel at Halakal, a small town a few kilometers to the east of Chichen
(see Figure 3.8b). According to Nikolai Grube and Ruth Krochock (2011: 162),
Ek Balam dominated the plains of northern Yucatan at this time, with Chichen
Itza, located approximately 50 km to the southwest, serving in a deferential
position to its neighbor (Figure 5.1). Fewer than 100 years after this event, the
rulers at Chichen were subservient to no one. Although there is little evidence
that Chichen Itza conquered (much less occupied) Ek Balam (Ringle et al.
2004), what is clear is that while unprecedented wealth from greater Meso-
america flowed into Chichen for elites and commoners alike, Ek Balam could
not keep pace. While Ek Balam clung to the old traditions typical of the rest
of the Maya area, Chichen Itza was transformed into an international city that
became known throughout Mesoamerica.

In 1998, William Ringle, Tomás Gallareta Negrón, and George Bey (Ringle
et al. 1998) published an influential article that sought to explain the glue that
bound together greater Epiclassic[1] Mesoamerica. Building upon the pioneer-
ing work of scholars such as Henry B. Nicholson (2001), J. Eric Thompson
(1970), and Gordon Willey (1976), and utilizing iconography, epigraphy, and
archaeology, they hypothesized that the similarities seen in major Epiclassic
sites (Chichen Itza, Tula, El Tajin, Cholula, Xochicalco, and others) were due
to the spread of a political ideology associated with the man-god Quetzalcoatl.
The model was elaborated and modified in subsequent publications (Bey and
Ringle 2011; Ringle 2004, 2009, 2014; Ringle and Bey 2009).[2] Much of their
focus has been an examination of how the ideology associated with the Feath-

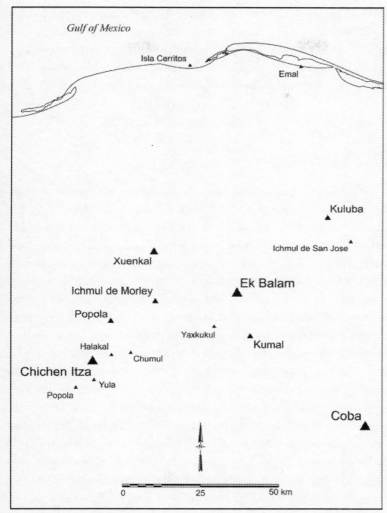

Figure 5.1. Map of north-central Yucatan showing sites mentioned in the text. By J. Gregory Smith.

ered Serpent functioned and spread, covering elite investiture, political and military leadership, and the architectural backdrop of these institutions. They concentrated their analysis on the major centers of Feathered Serpent ideology, known as Tollans, across Mesoamerica with particular attention paid to Chichen Itza. One of our principal research questions is how this pan-Mesoamerican phenomenon impacted local Maya communities in the vicinity of Chichen Itza in northern Yucatan (see Figure 5.1). To what extent did this in-

ternational foreignness so embraced at Chichen Itza penetrate into the lives of local elites and commoners? How did other social systems at Chichen, such as its long-distance trade network, articulate with the Feathered Serpent ideology and spread into its hinterlands? Our approach echoes other scholars who have investigated the organization of the Chichen polity not by looking at Chichen itself, but by considering the larger region of northern Yucatan where this city was embedded (A. P. Andrews et al. 1989; Kepecs et al. 1994).

Interpretive Framework

In concert with this volume's central theme of landscape, we investigate how the preexisting regional landscape of northern Yucatan was impacted by the ascendance of Chichen Itza. Landscape archaeology encompasses many different approaches (David and Thomas 2008; Knapp and Ashmore 1999), and in this chapter we emphasize the macroscale perspective implicit in it. We approach our study from the world-systems perspective utilized in Mesoamerica for several decades (Blanton and Feinman 1984). We favor the broad meaning of the term "world system" and use it as Michael Smith (2011) does: to refer to social processes that operate over large areas. In archaeology, world-systems approaches have traditionally placed explanatory emphasis on economics with political and religious structures serving an epiphenomenal role. As Smith (2011: 483) notes, Mesoamerican scholars are increasingly studying other topics, such as iconography, from a world-systems perspective. While we do consider conventional world-systems topics like long-distance trade, we also unpack elements of the Quetzalcoatl model of Ringle and his associates (1998) in order to better understand how this international ideology of leadership may have interdigitated with medium- and small-sized communities in the vicinity.

The chapter is organized into three main sections. First, we discuss the Feathered Serpent ideology in terms of how it might be expressed in the material culture of outlying settlements. We also consider aspects of Chichen's political economy that may have been tied to this ideology. Next, we examine the evidence of Chichen's presence in a half dozen sites in the area. At the conclusion of the chapter, we recap our interpretations and examine the patterns we see that illuminate how the presence of Chichen Itza was felt in the surrounding countryside of northern Yucatan.

Feathered Serpent Ideology

Several kinds of archaeological evidence may indicate the spread of Feathered Serpent ideology. Turning first to architecture, Ringle and his colleagues

(Ringle et al. 1998: 196–203) argue that I-shaped ballcourts were an impor-
tant location of elite investiture. I-shaped ballcourts have enclosed end zones,
have playing alleys with benches that are usually oriented vertically, often fea-
ture rings, and are typically oriented north-south. According to Ringle et al.,
the frenzy of I-shaped ballcourt construction at Epiclassic Feathered Serpent
centers—Chichen Itza has 10 (Cobos 2003: 197) and the El Tajin area has 17
(Koontz 2009: 37)—highlights the importance of the ballgame with Feathered
Serpent ideology.[3]

Ringle et al. (1998: 193–195) also note similar form and symbolism in the
pyramids at several Epiclassic sites. "Radial" pyramids at Chichen Itza, Cholula,
and El Tajin generally have a square base and stairways on all four sides. They
are also infused with calendrical symbolism and often adorned with Feathered
Serpent iconography, perhaps best exemplified by the balustrades on the Cas-
tillo at Chichen (similarly, the feathered serpents that appear on the Osario
follow this pattern, as discussed by Annabeth Headrick in Chapter 7).

Colonnaded halls, long masonry structures fronted by a series of columns,
are also an architectural element that is regularly seen at Chichen Itza and rare
elsewhere in Yucatan. Rafael Cobos (2003) argues that colonnaded halls func-
tioned as administrative buildings for Chichen elite. Columns and piers were
commonly carved with figures featuring elaborate costumes whose military
significance has recently been analyzed by Ringle and Bey (2009).

Another type of building that is common at Chichen, but virtually absent
everywhere else in Yucatan, is the gallery-patio (Kristan-Graham, Chapter 8;
Ruppert 1950). Gallery-patios are quite distinct in their spatial layout and usage
of columns to widen interior spaces. A long, open colonnaded gallery struc-
ture, sometimes vaulted, abuts a rectangular patio structure that features some
interior columns that create an open interior court. Mapping by Cobos (2003:
181) at Chichen Itza has revealed that there are at least 17 gallery-patios at the
site. While Cobos (2003: 182) interprets the primary function of these build-
ings as elite residences, Ringle and Bey (2009) view these structures as gather-
ing places for military orders associated with the emergent Feathered Serpent
ideology.[4]

Another important architectural element in Feathered Serpent ideology is
the presence of large civic plazas. While clearly multifunctional, one important
use of plazas for Quetzalcoatl centers is for amassing large numbers of people
to witness the investiture of new leaders (Ringle 2014). As an international
Mesoamerican phenomenon, it stands to reason that larger plazas would be re-
quired to accommodate locals and foreigners alike for purposes of legitimizing
the investiture events. Thus, communities that were the location of Feathered

Serpent investiture rituals would be expected to possess relatively large plazas compared to those communities that were not participating in the new ideology. This in large part explains why the Great Terrace at Chichen is so much larger than the main plaza at Ek Balam, even though the main civic pyramid at Ek Balam, La Torre, is more voluminous compared to the Castillo, its Chichen counterpart.

Another expression of the Feathered Serpent ideology is seen in the iconography of participating centers (Ringle et al. 1998: 192–213). Since the only iconographic evidence from the sites we discuss below concerns the ballgame, we focus here on this specific element of the Feathered Serpent visual system. In artistic representations of the ballgame, some Epiclassic sites (especially Chichen Itza and El Tajin) focus their attention on the sacrificial aftermath of these Feathered Serpent initiation rituals as opposed to the actual ballplaying commonly seen in Classic Maya artwork. At Chichen, the iconography associated with the Great Ball Court, especially the famous decapitation scenes on the benches, has been extensively studied by many scholars (Cohodas 1978; Greene Robertson 1991; Ringle 2004, 2009). Less known is that the iconography on other ballcourt benches at Chichen displays this same sacrificial theme (Krochock and Freidel 1994).

Turning to more ubiquitous material objects, we now look at how the Feathered Serpent ideology might be detected using ceramic data. Specific activity associated with the Feathered Serpent is evidenced by a particular set of ceramic types used in ritual activities—what has been called the *incensario* complex (Ringle et al. 1998: 214–218).[5] Vessel forms associated with the incensario complex include hourglass braziers, Tlaloc pots, spiked incensarios, and frying pan censers. These specific forms are consistently found in association with each other at Feathered Serpent centers and virtually absent at nearby neighbors, leading Ringle et al. (1998: 216) to suggest that they were involved in rituals related to the ideology. In Yucatan, the incensario complex is present at Chichen and other Maya sites that were involved in the Feathered Serpent network such as Uxmal. Meanwhile, none of these specialized forms are reported from the ceramic collections at Ek Balam (Bey et al. 1998) nor Coba (Robles Castellanos 1990). The presence of the incensario complex represents the most direct evidence of actual Feathered Serpent religious behavior, as these ceramics have a highly specialized function associated with ceremonial practices.

Another aspect of the Feathered Serpent ideology that we think can be investigated using ceramic evidence is cuisine preference. In accord with the general theme of embracing foreignness, it appears that elite Feathered Serpent members (and probably their commoner emulators) in Yucatan sought

to differentiate themselves from nonmembers in the cuisine that they ate. Food preparation techniques for some Chichen Itza inhabitants were quite different compared to non–Feathered Serpent centers of northern Yucatan, such as Ek Balam and Coba. The change in cuisine at Chichen is indicated by the introduction of *molcajetes* (grater bowls), which are common at nodes in the Quetzalcoatl network like El Tajin (Lira López 1995: 147), Tula (Cobean 1990: 289–335), and Cholula (McCafferty 1996: 310) and are a diagnostic form of Chichen Itza's Sotuta-sphere ceramics. There are at least four types of Sotuta grater bowls (R. E. Smith 1971: 174, 178, 182), and their presence at Chichen Itza suggests that some individuals desired cuisine that necessitated the use of these specialized vessels.[6] Looking outside of Chichen Itza in Yucatan, both George Brainerd (1958: 260) and Robert Smith (1971: 72) noted that practically no grater bowls were found in the collections of sites across the peninsula that used Cehpech-sphere ceramics. These observations are borne out at Ek Balam, where the Ek Balam Project has typed some quarter of a million sherds with fewer than five grater bowl fragments identified (Bey et al. 1998).

Lastly, pilgrimage is an institution that has been well documented in Mesoamerica from contact onward, especially at places such as Cholula and Chichen Itza. Ringle et al. (1998: 214, 227) suggest that this may have been a dispersal mechanism of Feathered Serpent ideology that has been understudied. Detecting Epiclassic pilgrimage in the communities around Chichen Itza is difficult since these pilgrims would have been passing through on their way to or from their main destination (probably the Sacred Cenote at Chichen). Local communities would have been obligated to house and feed these pilgrims on their way to and from Chichen. Food production efforts must have intensified for host communities, and the degree of this intensification was dependent on how many and how often pilgrims came through. For example, Ardren and Alonso Olvera (2016) have documented agricultural intensification at Xuenkal as this community, located 45 km north of Chichen (see Figure 5.1), became tightly integrated with the Itza capital.

The Political Economy of Chichen Itza

Recent studies are beginning to reveal the inner workings of the Chichen political economy (A. P. Andrews et al. 2003; Ardren and Alonso Olvera 2016; Ardren et al. 2010; Braswell and Glascock 2002; Cobos 2003; Kepecs 2011). The most relevant data sets we have to investigate the subsystems of the Chichen Itza political economy are ceramics and obsidian.[7]

While it is uncertain where Chichen's Sotuta complex ceramics were pro-

duced, it is clear that they were used and discarded primarily at Chichen itself (Cobos 2003; Pérez de Heredia 2010) and at immediate outliers like Yula (Anderson 1998) and Popola (see Johnson, Chapter 4). Other sites in Yucatan either have virtually no Sotuta complex ceramics, a light scatter (for example, Ichmul de Morley, see below), or highly localized deposits at specific locations (for example, Xuenkal [Manahan et al. 2012]). Sotuta complex pottery does differ from Cehpech complex pottery found across Yucatan at roughly the same time (Robles Castellanos 2006), although only in minor ways. While the presence of Sotuta complex pottery was once used by archaeologists to delineate the extent of Chichen's political power, it is now clear that this was an oversimplification. A careful consideration of the archaeological context of the Sotuta sherds and the specific types represented is needed to make more secure inferences about what it means in terms of human behavior, a point made by Bey (2003), Stanton and Gallareta Negrón (2001), and others. We take this case-by-case approach below with regard to the distribution of Sotuta ceramics.

Certain pottery types were also imported from long distances to Chichen Itza. The two most commonly imported ceramic groups were Fine Orange, likely produced on the Gulf Coast, and Plumbate, produced in the highlands of Guatemala. Moreover, Bey and Ringle (2011: 314) note that some of these tradeware ceramics are emblazoned with Feathered Serpent iconography, making their connection to the political ideology somewhat unambiguous. Various forms of these tradewares are found at Chichen Itza and are virtually absent from sites that were outside Chichen's trade network.

Because the nearest sources of obsidian are hundreds of kilometers away, archaeologists have long relied on sourcing obsidian artifacts as the primary way to delineate long-distance trade patterns in Yucatan. The link between Feathered Serpent ideology and obsidian bears a short discussion. Since bloodletting and sacrifice were important elements of Feathered Serpent elite investiture (Ringle 2004), obsidian would have been a desired commodity among adherents. However, much more obsidian is found at Chichen than could have possibly been used in conjunction with Feathered Serpent rituals. The sheer amount of obsidian that flowed into Chichen and that was distributed throughout the city in a fairly uniform fashion led Braswell and Glascock (2002) to conclude that a market was in operation. One possible motivation that Chichen had to import so much obsidian, which we explore more fully below, is that it may have been offered to subject communities in exchange for tribute and fealty.

The obsidian trade at Chichen Itza has been extensively studied by Braswell (1997, 2003). He determined that nearly 75 percent of the obsidian at Chichen Itza came from sources in Mexico, while approximately 25 percent of it came

Table 5.1. Pachuca percentages for sites in the Chichen Itza area

Site	n	Pachuca Count	Pachuca Percentage
Chichen Itza[a]	2,745	577	21
Ek Balam[a]	198	3	2
Xuenkal Structure 8M-1[b]	519	160	31
Ichmul de Morley[c]	38	8	21
Kuluba[d]	156	30	19
Popola[c]	18	6	33
Popola Structure 10	12	5	42
Rest of Popola	6	1	17
Yaxkukul[c]	12	0	0
Chumul[c]	11	4	36
Chumul Structure 29	10	4	40
Rest of Chumul	1	0	0

[a]Braswell (2003).
[b]Manahan et al. (2012).
[c]Smith (2000).
[d]Guzmán Ortiz Rejón (2007).

from sources in the highlands of Guatemala. The green obsidian of Pachuca is especially important in our study for two reasons: it can be reliably sourced visually, and it is located near the Tollan of Tula so it almost certainly had an important symbolic value associated with the Toltecs (Kepecs et al. 1994: 151). We would like to point out now (for the purposes of later comparison) that obsidian from Pachuca forms 21 percent of the assemblage at Chichen (Table 5.1).

Communities in the Shadow of Quetzalcoatl

We now turn our attention to some Epiclassic communities in northern Yucatan in order to see how the presence of Chichen Itza impacted people's lives. In talking about these communities, we utilize the site-ranking system employed by the Yucatan Atlas project (Garza Tarazona and Kurjack 1980). To recap this system, Rank 1 sites are the very largest in terms of the amount and size of civic architecture: Chichen Itza, Ek Balam, Uxmal, and Coba are examples. Rank 2 sites are smaller than Rank 1 sites but still maintained their political autonomy (at least most of the time). Rank 3 sites feature modestly sized civic architecture, probably represent secondary sites, and were not usually politically inde-

pendent. Rank 4 sites feature quite small civic architecture and were certainly under the political orbit of larger sites. In this chapter, we look at three Rank 3 sites (Ichmul de Morley, Kuluba, and Popola) and three Rank 4 sites (Yaxkukul, Chumul, and Ichmul de San Jose). Since there were dozens of sites that were integrated into the Chichen polity in one way or another, the six sites we discuss here may or may not be representative, but they do provide a sample of sites for which we have some detailed information to investigate the nature of Chichen's presence in the area. Thus, we will examine these sites with this question in mind: how large of a shadow did Chichen Itza cast onto these communities?

Ichmul de Morley

Ichmul de Morley is a Rank 3 site, located almost exactly halfway between Chichen Itza and Ek Balam (see Figure 5.1). The site received its name from famed Mayanist Sylvanus Morley (1919: fig. 1) and was briefly visited by the Cupul Project in 1988 (A. P. Andrews et al. 1989). Most recently, the senior author, along with William Ringle and other members of the Ek Balam Project, mapped the site center, a 30-hectare sample of adjacent residential settlement, and carried out some test pitting at the site (J. G. Smith 2000; J. G. Smith et al. 2006).

In mapping the civic center of the site (Figure 5.2), no obvious examples of Feathered Serpent–inspired architecture (I-shaped ballcourts, radial pyramids, gallery-patios, colonnaded halls) were observed. The lack of *any* ballcourt (I-shaped or otherwise) at the site is noteworthy because two limestone panels, purportedly (though not conclusively) from Ichmul, depict ballplayers in costumes and poses quite common in the Southern Lowlands, but unlike the iconography associated with the ballgame at Chichen Itza (Figure 5.3). Both panels show two ballplayers facing each other with a ball placed between them. Since Ichmul de Morley has no ballcourt (at least not one located in the civic center), the depicted events probably took place elsewhere. Based on the work of Grube and Krochock (2011: 160), who argue that the ruler Ukit Kan Lek Tok' of Ek Balam is depicted on Panel 1, we reason that these ballgame events took place at Ek Balam and not Chichen Itza. Graña-Behrens (2006: 110) has gleaned some readable hieroglyphic texts from Ichmul de Morley Panel 2. Significantly, he points out that the site may have had its own emblem glyph, minimally an indicator of the Classic Maya institution of rulership but perhaps a boast of political independence (Mathews 1991).

In all, over 45 residential structures outside the civic core of Ichmul de Morley were mapped, and none had pure or nearly pure deposits of Sotuta ceramics on them. This is in stark contrast with Xuenkal, a Rank 2 site located 17 km to

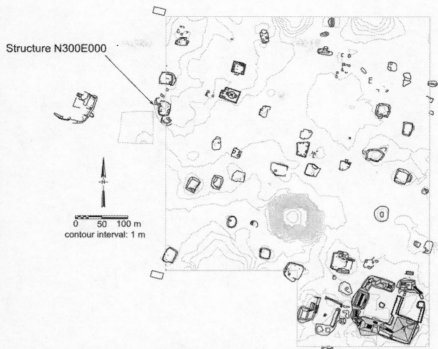

Structure N300E000

0 50 100 m
contour interval: 1 m

Figure 5.2. Map of Ichmul de Morley. By J. Gregory Smith.

the north of Ichmul de Morley (see Figure 5.1). At Xuenkal, several residential platforms featured distinct Sotuta occupations with very little Cehpech in the mix (Manahan et al. 2012). In looking at all the Cehpech and Sotuta ceramics we collected at Ichmul de Morley, we see that the former is 4 to 6 times as common as the latter. For example, some 3,938 sherds belonged to the Cehpech Muna Slate Group while only 625 belonged to the corresponding Sotuta Dzitas Slate Group. Sotuta ceramics are lightly scattered over elite and commoner structures at the site and are found in a wide range of contexts: on the surface of structures, in midden deposits off the sides of structures, and in construction fill.

Several authors have attempted to calculate how far a physically fit person carrying a modest load of goods could travel in a day (Ardren and Lowry 2011: 435; Drennan 1984: 105; Sluyter 1993: 195). While their estimates vary, all of them are less than 45 km, which is the distance between Chichen Itza and its strategic outpost of Xuenkal. People traveling between Chichen and Xuenkal would be hard-pressed to make the trip in a day. Because Ichmul de Morley is 28 km from Chichen and 17 km from Xuenkal, it would have been a very convenient place to spend the night. If so, we would expect to see some evi-

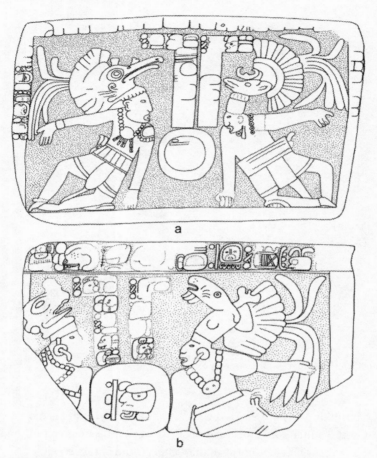

Figure 5.3. Stone sculpture from Ichmul de Morley: *a*, Panel 1, *b*, Panel 2.
Drawings by, and by permission of, Daniel Graña-Behrens.

dence of food production beyond household requirements to feed pilgrims or
merchants passing through. *Metates* are reliable indicators of food production,
and these artifacts are commonly seen strewn around the residential structures
at Ichmul. Most residences at the site have no more than three, but one in
particular, Structure N300E000, had no less than 18 metates associated with
it (Figure 5.4). We suspect that this platform was the location of intensified
food production because of increased demands for food required by traders,
pilgrims, and other personnel associated with Chichen Itza.

Not only is there evidence for increased food production at Ichmul, there is
also evidence that the food was being prepared in a way that would suit follow-
ers of the Feathered Serpent ideology. During our surface collections and exca-

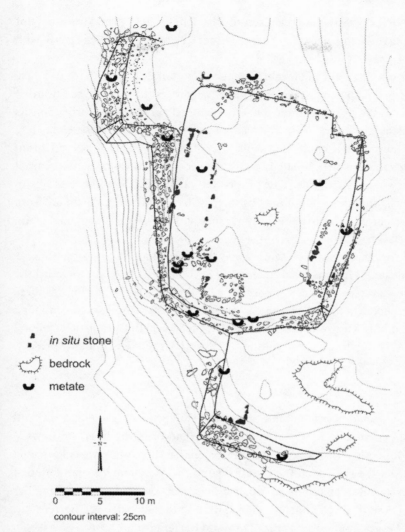

in situ stone

bedrock

metate

0 5 10 m

contour interval: 25cm

Figure 5.4. Drawing of Ichmul de Morley Structure N300E000. Drawing by, and by permission of, William M. Ringle.

vations at Ichmul de Morley, we identified 99 molcajete sherds in both elite and commoner contexts, including eight at Structure N300E000.[8] This suggests that at least some members of this community, and especially those residing at Structure N300E000, had either adopted or were preparing the foreign cuisine associated with the Feathered Serpent. Interestingly, while molcajetes are a diagnostic Sotuta form, many of these grater bowls had the paste and slip of Muna Slate, which is a very common Cehpech type. In our view these Sotuta-

Cehpech hybrid vessels are the result of local Ichmul potters making them but modifying them into a form not seen at other Cehpech-producing sites like Ek Balam or Coba.

What incentive did the local residents of Ichmul de Morley have to house and feed people passing through? One possibility is that they were rewarded by access to the obsidian trade network centered at Chichen. During Smith's fieldwork at Ichmul, 38 pieces of obsidian were collected. Of these, eight were visually sourced to Pachuca (see Table 5.1). Although the sample size at Ichmul de Morley is admittedly small, it is still noteworthy that Chichen and Ichmul de Morley have exactly the same proportion of Pachuca obsidian: 21 percent. In contrast, only three out of 198 obsidian artifacts (2%) at Ek Balam are from Pachuca. Ichmul, despite being only a fraction of the size of nearby Ek Balam, nevertheless had easier access to Pachuca obsidian.

It appears that Ichmul de Morley may have functioned as a way station for merchants and pilgrims associated with Chichen Itza. However, there is little evidence that Ichmul elites embraced the Feathered Serpent ideology as there are no ballcourts, radial pyramids, gallery-patio structures, or colonnaded halls. The only known artwork at the site, the two ballplayer panels, follows Classic Maya stylistic canons with no Feathered Serpent iconography present.

Kuluba

Kuluba is located nearly 90 km northeast of Chichen Itza (see Figure 5.1) and was first explored by E. W. Andrews IV (1941) and later by E. W. Andrews V (1979). Both noted that Kuluba was unusual in that there were two colonnaded buildings at the site which they connected to the more famous ones found at Chichen Itza. Recent and more expansive research has been conducted under the direction of Alfredo Barrera Rubio (Barrera Rubio et al. 2001, Barrera Rubio and Peraza Lope 2006; Peraza Lope and Barrera Rubio 2006).

There are three main groups of civic architecture at Kuluba: Groups A, B, and C. Group C is the focus here because it is the civic complex where the two colonnaded structures are found (Figure 5.5). One of the colonnaded structures, 10L11, is oriented east-west and faces north onto the main plaza. The other, 10L7, is oriented north-south and is located southwest of the main plaza. Like 10L11, it features two rows of columns that are now toppled over. If they ever had carvings on them (as many columns at Chichen do), they have weathered away (Figure 5.6).

The size of the Group C plaza is unusually large for a Rank 3 site. Given the hypothesis that Feathered Serpent centers would have larger plazas than

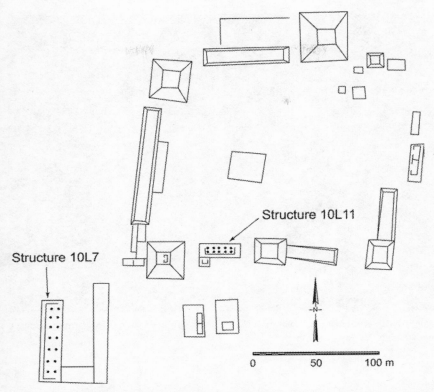

Figure 5.5. Map of Kuluba Group C. By J. Gregory Smith based on Barrera Rubio et al. 2001: fig. 5.

non-Feathered Serpent centers (because of the presence of many more visiting foreigners), we decided to look carefully at the Kuluba plaza and compare it with other sites in northern Yucatan. The results indicate that the Group C plaza at Kuluba is unusually large for a Rank 3 site and is even larger than the main plaza at the Rank 1 site, Ek Balam,[9] which is not Feathered Serpent–affiliated. We suggest that the reason for the inflated size of this plaza is its need to accommodate nonlocal people attending events pertaining to the Feathered Serpent ideology. There is no Feathered Serpent iconography associated with this plaza that would support this interpretation, but none of the buildings fronting the plaza have been fully excavated.

Fully published information about the artifacts found at Kuluba is more complete for obsidian than for ceramics.[10] The obsidian assemblage collected at Kuluba reported by Elvira Sol Guzmán Ortiz Rejón (2007) strongly suggests that it was tightly integrated into the Chichen trade network (see Table 5.1). As with Chichen Itza, Mexican obsidian sources predominate. Of the 156 sourced

Figure 5.6. Column drum at Structure 10L7 at Kuluba Group C; scale is in 10 cm increments. Photograph by J. Gregory Smith.

pieces, 95 (61%) come from Mexican sources, and 30 (19% of the total assemblage) come from Pachuca. The Pachuca proportion of obsidian is almost identical to that of both Chichen Itza and Ichmul de Morley.

In looking at Figure 5.1, it is apparent that Kuluba is off the most direct transportation route from Chichen Itza to its port of Isla Cerritos. Given that it would be a major detour for individuals traveling between Chichen and the coast, why would Chichen Itza be motivated to integrate Kuluba into its trade network? The regionally focused research of Susan Kepecs in the Chikinchel region of northeastern Yucatan just north of Kuluba may provide an answer. Her work has emphasized the singular importance of salt and argues that this was the exported resource that drove the political economy of Chichen Itza (Kepecs 2011; Kepecs et al. 1994). Kepecs points out that the saltworks at Emal (see Figure 5.1) was a large-scale facility whose production was unmatched in Mesoamerica. If Emal was so central to the functioning of Chichen's international trade network, then the incorporation of Kuluba could have been a strategic move to monopolize the salt trade of Yucatan. Perhaps Kuluba, located about halfway between Chichen Itza and Emal, was so strategic that the rulers of Chichen employed administrators in the colonnaded buildings at Kuluba to facilitate trade.

Ichmul de San Jose

Smith spent the summer of 2001 in the hinterlands of Kuluba, locating and mapping smaller sites in the vicinity (J. G. Smith 2002, 2003). Most sites dated to the Late Formative and Early Classic periods, but one in particular, Ichmul de San Jose, yielded primarily Cehpech and Sotuta complex pottery and is therefore at least partially coeval with Chichen Itza. The site, located nearly 14 km southeast of Kuluba (see Figure 5.1), features a modest 4.5-m-high pyramid (Structure 1) on the east side of a small (2,800 m²) plaza (Figure 5.7).

The site is altogether unremarkable except for a tiny scatter of Sotuta ceramics. More specifically, types included one Dzitas Slateware sherd found on Structure

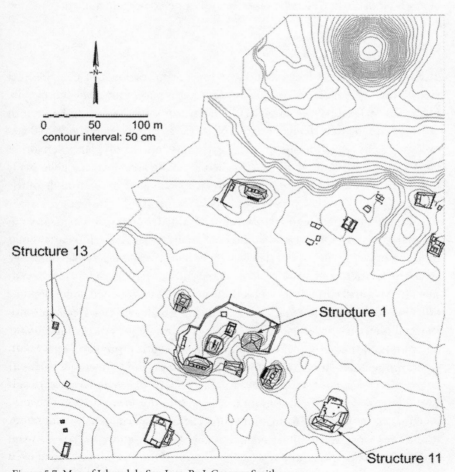

Figure 5.7. Map of Ichmul de San Jose. By J. Gregory Smith.

13 and two Balantun Black-on-Slate, one Chacmay Incised, and one Dzibiac Red sherd recovered from Structure 11. What does the presence of a few Sotuta complex sherds at Ichmul de San Jose mean? There is no reason to assume that the existence of Sotuta ceramics here means that the site must have been conquered or even visited by people from Chichen. Since Kuluba had ample amounts of Sotuta ceramics (Peraza Lope and Barrera Rubio 2006), in all likelihood the tiny scatter of Sotuta at Ichmul de San Jose almost certainly arrived from Kuluba, perhaps as a gift on the part of a noble from Kuluba. Because of its nearness to larger towns like Kuluba, elites and commoners in small villages like Ichmul de San Jose probably knew of the new political ideology centered on Quetzalcoatl but were too far removed to know much about the specifics. In any event, the presence of Sotuta ceramics at Ichmul de San Jose is certainly not good evidence of any kind of direct Chichen presence nor Feathered Serpent affiliation.

Popola

The site of Popola[11] is located about 16 km north/northeast of Chichen Itza (see Figure 5.1). Popola was originally recorded as part of the *Atlas* survey during a visit by David Vlcek in 1977 (Garza Tarazona and Kurjack 1980). Smith returned in 1998 to map and surface-collect the site center and conducted test excavations in 1999. The site center (Figure 5.8) consists of a large version of what Tatiana Proskouriakoff (1962) called a temple assemblage: a civic pyramid flanked by a long range structure with a small altar in the middle of the resulting plaza. The civic pyramid at Popola (Structure 1) is impressive (larger in volume than the analogous structure at Ichmul de Morley), but is clearly not a radial pyramid in the Feathered Serpent tradition since it has a rectangular base and only a single frontal stairway on its south side. Meanwhile, the range structure (Structure 20) at Popola is massive: it is over 100 m long and 25–30 m wide. Mayanists usually interpret these buildings as a council house or *popol nah* (Bey and May Ciau 2014; Fash et al. 1992). Ringle and Bey (2008; see also Bey and May Ciau 2014:345) call unusually long range structures "super *nahs*" and point out that examples of such buildings include Structure 44 at Dzibilchaltun, the Nohoch Na (Structure 424) at Edzna, the Governor's Palace at Uxmal, and Structure N300W040 at Kumal. Because of its comparable size, we would offer Popola Structure 20 for inclusion into this group.

Based on its location, form, and artifact assemblage, it appears that Structure 10 was the primary elite residence at Popola (see Figure 5.8). The platform is about 55 x 55 m in size and rises a few meters off the ground surface. Several superstructures, including the collapsed remains of a probable vaulted build-

Figure 5.8. Map of Popola. By J. Gregory Smith.

ing, are atop the platform. No evidence of columns, common at elite residences at Chichen Itza, was visible at this structure or anywhere else at the site.

While the form of this elite residence was not in the Chichen style, the ceramic assemblage certainly was. The sheer abundance of ceramics on this structure was impressive, as our six 2-x-2 m surface collection squares yielded some 520 sherds. Although Cehpech sherds were more numerous than Sotuta sherds,[12] many common Sotuta types were well represented, including Piste Striated, Dzitas Slate, and Balantun Black-on-Slate. Rare types included Provincia Plano-relief (from the Fine Orange Balancan Group), and a member of the Dzibiac Red Group known as Chan Kom Black-on-Red.

At the rest of the site, six sherds of the tradeware Tohil Plumbate were collected at nonmonumental structures in the site center. A total of 34 molcajete sherds were found at Popola, strong evidence that there was at least some adoption of the foreign culinary habits associated with the Feathered Serpent. On the other hand, no braziers, incensarios, or ladle censers were identified at

Popola; thus there is no direct evidence of specific ceremonies associated with Feathered Serpent ideology.

Turning to obsidian, a total of 17 blade or blade fragments was recovered from surface collections at the site (see Table 5.1). Altogether, six of these artifacts (35% of the total) were from Pachuca. Though our sample size is worrisomely low, it is still worth mentioning that this Pachuca percentage is much higher than that of Ichmul de Morley, Kuluba, and even Chichen Itza.

Based on this analysis, it appears that the local elite at Popola were tightly integrated into the Chichen trade network. This is a much different pattern than the one documented at Xuenkal. T. Kam Manahan and Traci Ardren discovered that the monumental site core at Xuenkal, including a probable royal palace, was almost devoid of Sotuta ceramics or Mexican obsidian (Manahan et al. 2012). Instead, they found pure deposits of Sotuta ceramics and abundant Mexican obsidian on rather austere residential platforms. In contrast, local elites at Popola enjoyed access to obsidian and elite tradeware ceramics, possibly as payment for meeting tribute demands plus housing and feeding Chichen personnel. But there is little reason to believe that they received legitimation by being initiated into the Feathered Serpent political ideology as the architectural types associated with it are absent at Popola. In fact, the monumental size of the temple assemblage at Popola can be interpreted as a strong statement embracing traditional Maya identity since this architectural complex is quite common across the entire Maya area.

Yaxkukul

The site of Yaxkukul was first recorded and mapped in 1998 by Smith and is located 36 km east-northeast from Chichen Itza (see Figure 5.1). The site center of Yaxkukul (Figure 5.9) features a small pyramid (Structure 1) some 7 m in height and a scatter of civic and domestic architecture. Were it not for a structure of singular importance, Yaxkukul would otherwise be a very typical Rank 4 site in Yucatan. What makes the site unique is the presence of a relatively large I-shaped ballcourt, one of the critically important types of architecture that Ringle et al. (1998) cite as being the location of Feathered Serpent investiture rituals.

The surface appearance of the Yaxkukul ballcourt consists almost entirely of rubble; only a few roughly shaped boulders were found in situ acting as retaining walls. While no standing architecture was detected during the mapping, the outline of rubble was quite distinct. What is striking about the ballcourt is that a systematic analysis of its dimensions revealed that it is essentially a miniature version of the Great Ball Court at Chichen Itza (J. G. Smith 2000).

Figure 5.9. Map of Yaxkukul. By J. Gregory Smith.

Adding to the intrigue is that surface collections and test excavations at the ballcourt revealed no Sotuta ceramics. An excavation unit that exposed the center of the west ballcourt bench revealed plain cut stone with no figural carvings (sacrificial or otherwise). No Pachuca obsidian was found associated with the ballcourt or anywhere else at the site (see Table 5.1).

What does this anomalous I-shaped ballcourt represent? One interpretation can be derived from iconographic analyses of the numerous processions depicted at Chichen Itza. Ringle (Ringle 2004, 2014; Ringle and Bey 2009) sees these processions as representing the organization of Chichen elite life. Especially relevant in the context of Yaxkukul is his observation that there are more client nobles depicted in these processions than there are compounds of elite architecture at Chichen (for example, the Initial Series Group or Far East Group). Ringle (2004: 201) suggests that some Chichen nobles, dressed as Feathered Serpent warriors, came from outside the city. Thus it is possible that the Yaxkukul ballcourt is part of one of these outlying noble houses. Why would Chichen be interested in incorporating the elite of Yaxkukul into its

Feathered Serpent ideology? We think the location of Yaxkukul in relation to Chichen Itza and Ek Balam could be key. Yaxkukul is found 17 km southwest of Ek Balam (see Figure 5.1) and the I-shaped ballcourt represents the closest example of Feathered Serpent architecture to this site. Although detecting boundaries between Northern Lowland kingdoms is notoriously difficult (Johnson, Chapter 4; J. G. Smith 2000), perhaps the Yaxkukul ballcourt represents a kind of ideological boundary statement made by Chichen whose intended audience was Ek Balam. The association between ballcourts and boundaries is found throughout Mesoamerica (Gillespie 1991: 341).

On the other hand, if the Yaxkukul ballcourt was part of an outlying noble house aligned with Chichen Itza, then an expectation would be regular visits between these two communities. However, the surface collections and test excavations at the ballcourt yielded no Sotuta ceramics or any Pachuca obsidian. Rather than being part of an outlying noble house associated with Chichen Itza, it appears that local Yaxkukul elite may have been emulating elements of the Feathered Serpent ideology related to elite investiture (I-shaped ballcourt) in an effort to associate themselves with Chichen. But the lack of any Chichen-style artifacts suggests that Yaxkukul ultimately failed to establish lasting ties. Despite the overture from Yaxkukul, it could be that Chichen Itza simply did not see this community as a strategic priority.

Chumul

Chumul is a Rank 4 site located 11 km east of Chichen Itza (see Figure 5.1). It was first recorded by members of the Cupul Project in 1988 (A. P. Andrews et al. 1989) and mapped and test excavated by Smith in 1998 and 1999 (J. G. Smith 2000). The site center consists of a modest temple assemblage that is much smaller than the one at Popola. The main civic temple (Structure 1) is about 10 m in height, and from atop its summit, one can see the Castillo at Chichen Itza off to the west on a clear day. Despite its proximity to Chichen, most of the site is completely lacking in any Chichen-related material culture. The dramatic exception to this pattern is a small platform some 350 m southeast of Structure 1 (Figure 5.10). This platform, named Structure 29, supports a modest superstructure on its west side in the form of a three-roomed house. A ceramic surface collection in 1998 produced both Cehpech sherds and Sotuta types such as Dzitas Slate, Balam Canche Red-on-Slate, and Piste Striated. Since these were the only Sotuta sherds recovered at Chumul, Smith returned the following year to conduct test excavations.

These excavations added much more support to the assertion that there was a very strong linkage between this structure and Chichen Itza. In addition to

Figure 5.10. Map of Chumul. By J. Gregory Smith.

more Sotuta ceramics, ten pieces of obsidian, featuring four Pachuca blades, are more evidence for interaction with Chichen and its trade network (see Table 5.1). To put this into comparative perspective, more Pachuca obsidian was recovered from this one structure at Chumul than from the entire known obsidian assemblage at Ek Balam. The recovery of two spindle whorls in a sin-

gle 2 x 2 m excavation unit adds even more evidence to a strong Chichen Itza connection since these artifacts are relatively common at Chichen itself (Kidder 1943) and at sites that were absorbed into its political economy (Ardren et al. 2010; Hernández Álvarez and Peniche May 2012). The presence of spindle whorls implies cloth production, a proportion of which was presumably sent to Chichen Itza as tribute. Despite these hypothesized tribute burdens, there is ample evidence the residents of Structure 29 had an incentive to participate: a relative abundance of prized obsidian.

To summarize the evidence at Chumul, our data suggest a single residential platform was tethered to the political economy of Chichen but with no evidence this community had much to do with the political ideology associated with the Feathered Serpent. Meanwhile, the rest of the site was either abandoned or simply not part of the international phenomenon happening just 11 km away. This situation is quite similar to the one documented at Xuenkal, the main difference being that only one Chichen-affiliated platform was identified at Chumul and over a dozen were identified at Xuenkal (Manahan et al. 2012: fig. 2).

Discussion

In the communities reviewed here, we have seen a number of different ways that the presence of Chichen Itza was felt. In some cases, such as at Kuluba and Popola, it appears that the ruling elite were tightly integrated with Chichen. At Kuluba, the presence of Chichen-style colonnaded halls might indicate the physical presence of Chichen administrators, although the lack of elite residences constructed in the Chichen tradition suggests that perhaps these administrators were not from Chichen itself but were local Maya. At Popola, the elite residence lacked columns, yet it was tied to the obsidian and ceramic distribution systems centered at Chichen. At Ichmul de Morley, we see some evidence that this site was a way station for Chichen Itza in the form of increased food production, a fairly light scatter of Sotuta complex ceramics across the site, and a relative abundance of Pachuca obsidian. At Yaxkukul, an I-shaped ballcourt, one of the key architectural forms associated with Feathered Serpent ideology, was built at the site center but was not associated with any Chichen-style artifacts. It could be that local leaders at Yaxkukul co-opted this element of the ideology in an attempt to establish ties with Chichen Itza but were ultimately unsuccessful at gaining access to Chichen's trade network. Very little evidence of direct Chichen impact is seen at the Kuluba outlier of Ichmul de San Jose. Here, a small scatter of Sotuta ceramics probably reflects an episode of gift giving from Kuluba to Ichmul de San Jose. Finally, at Chumul we have

evidence in the form of Sotuta ceramics, Pachuca obsidian, and spindle whorls that points to a close linkage to the Chichen political economy yet without any evidence that Feathered Serpent ideology spread there. The connection between Chumul and Chichen is limited to a single residence, as the other 33 structures we mapped at the site had very little evidence of Chichen material culture.

In sum, we see a variety of local responses to Chichen's rise to international prominence. The diverse ways and intensity by which these communities were integrated into the various networks emanating from Chichen suggest that there was no monolithic policy on the part of this polity that involved military conquest, political consolidations, or complete economic absorption. Instead, what emerges when looking at an assortment of different sites in the region is that leaders at Chichen dealt with these communities on a case-by-case basis. It seems to us that simply the location of these communities, coupled with their preexisting populations, were the two most important issues that leaders at Chichen had to consider. For instance, the location of Ichmul de Morley, between Chichen and the tribute-producing community of Xuenkal, would have made it a strategic community to integrate. This, along with the fact that Ichmul de Morley was one of the larger towns in the immediate vicinity, meant that there was a relative abundance of people who could house and feed Chichen personnel.

While recognizing the enormous power differential between Chichen Itza and the communities discussed in this chapter, we also think that these communities were not always passively doing whatever Chichen leaders told them to do. Instead, we think there is good reason to believe that at least some of these communities might have actively initiated relations with Chichen. Local leaders would have recognized the opportunities provided by Chichen (most obviously its access to long-distance trade goods like obsidian) that traditional kingdoms such as Ek Balam could not. Before the rise of Chichen into a religious, political, and economic powerhouse, prestige for local elites at our six sites probably came from interactions with Ek Balam, either by visiting or hosting. While this likely garnered a heightened reputation and a powerful political ally, it brought few tangible benefits. Yet while affiliation with Chichen Itza might have entailed not only increasing food or cloth production, but also housing merchants or pilgrims, this high cost was matched with a high payoff: an unprecedented abundance of useful and prestigious obsidian.

If we think about the long-distance traders and pilgrims whose destination was Chichen Itza, a worthy question to ask would be, just who were these people? In considering this, we draw from (and hopefully build on) the ideas

found in Ardren and Lowry (2011). In the Maya area, both pilgrimage (Palka 2014) and long-distance trade (Tokovinine and Beliaev 2013) appear to have been principally the domain of men. At Chichen, Krochock (2002) argues that most hieroglyphic inscriptions indicate that male elites were coming to Chichen and intermarrying with local women. If true, then one wonders how a large influx of men traveling through northern Yucatan would have impacted local communities. We have already discussed the evidence to support the hypothesis that local women at Ichmul de Morley were ratcheting up food production at this site. In addition to an increased demand for food, there is a possibility that the arrival of men would have led to an increased demand for what the Aztecs called *āhuiyani*: prostitutes (López Hernandez 2012). While it is clear that prostitution was present in Aztec society, Diego de Landa (Tozzer 1941) reports that the Maya of contact-period Yucatan were also familiar with this institution. Though seriously understudied for the ancient Maya, Houston (2014) marshals evidence derived from ethnohistory, linguistics, iconography, and epigraphy to show that prostitution was probably commonplace during Classic times and argues that it could have been under state control. He specifically connects the Aztec association of prostitutes and water (depictions of them in the Florentine Codex have them standing on water and holding a water glyph) to the Classic Maya. The scene on polychrome bowl K530 features suggestively dressed women with old male deities in what the associated glyphs describe as a "female water house." For Houston, the association between prostitutes and water among the Postclassic Aztec and the Classic Maya is not a coincidence and is instead an example of cultural continuity in Mesoamerica. If Houston is correct, then the unprecedented number of male traders and/or pilgrims flowing into Yucatan during Chichen's height may have obligated local leaders to house prostitutes from Chichen or provide local ones.[13]

To return to our opening scene at Halakal in 870, what we find striking in considering the impact of Chichen's rise in the towns and villages we have considered in this chapter is how rapid the transformation took place. A 10-year-old child who witnessed the visit of the Ek Balam ruler K'inich Junpik Tok' K'uh to Chichen Itza could tell his or her own grandchildren about it around 900. By this time, Ek Balam was in serious decline as monumental construction had ceased and stelae with Long Count dates were no longer being erected (Ringle et al. 2004). Traditional Maya rulership had been eclipsed by the introduction of Feathered Serpent ideology. Chichen Itza, subordinate to Ek Balam when this person was a child, had grown into a transcendent international Tollan known across Mesoamerica.

Acknowledgments

We wish to thank William Ringle, Linnea Wren, Cynthia Kristan-Graham, Kara Ryf, and two anonymous reviewers for reading and commenting on earlier versions of this chapter. We also acknowledge the librarians at Hinckley Library at Northwest College and Thomas Vance for their assistance in obtaining some relatively obscure sources in a remarkably timely fashion. We extend our biggest debt of gratitude to Linnea Wren for inviting us to contribute to the volume and join such an outstanding group of Chichen scholars.

Notes

1. The Epiclassic period spanned 700–1100; see Kristan-Graham and Wren (Chapter 1: Fig. 1.3) for a concordance of chronological dates and names.

2. Other recent scholars have provided insights into the Feathered Serpent phenomenon as well, including a penetrating look at its origins (Coggins 2002) and a consideration of its transformation in the Postclassic era (López Austin and López Luján 2000).

3. With 25, the site of Cantona in Puebla has the most ballcourts in Mesoamerica (Zamora Rivera 2004) and was probably the largest site in Mesoamerica during the Epiclassic with upward of 90,000 people (García Cook 2003: 339). Despite Cantona's large number of ballcourts, they exhibit virtually no Feathered Serpent iconography. The subject of how this important yet often overlooked site may have fit into the larger Epiclassic Quetzalcoatl network has recently been brought up by J. G. Smith (2014).

4. Shannon Plank's examination of the Mercado and other gallery-patios (2004) suggests that they were the location of fire rituals, an important element of Feathered Serpent placemaking (Coggins 2002: 37–38; Ringle et al. 1998: 185).

5. Their discussion of the incensario complex was foreshadowed by Richard Diehl's (1993) efforts at identifying a Toltec horizon.

6. It would be interesting to know how molcajetes are distributed across Chichen Itza. Are they limited to just Feathered Serpent architecture such as the Mercado and Great Ball Court or are they more uniformly spread out over the site, including commoner residences? We suspect that they are probably more concentrated at Feathered Serpent architecture but present throughout the site. After the initial introduction into elite Feathered Serpent contexts, commoners at Chichen may have emulated the foreign cuisine preferred by the elite or were obligated to prepare the food for foreign pilgrims. Unfortunately, there is no published information about the structure-by-structure distribution of molcajetes (or any other ceramic type) at Chichen.

7. At Xuenkal, several horizontal excavation operations have revealed relatively abundant quantities of shell and chert that are not plentiful enough to meaningfully analyze at the sites we discuss (Ardren et al. 2010; Ardren and Alonso Olvera 2016; Manahan et al. 2012).

8. The proportion of molcajete sherds to generic slateware sherds at this structure is significantly higher compared to the rest of the site: there were eight molcajete sherds and 225 slateware sherds recovered from N300E000 and 91 molcajete sherds and 9,929 slateware sherds collected from the rest of Ichumul de Morley. Using a chi-square test, the difference in the

proportion of molcajete sherds to generic slateware sherds at N300E000 compared to the rest of the site is extremely significant ($\chi 2 =15.2$, $p <0.01$).

9. To be more precise, we estimate the size of the Kuluba Group C plaza at 15,200 m^2 while the main plaza at Ek Balam is approximately 9,700 m^2 in size.

10. Peraza Lope and Barrera Rubio (2006: 446) report the presence of Tohil Plumbate and molcajetes and mention that there are significant quantities of Sotuta ceramics throughout the site, including Group C where the two colonnaded structures are located.

11. An unfortunately generic site name that is common across Yucatan and not to be confused with the site Scott Johnson worked at, which is 13 km southwest of Chichen Itza (Johnson 2012; Chapter 4, this vol.; see Figure 5.1).

12. In looking at comparable types, there were 101 Muna Slate (a very common Cehpech complex type) sherds compared to 19 sherds of its Sotuta counterpart, Dzitas Slate. However, in comparing redware (which are primarily elite serving vessels) at this structure, one sees a striking inversion of the ratio: eight Sotuta Dzibiac Red sherds and only one Cehpech Teabo Red sherd. One interpretation for this pattern is that Sotuta ceramics functioned more as prestige wares whereas Cehpech types were more common for utilitarian uses.

13. In a similar vein, Bruce Dahlin (2009: 356) suspects that brothels were present at the sprawling Early Classic trading center of Chunchucmil.

References Cited

Anderson, Patricia K.
 1998 Yula, Yucatan, Mexico: Terminal Classic Maya Ceramic Chronology for the Chichen Itza Area. *Ancient Mesoamerica* 9: 151–165.
Andrews, Anthony P., E. Wyllys Andrews V, and Fernando Robles Castellanos
 2003 The Northern Maya Collapse and Its Aftermath. *Ancient Mesoamerica* 14: 151–156.
Andrews, Anthony P., Tomás Gallareta Negrón, and Rafael Cobos Palma
 1989 Preliminary Report of the Cupul Survey Project. *Mexicon* 11: 91–95.
Andrews, E. Wyllys, IV
 1941 The Ruins of Culubá, Northeastern Yucatán. *Notes on Middle American Archaeology and Ethnology*, vol. 1, no. 3. Carnegie Institution of Washington, Division of Historical Research, Cambridge, Mass.
Andrews, E. Wyllys, V
 1979 Some Comments on Puuc Architecture of the Northern Yucatan Peninsula. In *The Puuc: New Perspectives—Papers Presented at the Puuc Symposium, Central College, May 1977*, edited by Lawrence Mills, pp. 1–17. Scholarly Studies in the Liberal Arts, Publication no. 1. Central College, Pella, Iowa.
Ardren, Traci, and Alejandra Alonso Olvera
 2016 The Artisans of Terminal Classic Xuenkal, Yucatan, Mexico: Gender and Craft during a Time of Economic Change. In *Gendered Labor in Specialized Economies: Archaeological Perspectives on Female and Male Work*, edited by Sophia E. Kelly and Traci Ardren, pp. 91–116. University Press of Colorado, Boulder.
Ardren, Traci, and Justin Lowry
 2011 The Travels of Maya Merchants in the Ninth and Tenth Centuries AD: Investigations

at Xuenkal and the Greater Cupul Province, Yucatan, Mexico. *World Archaeology* 43: 428–443.

Ardren, Traci, T. Kam Manahan, Julie Kay Wesp, and Alejandra Alonso

2010 Cloth Production and Economic Intensification in the Area Surrounding Chichen Itza. *Latin American Antiquity* 21: 274–289.

Barrera Rubio, Alfredo, and Carlos Peraza Lope

2006 Kulubá y sus interrelaciones con Chichén Itzá y el Puuc. In *Los mayas de ayer y hoy. Memorias del Primer Congreso Internacional de Cultura Maya*, vol. 1, edited by Ruth Gubler and Alfredo Barrera Rubio, pp. 405–432. Conaculta-Instituto Nacional de Antropología e Historia, Merida, Yucatan.

Barrera Rubio, Alfredo, Carlos Peraza Lope, Luis Pantoja Diaz, Georgina Delgado Sanchez, and Jose Estrada Faisal

2001 Exploraciones en el Sitio Arqueólogico de Culubá, Yucatán. In *Los Investigadores de la Cultura Maya*, 9: 124–143.

Bey, George J., III

2003 The Role of Ceramics in the Study of Conflict in Maya Archaeology. In *Ancient Mesoamerican Warfare*, edited by M. Kathryn Brown and Travis W. Stanton, pp. 19–30. AltaMira Press, Walnut Creek, Calif.

Bey, George J., III, Tara M. Bond, William M. Ringle, Craig A. Hanson, Charles W. Houck, and Carlos Peraza Lope

1998 The Ceramic Chronology of Ek Balam, Yucatan, Mexico. *Ancient Mesoamerica* 9: 101–120.

Bey, George J., III, and Rossana May Ciau

2014 The Role and Realities of Popol Nahs in Northern Maya Archaeology. In *The Maya and Their Central American Neighbors: Settlement Patterns, Architecture, Hieroglyphic Texts, and Ceramics*, edited by Geoffrey E. Braswell, pp. 335–355. Routledge, New York.

Bey, George J., III, and William M. Ringle

2011 From the Bottom Up: The Timing and Nature of the Tula–Chichén Itzá Exchange. In *Twin Tollans: Chichén Itzá, Tula, and the Epiclassic to Early Postclassic Mesoamerican World*, rev. ed., edited by Jeff Karl Kowalski and Cynthia Kristan-Graham, pp. 299–340. Dumbarton Oaks, Washington, D.C.

Blanton Richard E., and Gary M. Feinman

1984 The Mesoamerican World System: A Comparative Perspective. *American Anthropologist* 86: 673–682.

Brainerd, George W.

1958 *The Archaeological Ceramics of Yucatán*. Anthropological Records no. 19. University of California Press, Berkeley.

Braswell, Geoffrey E.

1997 El intercambio prehispánico en Yucatán, México. In *X Simpósio de Investigaciones Arqueológicos en Guatemala*, vol. 2, edited by Juan Pedro Laport and Héctor L. Escobedo, pp. 595–606. Museo Nacional de Arqueología y Etnología, Guatemala City.

2003 Obsidian Exchange Spheres. In *The Postclassic Mesoamerican World*, edited by Michael E. Smith and Francis F. Berdan, pp. 131–158. University of Utah Press, Salt Lake City.

Braswell, Geoffrey E., and Michael D. Glascock

2002 The Emergence of Market Economies in the Ancient Maya World: Obsidian Exchange

in Terminal Classic Yucatán, Mexico. In *Geochemical Evidence for Long Distance Exchange*, edited by Michael D. Glascock, pp. 33–52. Bergin and Garvey, Westport, Conn.

Cobean, Robert H.

1990 *La cerámica de Tula, Hidalgo*. Colección Científica 215. Instituto Nacional de Antropología e Historia, Mexico City.

Cobos Palma, Rafael

2003 *The Settlement Patterns of Chichén Itzá, Yucatán, Mexico*. PhD diss., Department of Anthropology, Tulane University, New Orleans. University Microfilms, Ann Arbor, Mich.

Coggins, Clemency Chase

2002 Toltec. *RES: Anthropology and Aesthetics* 42: 35–85.

Cohodas, Marvin

1978 *The Great Ball Court at Chichen Itza, Yucatan, Mexico*. Garland, New York.

Dahlin, Bruce H.

2009 Ahead of Its Time? The Remarkable Early Classic Maya Economy of Chunchucmil. *Journal of Social Archaeology* 9: 341–367.

David, Bruno, and Julian Thomas (editors)

2008 *Handbook of Landscape Archaeology*. Left Coast Press, Walnut Creek, Calif.

Diehl, Richard A.

1993 The Toltec Horizon in Mesoamerica: New Perspectives on an Old Issue. In *Latin American Horizons*, edited by Don Stephen Rice, pp. 263–294. Dumbarton Oaks, Washington, D.C.

Drennan, Robert D.

1984 Long Distance Transport Costs in Pre-Hispanic Mesoamerica. *American Anthropologist* 86: 105–112.

Fash, Barbara, William Fash, Sheree Lane, Rudy Larios, Linda Schele, Jeffrey Stomper, and David Stuart

1992 Investigations of a Classic Maya Council House at Copan, Honduras. *Journal of Field Archaeology* 19: 419–42.

García Cook, Ángel

2003 Cantona: La Ciudad/Cantona: The City. In *El Urbanismo en Mesoamérica/Urbanism in Mesoamerica*, edited by William T. Sanders, Alba Guadalupe Mastache, and Robert H. Cobean, pp. 311–343. Instituto Nacional de Antropología e Historia, México, D.F., and Pennsylvania State University Press, University Park.

Garza Tarazona de González, Silvia, and Edward B. Kurjack

1980 *Atlas Arqueológico del estado de Yucatan*. 2 vols. Instituto Nacional de Antropología e Historia, Mexico City.

Gillespie, Susan D.

1991 Ballgames and Boundaries. In *The Mesoamerican Ballgame*, edited by Vernon L. Scarborough and David R. Wilcox, pp. 317–345. University of Arizona Press, Tucson.

Graña-Behrens, Daniel

2006 Emblem Glyphs and Political Organization in Northwestern Yucatan in the Classic Period (A.D. 300–1000). *Ancient Mesoamerica* 17: 105–123.

Greene Robertson, Merle

1991 The Ballgame at Chichen Itza: An Integrating Device of the Polity in the Post-Classic. In *The Mesoamerican Ballgame*, edited by Gerard W. van Bussel, Paul L. F. van Don-

gen, and Ted J. J. Leyenaar, pp. 91–109. National Museum of Ethnology, Leiden, Netherlands.

Grube, Nikolai and Ruth J. Krochock

2011 Reading between the Lines: Hieroglyphic Texts from Chichén Itzá and Its Neighbors. In *Twin Tollans: Chichén Itzá, Tula, and the Epiclassic to Early Postclassic Mesoamerican World*, rev. ed., edited by Jeff Karl Kowalski and Cynthia Kristan-Graham, pp. 157–193. Dumbarton Oaks, Washington, D.C.

Guzmán Ortiz Rejón, Elvira Sol

2007 *Los artefactos de Kuluba y sus implicaciones sociales*. Unpublished licenciatura thesis, Escuela de Ciencias Antropológicas, Universidad Autónoma de Yucatan, Mérida.

Hernández Álvarez, Héctor, and Nancy Peniche May

2012 Los malacates arqueológicos de la Península de Yucatan. *Ancient Mesoamerica* 23: 441–459.

Houston, Stephen D.

2014 Courtesans and Carnal Commerce. https://decipherment.wordpress.com/2014/06/08/courtesans-and-carnal-commerce, accessed July 6, 2014.

Johnson, Scott A. J.

2012 *Late and Terminal Classic Power Shifts in Yucatan: The View from Popola*. PhD diss., Department of Anthropology, Tulane University, New Orleans. University Microfilms, Ann Arbor, Mich.

Kepecs, Susan M.

2011 Chichén Itzá, Tula, and the Epiclassic/Early Postclassic Mesoamerican World System. In *Twin Tollans: Chichén Itzá, Tula, and the Epiclassic to Early Postclassic Mesoamerican World*, rev. ed., edited by Jeff Karl Kowalski and Cynthia Kristan-Graham, pp. 95–111. Dumbarton Oaks, Washington, D.C.

Kepecs, Susan M., Gary M. Feinman, and Sylviane Boucher

1994 Chichen Itza and Its Hinterland: A World-Systems Perspective. *Ancient Mesoamerica* 5: 141–158.

Kidder, Alfred

1943 Spindle Whorls from Chichen Itza, Yucatan. In *Notes on Middle American Archaeology and Ethnology*, no. 16. Carnegie Institution of Washington, Washington, D.C.

Knapp, A. Bernard, and Wendy Ashmore

1999 Archaeological Landscapes: Constructed, Conceptualized, Ideational. In *Archaeologies of Landscape*, edited by Wendy Ashmore and A. Bernard Knapp, pp. 1–30. Blackwell, Oxford.

Koontz, Rex

2009 *Lightning Gods and Feathered Serpents: The Public Sculpture of El Tajin*. University of Texas Press, Austin.

Krochock, Ruth J.

2002 Women in the Hieroglyphic Inscriptions of Chichen Itza. In *Ancient Maya Women*, edited by Traci Ardren, pp. 152–170. AltaMira Press, Walnut Creek, Calif.

Krochock, Ruth, and David A. Freidel

1994 Ballcourts and the Evolution of Political Rhetoric at Chichen Itza. In *Hidden among the Hills: Maya Archaeology of the Northwest Yucatan Peninsula*, edited by Hanns J. Prem, pp. 359–375. Acta Mesoamericana, vol. 7. Verlag Von Fleming, Möckmühl, Germany.

Lira López, Yamile

1995 *Una Revisión de la Tipología Cerámica de El Tajín*. Annales de Antropología, Volumen 32, pp. 121–159. Universidad Nacional Autónoma de México, Mexico City.

López Austin, Alfredo, and Leonardo López Luján

2000 The Myth and Reality of Zuyúa: The Feathered Serpent and Mesoamerican Transformation from the Classic to the Postclassic. In *Mesoamerica's Classic Heritage: From Teotihuacan to the Aztecs*, edited by David Carrasco, Lindsay Jones, and Scott Sessions, pp. 21–84. University Press of Colorado, Boulder.

López Hernández, Miriam

2012 *Ahuianime*: Las sedectoras del mundo prehispánico. *Revista Española de Antropología Americana* 42: 401–423.

McCafferty, Geoffrey G.

1996 The Ceramics and Chronology of Cholula, Mexico. *Ancient Mesoamerica* 7: 299–323.

Manahan, T. Kam, Traci Ardren, and Alejandra Alonso Olvera

2012 Household Organization and the Dynamics of State Expansion: The Late Classic–Terminal Classic Transformation at Xuenkal, Yucatan, Mexico. *Ancient Mesoamerica* 23: 345–364.

Mathews, Peter

1991 Classic Maya Emblem Glyphs. In *Classic Maya Political History: Hieroglyphic and Archaeological Evidence*, edited by T. Patrick Culbert, pp. 19–29. Cambridge University Press, Cambridge.

Morley, Sylvanus G.

1919 Archaeology. Carnegie Institution of Washington, Yearbook no. 17 (1918): 269–276. Washington, D.C.

Nicholson, Henry B.

2001 *Topiltzin Quetzalcoatl: The Once and Future Lord of the Toltecs*. University Press of Colorado, Boulder.

Palka, Joel

2014 *Maya Pilgrimage to Ritual Landscapes: Insights from Archaeology, History, and Ethnography*. University of New Mexico Press, Albuquerque.

Peraza Lope, Carlos, and Alfredo Barrera Rubio

2006 La cerámica arqueológica de Kulubá, Yucatán. In *Los mayas de ayer y hoy. Memorias del Primer Congreso Internacional de Cultura Maya*, vol. 1, edited by Ruth Gubler and Alfredo Barrera Rubio, pp. 433–451. Conaculta-Instituto Nacional de Antropología e Historia, Merida, Yucatan.

Pérez de Heredia Puente, Eduardo J.

2010 Ceramic Contexts and Chronology at Chichen Itza, Yucatan, Mexico. Unpublished PhD diss., Faculty of Humanities and Social Sciences, School of Historical and European Studies, Archaeology Program, La Trobe University, Melbourne.

Plank, Shannon E.

2004 *Maya Dwellings in Hieroglyphs and Archaeology: An Integrated Approach to Ancient Architecture and Spatial Cognition*. BAR International Series 1324. British Archaeological Reports, Oxford.

Proskouriakoff, Tatiana

1962 Civic and Religious Structures at Mayapan. In *Mayapan, Yucatan, Mexico*, by H.E.D.

Pollock, Ralph L. Roys, Tatiana Proskouriakoff, and A. Ledyard Smith, pp. 88–164. Publication no. 619. Carnegie Institution of Washington, Washington, D.C.

Ringle, William M.

2004 On the Political Organization of Chichen Itza. *Ancient Mesoamerica* 15: 167–218.

2009 The Art of War: Imagery of the Upper Temple of the Jaguars, Chichen Itza. *Ancient Mesoamerica* 20: 15–44.

2014 Plazas and Patios of the Feathered Serpent. In *Mesoamerican Plazas: Arenas of Community and Power*, edited by Kenichiro Tsukamoto and Takeshi Inomata, pp. 168–192. University of Arizona Press, Tucson.

Ringle, William M., and George J. Bey III

2008 Preparing for Visitors: Political Dynamics on the Northern Plains of Yucatan. Paper presented at the *VI Mesa Redonda de Palenque: Homenaje a Ian Graham*. Palenque, México.

2009 The Face of the Itzas. In *The Art of Urbanism: How Mesoamerican Kingdoms Represented Themselves in Architecture and Imagery*, edited by William L. Fash and Leonardo López Luján, pp. 329–383. Dumbarton Oaks, Washington, D.C.

Ringle, William M., George J. Bey III, Tara Bond-Freeman, Craig A. Hanson, Charles W. Houck, and J. Gregory Smith

2004 The Decline of the East: The Classic to the Postclassic Transition at Ek Balam, Yucatan. In *The Terminal Classic in the Maya Lowlands: Collapse, Transition, and Transformation*, edited by Arthur A. Demarest, Prudence M. Rice, and Don S. Rice, pp. 485–516. University Press of Colorado, Boulder.

Ringle, William M., Tomás Gallareta Negrón, and George J. Bey III

1998 The Return of Quetzalcoatl: Evidence for the Spread of a World Religion during the Epiclassic Period. *Ancient Mesoamerica* 9: 183–232.

Robles Castellanos, Fernando

1990 *La sequencia cerámica de la region de Cobá, Quintana Roo*. Serie Arqueología 184. Instituto Nacional de Antropología e Historia, Mexico City.

2006 Las esferas ceramicas de Cepech y Sotuta del apogee del Clasico tardio (730–900 D.C.) en el norte de la peninsula. In *La produccion alfarera en el México antiguo III*, edited by Beatriz Leonor Merion Carrion and Ángel García Cook, pp. 281–343. Conaculta-Instituto Nacional de Antropología e Historia, Mexico City.

Ruppert, Karl

1950 Gallery-Patio Type Structures at Chichen Itza. In *For the Dean: Essays in Anthropology in Honor of Byron S. Cummings on His 89th Birthday*, edited by Erik K. Reed and Dale S. King, pp. 249–258. Hohokam Museums Association and the Southwestern Monuments Association, Tucson, Ariz., and Santa Fe, N.M.

Sluyter, Andrew

1993 Long-Distance Staple Transport in Western Mesoamerica: Insights Through Quantitative Modeling. *Ancient Mesoamerica* 4: 193–199.

Smith, J. Gregory

2000 *The Chichen Itza–Ek Balam Transect Project: An Intersite Perspective on the Political Organization of the Ancient Maya*. PhD diss., Department of Anthropology, University of Pittsburgh. University Microfilms, Ann Arbor, Mich.

2002 Regional Survey around Kulubá, Yucatán, Mexico. Paper presented at the 67th Annual Meeting of the Society for American Archaeology, Denver.

2003 *Final Report of the Kulubá Archaeological Project, 2001 Field Season.* Foundation for the Advancement of Mesoamerican Studies. www.famsi.org/reports/00051/index.html, accessed May 23, 2014.

2014 Epiclassic Cantona in the Mesoamerican World System. Paper presented at the 5th Annual South-Central Conference on Mesoamerica, Tulane University, New Orleans.

Smith, J. Gregory, William M. Ringle, and Tara M. Bond-Freeman

2006 Ichmul de Morley and Northern Maya Political Dynamics. In *Lifeways in the Northern Maya Lowlands: New Approaches to Archaeology in the Yucatan Peninsula*, edited by Jennifer P. Mathews and Bethany A. Morrison, pp. 155–172. University of Arizona Press, Tucson.

Smith, Michael E.

2011 Tula and Chichén Itzá: Are We Asking the Right Questions? In *Twin Tollans: Chichén Itzá, Tula, and the Epiclassic to Early Postclassic Mesoamerican World*, rev. ed., edited by Jeff Karl Kowalski and Cynthia Kristan-Graham, pp. 469–499. Dumbarton Oaks, Washington, D.C.

Smith, Robert E.

1971 *The Pottery of Mayapan, including Studies of Ceramic Material from Uxmal, Kabah, and Chichen Itza.* 2 vols. Papers of the Peabody Museum of Archaeology and Ethnology, vol. 66. Harvard University, Cambridge.

Stanton, Travis W., and Tomás Gallareta Negrón

2001 Warfare, Ceramic Economy, and the Itza: A Reconsideration of the Itza Polity in Ancient Yucatan. *Ancient Mesoamerica* 12: 229–245.

Thompson, J. Eric S.

1970 *Maya History and Religion.* University of Oklahoma Press, Norman.

Tokovinine, Alexandre, and Dmitri Beliaev

2013 People of the Road: Traders and Travelers in Ancient Maya Words and Images. In *Merchants, Markets, and Exchange in the Pre-Columbian World*, edited by Kenneth G. Hirth and Joanne Pillsbury, pp. 169–200. Dumbarton Oaks, Washington, D.C.

Tozzer, Alfred M. (editor and translator)

1941 *Landa's Relación de las cosas de Yucatán: A Translation.* Papers of the Peabody Museum of American Archaeology and Ethnology, vol. 18. Harvard University, Cambridge.

Willey, Gordon R.

1976 Mesoamerican Civilization and the Idea of Transcendence. *Antiquity* 50: 205–215.

Zamora Rivera, Monica

2004 Ubicación, descripción, y análisis de los juegos de pelota en Cantona, Puebla. *Arqueología* 34: 62–74.

6

The Castillo-sub at Chichen Itza

A Reconsideration

VIRGINIA E. MILLER

Despite its dominant position on Chichen Itza's Great Terrace, the Castillo remains one of the most enigmatic structures at the site. The first known drawing of any structure at Chichen Itza is Bishop Diego de Landa's sketch of this imposing pyramid (Figure 6.1). Although not very accurate—the plan looks more like the Pyramid of the Magician at Uxmal—the drawing does convey the existence of four stairways oriented to the cardinal directions and on top a small temple with four entrances. Landa's written description does not clarify matters, although he does refer to the steep stairway of 91 steps leading up to the temple, the carved serpent heads at the base of the stairways (which he inaccurately places at the base of each balustrade rather than only at the northern one), and a vaulted four-chambered structure with wooden lintels at the top (Tozzer 1941: 178–179). He identifies the building as having been dedicated to the worship of K'uk'ulkan, the Maya version of the Central Mexican deity and culture hero Quetzalcoatl (Tozzer 1941: 25). Although the bishop does not suggest that the temple was still in use when he was writing, like the Sacred Cenote, it was certainly a locus of ritual activity after the abandonment of Chichen Itza: ceremonial Chenku-Tases ceramics, for example, were found here as well as in numerous other structures (Pérez de Heredia 2010: 352). Francisco de Montejo, son of the conqueror of Yucatan, established a fort at the unoccupied site in the early 1530s, which was quickly abandoned in the face of native resistance. A gun was mounted in the western passage of the Castillo's temple, the hole only covered over when the structure was restored 80 years ago (Tozzer 1941: note 933) (see Volta et al., Chapter 2, for Landa's description of aspects of rulership, pilgrimage, tribute, and sacrifice associated with the site, as well as for a discussion of nineteenth-century visitors' overall investigations at Chichen).

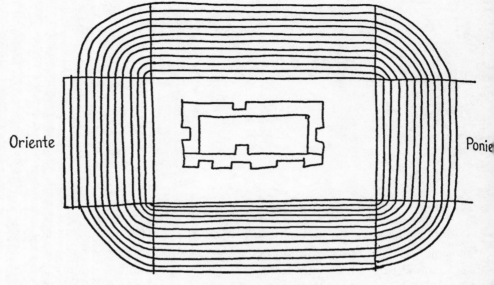

Oriente Ponie

Figure 6.1. Plan of Castillo by Diego de Landa (Tozzer 1941: 178) (Alfred M. Tozzer, ed., *Landa's Relación de las cosas de Yucatán: A Translation*, Papers of the Peabody Museum of American Archaeology and Ethnology, Harvard University, vol. 18, 1941). Reprinted courtesy of the Peabody Museum, Harvard University.

Chichen Itza and specifically the Castillo came to world attention through the 1843 publication by John Lloyd Stephens, who the year before took measurements of both the pyramid and the surmounting temple and commented on reliefs carved on the wooden lintels and stone jambs. One of the latter was illustrated by Frederick Catherwood, who also executed a drawing of the entire structure and another of the north stairway with its giant serpent heads (Stephens 1963, vol. 2: fig. 14, plates 38, 39). Stephens noted that Piste residents passed their Sundays promenading through the ruins and remarked on the local women, dressed in white *jipiles* and wrapped in their red *rebozos*, moving in and out of the Castillo's temple (Stephens 1963, vol. 2: 214).

Later nineteenth-century explorers include the French adventurer Désiré Charnay, who spent nine days at Chichen Itza in 1860 and took the first successful photographs of the site, including one of the Castillo, published in a large folio-sized volume in 1863 (Charnay and Viollet-Le-Duc 1863: plate 32; Davis 1981: 12–13, 16–17) (Figure 6.2). Apart from his role as an early photographer, Charnay's most original and enduring contribution to the incipient field of Mesoamerican archaeology was his recognition of the resemblance between Chichen Itza and Tula, which he excavated on a subsequent trip. He used specific examples to demonstrate his point such as the feathered serpent columns

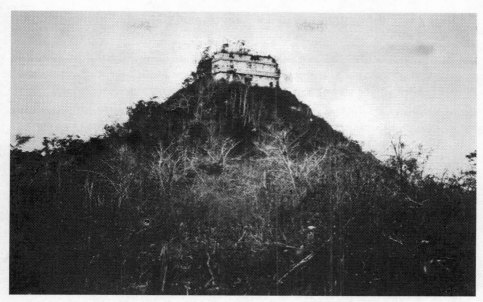

Figure 6.2. Earliest known photograph of Castillo, by Désiré Charnay (Charnay and Viollet-Le-Duc 1863: plate 32). Photo courtesy of the Peabody Museum of Archaeology and Ethnology, Harvard University, PM# 2004.24.29872 (digital file# 154010025).

from the Castillo and Pyramid B (Charnay 1887: 343–344). But Charnay also believed that none of the Mesoamerican sites he visited were very ancient, and he insisted that all Mesoamerican cultures had their origins in Tula (compare Jones 1995: 27–32). Another early visitor to the site, Augustus Le Plongeon, is now best remembered (if at all) for his eccentric ideas about Egypt and the Maya. He and his spouse spent three seasons at Chichen Itza (1875, 1883, and 1884). While their work did not focus on the Castillo, they did take some of the earliest photographs of the site, including details of the reliefs in the Castillo's temple in 1875 (Desmond and Messenger 1988: 38, 39).

The independent scholar Alfred P. Maudslay (1889–1902, vol. 3: 2) produced the first accurate map of the site. His plan and section of the Castillo and of its temple are remarkably accurate given the ruinous state of the building and lack of available labor (Maudslay 1889–1902, vol. 3: plate 55). Two of Maudslay's discoveries are related directly to the Castillo's temple. First of all, he realized that broken stone rattlesnake tails found scattered about had actually functioned as capitals for serpent columns supporting lintels. Secondly, he determined that the stone *grecas* found on the ground around the site had originally been set vertically along roofs, having seen some in place

on top of the Castillo temple (Graham 2002: 163; Maudslay 1889–1902, vol. 3: 27–28, 36).

Austrian explorer Teobert Maler first came to Mexico as a soldier in Emperor Maximilian's army and stayed on; after a sojourn back in Europe, he settled definitively in Yucatan in 1885. He visited and recorded around 100 archaeological sites throughout the Maya region, including Chichen Itza. Making his headquarters in the Monjas, as others had done before him, Maler spent three months there in 1891–1892, clearing the site, making a site plan, doing tracings, undertaking minor excavations, and taking superb photographs under difficult conditions. Although not much given to interpretation, Maler (1971: 108) was ahead of his time in suggesting that the figures represented on the reliefs of the temple of the Castillo were historical personages, seeing them as kings of the Kokom. Unfortunately, during his later years he was embittered by rivalry with others working in the Maya area, such as Maudslay and particularly the U.S. consul E. H. Thompson. The latter is best known for his dredging of the Sacred Cenote and the illegal export of artifacts found there to the Peabody Museum at Harvard, and secondarily for his 1896 excavation of the Osario, or High Priest's Grave, believed by most scholars to be a later copy of the Castillo (Thompson 1938).

William H. Holmes, curator of anthropology at the newly founded Field Columbian Museum in Chicago (now the Field Museum), spent a week at the site in 1895, publishing the report on his explorations in Yucatan before the end of the year (Holmes 1895). He drew sections and a plan of the Castillo's temple and included a photograph of the overgrown and partially collapsed entrance (Holmes 1895: figs. 35–37, plate XIV). Holmes (1895: 105) firmly believed that Chichen Itza was a purely Maya site, although constructed in a style unique to Yucatan. He was, then, possibly the last scholar for at least 70 years to view Chichen as free of Central Mexican influence (Jones 1995: 64).

The British artist Adela Breton first went to Chichen Itza in 1900 at the behest of Maudslay, who asked her to color his photographic plates and to check the accuracy of drawings for publication (McVicker 2005: 57). While she is most noted for her meticulous watercolor reproductions of the murals in the Upper Temple of the Jaguars, Breton also copied objects in a variety of other media at the site, including some of Thompson's finds from the Sacred Cenote. Among the reliefs she apparently reproduced are the carved jambs and lintels from the Castillo, but these drawings are unpublished (McVicker 2005: 120; Miller 1989: 34).

Before the advent of the Carnegie Institution of Washington excavation era in 1923, the most important contributions to the study of Chichen Itza were

made by the prolific and versatile German scholar Eduard Seler, who wrote a lengthy article on the site, as well as two others touching on it (1990, 1993, 1998). Although he focused largely on Central Mexico and codices, he was widely traveled in the Americas and visited Chichen Itza on at least three occasions, the first in 1903 (Sepúlveda y Herrera 1992: 32, 35, 39, 115).

Seler believed in the essential unity of what we now call Mesoamerica (Bernal 1980: 151; Coe 1999: 120). He also accepted as a given that Chichen Itza had been invaded by Central Mexicans, specifically the Toltecs, or at the very least by people of Mexican descent, whom he referred to as the Itza (Seler 1998: 103, 134). His comparisons of Central Mexican elements and Chichen were quite specific, and he also carefully pointed out which structures at the site were similar to Puuc and Chenes buildings (Seler 1998: 45, 53). Although the idea of "new" (that is, Toltec) and "old" (Maya) Chichen Itza had not yet been formulated, he did suggest that the Maya-style buildings with inscriptions predated those with non-Maya features (Seler 1998: 45, 135). Seler (1998: figs. 82–85, 122–128, 134–147) supported his arguments with profuse illustrations, including the excellent photographs by his wife Caecilie and others, such as Teobert Maler, as well as many drawings. Seler, trained as a linguist, made no archaeological discoveries at the end of a period of exploration and at the beginning of the era of scientific excavation, a time in which such discoveries attracted greater public attention than analysis and interpretation of archaeological finds. His importance, then, lies in his methodological, empirical approach and his rejection of the many baseless theories then in fashion (Bernal 1980: 151; Nicholson 1990: xv).

Systematic, scientific archaeological excavation at Chichen Itza begins only in the twentieth century, and particularly after the Mexican revolution. Attempts to restore the crumbling Castillo were made in 1905 and again in 1921 (Maldonado 1997: 108; Peña 2001: 164). Mexican archaeologists began their own excavations in tandem with the Carnegie Institution of Washington's work, starting in 1926 (Maldonado 1997) (see Volta et al., Chapter 2, for a discussion of the overall programs of investigation undertaken at Chichen Itza in the twentieth century). The Castillo was finally explored and restored between 1927 and 1936 by Eduardo Martínez Cantón, José Erosa Peniche, and Manuel Cirerol Sansores (Peña 2001: 164). Following a hunch, in 1931 they tunneled through the outer pyramid to find an earlier one encased within. In 1935, Cirerol located its temple, a rare example of a chamber found with furnishings and termination offerings intact. Plans, sections, and elevations were drawn at the time, most notably those of Miguel Angel Fernández, published by Marquina (1951) and still the standard reconstructions (Figure 6.3a). A series of

lesser-known drawings by French architect André Remondet provide a more imaginative and three-dimensional view of both the inner and outer temples (Figure 6.3b).

Despite the importance of this discovery, publications about the work at the Castillo substructure are laconic and obscure (Anonymous 1932, 1937; Carnegie Institution of Washington 1937; Cirerol 1940, 1948; Erosa 1946, 1947; Palacios 1935). The conclusions presented here are based in part on my own examination of the inner chamber as well as reports and photographs in the Archivo Técnico de la Coordinación Nacional de Arqueología in Mexico City.

Subsequent studies of the outer pyramid and a continuous program of mapping, excavation, and restoration throughout the site in the ensuing decades have made it possible to reexamine this early example of monumental architecture at Chichen Itza. Most recently, excavations under the Great Terrace in close proximity to the Castillo have pushed back the history of monumental architecture at the site before the great buildings we see today were constructed. I am grateful to Rafael Cobos and Geoffrey Braswell for sharing the results of this new work.

Some of the earliest platforms constructed on the Great Terrace, and in proximity to the Castillo, shared its orientation (Braswell and Peniche 2012: 241). A gallery-patio complex was built later to the east, and then dismantled and covered over by the continuing expansion of the plaza (Braswell and Peniche 2012: 250). Eventually the Castillo-sub and the West Colonnade were constructed. As suspected by Erosa, who made some exploratory tunnels, there is now evidence that an earlier pyramid lies buried beneath the two known iterations of the Castillo (Braswell and Peniche 2012: 249; Maldonado 1997: 117; Volta et al., Chapter 2). Based on southern Classic Maya models, could this building be the resting place of a ruler of Chichen Itza, perhaps the site's founder? While some funerary monuments were constructed in a single operation, such as Palenque's Temple of the Inscriptions, others, notably Tikal Temple 33 and Copan Structure 16, were rebuilt in phases over the tombs of early dynasts.

Newly calibrated radiocarbon dates and stylistic evidence suggest that the Castillo was constructed later in the tenth century, but before the Osario with its hieroglyphic date of 998 (Volta and Braswell 2014: 383; Volta et al., Chapter 2). On the basis of this information, and other data from the recent excavations, the inner pyramid was probably built after 900 (Volta and Braswell 2014: 379). Therefore, it may be one of the earliest monumental structures at the site, perhaps roughly contemporaneous with the Monjas Complex and the Caracol (Cobos 2011: 255; Braswell 2012). It certainly stood essentially alone on the

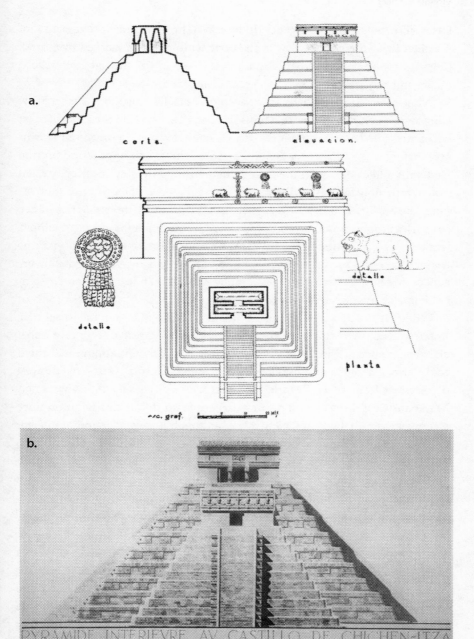

a.

corte. elevacion.

detalle.

detalle.

planta

esc. graf.

b.

PYRAMIDE INTERIEVRE AV CASTILLO DE CHICHEN-ITZA
YVCATAN · MEXIQVE

Figure 6.3. Plans, sections, and elevations of inner Castillo: *a*, Section, elevation, and plan of inner Castillo by Miguel Angel Fernández (Marquina 1951: plate 263); *b*, North elevation of Castillo showing inner Castillo, drawn by André Remondet. Courtesy of the Peabody Museum of Archaeology and Ethnology, Harvard University, PM# 50–63–20/17611 (digital file# 99320015).

Great Terrace for several decades. Indeed, it has recently been suggested that Chichen Itza suffered a decline in the early tenth century, marked by a slow-down in monumental construction and a pause in the hieroglyphic record (Volta and Braswell 2014: 388; Volta et al., Chapter 2).

While oriented north toward the Sacred Cenote, the Castillo was most likely constructed before the *sacbe* that links the Great Terrace with the cenote (Braswell 2012). The latter was undoubtedly a sacred destination drawing pilgrims even before the settlement was built, and the similar offerings found both in its depths and cached with the Castillo demonstrate their connection. Recent research demonstrates that the pyramid was placed at the center of four cenotes at the site, emphasizing its role as axis mundi (Guillermoprieto 2013: 110–111). The long-nosed zoomorphic masks on the upper façade of the temple, while in poor condition now, probably represent a *witz* or mountain, marking the structure as a sacred mountain, housing gods and ancestors and allowing access to a flowery solar paradise (Taube 2004: 85, 88, 93; see also Kristan-Graham, Chapter 8 for more information on witz).

While the Castillo is by no means the first radial pyramid in the Maya area, its size and commanding position at the center of the Great Terrace give it special prominence. It was imitated at least once at Chichen itself, in the form of the Osario, a smaller but more elaborately decorated structure to the southwest of the Great Terrace (see Headrick, Chapter 7, for a discussion of this pyramid). Mayapan's Castillo, also built over an earlier pyramid, was clearly meant to be a copy of the radial one at Chichen Itza, although it is smaller and of inferior quality. Dating to about 1300, it, too, was dedicated to K'uk'ulkan, according to Landa (Milbrath and Peraza Lope 2003: 16, 17, 23).

Investigators from the Instituto Nacional de Antropología e Historia and the Universidad Nacional Autónoma de México have just examined the interior of the Castillo at Chichen Itza using a new, nonintrusive technology called three-dimensional electrical tomography to allow them to "see" inside the massive structure. As was widely reported, the study demonstrated that the Castillo rests in part on the thick roof of an underground cenote, one that may be joined to others at the site (Romero 2015). If the Maya were aware of its presence, they may have deliberately placed the pyramid over the waters of the underworld, creating a cosmological map with the Castillo at the center linking the lower and upper worlds.

Another important factor that must have determined the location and orientation of the Castillo complex was the movement of the sun (compare Montero et al. 2014). Much has been written about the triangular shapes created by shadow and light that appear to transform the north balustrade into a

descending serpent twice a year within a week of the solar equinoxes (Aveni 2003: 47–62; Carlson 1999; Castañeda 2000). The shadows imitating the skin of a diamondback rattlesnake are created by the stepped northwest corner of the pyramid (Aveni et al. 2004: 130). Resting on the ground at the base of the staircase, the two open-mouthed serpent heads are poised as if the creatures were descending the stairs and slithering off along the sacbe leading to the cenote to the north. Although there is no way of knowing if the ancient Maya deliberately designed the pyramid in order to capture this light-and-shadow pattern, or if they simply observed it afterward, other aspects of the building, such as the feathered serpent iconography of the temple above, support the probability that the effect was intentional (Aveni et al. 2004: 130; Carlson 1999: 137; Šprac and Sánchez 2013: 45). Susan Milbrath (1988: 61) also proposed that the west and east sides of the temple are oriented toward zenith sunset on May 25 and nadir sunrise on November 22, respectively, thereby marking the beginnings of both the rainy, planting season and the dry, harvesting season (Šprac and Sánchez 2013: 42). Additionally, at the solar zenith (May 23 and July 19), the sun passes directly over the Castillo and then moves to the northwest, passing directly over the Holtun Cenote before setting in the west (Guillermoprieto 2013: 110–111).

With its 364 steps plus the temple level, the pyramid has often been interpreted as a great calendrical marker. Its plan resembles the pan-Mesoamerican quadripartite design for the cosmos (Aveni et al. 2004: 129; Coggins 1989). The calendar round of 52 years may be represented by recessed panels on both sides of each stairway. There are a number of other possible calendrically significant features, including the 20 finials once present on the temple's roof, representing the number of days in the Maya month (Carlson 1999: 141).

The nine-tiered inner Castillo is obviously smaller and less complex than the structure that covers it. It measured 33 m square and 17 m in height, minus the superstructure. It is in Puuc style, with the exception of the decoration on the upper façade of the temple (Ringle and Bey 2009: 345). Competing reconstruction drawings have been published of this façade, no longer easily visible. Figure 6.4 presents several of these variations demonstrating the differences: apparently the serpent heads were missing at the time of discovery and were not recovered (compare Figure 6.3; Cirerol 1948: 119).

While the simple moldings, as well as the geometric mosaic elements and intertwined serpentine motifs (apparently also present on the rear wall), might have been taken from a Puuc building, the prowling felines and shields with streaming pendants are similar to motifs on the later Upper Temple of the Jaguars, as well as to many examples at Tula. The element topping the serpent

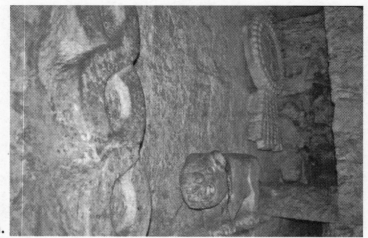

a.

b.

Facade of Substructure inside of "El Castillo"

c.

Figure 6.4. Photograph and drawings of the inner Castillo façade: *a*, Photo by E. Kurjack, 1994, by permission of Ilona Kurjack Mueller; *b*, Reconstruction drawing (Cirerol 1940); *c*, Reconstruction drawing (Cirerol 1948); *d*, Reconstruction drawing (Erosa 1947); *e*, Reconstruction drawing (Tozzer 1957:fig. 86) drawn by André Remondet in 1938 (Alfred M. Tozzer, *Chichen Itza and Its Cenote of Sacrifice: A Comparative Study of Contemporaneous Maya and Toltec*, Memoirs of the Peabody Museum of Archaeology and Ethnology, 1957: vols. 11, 12). Copyright 1957 by the President and Fellows of Harvard College.

motif may be a reed glyph, a possible reference to Tollan (Bey and Ringle 2011: 327). This hybrid style, incorporating features of the Late Classic and the later, more "foreign," style at the site, has recently been dubbed the Transitional style (Braswell and Peniche 2012: 254). An "International Style," incorporating elements such as serpent columns, balustrades, and colonnades, can be identified even in structures predating the Castillo-sub, suggesting that change at Chichen was gradual, not the result of a sudden takeover of the site by outsiders or of the rapid introduction of a foreign religion (Braswell and Peniche 2012: 259–260).

The temple consisted of two parallel corbel vaulted chambers each 10.6 m long, with a larger outer room measuring 2.3 m wide to 1.84 m wide for the inner room. Red rings painted around the holes by the original wooden beams of the vault, now vanished, suggest that the beams themselves may have been painted red, possibly with specular hematite. During recent restoration work, paint splashes that could have resulted from painting the beams were noted on the vaults and walls of the inner chamber. The sloppiness of this work suggests that the beams may have been painted when the temple was decommissioned (Pérez de Heredia 2015). In any case, when the rooms were abandoned, the

outer chamber's single door was walled off and the capstones of both rooms removed. Through these openings both chambers were filled with rubble to form the base of the later temple above (Cirerol 1948: 120–121).

In front of the entrance to the antechamber stood a perfectly preserved *chacmool*, from Chichen's corpus of at least 18 (Figure 6.5). It retains traces of its original color and has eyes and toenails inlaid with shell. The black pupils may be pitch (Carnegie Institution of Washington 1937: 116). Elsewhere I have proposed that the chacmool represents an Itza warrior, rather than a

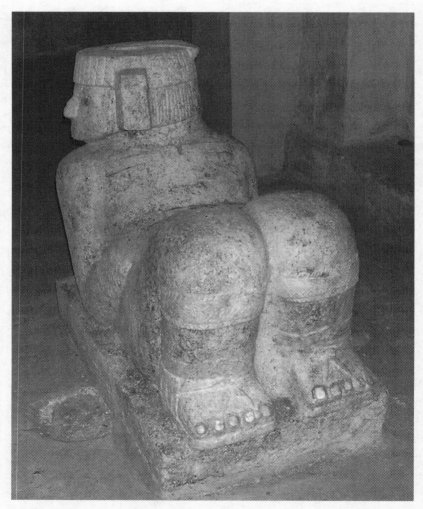

Figure 6.5. Chacmool at the entrance to the temple of inner Castillo, photo by Ed Kurjack, 2007, by permission of Ilona Kurjack Mueller.

deity or captive, as others have also recently argued (Miller 2006; compare Carlson 2013 and Ringle and Bey 2009: 33). Most chacmools at the site wear the distinctive headgear and other costume elements seen on representations of standing warriors, such as those depicted on the jambs of the Upper Temple of the Jaguars (Schele and Mathews 1998: figs. 6.25–6.28). Furthermore, there is nothing about these figures' demeanor that suggests humiliation or defeat. The chacmool found in the Temple of the Chacmool carries trophy heads, for example, and at Tula some have knives strapped to their arms. The receptacle on the abdomen may have been used in fire-drilling rites, possibly for the Maya equivalent of the Aztec New Fire Ceremony (Coggins 1987: 446). Burning and fire-drilling events are recorded in Chichen's inscriptions, but these texts, like the local rituals, are still poorly understood (Grube et al. 2003, part 2: 40–42, 44, 45, 48–49, 70; Krochock 1998: 64–66, 76, 79; Plank 2004: 166; Ringle 2004: 197) (see Pérez and Bíró, Chapter 3, for a discussion of the prevalence of fire rituals in Chichen's inscriptions).

When temples were renovated, chacmools were sometimes interred in place or removed for deposit elsewhere: three are known from the Tzompantli area alone. Throughout Mesoamerica, chacmools tend to be placed in liminal spaces: at the crossroads of sacbes, on top of platforms, at the foot of stairs, before altars, or at temple entrances (López Luján and López Austin 2001: 61). They are therefore probably not foci of worship, but mediators in rituals, where offerings were placed temporarily as participants passed into the inner sanctum. The chacmool's recumbent form echoes the image of Palenque's ruler Pakal on his sarcophagus lid, now thought to be rising from the dead, like both new maize and the morning sun, rather than journeying to the underworld (Stuart and Stuart 2008: 174–177). If there is a tomb deep within the Castillo, this figure may either guard or represent the deceased.

When the inner room was cleared out, a large box of limestone blocks was found covering a stone jaguar throne (Anonymous 1937: 116). Traces of woven matting surrounded the jaguar (Erosa 1946: 23). Painted bright red, it has white stone teeth, spherical jade eyeballs, and for spots, over 70 inset apple-green jade disks (Marquina 1951: 855) (Figure 6.6). The chacmool and jaguar were subsequently covered with a protective varnish, and the latter encased in a glass box (Carnegie Institution of Washington 1937: 116). During recent restoration work, conservators determined that the pigment used to color the jaguar was cinnabar (García 2015). Thrones in the form of jaguars are known elsewhere at the site and further afield—a double-headed example is still in place before Uxmal's Palace of the Governor and there are about six known from Chichen (Ringle 2004: fig. 8; Silverstein 1998: 49–50). Paintings and re-

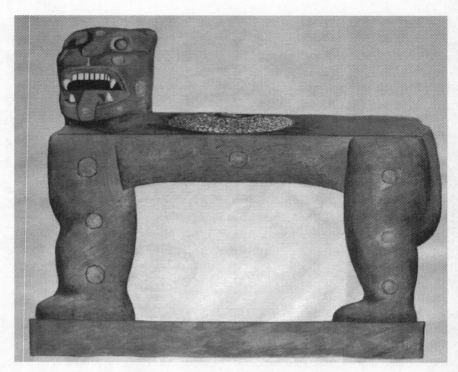

Figure 6.6. Side view of the jaguar throne in inner Castillo, watercolor by Miguel Angel Fernández in Archivo Técnico de la Coordinación Nacional de Arqueología, Instituto Nacional de Antropología e Historia, Mexico City, by permission of the Instituto Nacional de Antropología e Historia.

liefs in later structures around the Great Terrace also depict figures seated on such thrones, usually singly but sometimes in groups (Kowalski et al. 2002: 99; Morris et al. 1931, vol. 2: plates 135, 136; Silverstein 1998: 50).

Found on the throne was a wooden disk covered in turquoise mosaic on which something (possibly copal) had been burned, like other disks recovered at the site (Cirerol 1936; Coggins 1987: 465–466). The association of the disks— whose centers are usually inlaid with pyrite—with the hearth and fire-making is well documented (Taube 2000: 317–319). These objects, widespread throughout Mesoamerica and beyond, also have solar connotations. Despite the damage, the disk's design was still visible at the time of discovery, but no clear image has ever been published. The four symmetrical radiating motifs appear to be abstract square-nosed fire serpents, while the central part is described as a raised design in the form of an inverted flower (Cirerol 1948: 24; Marquina 1951: 855) (Figure 6.7a). Left in place on the back of the jaguar, the disk was damaged

during cleaning and it is in fragile condition, stored in the Regional Museum
of Anthropology in Mérida (García and Vázquez 2007: 63).[1]

On top of the disk lay a number of offerings, never published completely, but
which included a necklace of shell or coral, two large jade beads, and a small
carved jade head (Anonymous 1937: 116; Erosa 1946: photos 10–12; Marquina
1951: 855, photos 424, 425; Willard 1933: 433, 1941: 219) (Figure 6.7b). While the

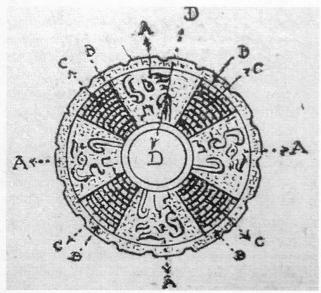

a.

b.

Figure 6.7. Details of the jaguar
throne: *a*, Drawing of the disk
found on the back of the jaguar
throne (Cirerol 1948: 124); *b*,
Photograph of the jade head
found on the back of the jaguar
throne, photo in Archivo Técnico
de la Coordinación Nacional de
Arqueología, Instituto Nacional de
Antropología e Historia, Mexico
City, by permission of the Instituto
Nacional de Antropología e
Historia.

three beads have been described as representing a cosmic hearth, the exact number of objects, their size, and position of the offering is not reported or illustrated anywhere, making interpretation difficult (Schele and Mathews 1998: 227).

A feature unique to the inner chamber is the two rows of human femurs embedded into the south wall and at one time projecting from it (Anonymous 1937: 116; Cirerol 1940). Elaborate constructions of human bone are known from northwestern Mexico—an area with poorly understood connections to Chichen Itza (Kristan-Graham 2011; Miller 2007)—but I am unaware of any similar use of bone as an architectural element in Mesoamerica. Human bones, however, whether of revered ancestors or unwilling victims, were reworked and manipulated in a great variety of ways. The contemporary K'iché believe that an individual's patrilineage resides in the thigh, for example (Tedlock 2003: 146–147). More to the point, femurs were common military trophies for both the Maya and the Aztecs, and one Maya term for captive was *baak*, or bone. A sculpture that Eduard Seler (1998: fig. 64) discovered leaning against the Iglesia at Chichen depicts a male torso (found headless) with a large bone clutched in the right hand, perhaps representing such a trophy. The thigh is also the most common bodily location for hieroglyphic tags naming captives (Burdick 2016). The human femurs may have been those of captives killed prior to the temple's construction and retained and exhibited as permanent, visible mementos of both successful warfare and sacrificial activities that took place in or around the temple.

The inner Castillo was visible for no more than a few decades, after which it was encased by the structure we see today, probably during the last half of the tenth century (Volta and Braswell 2014: 383). The temple's preservation has parallels elsewhere in Mesoamerica, as at Copan with Rosalila, carefully covered over by Temple 16. A limestone box was placed under the north stairs of the Castillo, possibly to terminate the old building and dedicate the new. The size and contents of the box have never been adequately described, and published descriptions are contradictory. But it included two mosaic plaques, three necklaces of coral, jade, and turquoise, seven jade heads, five carved jade pendants, about 2,000 turquoise beads, a clay vessel containing snake or iguana bones, some scraps of cloth, a stone ball (possibly a *sastun* or divining stone), and up to four flint knives (Anonymous 1932; Carnegie Institution of Washington 1937: 113; Marquina 1951: figs. 426–428; Willard 1941: 207, 216–217).

As Ringle and Bey (2009: fig. 9) have noted, parts of the offering correspond nicely to the accoutrements of a typical Chichen warrior, and the male body found next to the box may have been a military prisoner killed to dedicate the new temple. Disks like the ones found here, for example, resemble shields worn

on warriors' backs at both Chichen and Tula, where similar disks have been found. The two restored disks were originally wood encrusted with turquoise, coral, and shell. While slightly different from each other, the designs include the fire square-nosed serpent motif typical of these disks (Figure 6.8).

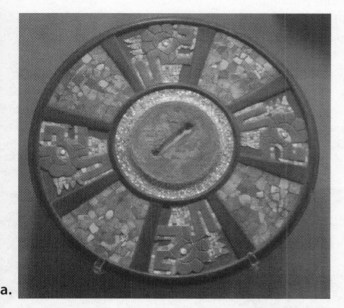

a.

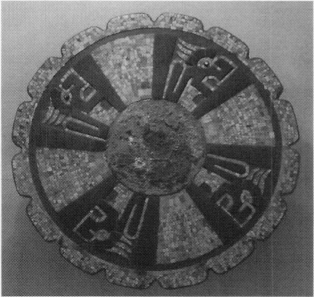

b.

Figure 6.8. Photographs of the turquoise-encrusted disks found in the offering beneath the north staircase, in Museo Nacional de Antropología, Mexico City: *a*, photo by Virginia Miller; *b*, photo by permission of Mary E. Miller.

Among the offerings were several jade plaques, one reminiscent of examples found in the Sacred Cenote, classified by Tatiana Proskouriakoff (1974: 159–60, plate 67) as Late Classic "silhouette-plaques." Based on the somewhat dubious retouched photo from one of T. A. Willard's books, the seated figure is apparently wearing a large jaguar headdress and may be a miniature manifestation of the avian-serpent anthropomorphic reliefs prevalent in architectural sculpture at Chichen (compare Coggins and Shane 1984: plate 61) (Figure 6.9a). Another two belong to the "drooping mouth" category of faces, probably dating to the Terminal Classic (Coggins and Shane 1984: plate 8; Palacios 1935: fig. 6; Proskouriakoff 1974: 97–08, color plate 1, plate 53) (Figure 6.9b). Both of these dates are consistent with the proposed time period for the Castillo. One broken plaque displays a possible Calakmul emblem glyph, reminiscent of the practice of depositing imported jades (from Nebaj and Piedras Negras) in the Sacred Cenote (Ringle et al. 1998: fig. 18d).

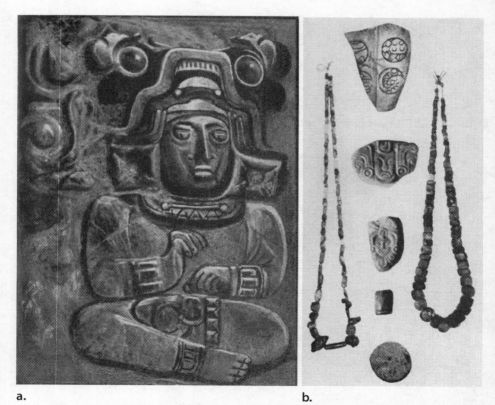

a. b.

Figure 6.9. Jade pieces found in the offering beneath the north staircase: *a*, Jade plaque, retouched photo (Willard 1941: 219); *b*, Various jade items (Marquina 1951: photo 428, right).

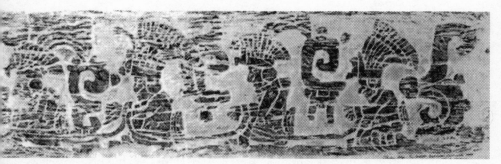

Figure 6.10. Rubbing of a carved wooden lintel from Castillo temple showing seated, roped figures. Copyright Merle Greene Robertson, 1994.

The Castillo-sub, then, appears to be a Transitional building with elements of both Puuc and the so-called International style present in its architecture, furnishings, and offerings. It could be argued, of course, that the chacmool, generally considered to be a later motif at Chichen, was placed at the entryway at some point after the temple's completion, but the military iconography of the temple's façade serves to anchor the structure's stylistic date in the Terminal Classic.

The inner pyramid had nine tiers, the customary number of levels used to construct Late Classic funerary monuments. The proposed presence of an even earlier pyramid beneath strengthens the hypothesis that the Castillo marks a royal burial place, rebuilt twice to honor a founding ancestor, possibly even the legendary ruler K'ak'upakal, mentioned in both the site's inscriptions between 869 and 890 and in colonial sources (Boot 2005: 356; Grube and Krochock 2011). The temple chambers may have served as a gathering place for a small group of nobles and a paramount ruler, who would have occupied the jaguar throne. Autosacrifice or human sacrifice may have been undertaken in the inner chamber, with its bone-studded wall. I have argued elsewhere that at Chichen, at least in its later phases, public spaces were the loci of decapitation, while heart sacrifice and individual bloodletting were conducted within interiors (Miller 2003).

If a cult of Quetzalcoatl swept across much of Mesoamerica during the Terminal Classic, as has been proposed (Ringle et al. 1998), it was manifested in the later outer Castillo. The exterior decoration of the outer Castillo includes the restrained use of Puuc-style long-nosed masks between the medial and superior moldings, as well as *almenas* in the form of cut conch shells, a pan-Mesoamerican symbol of the Feathered Serpent deity.

The poorly documented and understudied reliefs of this temple include jambs, supporting piers, and carved wooden lintels, most of which recall the

political and militaristic iconography of later structures on the Great Terrace. Feathered serpent imagery appears in a range of contexts: the lintel at the north entrance to the temple is held up by upside-down feathered serpents, for example, while the two outer west jambs show cloud serpents intertwined with typical Itza warriors, a possible symbol of military leadership (Ringle 2009: 41). While they are in poor condition, the carved wooden lintels in the Castillo temple interior display a scene very similar to the one visible today on the lintel of the Upper Temple of the Jaguars: two figures, one with a serpent around him, the other a sun disk, addressing each other across a container of what appear to be tamales. Another lintel shows a group of figures bound together at the wrists, similar to the figures represented in procession on the carved bench of the Mercado. While they may be captives, their seated positions, elaborate headdresses, and large speech scrolls suggest that they are nobles participating in a bloodletting ceremony (Figure 6.10).

The Castillo faced north toward the Sacred Cenote, the site's most prominent topographical feature, and possibly the reason for its existence. Caves and cenotes, of course, have a long history in Mesoamerica as places of communion between humans and the supernatural world, and Chichen's largest cenote must have been a particularly potent portal. Placed as it was between four outlying cenotes and over another one, the Castillo was the axis mundi of the site's center, whatever other functions the pyramid and its substructures may have served. The question of astronomical orientation is still unanswered: opinion is divided as to whether the serpent-of-light phenomenon observed on the north face of the outer Castillo would have been produced on the earlier façade as well (Aveni et al. 2004: note 5; Carlson 1999; Šprac and Sánchez 2013: 41). The intriguing possibility that there is yet another structure underneath the complex raises more questions. The next phase of the tomography project is to determine what is in the interior of the pyramid, and how many construction phases exist (Romero 2015). A pyramid housing a royal tomb would be in keeping with the Classic Maya practice of ancestor worship, as would the addition of an outer layer by a subsequent ruler. The Maya may have repurposed the complex as a more public structure with calendrical implications during a time of resurgence and renewal at Chichen Itza, when other cities in the northern region had collapsed.

The Castillo not only holds the dominant position on the Great Terrace, it was also the most visible structure for miles around, sighted by travelers from great distances (Ardren and Lowry 2011: 435). This artificial mountain rises from the center of a leveled terrace in a region mostly remarkable for its unvaried topography: as Landa famously stated at the beginning of his treatise

on Yucatan, "it is a very level land and without mountains" (Tozzer 1941: 3). Later reiterating how flat the peninsula was, he marveled at the vista from the monastery at Izamal, built over a large pyramid, from which the sea could be seen (Tozzer 1941: 173). With the low Puuc hills quite distant from Chichen Itza, there was probably no other landmark as visible as the Castillo in the northern half of the peninsula. The fact that it was still an identifiable, named structure in Landa's time attests to its continuing importance to the Maya years after the site was largely abandoned and other buildings were buried under earth and vegetation, mostly untouched until the late nineteenth century. Like the Sacred Cenote, the building remained a focal point of ritual and (at least during the nineteenth century) social activity. Today, it is a pilgrimage place of a different magnitude, the center point of a city drawing thousands of tourists a day, with tens of thousands gathering around the Castillo itself on the equinoxes. The presence of an inner pyramid, and even a ruler's final resting place, as well as the discovery of water beneath the structure, will bring more scholarly, as well as popular, attention to this important and complex building.

Note

1. The disk illustrated in Figure 6.8b is often mistakenly published as the one found on the jaguar throne.

References Cited

Anonymous
 1932 Maya Tomb under Castillo Stairway. *El Palacio* 33: 6.
 1937 El Castillo, Pyramid-Temple of the Maya God, Kukulcan. *Carnegie Institution of Washington News Service Bulletin* 4(12): 106–116.
Ardren, Traci, and Justin Lowry
 2011 The Travels of Maya Merchants in the Ninth and Tenth Centuries AD: Investigations at Xuenkal and the Greater Cupul Province, Yucatan, Mexico. *World Archaeology* 43: 428–443.
Aveni, Anthony F.
 2003 *The Book of the Year: A Brief History of Our Seasonal Holidays.* Oxford University Press, New York.
Aveni, Anthony F., Susan Milbrath, and Carlos Peraza Lope
 2004 Chichen Itza's Legacy in the Astronomically Oriented Architecture of Mayapan. *RES: Anthropology and Aesthetics* 45: 123–143.
Bernal, Ignacio
 1980 *A History of Mexican Archaeology: The Vanished Civilizations of Middle America.* Thames and Hudson, London.

Bey, George J., III, and William M. Ringle

2011 From the Bottom Up: The Timing and Nature of the Tula–Chichén Itzá Exchange. In *Twin Tollans: Chichén Itzá, Tula, and the Epiclassic to Early Postclassic Mesoamerican World*, rev. ed., edited by Jeff Karl Kowalski and Cynthia Kristan-Graham, pp. 299–340. Dumbarton Oaks, Washington, D.C.

Boot, Erik

2005 *Continuity and Change in Text and Image at Chichén Itzá, Yucatan, Mexico: A Study of the Inscriptions, Iconography, and Architecture of a Late Classic to Early Postclassic Site.* Centre for Non-Western Studies Publication no. 135. Research School Centre for Non-Western Studies, Leiden.

Braswell, Geoffrey E.

2012 Personal e-mail, April 8.

Braswell, Geoffrey E., and Nancy Peniche May

2012 In the Shadow of the Pyramid: Excavations of the Great Platform of Chichen Itza. In *The Ancient Maya of Mexico: Reinterpreting the Past of the Northern Maya Lowlands*, edited by Geoffrey E. Braswell, pp. 229–258. Equinox, Sheffield, England.

Burdick, Catherine E.

2016 Held Captive by Script: Interpreting "Tagged" Prisoners in Late Classic Maya Sculpture. *Ancient Mesoamerica* 27: 31–48.

Carlson, John

1999 Pilgrimage and the Equinox: "Serpent of Light and Shadow": Phenomenon at the Castillo, Chichén Itzá, Yucatán. *The Journal Archaeoastronomy: Journal of Astronomy in Culture* 14: 136–152.

2013 Chacmool: Who Was That Enigmatic Recumbent Figure from Epiclassic Mesoamerica? Reposing the Question. *The Smoking Mirror* 21(4): 2–7.

Carnegie Institution of Washington

1937 El Castillo, Pyramid-Temple of the Maya God, Kukulcan. *Carnegie Institution of Washington News Service Bulletin* 4(12): 106–116.

Castañeda, Quetzil E.

2000 Approaching Ruins: A Photo-Ethnographic Essay on the Busy Intersections of Chichén Itzá. *Visual Anthropology Review* 16(2): 43–70.

Charnay, Désiré

1887 *The Ancient Cities of the New World: Being Voyages and Explorations in Mexico and Central America from 1857–1882*, translated by J. Gonino and Helen S. Conant. Harper & Brothers, New York.

Charnay, Désiré, and Eugène Emmanuel Viollet-Le-Duc

1863 *Cités et ruines américaines: Mitla, Palenqué, Izamal, Chichen-Itza, Uxmal.* Gide, Paris.

Cirerol Sansores, Manuel

1936 Informe de las exploraciones y descubrimiento en la segunda cámara de la subestructura del Castillo. Archivo Técnico de la Coordinación Nacional de Arqueología, México, Instituto Nacional de Antropología e Historia, Mexico City.

1940 *El Castillo (The Castle) Mysterious Mayan Pyramidal Temple of Chichén Itzá.* Talleres Gráficos del Sudeste, Merida, Yucatan.

1948 *Chi Cheen Itsa: Archaeological Paradise of America.* Talleres Gráficos del Sudeste, Merida, Yucatan.

Cobos Palma, Rafael

2011 Multepal or Centralized Kingship? New Evidence on Governmental Organization at Chichén Itzá. In *Twin Tollans: Chichén Itzá, Tula, and the Epiclassic to Early Postclassic Mesoamerican World*, rev. ed., edited by Jeff Karl Kowalski and Cynthia Kristan-Graham, pp. 249–271. Dumbarton Oaks, Washington, D.C.

Coe, Michael

1999 *Breaking the Maya Code*. Thames and Hudson, New York.

Coggins, Clemency Chase

1987 New Fire at Chichen Itza. In *Memorias del Primer Coloquio Internacional de Mayístas 5–10 Agosto, 1985*, pp. 427–482. Centro de Estudios Mayas, Universidad Nacional Autónoma de México, Mexico City.

1989 A New Sun at Chichen Itza. In *World Archaeoastronomy*, edited by Anthony F. Aveni, pp. 260–275. Cambridge University Press, New York.

Coggins, Clemency Chase, and Orrin C. Shane III (editors)

1984 *Cenote of Sacrifice: Maya Treasures from the Sacred Well at Chichén Itzá*. University of Texas Press, Austin.

Davis, Keith F.

1981 *Desire Charnay, Expeditionary Photographer*. University of New Mexico Press, Albuquerque.

Desmond, Lawrence Gustave, and Phyllis Mauch Messenger

1988 *A Dream of Maya: Augustus and Alice Le Plongeon in Nineteenth Century Yucatan*. University of New Mexico Press, Albuquerque.

Erosa Peniche, José A.

1946 *Exploraciones arqueológicas en Chichén-Itzá. Descubrimiento y exploración de la subestructura del Castillo*. Imp. Guerra, Merida, Yucatan.

1947 Descubrimientos y exploración arqueológica de la subestructura del Castillo en Chichén Itzá. *Actas de la Primera Sesión del XXVII Congreso Internacional de Americanistas, México 1939*, 2: 229–248. Instituto Nacional de Antropología e Historia, Mexico City.

García Solís, Claudia

2015 Personal e-mail, July 3.

García Solís, Claudia, and Adela Vázquez Veiga

2007 Informe de las actividades de restauración y mantenimiento de la Gran Nivelación: El Castillo, Subestructura del Chaacmool y Templo Superior de Jaguares. Temporada Noviembre–Diciembre 2006. Unpublished text. Archivo del Área de Conservación-Restauración del Instituto Nacional de Antropología e Historia, Merida, Yucatan.

Graham, Ian

2002 *Alfred Maudslay and the Maya*. British Museum Press, London.

Grube, Nikolai, and Ruth J. Krochock

2011 Reading Between the Lines: Hieroglyphic Texts from Chichén Itzá and Its Neighbors. In *Twin Tollans: Chichén Itzá, Tula, and the Epiclassic to Early Postclassic Mesoamerican World*, rev. ed., edited by Jeff Karl Kowalski and Cynthia Kristan-Graham, pp. 157–193. Dumbarton Oaks, Washington, D.C.

Grube, Nikolai, Alfonso Lacadena, and Simon Martin

2003 Chichén Itzá and Ek Balam: Terminal Classic Inscriptions from Yucatan. In *Notebook*

for the XXVIIth Maya Hieroglyphic Forum at Texas, part 2, pp. 1–105. Maya Workshop Foundation, University of Texas at Austin.

Guillermoprieto, Alma

2013 Underwater Secrets of the Maya. *National Geographic* (August): 98–121.

Holmes, William H.

1895 *Archaeological Studies among the Ancient Cities of Mexico: Part 1, Monuments of Yucatan.* Publication 8, Anthropological Series, vol. 1, no. 1. Field Columbian Museum, Chicago.

Jones, Lindsay

1995 *Twin City Tales: A Hermeneutical Reassessment of Tula and Chichén Itzá.* University of Oklahoma Press, Norman.

Kowalski, Jeff Karl, Rhonda Beth Silverstein, and Mya Follansbee

2002 Seats of Power and Cycles of Creation: Continuities and Changes in Political Iconography and Political Organization at Dzibilchaltún, Uxmal, Chichén Itzá, and Mayapán. *Estudios de Cultura Maya* 22: 87–111.

Kristan-Graham, Cynthia

2011 Structuring Identity at Tula: The Design and Symbolism of Colonnaded Halls and Sunken Spaces. In *Twin Tollans: Chichén Itzá, Tula, and the Epiclassic to Early Postclassic Mesoamerican World*, rev. ed., edited by Jeff Karl Kowalski and Cynthia Kristan-Graham, pp. 429–467. Dumbarton Oaks, Washington, D.C.

Krochock, Ruth

1998 The Development of Political Rhetoric at Chichén Itzá, Yucatan, Mexico. Unpublished PhD diss., Department of Anthropology, Southern Methodist University, Dallas.

López Luján, Leonardo, and Alfredo López Austin

2001 El chacmool mexica. *Caravelle* 76–77: 59–84.

McVicker, Mary F.

2005 *Adela Breton: A Victorian Artist amid Mexico's Ruins.* University of New Mexico Press, Albuquerque.

Maldonado Cárdenas, Rubén

1997 Las intervenciones de restauración arqueológica en Chichén Itzá (1926–1980). In *Homenaje al profesor César A. Sáenz*, coordinated by Angel García Cook, Alba Guadalupe Mastache, Leonor Merino, and Sonia Rivero Torres, pp. 103–132. Serie Arqueología, vol. 351. Instituto Nacional de Antropología e Historia, Mexico City.

Maler, Teobert

1971 *Bauten der Maya, aufgenommen in den Jahren 1886 bis 1905 und beschrieben/Edificios mayas: trazados en los años de 1886–1905 y descritos.* Gebr. Mann Verlag, Berlin.

Marquina, Ignacio

1951 *Arquitectura prehispánica.* Memorias del Instituto Nacional de Antropología e Historia I: Instituto Nacional de Antropología e Historia and Secretaría de Educación Pública, Mexico City.

Maudslay, Alfred P.

1889–1902 *Archaeology.* 6 vols. In *Biologia Centrali-Americana*, edited by F. Ducane Godman and Osbert Salvin. Porter and Dulau, London.

Milbrath, Susan

1988 Astronomical Images and Orientations in the Architecture of Chichen Itza. In *New Directions in American Archaeoastronomy*, edited by Anthony F. Aveni, pp. 57–79. Pro-

ceedings of the 46th International Congress of Americanists. BAR International Series 454. British Archaeological Reports, Oxford.

Milbrath, Susan, and Carlos Peraza Lope
2003 Revisiting Mayapan, Mexico's Last Maya Capital. *Ancient Mesoamerica* 14: 1–46.

Miller, Virginia E.
1989 Adela Breton in Yucatan. In *The Art of Ruins: Miss Adela Breton and the Temples of Mexico,* edited by Sue Giles and Jennifer Stewart, pp. 33–41, City of Bristol Museum & Gallery, Bristol, England.

2003 Representaciones de sacrificio en Chichén Itzá. In *Antropología de la eternidad: La muerte en la cultura maya,* edited by Andrés Ciudad Ruiz, Mario Humberto Ruz, and María Josefa Iglesias Ponce de León, pp. 383–404. Sociedad Española de Estudios Mayas and Centro de Estudios Mayas and Instituto de Investigaciones Filológicas, Universidad Nacional Autónoma de México, Madrid and Mexico City.

2006 The Maya Chacmool. Paper presented at the 52nd International Congress of Americanists, Seville.

2007 Looking for Palaces at Chichén Itzá. Paper presented at the XVII Encuentro Internacional de Investigadores de la Cultura Maya, Campeche.

Montero, García, Ismael Arturo, Jesús Galindo Trejo, and David Wood Cano
2014 El Castillo en Chichén Itzá: un monumento al tiempo. *Arqueología Mexicana* 12 (May–July 2014): 80–85.

Morris, Earl H., Jean Charlot, and Ann Axtell Morris
1931 *The Temple of the Warriors at Chichen Itzá, Yucatan.* 2 vols. Publication 406. Carnegie Institution of Washington, Washington, D.C.

Nicholson, H. B.
1990 Gesammelte Abhandlungen zur Amerikanischen Sprach-und Aterthumskunde: A Historical Review. In *Eduard Seler: Collected Works in Mesoamerican Linguistics and Archaeology (English translations of German papers from Gesammelte Abhandlungen zur Amerikanischen Sprach-und Aterthumskunde),* edited by J. Eric S. Thompson and Francis B. Richardson, pp. xiii–xvi. 2d ed., vol. 1, Frank E. Comparato, general editor. 6 vols. Labyrinthos, Culver City, Calif.

Palacios, E. J.
1935 *Guía Arqueológica de Chichen Itza.* Talleres Gráficos, Mexico City.

Peña Castillo, Agustín
2001 Arqueología en la Península de Yucatán. In *Descubridores del Pasado en Mesoamérica,* edited by Lucinda Gutiérrez and Gabriela Pardo, pp. 161–195. Editorial Oceano, Mexico City.

Pérez de Heredia Puente, Eduardo J.
2010 Ceramic Contexts and Chronology at Chichen Itza, Yucatan, Mexico. Unpublished PhD diss., Faculty of Humanities and Social Sciences, School of Historical and European Studies, Archaeology Program, La Trobe University, Melbourne.

2015 Personal e-mail, June 25.

Plank, Shannon E.
2004 *Maya Dwellings in Hieroglyphs and Archaeology: An Integrated Approach to Ancient Architecture and Spatial Cognition.* BAR International Series 1324. British Archaeological Reports, Oxford.

Proskouriakoff, Tatiana

1974 *Jades from the Cenote of Sacrifice, Chichen Itza, Yucatan.* Memoirs of the Peabody Museum of Archaeology and Ethnology, vol. 10, no. 1. Harvard University Press, Cambridge, Mass.

Ringle, William M.

2004 On the Political Organization of Chichen Itza. *Ancient Mesoamerica* 15: 167–218.

2009 The Art of War: Imagery of the Upper Temple of the Jaguars, Chichen Itza. *Ancient Mesoamerica* 20: 15–44.

Ringle, William M., and George J. Bey III

2009 The Face of the Itzas. In *The Art of Urbanism: How Mesoamerican Kingdoms Represented Themselves in Architecture and Imagery,* edited by William L. Fash and Leonardo López Luján, pp. 329–383. Dumbarton Oaks, Washington, D.C.

Ringle, William M., Tomás Gallareta Negrón, and George J Bey

1998 The Return of Quetzalcoatl: Evidence for the Spread of a World Religion during the Epiclassic Period. *Ancient Mesoamerica* 9: 183–232.

Romero, Laura

2015 Hay un cenote bajo el templo de Kukulkán. Gaceta Digital, Universidad Nacional Autónoma de México, August 13. www.gaceta.unam.mx/20150813/hay-un-cenote-bajo-el-templo-de-kukulkan, accessed August 28, 2015

Schele, Linda, and Peter Mathews

1998 *The Code of Kings: The Language of Seven Sacred Maya Temples and Tombs.* Scribner's, New York.

Seler, Eduard

1990 Quetzalcoatl-Kukulcan in Yucatan. In *Collected Works in Mesoamerican Linguistics and Archaeology, English Translations of German Papers from Gesammelte Abhandlungen Zur Amerikanischen Sprach Und Alterthumskunde,* edited by J. Eric S. Thompson and Francis B. Richardson, pp. 355–391. 2d ed., vol. 1, Frank E. Comparato, general editor. 6 vols. Labyrinthos, Culver City, Calif.

1993 Studies on the Ruins of Yucatan. In *Collected Works in Mesoamerican Linguistics and Archaeology, English Translations of German Papers from Gesammelte Abhandlungen Zur Amerikanischen Sprach Und Alterthumskunde,* edited by J. Eric S. Thompson and Francis B. Richardson, pp. 346–350. 2d ed., vol. 4, Frank E. Comparato, general editor. 6 vols. Labyrinthos, Culver City, Calif.

1998 The Ruins of Chichén Itzá in Yucatan. In *Collected Works in Mesoamerican Linguistics and Archaeology, English Translations of German Papers from Gesammelte Abhandlungen Zur Amerikanischen Sprach Und Alterthumskunde,* edited by J. Eric S. Thompson and Francis B. Richardson, pp. 41–165. 2d ed., vol. 6, Frank E. Comparato, general editor. 6 vols. Labyrinthos, Culver City, Calif.

Sepúlveda y Herrera, María Teresa

1992 *Eduard Seler en México.* Colección Científica 251. Instituto Nacional de Antropología e Historia, Mexico City.

Silverstein, Rhonda Beth

1998 The Maya Jaguar Throne in Ancient Mesoamerica, M.A. thesis, Department of Art History, Northern Illinois University. DeKalb.

Šprac, Ivan, and Pedro Francisco Sánchez Nava
 2013 Astronomía en la arquitectura de Chichén Itzá: Una reevaluación. *Estudios de Cultura Maya* 41: 31–60.
Stephens, John L.
 1963 *Incidents of Travel in Yucatán.* 2 vols. Dover, New York.
Stuart, David, and George Stuart
 2008 *Palenque: Eternal City of the Maya.* Thames and Hudson, New York.
Taube, Karl A.
 2000 The Turquoise Hearth: Fire, Self-Sacrifice, and the Central Mexican Cult of War. In *Mesoamerica's Classic Heritage: From Teotihuacan to the Aztecs,* edited by David Carrasco, Lindsay Jones, and Scott Sessions, pp. 269–340. University Press of Colorado, Boulder.
 2004 Flower Mountain: Concepts of Life, Beauty, and Paradise among the Classic Maya. *RES: Anthropology and Aesthetics* 45: 69–98.
Tedlock, Dennis
 2003 *Rabinal Achi: A Mayan Drama of War and Sacrifice.* Oxford University Press, New York.
Thompson, Edward H.
 1938 *The High Priest's Grave, Chichen Itza, Yucatan, Mexico.* Anthropological Series, pub. 412, vol. 27, no. 1, prepared for publication with notes and introduction by J. Eric Thompson. Field Museum of Natural History, Chicago.
Tozzer, Alfred M.
 1957 *Chichen Itza and Its Cenote of Sacrifice: A Comparative Study of Contemporaneous Maya and Toltec.* 2 vols. Memoirs of the Peabody Museum of Archaeology and Ethnology. Vols. 11 and 12. Harvard University, Cambridge, Mass.
Tozzer, Alfred M. (editor and translator)
 1941 *Landa's Relación de las cosas de Yucatán: A Translation.* Papers of the Peabody Museum of American Archaeology and Ethnology, vol. 18. Harvard University, Cambridge, Mass.
Volta, Beniamino, and Geoffrey E. Braswell
 2014 Alternative Narratives and Missing Data: Refining the Chronology of Chichen Itza. In *The Maya and Their Central American Neighbors: Settlement Patterns, Architecture, Hieroglyphic Texts and Ceramics,* edited by Geoffrey E. Braswell, pp. 356–402. Routledge, London.
Willard, Theodore A.
 1933 *The Lost Empires of the Itzaes and Mayas.* Arthur H. Clark, Glendale, Calif.
 1941 *Kukulcan, the Bearded Conqueror: New Mayan Discoveries.* Murray and Gee, Hollywood, Calif.

7

The Osario of Chichen Itza

Where Warriors Danced in Paradise

ANNABETH HEADRICK

Whether designated as the Osario or the more romantic moniker of the High Priest's Grave, the names applied to the radial pyramid just south of Chichen Itza's Great Terrace affirm the important role burial plays in the structure's meaning (Figure 7.1). Earlier interpretations have sought to identify Chichen's rulers among the skeletal material housed within the structure, while later scholars have viewed the human remains as residue from debased warfare victims of Quetzalcoatl-related rituals (Headrick 1991; Masson and Peraza Lope 2007; E. H. Thompson 1938). Further problematizing the interpretation of the remains is the fact that iconographic studies of the temple have often targeted specific aspects of the building's complex sculptural program, but rarely ventured to synthesize the overall artistic program or fully considered how this program intersects with the building's artifactual record. This study will address these issues by integrating the structure's sculptural and osteological features to suggest that the Osario stood as a monument to war, and, more specifically, as a memorial to the warriors who had fought the good battle and passed to the supernatural world as the heroes of Chichen's military machine.

In some regards, the Osario mirrors the Castillo, the structure that functioned as the primary temple of Chichen Itza. Both pyramids have a stairway on each of their four sides, and a temple surmounts the substructure oriented toward a set of constructed and natural features that incorporate the temples into complexes. Like the Castillo, the Osario resides on a substantial raised acropolis, and in parallel fashion, a so-called Venus platform sits just in front of the pyramid (Figure 7.2). With stairs on each of their four sides and a flat, raised surface at the summit, the Venus platforms likely served as elevated stages during civic events. Beyond the Venus platforms raised *sacbeob* begin at

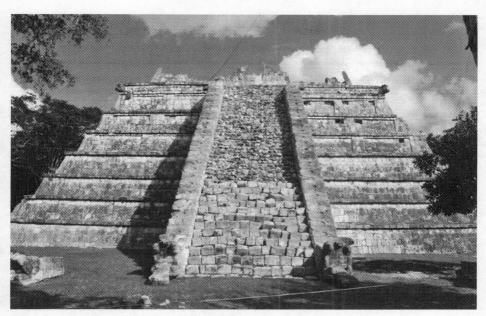

Figure 7.1. The Osario, Chichen Itza. Photograph by Annabeth Headrick.

the edge of the acropolises and lead to one of the area's distinctive water-filled sinkholes, a *cenote*. In the case of the Castillo, the cenote is the well-known Sacred Cenote whose sheer straight walls inspire visions of sacrificial victims making their transit to the watery depths below. Whether deposited alive or dead, the skeletal remains found in the cenote offer tangible evidence that the sinkhole was the resting place of numerous individuals (Coggins 1984: 26; Hooton 1977). As for the Osario, Sacbe 15 leads to the Xtoloc Temple that sits on the northern edge of the Xtoloc Cenote. The gentler slope of this cenote has not inspired nearly as much archaeological attention nor engendered the same level of romanticized fascination as the Sacred Cenote, so a complete picture of the Xtoloc Cenote's function is currently unavailable. However, the water-side temple and the sacbe linking the cenote to the Osario would make ritual use of the cenote a likely prospect.

Taken altogether, the twin arrangement of pyramid, sacbe, and cenote provides evidence that processional rituals incorporating these components were important aspects of Chichen's public activities. While the more famous assemblage of the Castillo, Venus Platform, and Sacred Cenote forms a north-south axis, the Osario and its accompanying Venus Platform, and the Xtoloc Cenote, provide an east-west axis. Further distinguishing the two

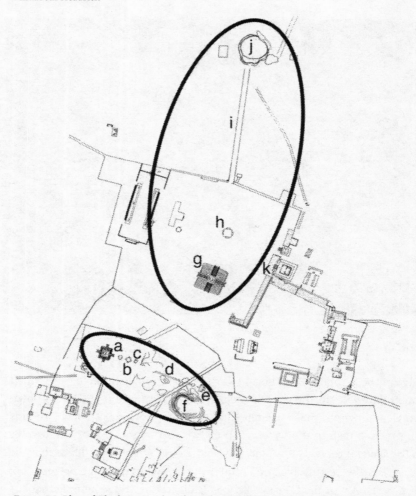

Figure 7.2. Plan of Chichen Itza identifying the Castillo and Osario complexes: *a*, Osario; *b*, Venus Platform in Osario Group; *c*, Tumbas Platform; *d*, Sacbe 15; *e*, Xtoloc Temple; *f*, Xtoloc Cenote; *g*, Castillo; *h*, Venus Platform in Castillo Group; *i*, Sacbe 1; *j*, Sacred Cenote; *k*, Temple of the Warriors and Northwest Colonnade. Drawing modified from Schmidt (2007: 431).

complexes are a circular platform between the Osario and its Venus Platform as well as the Tumbas Platform positioned on the opposite side of the Venus Platform, suggesting that the Maya incorporated additional rituals and functions into this smaller, processional complex between the temple and its body of water. Both complexes reveal a penchant of the Itza to create a composite landscape by incorporating the existing natural features into their built environment. The cenotes that may have originally drawn people to settle this location became seamlessly fused to their respective man-made

pyramidal mountains through the physicality of their connecting sacbeob. The consistent enactments of ritual where the participants moved from pyramid to platform to cenote via a sacbe solidified this contrived human-natural landscape.

Comparisons of the Osario with the Castillo as well as the troubled debates over the Maya or Toltec identity of the city's inhabitants have led to numerous discussions of the relative dates of the two structures.[1] The precise date of the Osario should, on its surface, have been relatively easy to determine, as a carved column upon its summit includes a relief depicting a captive with bound hands

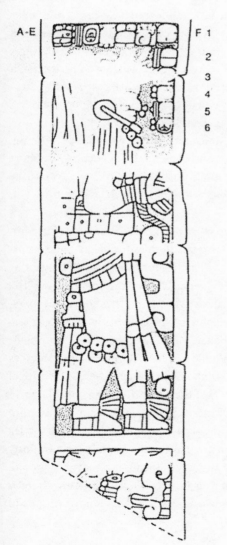

Figure 7.3. Column 4, Osario, Chichen Itza. The date appears in positions A-B. Drawing modified from Wagner (1995). By permission of Mexicon.

and a hieroglyphic inscription including a carved date (Figure 7.3). The date on the Osario long defied precise interpretation because during the Terminal Classic to Late Postclassic in the Yucatan, the use of the Long Count became increasingly rare as the Itza substituted a system that J. Eric Thompson (1937) first discovered and called the Short Count. On the Osario text, the first two glyph blocks (A–B) exhibit a clear Calendar Round date of 2 Ahaw 18 Mol, while the poor condition of other hieroglyphs in the text resulted in several scholars failing to recognize that the text did indeed include a second date that was a Short Count. Therefore, some researchers, including myself, relied on less secure elements like style to determine the correlating Long Count date (Headrick 1991: 43–44; Schele and Freidel 1990: 500, note 26). While much earlier in my career I asserted that the Osario dated to 10.0.12.8.0, or June 20, 842, and served as a model for the larger Castillo, I now agree with the assertions of Graña-Behrens et al. (1999) who intensively studied and redrew the hieroglyphs to reveal that a second date functioning as a Short Count did indeed exist (F2–F6) (see Volta et al., Chapter 2, and Pérez and Bíró, Chapter 3, for similar conclusions regarding the dating by Graña-Behrens et al.). This date, 10 K'an 2 Zotz' in the 11th Tun of the K'atun 2 Ahaw, translates to 10.8.10.6.4, or February 6, 998. Because the pattern holds that associated Calendar Round dates would fall nearby the Short Count, the 2 Ahaw 18 Mol date is now securely positioned at 10.8.10.11.0, or May 13, 998, firmly situating the structure within the Early Postclassic period (ca. 950–1100).

Excavations within the Osario Group convinced Peter Schmidt (2011: 120–121, 148) that construction of the Osario was late in the site's history, and stratigraphic arguments based on Braswell and Peniche's (2012: 237–238) excavations in the Great Terrace offer convincing evidence supporting this dating.[2] The Osario, then, emulated the Castillo to some degree, and as Geoffrey Braswell and Nancy Peniche contend, its iconography forthrightly fits within the International style they identify for Chichen's late stages. Furthermore, their positioning of the Osario roughly contemporary with the Temple of the Warriors neatly fits with the military associations of the Osario argued below. Of critical importance to this discussion is the fact that the excavation and consolidation of the building under the direction of Peter Schmidt revealed a vastly more complex iconographic program than previously understood, which includes imagery like jeweled and precious serpents that feature prominently in Postclassic iconography. In other words, the imagery of the Osario may incorporate precursors to the dominant themes seen in Postclassic iconography, thereby dually justifying the later date of the Osario and helping explain the origins of Postclassic iconography.

The balustrades framing both the Castillo and Osario stairs provide an example of the Osario's heightened sculptural complexity. As Virginia Miller stresses in this volume (Chapter 6), the Castillo emphasizes its northern orientation toward the Sacred Cenote with feathered serpents exclusively on the north-facing balustrades. In contrast, the sculptors of the Osario lavishly decorated all four staircases with serpentine balustrades. A pair of serpents intertwines on each balustrade (Figure 7.4) with a serpent head sitting at the base and top of each balustrade and the tail of a partner serpent jutting out into space and resting near these heads. Not only do the Osario balustrades incorporate more imagery than the Castillo, the serpentine elements are decidedly more diverse on the smaller structure. On each balustrade a feathered serpent, the ubiquitous serpent of Chichen Itza, makes an appearance, but it is partnered with a serpent exhibiting small curls on its body that identify it as a cloud serpent.[3]

The cornice of the substructure further enhances the richness of the serpent imagery on the temple (Figure 7.5). Here, entwined serpents appear again, though this time they slither along in a vertical fashion, with heads projecting from the corners and tails hanging to the side of each head. A precedent for this decoration appears on the earlier Castillo-sub structure to the north. Miller's (Chapter 6) careful reanalysis of the data from the Castillo-sub explains that entwined serpents graced its Transitional style upper façade, though, as she notes, the historic record includes very little information about specifics of these serpents. On the Osario cornice, one serpent has the elongated pendants of Classic period jade ornaments, and the other has the circular pierced disk of the *chalchihuitl*, the omnipresent symbol of Postclassic Central Mexico, which represents turquoise, water, preciousness, and sacredness (Schmidt 2011: 130–132). By pairing jade, the exalted stone of the Classic period Maya, with turquoise, the Postclassic substitute for all things symbolizing life, water, and elite status, the temple seems to acknowledge the emerging shifts in trade routes and the accompanying changes in prestige goods that occurred during the Terminal Classic to Early Postclassic periods.[4] To underscore the importance of trade to Chichen's success, Smith and Bond-Freeman (Chapter 5) demonstrate how varied the pattern of such trade routes was by recognizing the uneven manner in which northern Yucatecan sites were integrated into the Chichen trade network. Thus, the Osario's inclusion of opposing luxury trade goods, jade and turquoise, in its iconographic program looks to both the past and the future. The jade and turquoise serpents succinctly reflect Chichen Itza's role in this transitional phase in Mesoamerican history.

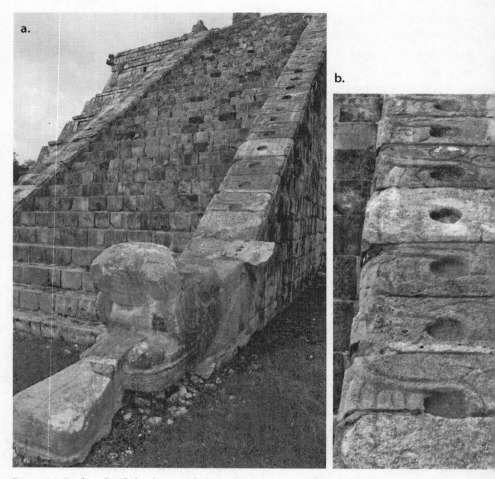

Figure 7.4. Feathered and cloud serpent balustrades, Osario, Chichen Itza: *a*, Left; *b*, Right. Photographs by Annabeth Headrick.

Taking all of the serpents as a whole, however, an even richer picture emerges. In truth, the feathered serpent has many meanings, but the emerald green feathers of its quetzal-clad body are a sought-after component of elite costume, including headdresses, and they were a perpetual elite trade item. In a similar fashion, jade and turquoise are the precious hard substances that elites manipulated as ritual objects or in costumes to represent water, agricultural growth, and the concept of the center.[5] Moreover, the value of these coveted stones partially resided in their rarity and their acquisition through distant trade. Although the cloud serpents might not represent an item obtained through trade, the

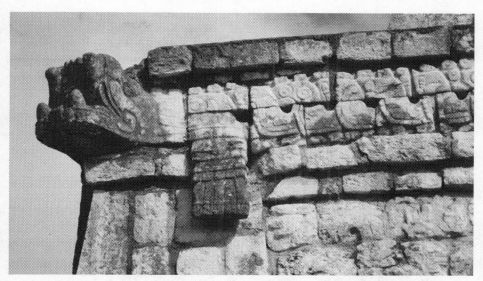

Figure 7.5. Jade and turquoise serpents on the cornice of the Osario substructure. Photograph by Annabeth Headrick.

rain they brought to agriculturally challenged Mesoamerica was likely coveted even more. Altogether, the serpents convey a lush world of quetzal feathers, jade, turquoise, and clouds filled with the promise of rain, a vision of precious objects, and plenty. The Osario, through the serpents draped over the exterior substructure, offers a view of a truly luscious and sumptuous wealth.

Sitting upon the opulently rich world created by the serpents is the temple proper where stacks of masks commonly identified as Chahk adorn each of the corners (Figure 7.6). More recently, Karl Taube (2004: 85–86) has alternatively identified these heads as mountains, or *witz* heads. He bases this identification partially on similar stacked witz heads that appear on the corners of structures during the preceding Late Classic period; Copan's Temple 22 offers a fine example of this tradition.[6] In this volume (Chapter 8), Cynthia Kristan-Graham expands upon the ubiquity of architectural references to mountains in Maya buildings, including the sloping *taluds* of the Mercado's dais, an observation that offers greater contextualization of the witz reference on the Osario. Furthermore, Taube examines the headband worn by the Osario witz heads, noting that a petaled flower at the center of headbands precisely designates these mountain heads as floral mountains. Viewing this as the key iconographic element of the Osario, Taube explains that the building is an earthly manifestation of a paradisiacal location in Maya myth, Flower Mountain. In his elaboration of this

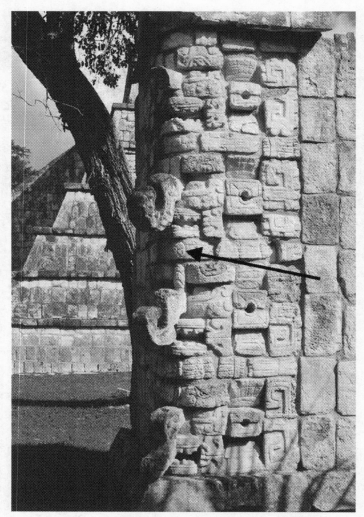

Figure 7.6. Stacked witz heads with floral headbands from the corners of the
Osario superstructure; the arrow points to the headband. Photograph by
Annabeth Headrick.

concept, Taube relates that, "among the Maya, Flower World concerned a floral
mountain that served both as an abode for gods and ancestors and as a means
of ascent into the paradisiacal realm of the sun" (Taube 2004: 69). His proposal
suggests that the Maya had a concept of Flower World and its mountain as a
place of abundance filled not only with the sweet scents of flowers but also jade
and other precious substances. Such an interpretation illuminates the various
serpents depicted on the temple, for the jade, turquoise, cloud, and feathered

serpents effectively create this luscious, utopian location in Maya mythology. By inserting these various serpents into Taube's model, the Osario emerges as an even more elaborately articulated image of Flower Mountain.

Beyond identifying Flower Mountain as a beautiful paradise, Taube (2004) incorporated it into ancient Maya concepts of the afterlife. Significant ethno-historic and ethnographic evidence reveals that Mesoamerican concepts of the afterlife included several different realms of the dead, and the lives individuals led and roles they played in society while alive determined which of these worlds they would inhabit after death.[7] Flower World was the abode of elite ancestors, and, most notably, deceased warriors who were rewarded for a life of risk. Critical to understanding the rationale behind constructing a public monument that manifested the realm of dead warriors in particular are the risks these warriors took and the city's inherent interest in motivating its male population into participating in military activities.[8] Though hazardous on a personal level, military actions empowered the community politically, militarily, and perhaps most importantly, economically; thus the Osario may have played a motivational role in promoting military service. This argument nicely mirrors Scott Johnson's (Chapter 4) position that warfare was often waged to keep trade routes open, and that war thereby increased access to resources and tribute in addition to fostering alliances. That the jade, turquoise, and feathers depicted on the backs of the Osario's serpents may have been at least partially obtained through militarily backed trade would suggest that not only were these substances depicted as a reminder of the richness warriors could expect in the afterlife, but also as a testament to the service military combatants offered to their city through the enhancement of its wealth. Furthermore, on the Osario the most explicit statement of the reward warriors could expect upon their death appears on the walls of the temple superstructure.

Sculptural panels on the temple portray pairs of individuals, positioned standing atop one another with outstretched arms (Figure 7.7). In their hands they carry knives or feathered wands, bags, and possibly rattles as they stand in a rigid pose with their feet together. Despite their firmly planted feet, the rattles and feathered wands may indicate that these figures participate in a more animated form of performance, even a type of dance. They wear short wrapped skirts and loincloths as well as beaded collars defined by large circular disks on their chests. Their headdresses include several stacked elements, and the diagnostic component is a feathered band with a floral motif at its center, precisely matching the floral headband of the Flower Mountain heads on the temple's corners (Figures 7.6 and 7.7) (Taube 2004: 86). The floral headbands indicate that these individuals are deceased warriors who inhabit Flower World.

Figure 7.7. Deceased warrior from the exterior walls of the Osario superstructure. Drawing modified from Taube (2004: fig. 14d).

Concomitant with their headbands, the warriors exhibit avian traits that characterize the inhabitants of the floral abode. The figures have beaked masks that surround their otherwise human mouths, and although Taube (2015) has identified these figures as the duck-billed wind god, Ehecatl, I would maintain that the subsequent discussion concerning the militant flavor of the Osario's burial material makes their identification with warriors more likely.[9] As such, the beaks indicate a metamorphosis from human mouths to avian which is echoed by the presence of befeathered wings sprouting below the figures' arms. The sculptors have carefully incorporated human and birdlike features to communicate that these figures are transforming into the avian beings of their afterlife existence. This avian transformation provides evidence that Chichen Itza enfolded Central Mexican traditions into its rhetoric of warfare. Sahagún (1950–1982: 49) famously recorded the later Aztec belief that warriors who died either on the battlefield or as sacrificial victims metamorphosed into birds and butterflies that flitted about in a pleasurable afterlife. Citing considerable visual evidence from murals and decorated ceramics, I have argued that precedent for these beliefs existed at Classic period Teotihuacan where the state propa-

gated the role of warrior as the standard male gender role to promote the city's military and economic strength (Headrick 2007: 124–154). The transformative nature of the birdlike humans on the Osario indicates that the Central Mexican motivational doctrine infused Early Postclassic Chichen Itza, and this aligns with the city's strikingly international character. Furthermore, the appearance of this belief in a warrior's avian paradise during the Early Postclassic would suggest that a tradition originating at Teotihuacan survived, flourished, and was eventually transmitted to the Aztec of the Postclassic. In truth, there are large temporal gaps between these manifestations of a warrior's paradise in Mesoamerican history, but the Osario provides one piece in this incomplete puzzle. Altogether, these warriors likely represent deceased warriors who transform into birds following Central Mexican traditions, but the realm they inhabit is closely aligned with the Maya conceptions of Flower World. The elaboration of this flowery place appears in the sculptural background (Figure 7.7), for interspersed with the warriors the relief contains cacao pods, jade beads, and chalchihuitls, indicating that these celebrated warriors have indeed apotheosized into the flowery world they were promised in return for their military service.

In sum, Taube's identification of the Osario as a manifestation of Flower Mountain seems entirely warranted, and the incorporation of the serpent imagery into this model only strengthens his suggestions that this was a verdant mythical locale filled with exotic, precious substances obtained through the actions of trade and its integration with warfare. If the sculptural program was designed to celebrate the deceased warriors and entice the living to covet this desirable afterlife, then the structure's interior made concrete the reality that Chichen's deceased militia actually did reside inside of Flower Mountain. The burial remains found within the temple's shaft and associated cave provide evidence that Chichen's warriors did, in fact, come to rest in the heart of the mountain.

Upon entering the inner sanctuary of the Osario, on the floor immediately across from the room's door, is a shaft that penetrates straight through the structure's core (Figure 7.8).[10] The shaft is approximately 9 m (30 ft.) long and consists of protruding stonework that would function like a ladder facilitating descent and ascent of the shaft.[11] At the point where the shaft encounters bedrock, the facing stones of the shaft cease, followed by a series of nine steps cut into the bedrock. Because the shaft ultimately leads to a cave, the number nine, which the Maya associated with the underworld, is especially intriguing (J. E. Thompson 1970: 195). Edward Thompson (1938: 27), who conducted the first excavations of the shaft, reported that two of these steps were quite worn, which would suggest that they were repeatedly used as ritual practitioners de-

scended to engage with the cave below. The steps lead to a ledge formed by the bedrock that provides access to the cave's mouth, and from here it is a drop of approximately 15.8 m (52 ft.) to the floor of the cave. Caves are rather common in the Yucatan because of the actions of underground rivers inside the peninsula's limestone shelf. The Osario's cave was apparently dry by the time the people of Chichen began using it, and it appears to be natural but modified by humans, with a circumference of about 7.6 m (25 ft.). Underscoring how common such cenotes are under Chichen, archaeologists recently announced the discovery of a cenote directly below the Castillo (DGCS 2015). They found the feature using an electrical resistance survey, a process that measures resistance underground, though it is yet to be determined whether the original residents of Chichen knew of the cenote's presence. Nevertheless, additional investigation may reveal that Chichen had an established pattern of building pyramidal structures over cenotes. Both the Osario's cave and the new features emerging from underneath the Castillo offer further testament to the incorporation of the natural world into the ritual spaces of Chichen Itza. The underground spaces beneath the Castillo and the Osario offer these pyramidal structures a vertical axis, rising from the natural underworld cave to the celestial realm at the top of the man-made pyramid. Moreover, through the connecting thread of their sacbeob, a horizontal axis also connects the cave/pyramids to their watery cenotes, thereby creating a revised landscape that infused the natural with a human presence that could no longer be disentangled either physically or mentally.

Given that Edward Thompson, then the U.S. Consul to the Yucatan and the owner of the Hacienda Chichen Itza, excavated the Osario's cave in 1896, an early time when the definition of archaeology was quite different than in the present day, the precise nature of the cave is somewhat difficult to determine. Coupled with the fact that he never published the account himself, left only his letters to W. H. Holmes, and shipped drawings and select artifacts to Chicago's Field Museum of Natural History, aspects of the shaft and the cave remain difficult to discern. Some of the discrepancies or uncertainties were addressed by J. Eric Thompson (no relation) in 1938 when he gathered up the remaining data and endeavored to publish the material as clearly as possible. Suffice it to say, the romantic nature of the earlier Thompson's letters takes the reader to a former time, filled with anecdotes such as Edward Thompson's (1938: 30) account of clenching a Bowie knife in his teeth as he descended to the cave bottom on a rope with a lantern firmly clutched in his free hand. Nonetheless, the report offers a broad and somewhat detailed picture of the shaft, cave, and their associated artifacts.

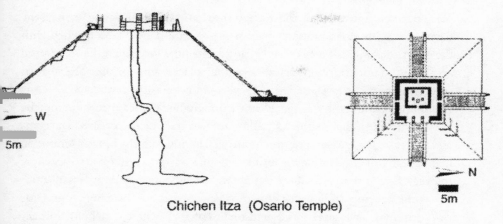

W

5m

N

5m

Chichen Itza (Osario Temple)

Figure 7.8. Plan of the Osario, Chichen Itza. Drawing modified from Masson and Peraza Lope (2007: fig. 2). By permission of *Mexicon*.

Beginning with the cave itself, Thompson encountered a mound of earth and ash directly below the opening to the cave. The ash included a significant amount of charred human bones and was about 2.4 m (8 ft.) deep at its center, tapering to .91 m (3 ft.) at the edges. The position of the charred remains suggests that, rather than entering the cave to place the cremated material, the Itza deposited the ash from above, pouring it down from the cave's aperture in the bedrock. In addition, other offerings appeared within the cremated remains, including a large jade bead, a white marble vase, real and simulated jaguar teeth, and an eccentric chert in the shape of a crescent which might allude to lunar symbolism for the cave. Objects which can be imbued with military symbolism include two stone points, one of obsidian and the other of chert. (For another example of large jade beads in an elaborate offering, see Miller, Chapter 6.)

This early use of the cave, therefore, consisted of decanting cremated human remains into the cave from above while periodically adding precious offerings to the ever-increasing mound. Although Edward Thompson reported these as the remains exclusively of adults, a later visit by Thomas Gann indicated that some children might also have been included (Gann 1924: 214; E. H. Thompson 1938: 53). Unfortunately, the data to confirm this are decidedly murky. While acknowledging this possibility, the chert and obsidian points do offer evidence of military symbolism for the cremated remains.

At some point in Chichen's history, the function of the temple was altered, and the Itza closed off the cave from further deposits. They sealed the cave with a carefully cut stone slab, then placed an offering of a small carved jade

fish—perhaps a symbol of the watery associations of the underworld cave. From this point, cremation deposits of ash and human bone continued with the occasional inclusion of crystal beads in the fill. Once again the Itza closed access to the underground chamber, as they placed another precisely shaped stone where the bedrock ended. This period of depositing cremated remains within the cave and the passage leading through the bedrock nicely mirrors the fiery immolation that Taube (2004) argues was the fate of deceased warriors, and therefore the crematory remains are well in line with the Flower Mountain iconography of the temple's exterior. The human remains could be those of the very figures sculpted on the temple walls who dance about in a paradisiacal world wearing the flowery crown of heroic, deceased warriors. The Osario, then, may have served as a mausoleum of sorts where Chichen's military transformed upon their deaths into carefree birds that reaped the fruit of their labors in the service of the city. However, at the point where the masonry-constructed shaft replaces the natural aperture, the burial practices transform and are decidedly different in character.

In the architectural section of the shaft, the funerary symbolism of the Osario continued, but now through a series of seven roughly defined burials. Stacked one upon the other with stones and earth fill between them, these burials were lined by reused parallel stone slabs approximately two feet apart and oriented in an east-west manner to make a small chamber. Edward Thompson did not explain precisely how the skeletal material was positioned, but some of the bones were crushed, and skeletal material seemed incomplete, which led Schmidt (2007: 173) to suggest that these were probably secondary burials that dated to the Middle to Late Postclassic. Likewise, it is entirely possible that some of the burials may have held the remains of more than one individual. The overall pattern in this section seems to consist of a stone-framed burial, fill containing earth and reused sculpted stones, followed by another burial, reaching up to around 4.8 m (16 ft.) below the temple floor.

The grave goods included with the interred individuals attest to the status they held. Red pottery, including grater bowls, was typical; however, because J. Eric Thompson was unable to securely match the vessels in the Field Museum collections to the report, further discussion of them is problematic. (See Smith and Bond-Freeman in Chapter 5 for the connection between grater bowls and Itza identity.) The grave goods included jade, as well as crystal and red shell beads; of particular note, only the burials above the bedrock include copper bells and turquoise. Frequently depicted as part of the accouterments of warrior costume on the carved columns that front the Temple of the Warriors, I might tentatively venture that the presence of such bells in the upper deposits

could assist in determining when this new trade item arrived at Chichen Itza. In a parallel fashion, the turquoise in these burials might indicate that these interments date to a period when Chichen's trade networks were highly developed and new sources of wealth and status appeared. As a whole the more formal burials in the shaft above bedrock offer an image of an increasingly wealthy Chichen with access to exotic goods from even further distant locales.

Although the cremation exhibited in the Osario deposits is unusual within the Maya area, there are precedents for this type of burial treatment during the Classic period at Teotihuacan and at Maya cities that interacted with Teotihuacan. Since early research by Laurette Séjourné (1959), the connection between cremation and high status has been a well-established fact at Teotihuacan. The later and much more comprehensive study of Teotihuacan burial patterns by Martha Sempowski and Michael Spence (1994: 251) further confirmed the association between the "complexity" of burial offerings and cremation, and they additionally noted a slight increase in this practice during the Tlamimilolpa (170–350) and Xolalpan (350–550) phases that was sustained during the Metepec phase (550–650).[12] Taube (2000) has compiled a good deal of visual and archaeological data suggesting that Teotihuacanos burned warrior bundles and posited that ceramic theater censers with butterfly imagery function as images of the cremated bundles. In the Maya area the presence of charred human bone in association with ceramics and other materials bearing Teotihuacan characteristics led Clemency Coggins (1975: 181, 1979: 40–41) to interpret Tikal's Problematic Deposits 22, 50, and 74 as possible elite Mexican cremation burials. The suggestion is intriguing, given the now well-established intrusion of Teotihuacanos into Tikal during the fourth century (Coggins 1975, 1979, 1983; Proskouriakoff 1993; Stuart 2000).

An even more compelling case of a Teotihuacan-style cremation burial in the Maya area derives from Caracol, Belize (Chase and Chase 2011). Special Deposit C117F-1 dates to 250–350, which positions it nicely within the Early Classic period of Teotihuacan influence in the Maya region. Like Tikal's Problematic Deposits and the remains at the Osario, there is not just one individual in the Caracol deposit—the skeletal material of at least three individuals appeared in the burial, including an adult, a child of 10–15 years, and a subadult who died around five years of age. Arlen Chase and Diane Chase (2011: 9–11) noted the unique nature of this burial at Caracol, as it differs from all other burials at the site. Positioned beneath a courtyard of the Northeast Acropolis, the deposit consisted of a square pit with rounded corners that measured 1.6 m by 1.6 m and had calcined sides, indicating that the intensive burning of the pit's contents occurred in situ.[13] The 20 ceramic vessels included in the

deposit attest to the elite status of at least one occupant, as do the hematite ear-
rings, jade and shell beads, and hematite mirror. Likewise, Chase and Chase
(2011: 11, 13–14) document an earlier tomb (ca. 150) of an elite woman buried
in a more Maya style on the Northeast Acropolis, suggesting that this loca-
tion had a strong association with high status. The distinctive cremation-style
pit burial was not the only evidence of Teotihuacan associations for Special
Deposit C117F-1. A wealth of green obsidian objects included 15 blades and 6
spear points whose size and configuration echo similar obsidian objects found
within deposits of Teotihuacan's Pyramid of the Moon and the Temple of the
Feathered Serpent.[14] The spear points, in particular, indicate that the adult oc-
cupant of the burial had military associations, as does a carved shell artifact
that Chase and Chase (2011: 11) suspect was the throwing tip of an *atlatl*.

The data from Tikal and Caracol demonstrate a pattern of Teotihuacan cre-
mation burial practices being exported to locations where the Early Classic
Maya had various sorts of sustained contact with the foreign city. Exactly who
the individuals interred within the Caracol burial pit were is as of yet unde-
termined, although the military components within this cremation burial re-
inforce proposals that the ideology of a fiery transformation of warriors upon
their death was a key element of Teotihuacan ideology (Taube 2000, 2004). If
the Osario's exuberant decoration depicts Flower Mountain and the sculpted
figures portray deceased warriors in that flowery world, then the cremated
remains poured into the cave are arguably those of expired warriors. The Early
Postclassic date of the Chichen temple would suggest that this fundamental
association between military participants and cremation burial survived the
demise of Teotihuacan until it flourished in vivid form at Chichen Itza. As
cremation burials from Teotihuacan, Caracol, and perhaps Tikal reveal, the
Osario was not the only or even the earliest expression of the fiery transforma-
tion of warriors upon their death. By the time that Itza ritualists poured hu-
man ashes into the Osario's cave, there was a long tradition of dispatching the
earthly remains of successful warriors in a blazing display.

To the northeast of the Osario on the Great Terrace is further evidence that
cremation was intimately linked with the life cycle of a warrior. During four
field seasons beginning in 1925, archaeologists of the Carnegie Institution of
Washington excavated the Temple of the Warriors, the Temple of the Chac
Mool, and the buildings' accompanying colonnades. In a floor that postdated
the Castillo but preceded the Temple of the Chac Mool, they found a square
masonry-walled cremation pit that measured 1.42 m by 1.42 m and 61 cm
deep. The bottom of the pit contained charcoal and wood ash, and a layer of
bone ash ranging from 7.6 to 18 cm thick surmounted the charcoal and burned

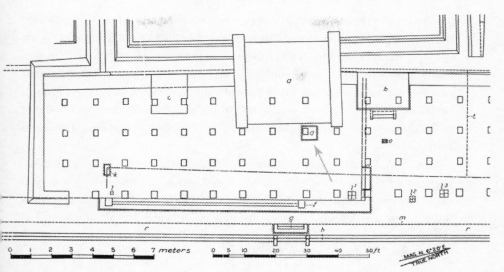

Figure 7.9. Plan of the Northwest Colonnade showing the location of the cremation pit (marked with arrow), Temple of the Warriors, Chichen Itza. Drawing modified from Morris, Charlot, and Morris (1931: vol. 2: plate A).

wood (Morris 1931: 173–174). The location of the cremation pit is partially below one of the later columns that eventually stood in front of the stairs leading from the colonnade to the Temple of the Warriors temple itself (Figure 7.9). In his discussion of the pit, Earl Morris interprets the burned bone as human and even goes so far as to compare it to modern Yucatec practices of exhuming and cremating remains after they had been buried in a cemetery for a few years. In truth the pit itself contained little evidence linking it to military rituals beyond cremation. However, given the overt militant symbolism of the temples later built in this location, it seems justifiable to conjecture that military activities might have transpired in this location before the more elaborate architecture thoroughly crystalized such practices.[15] The deposit also demonstrates that a tradition of burning human bone within a subfloor pit existed at Chichen Itza; thus a similar pit contemporary with the Osario likely existed somewhere at the site. This cremation pit may also represent an early manifestation of military cremation burials that was later displaced to the Osario. In later periods the Temple of the Warriors may have narrowed its focus to ritual displays in the colonnades, sacrificial rites, and convocations within its upper temple, while the Osario may have become the focus of important military funerary rites. That said, even if the Temple of the Warriors no longer served the function of funerary activities, its decoration nevertheless conveyed the

ultimate promise made to Chichen's warriors. Like the Osario, the corners of the Temple of the Warriors proper similarly consist of stacked witz heads sporting floral headbands, and elsewhere on the temple complex bird-beaked humans wear the floral headband.[16] The colonnades may suggest that military processions were key ritual events at the Temple of the Warriors, yet even in such celebrations, the iconography of the Temple of the Warriors echoed that of the Osario and reminded the participants of the better afterlife accorded to warriors.

Two temples at the site of Postclassic Mayapan, Temples Q-58 and Q-95, document that the practice of cremation and deposition within a temple continued in the Yucatan after the decline of Chichen Itza (Figure 7.10).[17] Most intriguingly, these temples also replicated the unusual burial shaft found in the heart of the Osario. Both temples reflect the Osario's shaft with an aperture

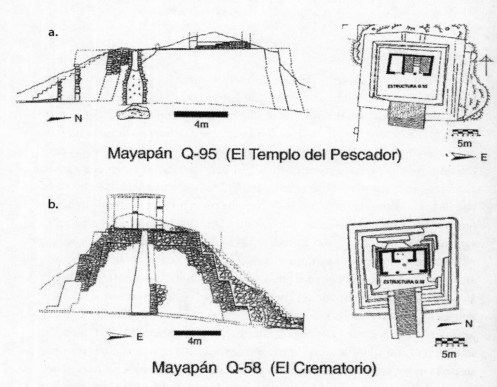

Figure 7.10. Plans of two burial shaft temples at Mayapan: *a*, Temple Q-95 (El Templo del Pescador); and *b*, Temple Q-58 (El Crematorio). Drawings modified from Masson and Peraza Lope (2007: fig. 2).

in the floor near the doorway of the temples' superstructures. Each shaft is roughly bottle-shaped but with smooth walls not designed to facilitate descent, and Temple Q-95 even includes a small cavelike chamber in the bedrock below the shaft. These shafts served as the repositories for human and animal bone as well as ceramic fragments. Temple Q-58 was subject to looting, but nevertheless, Carnegie archaeologists did recover skeletal material from both adults and children. Temple Q-95's more intact burial shaft contained at least 40 adult males and females, adolescents, and children (Shook 2006: 158–159, 175).

Despite the striking congruencies between the two Mayapan temples and the Osario, certain features indicate that there may be alternative explanations and differing rituals occurring at the later temples. As Marilyn Masson and Carlos Peraza Lope point out, Temple Q-95 is also known as the Templo del Pescador because of the temple's mural depicting a fisherman. Citing the shell pectoral on the fisherman in addition to certain elements that reflect Central Mexican mythology, Taube (personal communication in Stuart 2005: 179) and Masson and Peraza Lope (2007) associate the mural with the myth of Kukulkan/Quetzalcoatl in which he obtains human bones from the past and grinds them up with blood to create the humans of the present creation. Furthermore, archaeologists recovered a sacrificial stone used for heart extraction on the summit of Q-95, and a small version of a *tzompantli*, or skull rack (Shrine Q-89), shares the same courtyard, though not on axis with the temple. Taking these facts together with the fragmented nature of the bone found in the temple's shaft, Masson and Peraza Lope interpret the broken and cremated bones as the remains of captives, "sacrificed to deities associated with death and creation" (Masson and Peraza Lope 2007: 78). Another consideration is that the function of Q-95 changed over time, just as the deposits in the Osario cave and shaft reflect differing burial practices. The subterranean, cavelike chamber beneath the Q-95's shaft contained an elderly couple, of which the female exhibited head deformation. Subsequently the chamber was filled with ash, charcoal, animal and bird bone, objects of bone, shell and stone, and two disarticulated children with cranial deformation. Edwin Shook (2006: 171–173) interprets this as midden deposits, but it seems likely that this was an ancestral couple because two whole ceramic vessels were placed atop the deposit and a capstone sealed the chamber upon the construction of the burial shaft and temple above. The presence of the sacrificial stone atop the later temple certainly upholds a sacrificial context for the individuals within the burial shaft, but the placement of the aged couple inside the original cavelike chamber asserts that the initial function of this location was ancestor worship.

As for Temple Q-58, two round shrines that were later remodeled into square structures sit before the temple and could, as Masson and Peraza Lope suggest, reflect a Quetzalcoatl association, yet in this case, their argument that the human remains represent captives seems to largely rest on their fragmentary nature (Masson and Peraza Lope 2007: 80). Given that the bones Quetzalcoatl recovered in the myth were those of ancestors from a previous creation, there is reason to entertain the idea that the skeletal material from Q-58 might not necessarily be the result of desecratory actions perpetrated on captives, but might instead be the remains of revered ancestors or deceased warriors who were the primary candidates for a fiery apotheosis in Flower World. In addition, the Carnegie archaeologists recorded evidence of frequent burning on the front terrace around the orifice of the burial shaft and between the temple's doorway columns, and human effigy censer fragments were found in substantial quantities on the temple floor. Such practices, when viewed through the lens of Central Mexican elite crematory practices, could result from ancestor worship. Materials recovered from one of the low altars (Q-59a) in front of Q-58 seem to corroborate the proposal that Central Mexican burial traditions characterized some activities at Mayapan. Underneath this altar was a pit dug into bedrock capped by a shaft that penetrated the structure. At the bottom of the shaft within a matrix of ash, lime, and gravel, archaeologists found a series of three burials, one atop the other, and each of these was a primary burial, as the bodies were articulated. The middle, or second, burial rested upon a layer of ash, charcoal, and broken pottery, and because only some of the bones exhibited evidence of burning, it was clear that the partial cremation of the second individual took place within the pit itself. As Shook acknowledges in his analysis, the treatment of these individuals implies high status, and considered in the light of the arguments made here, indicates that cremation in Postclassic Yucatan could have elite connotations, just as it did at Teotihuacan and Caracol.

The data assert that the Central Mexican association of cremation with exalted status intruded into the Early Classic Maya region and typified some burial practices in Terminal Classic through Postclassic Yucatan. The distinctive architectural expression of a temple with a shaft penetrating its core may, in some cases, such as the Osario and Mayapan's Q-58, represent a modification of earlier ritual practices designed to celebrate individuals who served in a city's military. If Taube's (2000) assertion that Teotihuacanos burned warrior bundles at Teotihuacan is correct, then the Itza of Chichen may have maintained but transformed this tradition by periodically climbing down the Osario's shaft to deposit additional cremated warrior remains in the cave under-

neath the temple. Tantalizing offerings like the two stone points indicate that the deceased individuals did indeed have military associations. In all truth, however, the suspect excavation techniques of Edward Thompson, his less-than-thorough reporting, and certain features of the remains, nevertheless cloud a precise interpretation of the Osario cremations. The possible inclusion of children in the deposit could indicate a different explanation, or they might align with the present warrior hypothesis if they served as offerings to the deceased militia. Schmidt's (2011: 128) recovery of a child sacrifice in a small chamber behind the east wall of the Osario shaft suggests that child sacrificial victims may have been more dedicatory in nature and functioned to supplement the larger martial symbolism of the temple. Also important to note is that the early excavation of the shaft and cave did not include any exploration of the sexual features of the interred individuals. The imprecision of the archaeology, then, forces a greater reliance on the sculptural decoration of the temple, which offers copious evidence that the structure commemorated departed warriors who lived in a special afterlife.

From the feathered, jeweled, and cloudy serpents that slither around and down the temple to the warriors who dance surrounded by cacao, the temple exudes a lush and pleasurable place filled with luxury. The copious use of jade, turquoise, and quetzal feathers when overlaid upon the deceased below implies that these individuals will be plied with the finest rewards when they reach their final destination. Just as the fire transformed their bodies for this journey, the beaks that emerge around their mouths and the feathers that sprout from their arms express the warriors' conversion into birds that fly about drinking in the sweetness of this special abode. The floral headbands sported by the warriors and the witz heads are an unmistakable locative that identifies this afterlife as Flower Mountain. As Taube (2004) emphasized in his discussion of the floral world, the flowers convey not only beauty, but also the sweetness of their perfume. Permeating the air of this world, such perfume was perhaps a welcome experience after the horrid stench of battle and death.

The decoration of the Osario is further important in understanding the architectural trajectory of Chichen Itza in addition to the evolution of Central Mexican beliefs and iconography from the Classic period well into the Postclassic. The radial nature of the Osario clearly mimics the Castillo, and the comparative stratigraphic dating and the late hieroglyphic date on the temple's column all reveal that the Osario is indeed a late example of Chichen architecture. The Osario also adopted the earlier Castillo's architectural complex of Venus platform and cenote bound together with a sacbe that facilitated processional rites, although the later structure added architectural elements that

featured its funerary symbolism. Additional architectural features were not the only adaptation, for the Osario is far more flamboyantly sculpted than the Castillo. Not one, but four different serpents enhance the smaller temple, and these serpents extend to all four sides. Almost like the thirteenth-century Gothic church of Sainte-Chapelle, the architects of the Osario seem to have taken the liberty of decorating the smaller structure to the fullest, filling every space with lavish sculptural ornamentation.[18] In particular, the pairing of two serpents, the jade and turquoise serpents, is well in line with the late date of the temple and helps explain the development of subsequent Central Mexican iconography. The jade elements, though somewhat novel on the back of a serpent in the Maya area, nevertheless represent the established standard of wealth and fertility. When the Itza coupled it with a chalchihuitl, or turquoise serpent, they acknowledged the economic shift present in the Terminal Classic to Early Postclassic and presaged the later Postclassic obsession with this new version of the blue-green stone. The jade, turquoise, feathers, and clouds on the serpents convey just how sumptuous Flower World, the land of elites and warriors, was, yet the precious stones and feathers further indicate that the business of warfare was intimately linked with trade and obtaining the rare products of distant lands. Looking both back to Teotihuacan and the Classic period cremation of warriors as a transformative reward for their service, and forward to the Postclassic Mexica who extended Early Postclassic trade strategies that married warfare with merchant activities, the Osario stands as a monument to the warriors who brought wealth to the city of Chichen Itza during their lives and reveled in this same prosperity in the afterlife.

Notes

1. For key discussions of the debate over the Maya or Toltec identity of Chichen's inhabitants see Schele and Freidel (1990), Taube (1994), J. E. Thompson (1970), and Tozzer (1957).

2. In a personal communication (2015) with Geoffrey Braswell, he emphasized that the Osario Group is a distinct unit wedged between the Great Terrace and "Old Chichen" to the south, which makes it difficult to stratigraphically tie it to these flanking groups and their chronologies. He underscored that ceramics from the Osario indicate that it is at least as recent or as late as the visible architecture on the Great Terrace and that the architecture is stylistically later than the Castillo and possibly contemporary with the Temple of the Warriors and the Upper Temple of the Jaguars. Furthermore, Braswell pointed out that the Osario Group's distinctive arrangement of a temple with three altars is "unique in central Chichen Itza," and may be a late development at the site, serving as a precursor to somewhat similar architectural arrangements at later Mayapan.

3. The marks on the cloud serpent resemble an apostrophe and derive from the cloud scrolls

that developed in Formative period Olmec iconography (Taube 1995). Peter Schmidt (2007: 174) was the first to identify this as a possible cloud serpent.

4. A review of the literature on trade during the Terminal Classic to Early Postclassic periods appears in Braswell (2012: 22–25). See Schmidt (1998) for a discussion on how important trade was to Mesoamerica and especially Chichen Itza. See also Aztzin Martinez (2005) for additional discussion of warriors and trade.

5. For a succinct explanation of the Mesoamerican cosmological worldview explaining the directional associations of colors, see Schele and Freidel (1990: 66–67).

6. For more on the identification of the witz heads, see David Stuart (1997).

7. Fray Bernadino de Sahagún (1950–1982: 41–49) provided some of the clearest evidence for differing afterlives in Mesoamerica.

8. I have made similar arguments about the Teotihuacan state motivating its male population to participate in military service, and I suspect that this strategy survived in some form at Chichen Itza (Headrick 2003; 2007: 124–154).

9. To be clear in an earlier essay, Taube (2004) identified the human figures in the Flower World context as warriors, but in a later presentation offered an alternative view of the Osario figures as Ehecatl. Regardless, Taube was the first to identify the beaked figures on the Osario as warriors. Furthermore, Cynthia Kristan-Graham (2015) suggested that a butterfly proboscis, an element frequently seen in the imagery of deceased warriors (Headrick 2007: 125–145, 154–155), might have inspired the duck-billed feature, though I would argue that here the element is more avian in nature.

10. The following description of the Osario and its contents comes from Thompson (1938).

11. Because Edward Thompson (1938) reported his measurements in feet, I offer his original estimates as well as their conversion into the standard metric system.

12. Additional arguments for the connection between cremation and high status at Teotihuacan appear in Manzanilla (2002: 61), Manzanilla and Serrano (1999), Rattray (1992: 53), Serrano (1993: 112), and Sugiyama (2005: 207). Furthermore, the dating for Teotihuacan periods used here reflects George Cowgill's (2015) most recent position.

13. Several scholars have noted that Teotihuacanos frequently positioned high-status burials in similar, public locations, particularly the principal patios (Manzanilla 2002; Sempowski and Spence 1994: 251; Serrano 1993).

14. Information about the artifacts recovered from Teotihuacan's Pyramid of the Feathered Serpent and the Moon Pyramid appears in Sugiyama (2005), Sugiyama and Cabrera (1999, 2000, 2003, 2007), Sugiyama et al. (2004), and Sugiyama and López Luján (2007).

15. Andrea Stone (1999: 315–316) noted that military iconography was pervasive throughout the Temple of the Warriors and suggested that murals above the Northwest Colonnade dais may record a "dance of the warriors." Given that this later dais is in close proximity to the cremation pit, this location may have had a lengthy association with military rituals at Chichen Itza.

16. Morris published clear images of the witz masks with floral headbands as well as an image of a human head from the Northwest Colonnade with a bird's beak and floral headdress (Morris 1931: figs. 15, 44).

17. As noted by Masson and Peraza Lope (2007), other burial shafts occur in Mayapan's outlying groups of Izamal Chen (H-18) and X-Coton (T-72).

18. The Osario incorporates additional sculptural elements that are not discussed here but are included in Schmidt (2011).

References Cited

Aztzin Martinez, De Luna Lucha

2005 *Murals and the Development of Merchant Activity at Chichen Itza*. M.A. thesis, Department of Anthropology, Brigham Young University, Provo, Utah.

Braswell, Geoffrey E.

2012 The Ancient Maya of Mexico: Reinterpreting the Past of the Northern Maya Lowlands. In *The Ancient Maya of Mexico: Reinterpreting the Past of the Northern Maya Lowlands*, edited by Geoffrey E. Braswell, pp. 1–40. Equinox, Sheffield, England.

2015 Personal communication.

Braswell, Geoffrey E., and Nancy Peniche May

2012 In the Shadow of the Pyramid: Excavations of the Great Platform of Chichen Itza. In *The Ancient Maya of Mexico: Reinterpreting the Past of the Northern Maya Lowlands*, edited by Geoffrey E. Braswell, pp. 227–258. Equinox, Sheffield, England.

Chase Arlen F., and Diane Z. Chase

2011 Status and Power: Caracol, Teotihuacan, and the Early Classic Maya World. *Research Reports in Belizean Archaeology* 8: 3–18.

Coggins, Clemency Chase

1975 *Painting and Drawing Styles at Tikal: An Historical and Iconographic Reconstruction*, Pt. 1. PhD diss., Department of Fine Arts, Harvard University, Cambridge. University Microfilms, Ann Arbor, Mich.

1979 A New Order and the Role of the Calendar: Some Characteristics of the Middle Classic Period at Tikal. In *Maya Archaeology and Ethnohistory*, edited by Norman Hammond and Gordon R. Willey, pp. 38–50. University of Texas Press, Austin and London.

1983 An Instrument of Expansion: Monte Alban, Teotihuacan, and Tikal. In *Highland-Lowland Interaction in Mesoamerica: Interdisciplinary Approaches*, edited by Arthur G. Miller, pp. 49–68. Dumbarton Oaks Research Library and Collection, Washington, D.C.

1984 Introduction: The Cenote of Sacrifice. In *Cenote of Sacrifice: Maya Treasures from the Sacred Well at Chichen Itza*, edited by Clemency Chase Coggins and Orrin C. Shane III, pp. 22–29. University of Texas Press, Austin.

Cowgill, George L.

2015 *Ancient Teotihuacan: Early Urbanism in Central Mexico*. Cambridge University Press, New York.

DGCS (Dirección General de Comunicación Social, Universidad Nacional Autónoma de México)

2015 Descubren Universitarios un Cenote Debajo de la Pirámide de Kukulkán, en Chichén Itzá. *Boletín UMAM-DGCS-466*. www.dgcs.unam.mx/boletin/bdboletin/2015_466. html, accessed December 15, 2015.

Gann, Thomas

1924 *In an Unknown Land*. Scribner's, New York.

Graña-Behrens, Daniel, Christian Prager, and Elisabeth Wagner

1999 The Hieroglyphic Inscription of the "High Priest's Grave" at Chichén Itzá, Yucatán, Mexico. *Mexicon* 21: 61–66.

Headrick, Annabeth

1991 *The Chicomoztoc of Chichén Itzá*. M.A. thesis. Department of Art History, University of Texas, Austin.

2003 Butterfly War at Teotihuacan. In *Ancient Mesoamerican Warfare*, edited by M. Kathryn Brown and Travis Stanton, pp. 149–170. AltaMira Press, Walnut Creek, Calif.

2007 *The Teotihuacan Trinity: The Sociopolitical Structure of an Ancient Mesoamerican City.* University of Texas Press, Austin.

Hooton, Earnest A.

1977 Skeletons from the Cenote of Sacrifice at Chichen Itzá. In *The Maya and Their Neighbors: Essays on Middle American Anthropology and Archaeology*, edited by Clarence L. Hay, Ralph L. Linton, Samuel K. Lothrop, Harry L. Shapiro, and George C. Vaillant, pp. 272–280. Dover, New York.

Kristan-Graham, Cynthia

2015 Personal communication.

Manzanilla, Linda

2002 Houses and Ancestors, Altars and Relics: Mortuary Patterns at Teotihuacan, Central Mexico. *Archaeological Papers of the American Anthropological Association* 11: 55–65.

Manzanilla, Linda, and Carlos Serrano (editors)

1999 *Prácticas funerarias en la ciudad de los dioses: Los enterramientos humanos de la Antigua Teotihuacan.* Instituto de Investigaciones Antropológicas, Universidad Autónoma de México, Mexico City.

Masson, Marilyn A., and Carlos Peraza Lope

2007 Kukulkan/Quetzalcoatl, Death God, and Creation Mythology of Burial Shaft Temples at Mayapán. *Mexicon* 29: 77–85.

Morris, Earl H.

1931 Description of the Temple of the Warriors and Edifices Related Thereto. In *The Temple of the Warriors at Chichen Itzá, Yucatan*, Earl H. Morris, Jean Charlot, and Ann Axtell Morris, vol. 1, pp. 11–227. Publication no. 406. Carnegie Institution of Washington, Washington, D.C.

Morris, Earl H., Jean Charlot, and Ann Axtell Morris

1931 *The Temple of the Warriors at Chichen Itzá, Yucatan.* 2 vols. Publication 406. Carnegie Institution of Washington, Washington, D.C.

Proskouriakoff, Tatiana

1993 *Maya History.* University of Texas Press, Austin.

Rattray, Evelyn

1992 *Teotihuacan Burials and Offerings: A Commentary and Inventory.* Vanderbilt University Publications in Anthropology no. 42. Vanderbilt University, Nashville, Tenn.

Sahagún, Fray Bernadino de

1950–1982 [1575–1580] *Florentine Codex: General History of the Things of New Spain.* Translated by Arthur J. O. Anderson and Charles E. Dibble. Book 3: The Origin of the Gods. Monographs of the School of American Research and the Museum of New Mexico. School of American Research and the University of Utah, Santa Fe.

Schele, Linda, and David A. Freidel

1990 *A Forest of Kings: The Untold Story of the Ancient Maya.* William Morrow, New York.

Schmidt, Peter J.

1998 Contacts with Central Mexico and the Transition to the Postclassic: Chichén in Central Yucatán. In *Maya Civilization*, edited by Peter Schmidt, Mercedes de la Garza, and Enrique Nalda, pp. 427–449. Thames and Hudson, New York.

2007 Birds, Ceramics, and Cacao: New Excavations at Chichén Itzá, Yucatán. In *Twin Tollans:*

Chichén Itzá, Tula, and the Epiclassic to Early Postclassic Mesoamerican World, edited by Jeff Karl Kowalski and Cynthia Kristan-Graham, pp. 151–203. Dumbarton Oaks, Washington, D.C.

2011 Birds, Ceramics, and Cacao: New Excavations at Chichén Itzá, Yucatan. In *Twin Tollans: Chichén Itzá, Tula, and the Epiclassic to Early Postclassic Mesoamerican World*, rev. ed., edited by Jeff K. Kowalski and Cynthia Kristan-Graham, pp. 113–155. Dumbarton Oaks, Washington, D.C.

Séjourné, Laurette

1959 *Un palacio en la ciudad de los dioses: Exploraciones en Teotihuacan, 1955–1958*. Instituto Nacional de Antropología e Historia, Mexico City.

Sempowski, Martha L., and Michael W. Spence

1994 *Mortuary Practices and Skeletal Remains at Teotihuacan*. University of Utah Press, Salt Lake City.

Serrano Sánchez, Carlos

1993 Funerary Practices and Human Sacrifice in Teotihuacan Burials. In *Teotihuacan: Art from the City of the Gods*, edited by Kathleen Berrin and Esther Pasztory, pp. 109–115. The Fine Art Museums of San Francisco and Thames and Hudson, San Francisco.

Shook, Edwin M.

2006 Three Temples and Their Associated Structures at Mayapan. Current Reports no. 14, Carnegie Institution of Washington, D.C. In *The Carnegie Maya: The Carnegie Institution of Washington Maya Research Program, 1913–1957*, compiled by John M. Weeks and Jane A. Hill, pp. 157–177. University Press of Colorado, Boulder.

Stone, Andrea

1999 Architectural Innovation in the Temple of the Warriors at Chichén Itzá. In *Mesoamerican Architecture as a Cultural Symbol*, edited by Jeff Karl Kowalski, pp. 298–319. Oxford University Press, New York.

Stuart, David

1997 The Hills Are Alive: Sacred Mountains in the Maya Cosmos. *Symbols* (Spring): 13–17.

2000 The Arrival of Strangers: Teotihuacan and Tollan in Classic Maya History. In *Mesoamerica's Classic Heritage: From Teotihuacan to the Aztecs*, edited by Davíd Carrasco, Lindsay Jones, and Scott Sessions, pp. 465–513. University Press of Colorado, Boulder.

2005 *The Inscriptions from Temple XIX at Palenque*. Pre-Columbian Art Research Institute, San Francisco.

Sugiyama, Saburo

2005 *Human Sacrifice, Militarism, and Rulership*. Cambridge University Press, Cambridge.

Sugiyama, Saburo, and Rubén Cabrera Castro

1999 Proyecto Arqueológico de la Pirámide de la Luna. *Arqueología* 21, segunda época: 19–34.

2000 Proyecto Pirámide de la Luna: algunos resultados en la segunda temporada 1999. *Arqueología* 23, segunda época: 161–172.

2003 Hallazgos recientes en la Pirámide de la Luna. *Arqueología Mexicana* 11(64): 42–49.

2007 The Moon Pyramid Project and the Teotihuacan State Polity. *Ancient Mesoamerica* 18: 109–125.

Sugiyama, Saburo, Rubén Cabrera Castro, and Leonardo López Luján

2004 The Moon Pyramid Burials. In *Voyage to the Center of the Moon Pyramid: Recent Discoveries in Teotihuacan*, edited by Saburo Sugiyama, pp. 20–30. Arizona State University, Tempe.

Sugiyama, Saburo, and Leonardo López Luján

2007 Dedicatory Burial/Offering Complexes at the Moon Pyramid, Teotihuacan. *Ancient Mesoamerica* 18: 127–146.

Taube, Karl A.

1994 The Iconography of Toltec Period Chichen Itza. In *Hidden among the Hills: Maya Archaeology of the Northwest Yucatan Pennisula*, edited by Hanns J. Prem, pp. 212–246. Acta Mesoamericana, vol. 7. Verlag von Fleming, Möckmühl, Germany.

1995 The Rainmakers: The Olmec and Their Contributions to Mesoamerican Belief and Ritual. In *The Olmec World: Ritual and Rulership*, pp. 83–103. Art Museum, Princeton University in association with Harry N. Abrams, Princeton, N.J., and New York.

2000 The Turquoise Hearth: Fire, Sacrifice, and the Central Mexican Cult of War. In *Mesoamerica's Classic Heritage: From Teotihuacan to the Aztecs*, edited by Davíd Carrasco, Lindsay Jones, and Scott Sessions, pp. 269–340. University Press of Colorado, Boulder.

2004 Flower Mountain: Concepts of Life, Beauty, and Paradise among the Classic Maya. *RES: Anthropology and Aesthetics* 45: 69–98.

2015 The Birth of Ehecatl: The Cultural Origins of the Avian Wind God of Central Mexico. Paper presented at the 80th Annual Meeting of the Society for American Archaeology, San Francisco.

Thompson, Edward H.

1938 *The High Priest's Grave, Chichen Itza, Yucatan, Mexico.* Anthropological Series, Pub. 412, vol. 27, no. 2, prepared for publication with notes and introduction by J. Eric Thompson. Field Museum of Natural History, Chicago.

Thompson, J. Eric S.

1937 *A New Method of Deciphering Yucatecan Dates with Special Reference to Chichen Itza.* Contributions to American Archaeology and Ethnology no. 22. Publication 483. Carnegie Institution of Washington, Washington, D.C.

1970 *Maya History and Religion.* University of Oklahoma Press, Norman.

Tozzer, Alfred M.

1957 *Chichen Itza and Its Cenote of Sacrifice: A Comparative Study of Contemporaneous Maya and Toltec.* 2 vols. Memoirs of the Peabody Museum of Archaeology and Ethnology, vols. 11 and 12. Harvard University, Cambridge.

Wagner, Elisabeth

1995 The Dates of the High Priest Grave ("Osario") Inscription, Chichén Itzá, Yucatán. *Mexicon* 17: 10–13.

8

The Least Earth

Curated Landscapes at Chichen Itza

CYNTHIA KRISTAN-GRAHAM

Diego de Landa, a sixteenth-century bishop of Yucatan, described the land there as "the least earth that I have ever seen, since all of it is one living rock" (Landa in Tozzer 1941: 186). Despite this account of a meager landscape, which consisted of a few inches of soil atop karstic land, Maya in the Northern Lowlands made efficient use of their environment. For example, at Chichen Itza, cenotes, *aguadas*, and *chultuns* collected rainwater, and plazas and buildings were designed to help prevent flooding (González de la Mata et al. 2004: 2–10). In this chapter I suggest that landscape was a key component of Chichen Itza's embellishment, that references to nature were imbued with aesthetic and sociopolitical import, and specifically that a sculpted dais in the Mercado was a surrogate sky-mountain that embodied the "least earth" for political theater.

The milieu in which Chichen Itza became the largest and most powerful Northern Lowland Maya site was the Terminal Classic–Early Postclassic (ca. 800–1100) re-formation of sociopolitical patterns in which new forms of international writing and symbol systems, shared building types, and long-distance trading relationships developed (Berlo 1989; Braswell and Peniche 2012). I follow the approaches of other scholars today who abandon the problematic and unfounded conquest theories implicating Tula in Central Mexico and instead recognize Chichen Itza as multiethnic and consider its heterogeneous visual culture a political strategy that served a wide constituency (Kowalski and Kristan-Graham 2011; see Chapters 3–5 regarding Chichen Itza's interactions with other sites). Moreover, I avoid the term "Toltec," which is timeworn and too elastic to convey specific meaning, particularly whether referents are historical or mythical.

A discussion of Chichen Itza's environs, or "least earth," prefaces an analy-

sis of landscape and the Mercado. Today Chichen Itza is verdant during the rainy season, punctuated with many fragrant vines and towering fruit and hardwood trees. However, the Early Postclassic Chichen Itza under discussion was a carefully curated, fabricated landscape.[1] The rocky limestone earth was leveled to form architectural terraces and causeways, the former painted red and the latter faced with white stucco (Figure 1.1). Most terraces supported domestic and public buildings that were spheres of activity, which causeways linked to form networks of peoples and places. Landscape was reintroduced into this synthetic environment via art: lakes, hills, fauna, and flora appear in wall paintings and/or figural compositions and portraits carved on walls and architectural supports in temples and colonnades, as the Temple of the Warriors exemplifies (Charlot 1931: plate 40; E. H. Morris 1931: plate 159). Groups of pillars formed panoramic colonnades that could be viewed against a wider backdrop of *milpas* and kitchen gardens, the latter located between platforms. Some compositions were narratives about myth and idealized history, and plausibly represented ancestors and the polity.

Related to this are landscapes, where life unfolds and the loci where personhood, lineages, and social groups originate and operate. At once material and intangible, landscapes comprise natural terrain, cultural constructions such as buildings and territories, and ideas and activities related to the land. Landscapes can appear to be "real" or natural, even if they are not, because they embody or represent natural elements. People are in constant physical, perceptual, and cognitive dialog with landscapes. Rather than being static, landscapes are kaleidoscopes of senses, perceptions, and relationships that shift according to experience and constituencies, and this fluidity can animate ideas about time and place. Events that occur in familiar places may seem casual, but they also can be causal because they are more likely to be reinforced and remembered in intimate, lived spaces. Moreover, living in, seeing, and recalling landscape are crucial to the process of "becoming," or the constitution of an individual according to personal experience and social norms. "Becoming" in this sense is contingent and relational (Bender 1993; Deleuze 1993; Fowler 2008; Hendon 2010; Thomas 1993; Van Dyke 2008).

In addition, landscapes are where people create codes of comprehension in order to understand and navigate their personal and social spaces. They are "institutional as space is structured and behavior normalized through codified social practice. Landscape concerns moral codes, who can go where, under which conditions. . . . Landscapes are always territorial spaces in that they are controlled and contested in social and political practice" (David and Thomas 2008: 38).

The Mercado and Gallery-Patio Structures

One intricate landscape is found in the Mercado, a building in the Group of the Thousand Columns, Chichen Itza's largest walled compound (Pérez Ruiz 2005), which is located on the Great Terrace, both the site's nucleus and largest architectural terrace (Figures 8.1–8.2). The Great Terrace supports the largest buildings at Chichen Itza—the Castillo, Great Ball Court, and Temple of the Warriors—and many causeways connect here. I have suggested that the Group of the Thousand Columns was a royal architectural compound with both proximity to and privacy from the site center (Kristan-Graham 2014). Supporting evidence includes Structure 3D7 (the Palace of the Sculpted Columns), on whose façade sculpted figures are seated in the cross-legged pose of Maya lords. Façades on the nearby Structures 3D5 and 3D6 depict jaguars, animals associated with royalty, and *ajaw* and *k'awil* glyphs. The former is read as "lord" and both comprise a title linked to K'ak'upakal, a putative ninth-century ruler of Chichen Itza (Schmidt 2011). The carving of other nearby façades imitates the form of turquoise mosaic, a material found on shields and other elite objects at the site, and a valued foreign item that was traded after the Classic period. These factors suggest that at the very least the Group of the Thousand Columns was elite, and that most likely it was royal.

Despite evidence for royal associations, relatively little is known about the

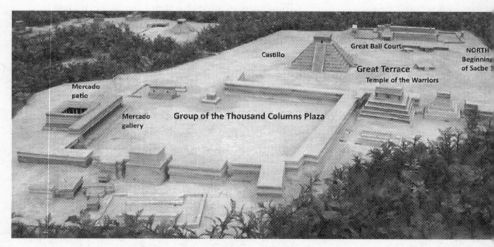

Figure 8.1. Model of Chichen Itza, museum at Zona Arqueológica Chichén Itzá. At center is the Great Terrace (*top*) and the Group of the Thousand Columns, with some major structures labeled. Photograph by Cynthia Kristan-Graham.

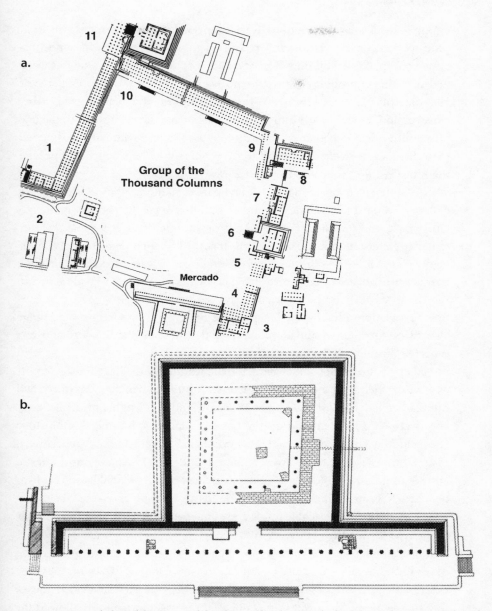

Figure 8.2. General plan of the Group of the Thousand Columns, Chichen Itza, with a separate plan of the Mercado: *a*, Plan of the Group of the Thousand Columns, Chichen Itza (adapted from Braswell and Peniche May 2012: fig. 9.2); the Mercado is labeled (*bottom center*); other structures include (1) 3D1, West Colonnade; (2) 3D4, Ballcourt; (3) Southeast Colonnade; (4) 3D10, Southeast Colonnade; (5) 3D9, Thompson's Temple; (6) 3D8, Temple of the Little Tables; (7) 3D7, Temple of the Sculpted Columns; (8) Northeast Colonnade; (9–10) 2D10, North Colonnade; (11) Temple of the Warriors; (12) (the latter is on the Great Terrace) (adapted from Pérez de Heredia 2010: fig. 152); *b*, Plan of the Mercado (adapted from Kristan-Graham 2011: fig. 13.9). Drawing by permission of Nikolay Lyutskanov.

Group of the Thousand Columns. Karl Ruppert's 1943 monograph on the Mercado focused on excavation and reconstruction, and remains the only sustained study of this building. Recent ceramic and stratigraphy analyses clarified site-wide chronology (Braswell and Peniche 2012; Chung 2008; Pérez de Heredia 2012). The Group of the Thousand Columns apparently was a late construction, as were most buildings on the Great Terrace; it dates to the end of the fifth of six occupations, or 950/980–1050/1100 in the Early Postclassic period, coeval with the Temple of the Warriors and Great Ballcourt but later than the Castillo (Volta and Braswell 2014: 372, 389).

The Mercado is not a market as its Spanish name implies. Rather, it is a gallery-patio, a Late Classic–Epiclassic building type that occurs in Belize, Guatemala, and the Northern Lowlands of Yucatan. It fuses a square or rectangular gallery with a square patio to form a T-shaped or rectangular footprint (Figure 8.2b bottom). Some of the other gallery-patios at the site, which number over 20, are smaller, measuring just a few meters on each side (Lincoln 1990: map sheet II; Ruppert 1943, 1950, 1952). Charles Lincoln's (1990: 622–642) 1980s excavations established that gallery-patios, along with temples and range structures, form an architectural complex that defined the site core and was repeated throughout the city.

Gallery-patios share some characteristic features with Maya lineage/council houses, including a colonnaded hall with built-in benches. Maya council houses—called *popol nah* and *nimja* in Lowland and Highland dialects, respectively—are so identified on the basis of plan, glyphs, and ethnohistory (Bey and May Ciau 2014; Fash et al. 1992; Fox 1989; Freidel 1981; Ruppert 1943, 1950; Stomper 1996; Stone 1999; compare Plank 2004).[2] Analogous domestic and administrative buildings at Tula also include colonnaded halls and built-in benches (Kristan-Graham 2011, fig. 13.8).[3] Because council houses and gallery-patios share many physical features and some apparent filial functions, I refer to them as the "council house tradition."

Some contact-period writers saw such buildings in use and queried the Maya in the decades after the Conquest. In 1566, Landa (Tozzer 1941: 85–86) described Yucatec houses that he had seen earlier in which a wall divided houses into two sections. The front room's open façade was more public, allowed for surveillance of enemies, and provided space for elite lords to house and entertain guests (see also *Relaciones* in Scholes and Roys 1968: 53). The back room contained beds and had several doors. The stone benches built into gallery-patios are similar in placement and form to those at Tikal, Caracol, Palenque, Tula, and elsewhere, and one function could have been sleeping platforms (Chase and Chase 2001; Guevarra Chumacero 2004; Harrison 2001; Kristan-Graham

2015; Plank 2004). Testimony from Hernán Cortés' time to the modern era notes that Maya palaces are comfortable and cool, and that the benches are pleasant sleeping platforms (Webster 2001: 138). The dwelling aspects of these Maya domiciles are significant, for even if they were occupied only sporadically for lineage events, filial symbolism was apparent.

The Mercado is the largest and grandest gallery-patio in Mesoamerica. The gallery is the building's public face, rising 2 m above the plaza (Figure 8.3).[4] A central stairway and steps at the east and west ends provided access between

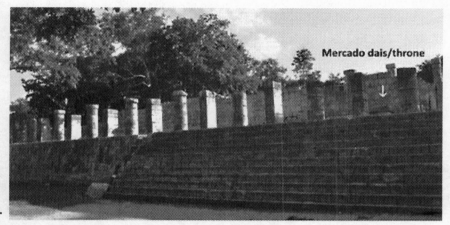

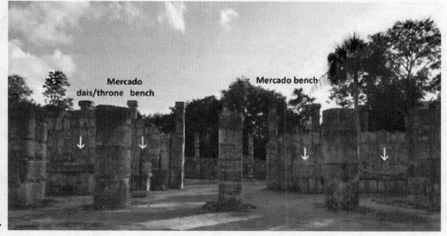

Figure 8.3. Two views of the Mercado gallery: *a*, View of the Mercado gallery, by permission of Annabeth Headrick; *b*, View of the Mercado gallery and seats, by permission of Annabeth Headrick.

the plaza and the gallery. Twenty-four alternating piers and columns painted with yellow, red, and blue registers once supported a vaulted roof (Ruppert 1943: 242, fig. 4a). Benches project from the gallery walls, and a projecting dais is at the west end of the doorway that leads to the patio. The bench is an elongated C-shape, like many Classic and Terminal Classic Maya seats, but the doorway to the patio interrupts the long back of the "C." These features suggest a performative function, with the supports creating a colorful porous veil through which to view action in the plaza or the gallery, depending upon vantage point. The benches and dais also provided an ideal setting to outline hierarchy via seating order.

In contrast, the walls of the adjacent enclosed patio provided privacy (Figure 8.4). Columns that once supported a roof frame a shallow impluvium. Rainwater dripped through a thatch roof or an opening in the roof, and a drain carried away runoff water (Ruppert 1943: 255). This type of design could recall Tollan, the paradigmatic Mesoamerican homeland, with columns and water serving as surrogate reeds and a lake (Kristan-Graham 2011). Accordingly, the central part of the patio was given great care; the impluvium was

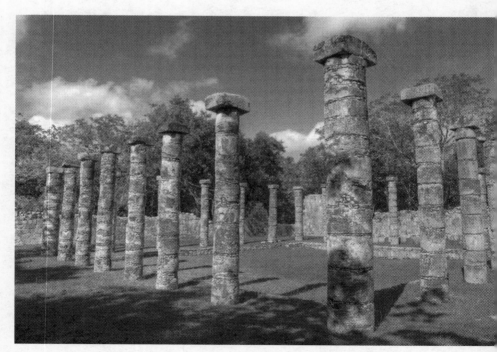

Figure 8.4. View of the Mercado patio. Adobe Stock royalty free image file # 64958985.

lined with plaster and smooth stones, and a 2 m² stone box buried beneath contained carved jadeite pieces and over 100 spondylus shell beads (Ruppert 1943: 256–57, figs. 34–35).

The Mercado has been variously identified as a judicial court (Ruppert 1943: 23), an elite residence (Freidel 1981: 323); and a temple dedicated to drilling fire (Plank 2004: 193–199). Caches and fireboxes support the latter two interpretations. The gallery's siting and outward focus were suitable for dramaturgical events to engage crowds, and the benches provided a locale to outline hierarchy via seating order; the enclosed patio could have hosted private rituals.

As a paradigmatic gallery-patio, the Mercado provides an epitome of how such buildings functioned. In addition to being a venue for dual public-private use, the Mercado can be understood as a multivalent structure. Despite its large size, central location, fine construction, and plausible royal associations, the building incorporates spatial features of structures in the "council house tradition." The rectangular gallery would have afforded basically similar spatial experiences to anyone inhabiting this portion of a gallery-patio, or the gallery of a council house. Shared experiences include occupying a three-dimensional rectangle, sitting on in situ benches, and sharing comparable viewpoints from a raised position on a plaza. The gallery and bench forms comprised an expansive version of one form of a Maya house, thereby adding filial and domestic symbolism.[5] Buildings that enable shared spatial practices may be just as foundational as those with similar narrative programs. In fact they may be more edifying, as people live in a three-dimensional world—the realm of social relations—where one can embody knowledge via bodily movement and sight. This is not to imply that buildings are dictatorial, but that architecture can normalize, instruct, and evince parallels *and* contrasts. Spatial organization and awareness are intimately interwoven with daily and ritual routines, which can lead to distinctive cultural patterns, such as tendencies to interact with people and their environs in like ways.

The Mercado and Its Dais

Whoever sat in the Mercado gallery had a privileged view of the plaza and would have been easily seen. Stone benches proliferated in Mesoamerica during the Classic period, at the very time when palaces were built in great numbers. In addition to sleeping platforms, benches also could have functioned as thrones (Guevarra Chumacero 2004; Harrison 2001; Plank 2004). The dais is higher and larger than the bench, and its 2-x-3 m top surface provided ample space for more than one person to sit on, to display items (such as tribute), or

to use as an altar or even a sacrificial platform (Ruppert 1943: 243–245) (Figure 8.3). These seats were added after the Mercado's original construction. The initial appearance of the seating arrangement in the gallery is not clear, except for an earlier dais encased by the one under discussion.[6]

The silhouettes of the seats are symbolic, as are other daises and altars at Chichen Itza. Both the bench and the dais share a similar profile with a cantilevered rectangular cornice above an angled face or *talud*. This recalls Teotihuacan *talud-tablero* building profiles and walls with taluds (Figures 8.5 and 8.6).[7] The sloping talud echoes an abstracted mountain and a basic pyramidal profile; the latter can be seen throughout the site, including the Group of the Thousand Columns. Both forms recall sacred origins. Mountains contained caves, which were homes of deities and ancestors and sites of emergence and sequestered religious rites. Rulers amplified their status by linking themselves with such forms associated with fertility and ancestry.[8] The entire building rests on a stone platform that has a talud-shaped profile; this standard platform shape can be understood as a mountain resting directly on the plaza floor in a minimal sort of sacred geology. The Mercado, its seats and dais can be perceived as surrogate mountains—which were prevalent in Maya myths yet not part of the topography near Chichen Itza—that provided an appropriate setting for religious and political rites.

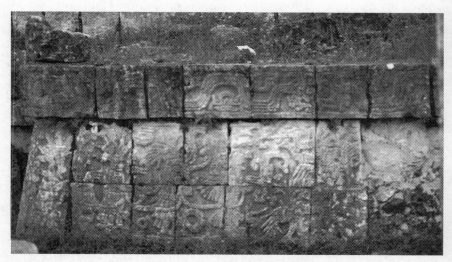

Figure 8.5. View of the left and center portion of the Mercado dais/throne front/north face; note the damage to the right portion of the dais face that is visible. Photograph by Cynthia Kristan-Graham.

Figure 8.6. Drawings of the Mercado dais/throne from various angles: *a*, Drawing of the Mercado dais/throne north (front) face (after William L. Lincoln in Ruppert 1943: fig. 23, bottom); *b*, Drawing of the Mercado dais/throne east side (after William L. Lincoln in Ruppert 1943: fig. 24, bottom); *c*, Drawing of the Mercado dais/throne west side (after William L. Lincoln in Ruppert 1943: fig. 25, bottom).

Geological symbolism extends to Maya writing, as glyphs identified some buildings and sculpture as mountains, which were considered animate forces. The Maya glyph for mountain/hill is *witz* (Figure 8.7a). As an animate form, witz is the Kawak Monster with ophidian or reptilian traits. Witz monsters whose skulls had a stepped profile could appear architectonic, and structures that were marked glyphically as mountains simulated the "sacred landscape, thereby sanctifying ritual spaces" (Stone and Zender 2011: 139). (In Chapter 7 Headrick discusses witz symbolism while I am more concerned with geologi-

cal and linguistic aspects of witz.) While the Mercado seats may have recalled witz associations, its seats lack glyphic references and are a more straightforward visual link with mountains, a trait that is typical of nonphonetic writing traditions. For example, the Aztec *Codex Boturini* exemplifies how some Postclassic and contact-period codices continued earlier writing practices, as the glyph for "Snake Mountain" unites a hill and serpents in logographic writing (Figure 8.7b).

As the focus of the Mercado gallery and the Group of the Thousand Columns plaza, the dais talud offers a compelling narrative. This typical Chichen Itza processional scene features two rows of figures bound at the wrists who seem to emerge from the gallery wall and converge on the talud's north side that faces the plaza: two supine males are below an elaborately clad standing male who holds a knife (Figure 8.6a). Ruppert (1943: fig. 22a) read this as a sacrificial scene. The overall processional composition parallels other narratives, such as the Temple of the Warriors dais and others in the Group of the Thousand Columns, whose central scenes depict human sacrifice or bloodletting (Charlot 1931; Stone 1999).

Who is represented on the dais? All of the figures wear distinctive costumes, carry weapons, and have glyphs near the head that plausibly identify lineage names (Kristan-Graham 2001; Schmidt 2011: 125), including metate, Ka' or Cha' (Stuart 2014), shield, Chimal (Roys 1940), and flora and fauna that are rendered too generally to identify (Figure 8.7c). No traces of decoration on the earlier dais remain for comparison (Ruppert 1943: 245, fig. 7). Maya lords often were depicted with both martial and political regalia, and the dais costumes indicate

a b c

Figure 8.7. Various glyph drawings: *a*, Drawing of a witz glyph (T529) (after *John Montgomery Dictionary Maya Hieroglyphs*, John Montgomery Drawings Collection, Foundation for the Advancement of Mesoamerican Studies); *b*, Drawing of "Snake Mountain" in Codex Boturini, p. 6 (after John Montgomery Drawings Collection, Foundation for the Advancement of Mesoamerican Studies); *c*, Drawing of some Mercado dais/throne name glyphs (after Ruppert 1943: fig. 7).

that elite captives are depicted. Instead of the routine assumption that captives memorialize victories, the field of memorial studies offers alternative readings, including imagery that is intended to elicit specific reactions, to spark explicit memories, or to connect with targeted viewers (Savage 2009). Some Maya stone benches and altars were used to venerate ancestors, and this might be the case here (Schwarz 2013: 313).

Was the Mercado Dais a Throne?

Many of the aforesaid qualities of the Mercado seats indicate that they likely were intended for elites, and they clearly fit within the category of Maya thrones regarding form and embellishment. Murals, relief sculpture, and painted vases depict Maya thrones in both interior and exterior locations, and archaeology confirms these locations. Exterior thrones usually were sited so that sitters could view rituals and be the focus of theatrical events (Inomata 2006: 8), and this seems to be the case for the Mercado seats.

Two Classic-period thrones have especially close parallels to the Mercado dais. Copan's Group 8N-11 parallels the hierarchy of seats in the Mercado. This elite nonroyal complex northeast of the Main Group includes a 5.5-m-long bench that occupies most of Structure 66 Central's main chamber (Figure 8.8a). The Skyband Bench, which gave the group its moniker "Skyband Group," features calendrical and celestial themes such as the Sun God and Pawahtuns (Webster et al. 1998: 325–326), and directional-celestial symbols in the form of the sun's day and night aspects relate to the building's alignment with the solar zenith passage (Bricker and Bricker 1999). These themes accord with elevated status, and those seated on the Skyband Bench symbolically occupied "a central and elevated place in the Maya cosmos" (Webster et al. 1998: 340). In contrast, plain benches occupy the smaller framing Structures 66 South and North.[9] However, all of the benches were elite, and location, scale, and adornment—or lack thereof—signified relative status.[10]

The Mercado dais also shares parallels with Palenque Bench 1 (Figure 8.8b). The bench form signifies celestial and political events and beings. The skyband includes a text about a dance that Lord K'inich Janab Pakal performed at his "stone seating" or throne dedication (Stuart 2003: fig. 1) (skybands are discussed in the following section). The bench shape evokes "Starry Deer Alligator," a form of the Cosmic Monster or reptilian that often bears a skyband on its body (Stuart 2003: 2). Starry Deer Alligator's identity is close to the Kawak Monster, it may be associated with the Venus sign T150, and it may symbolize the rising Sun in conjunction with the Quadripartite Monster (Stone 1985:

Figure 8.8. Drawings of benches from Copan and Palenque: *a*, Drawing of "Skyband Bench," Structure 66 Central, Skyband Group, Copan (after Webster et al. 1998: fig. 11a); *b*, Drawing of the left portion of the front face of Bench 1's seat, Palace, Palenque (after Linda Schele, Object number SD-123, Linda Schele Drawings Collection, Foundation for the Advancement of Mesoamerican Studies). The glyph band occupies the place of skybands on other seats. Some of the glyphs on the left and front of the bench form a couplet that can be translated as "passing in the sky, passing in the earth," which describes the "Starry Deer Alligator" aspect of the Cosmic Monster; this parallels Maya images of the vault/arch of the sky, and could reference the Milky Way (Stuart 2003).

47). These brief comparisons display some Classic Maya precedents for the Mercado dais as a throne wherein form and embellishment link the seat and its occupants to heavenly bodies.

Skybands, Time, and Lineage

Like some Late Classic Maya thrones, the Mercado bench and dais/throne included skybands carved into the cornices/taluds, just below the seat.[11] Skybands have great time depth in Mesoamerican art, appearing as early as the Formative period. The most common skyband element is T552 in which the X-composition or crossed-band motif represents the sky and recalls the quadripartite division of the world (Carlson and Landis 1985: 123). The words for "sky" and "four" are near homophones in many Maya languages, and this bolsters associations with the quadripartite universe (Hopkins and Josserand n.d.: 18). Other skyband signs, including the year sign *kin*, Lamat/Venus, and the Sun/sun deity, combine and conflate iconic, calendric, and linguistic references

to planets, maize, and deities (Carlson and Landis 1985), and the standard design format of horizontally arranged signs might reinforce the notion about the regularity of cosmic forces.[12] Susan Milbrath (1999: 79) interprets skybands as representations of the Milky Way, a galaxy prominent in Maya art and a particular focus of Maya cosmology as the physical context for the path of the afterlife, and an epicenter of royal birth and apotheosis.

Skybands can also be read as skyscapes. To the Maya the sky was more than a vista above the horizon—it was the realm of astral elements that were tracked for time keeping, supernatural beings, and forces that were understood as prognostications. Viewing the dais/throne as sky above a mountain leads to the topographical and logographical readings of "sky-mountain" or *k'an witz*, which appears in glyphic form on sculpture and painted vessels.[13] According to Quirigua Stela C's text, creation began with the "manifestation of an image" in the form of a jaguar throne that the Paddler Gods placed at Na-Ho-Chan ("House [or First or Female] Five-Sky") and a snake throne that an unknown god built at Kab-Kah, "Earth-town" (Schele and Villela 1996: 1, fig. 1). Some ceramic inscriptions have longer names for these locales, with Na-Ho-Chan becoming Na-Ho-*Chan-Witz*-Xaman "Female Five-Sky-Mountain-North" (author's emphasis; Schele and Villela 1996: 3, fig. 2b). The Mercado dais/throne thus may recall creation and early deities in addition to more general sky-earth symbolism.

As the most prominent seat in the Mercado and the entire Group of the Thousand Columns, the dais/throne's landscape elements could have performed multivalent roles, representing k'an witz and other symbolic terrain. As landscape referents, they had the capacity to make experiences and their memories more vivid. Operating in both physical and ideational realms, landscape is an effective means to help evoke networks of people, places, and ideas. Inhabiting a landscape can provide more than an awareness of the palimpsest of past human activity, as inhabitation can instill locational and temporal memories, or specific points of access to deep senses of belonging, such as place-memory and time-memory (Chapman 2008: 188).

The Mercado dais/throne skyband is plainer than many other Maya skybands, as it includes only Venus glyphs and plumed serpents. Plumed serpent imagery proliferated in Classic Mesoamerica, and it came to be inextricably linked with the enigmatic deity-ruler Quetzalcoatl, K'uk'ulkan and Gugumatz ("Plumed Serpent" in Nahuatl and Yucatec and K'iché Maya, respectively). All were linked with Venus, the Pleiades, the day Ik,' lineage, political organization, and agricultural fertility (see also Noble 1999: 120–124). In Maya languages the throne also can be understood as "Snake-Mountain" or *kaan witz*, which paral-

lels the symbolic logogram in the *Codex Boturini* discussed above and that the Mexica passed on their travels to Tenochtitlan.[14]

The skyband serpents are evocative in other ways. The Maya generally recognized serpents as means of transformation (Noble 1999: 114). Today some Maya associate serpents with rain, clouds, and lightning, and in ancient art serpents with or without plumes could have symbolized the "recurrent natural processes in the earth, bodies of water, and sky . . . [S]erpent imagery also seems to have been employed as a symbol of transcendence . . . a divine conduit through which priests, aristocrats, souls, ancestors and deities were transported between the natural world and the supernatural otherworld of the gods" (McDonald and Stross 2012: 75).

Astral associations are apparent in the snake rattles on the sides of the dais/throne. The Yucatec Maya word for snake rattles is *tzab*, which is also the name for the time of year when Venus passed by the Pleiades. In the Early Postclassic period when the throne was created, the period of approximate conjunction when Venus passed by the Pleiades fell within a three-month period from spring equinox to the summer solstice (Milbrath 1999: 210). This period forecast the start of the rainy season, so the snake rattles signified rain, fertility, and seasonal change at a specific place and time period.[15]

On all three dais/throne sides, Venus glyphs in the skybands are adjacent to undulating serpent bodies. Milbrath (1999: 193) notes that monuments and buildings marked with star glyphs, such as *chak ek*, are associated with dates or orientations related to Venus events; often Venus was linked with warfare so that a star glyph (T510) placed above a symbol for earth, a shell, or a place name denoted raid. This indicated that, like the sky, Maya landscapes were more than the sum of their physical makeup because they were imbued with supernatural inclinations (see Table 8.1 for more information about astronomical and numerical symbolism).

Rattlesnakes with feathers may also evoke concepts of governance and ancestry. Given the import of serpents in Maya culture, it is possible that serpents on benches referenced "past events of transformation and change that legitimized hierarchically designated authority and the persons who occupied Seats-of-Authority" (Noble 1999: 132). For the more specific Feathered Serpent, the name Kukulcan derives its first syllable from the word *k'uk'*. In Chol Maya this denotes quetzal feathers and in Yucatecan it signifies quetzal (Barrera Vazquez et al. 1980: 420; Kaufman and Norman 1984: 124; Roys 1933; see also Macri and Looper 2003: 94). K'uk' can metaphorically mean sprout or shoot, in the way that a feather grows from a bird's body, and more generally to offspring (Martínez Hernandez 1929: 526).[16] In this vein, the preciousness of quetzal feathers is

Table 8.1. Chart summarizing astronomical and numerical symbolism
of the Mercado dais/throne

VENUS AND THE VENUS CYCLE

Venus signs on the dais/throne are half-Venus signs, each with three lobes and five rays
(Figures 8.6a–c). The Venus cycle consists of 584 days divided into four periods. Two long
periods average 263 days each, when Venus appears as the Morning and Evening Star (Aveni
2001: table 6).

VENUS AND IK'

Ik' is the second day sign in the 260-day *tzolkin* calendar; it is related to the east, black,
ancestors, death, and in many Maya languages it means "wind." According to the Central
Mexican *Codex Borgia* the birthdate of the wind patron, Ehecatl-Quetzalcoatl, is 9 Wind;
the date's Maya counterpart is Ik,' and is related to the emergence of the Evening Star, which
is associated with Kukulcan (Lounsbury 1974: 11; Milbrath 1999: 199, 205). A conceptual
relation is found in council houses and gallery-patios: Ik' is a T-shape, like the footprint of
many gallery-patios; like Ik,' these are associated with ancestors.

FIVE

The north, or front, face of the throne/dais features five Venus glyphs and undulating feath-
ered serpent bodies. The cornice design suggests that the damaged left section included a
Venus glyph, which brings the total to five (Figure 8.6a). Five is the number of Venus cycles
in the Venus almanac, as seen in the *Dresden Codex* Venus pages. Likewise, each Venus
glyph on the throne/dais has five rays.

FOUR

The east and west sides of the dais each feature four Venus glyphs (Figures 8.6b–c). Four
may recall the four phases of the Venus cycle, and together they may recall the eight solar
years, comprised by five Venus cycles, in the Venus almanac (Milbrath 1999: 181, fig. 5.5d).

equal to the preciousness of children (Thompson 1958: 35). Another part of Ku-
kulcan's name, *can* or *chan*, can signify a "tangled bramble" rather than a snake
according to the *Diccionario Maya Cordemex* (Barrera Vasquez et al. 1980: 291).

Contemporary evidence from the 1980s, when Lincoln (1990: 119) was map-
ping Chichen Itza, includes reports from Yucatec Maya living near the site that
when rattlesnakes become 52, a significant number in Mesoamerican calen-
dars, their skin begins to "ruffle" and then resembles and ultimately functions
like feathers, thereby transforming to "feathered serpents" whose bodily sur-
faces resemble the growth of fresh leaves on trees or branches. Lincoln does not
record any ideas about the genesis of this belief, yet he remarks on the evidence
of Maya seeing parallels between the definitions of k'uk,' quetzal feathers, and
vegetation, and concludes that plumed serpents are "based in ideas of kinship

and kingship" (Lincoln 1990: 120). The association of *k'uk'* with lineage predates Chichen Itza, since k'uk' is part of many ruler names in the Classic period, including Palenque and Copan. The Feathered Serpent, then, need not always refer back to Maya religion and mythology and instead can be understood as a process of plant growth and metaphorical human family trees.

Cosmological import is also found in the corbel vault that once enclosed the Mercado gallery. The Maya envisioned profiles of vaulted rooms as portals or open mouths through which the Maize God and other deities moved (Carrasco and Hull 2002). Ethnographic evidence from Maya groups indicates that corbelled roofs reference creation, and this intersects with the reading of the throne as k'an witz. Because Mesoamerican council or lineage houses often had vaulted roofs, they too were symbolically linked with divine origins and this symbolism could have extended to lineages. Because lineage name signs appear on the throne, it is possible that the Mercado served the interests of more than one royal lineage, or hosted elite families.

The geological, astronomical, filial, and royal symbolism of the throne/dais demonstrates a spectrum of symbolism and understandings that may have been apparent to actors and audience members in the Group of the Thousand Columns. What appears to be "just one more bench" at Chichen Itza very probably displayed imagery that was adapted for its specific location, era, audience, and practices. The readings offered here may have implications for understanding other daises/benches at Chichen Itza (Stone 1999), Tula, and coeval sites.

Courts, Choreography, and Color

The Mercado gallery can also be understood by comparisons with court scenes painted on Maya ceramics. In one genre, a lord sits on a throne while courtiers, visitors, priests, and/or captives stand or sit on the floor while gifts, tribute, and ritual items also fill the court area (Figure 8.9). This may parallel some ethnohistoric information that Maya rulers and lineage heads sat on thrones and benches according to hierarchical order (Jackson 2013: 50). Originally the Mercado gallery may have operated as an actual court, with human actors performing some of the roles seen on painted ceramics. As a seat *and* an architectonic landscape visible to the second-largest plaza at Chichen Itza, the Mercado dais/throne and associated rituals plausibly diagrammed basic tenets about the natural and social worlds. Because landscapes have the capacity to make action seem routine, to foster memories, and to help craft identity, they can be understood as "structuring structures."

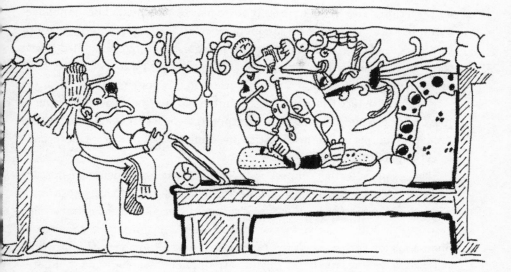

Figure 8.9. Drawing of a detail from a Maya vase that represents a lord on a throne; its profile is similar to the Mercado dais and benches. Unlike many Maya vases that seem to depict a throne with people both in front and back of it, and thus detached from a wall, this one appears to be set against a wall (after K5764).

It is significant that the narrative of bound captives is ever-present in the Group of the Thousand Columns plaza, even when devoid of actors. The cantilevered skyband at the top of the dais/throne highlights the seam between sitter and seat, and plausibly bridged ancestral and present times. The captives depicted below on the talud, named and dressed in the noble warrior garb that was de rigueur at Chichen Itza, may have helped to figuratively transport the narrative to contemporaneous times. When combined with actors, the throne may have explicated shared Mesoamerican themes, such as the divinity of rulers, who could occupy sacred landscapes and whose sanction to rule extended back to primordial times and places, such as *chan witz*. Mythical and geological allusions possibly echoed how the past and present were intertwined.

Related to the vivid presence of landscape is choreography. The relief of bound figures offers one plausible ritual scenario that involved movement, and others no doubt accorded with calendrical and political requisites.[17] Rituals performed in the Mercado surely involved walking, as the imagery, the three gallery stairways, and the proscenium suggest. Many Chichen Itza murals and sculpture, particularly colonnade panoramas, imply individual and group movement. This suggests that, like causeways, colonnades were routes for foot traffic adjacent to and in between pillars that represent priests, elites,

and warriors. The Maya have rich vocabularies and metaphors for movement. In Yucatec Maya, a person literally walks "over" a road or path as opposed to "under" a forest in order to distinguish ordered, inhabited places from untamed ones. The "right road" is a metaphor for a correct path in life, and this trope continues with the phrase "How is your road?" used in the sense of the English "How are you?" (Hanks 1990: 311–312). To modern Maya, movement is a spiritual act that corresponds to heavenly bodies moving on preappointed paths, confirming that movement and time are conceptually intertwined (Keller 2009).

Places and routes that connect places are two basic components of landscape (Tilley 2008: 272). Chichen Itza highlights these features with crisscrossing architectural terraces and causeways. Causeways and footpaths remind us that landscape is often perceived while moving and from shifting viewpoints (see Shaw 2008 for Yucatec roads; see O'Sullivan 2011 for Roman roads, which have parallels with Maya roads; see Ingold 2011 for phenomenology and walking).

While walking through Chichen Itza, where nature was in part remade according to some Maya aesthetic and philosophical notions, it is likely that color symbolism was operational. Red platform surfaces were probably associated with east and white causeways with north and up.[18] The Maya word for causeway is *sak beh*, "white road," which is also the name for the Milky Way, one likely referent of the Mercado dais/throne skyband, and the path traveled upon death. A Classic Maya logographic form of T535, "white," resembles sprouts, seeds, or an unidentified flower. All recall fertility, and connote pale, clouded, a lack of color, shining, and artificiality, the latter regarding a man-made object. Two later meanings, constructed and shiny, reference gleaming white stucco in sunlight and describe the surface of a sak beh (Houston et al. 2009: 13, 21, 72; Tokovinine 2012).

Red, or *chak*, is associated with heat, fire, and the sun. In Classic Maya texts, glyphs for red appear with weather episodes such as lightning and storm clouds, and with the ideas big and intense. The Maya may have preferred red over other colors, perhaps for some of these positive associations and for aesthetic reasons. This may explain why many Maya cityscapes had structures and plaza floors painted red, and red floors and backgrounds of some Chichen Itza wall paintings may have connoted sacred (Houston et al. 2009: 20, 27, 30, 92; Tokovinine 2012). Ruppert (1943: 249) labeled several floor levels in the Mercado gallery near the throne as "red" or "yellowish red," but offered no details about shade or color intensity. Red here probably conjured the idea of sacred space and/or embodied Maya aesthetic preferences.

In addition, sculpted animals populated the curated landscape of Chichen

Itza, as wall paintings of sea life in the Temple of the Warriors (A. Morris 1931: plates 139, 146) and reliefs of owls, eagles, jaguars, monkeys, and coyotes in the Initial Series Group and on the Temple of the Warriors show (Schmidt 2011: figs. 29, 32, 36). It is difficult to walk through Chichen Itza without encountering carved balustrades in the form of the Feathered Serpent. Other three-dimensional carvings, such as the turtle altar in the Initial Series Group, and atlantids and *chacmools*, appear throughout the site (Ruppert 1952: figs. 132, 143d; Schmidt 2011: fig. 37). In addition, sculpted feathered serpent heads framed Sacbe 1, which runs from the northern edge of the Great Terrace to the Sacred Cenote; this transforms the causeway, already symbolic due to its whiteness, into a figurative road. The causeway is almost on axis with Castillo's north façade, whose balustrades are sculpted in the form of feathered serpent heads. Sculpted walls in the shape of feathered serpent heads that were once attached to the northern end of the sacbe were found in the Sacred Cenote. At one time, then, Sacbe 1 was visualized as an enormous feathered serpent with two heads at each end (Pérez de Heredia 2008; Piña Chan 1970).[19]

Reptilian imagery continues on the western rim of the Sacred Cenote, where three frog sculptures rise from the living rock (Ruppert 1952: 8). Frogs are one of the many animals that inhabit cenotes. They provide nighttime symphonies in Yucatan, croaking before and after rainfall, to serenade potential partners and to establish territory. The close location of the feathered serpent and frog sculptures indicates that some nocturnal reptilians punctuated the landscape of Chichen Itza and provided a mirror image of the night sky that is a frequent subject of inquiry.[20]

Instead of imagining how ancient peoples at Chichen Itza might have interacted with the Mercado gallery, one can turn to the disciplines of philosophy, linguistics, and anthropology for direction in understanding performance as extensions of a synchronized inner life. Phenomenology elucidates how people interact with the world, especially through spatial, kinesthetic, and ritual means. Phenomenology is defined here as the practice of "living in the world." A central tenet is that the realm of space, people, and things is experienced via bodies and senses, which in turn inform consciousness and being or the sense of "becoming" that was discussed. In other words, experiences silently work together to form social bodies, memories, and identities. In the absence of written records, archaeologists often turn to phenomenology—along with architecture and imagery—to try and comprehend how individuals and groups intersected with their environment by inhabiting, traversing, building, manipulating, and embellishing natural and cultural places (Joyce 2005: 148, 150; Lesure 2005), and art historians would do well to follow this lead (see Bachand

et al. 2003 and Seamon 2013 regarding phenomenology, architecture, and urbanism; see Bourdieu 1977 for the related practice of habitus).

In addition, movement and body-memory can create and encode awareness through routinized, unselfconscious activity in which literal and physical viewpoints, aesthetics, and space are privileged as active agents. Landscape is the context for spatial practices of the body, and space is so influential that it sometimes is considered to be "alive" (Basso 1996; Hutson 2010; Joyce 2003; and Normark 2006 consider phenomenological approaches to ancient American and Mesoamerican archaeology).

How is phenomenology relevant to the Group of the Thousand Columns? The performative setting that was discussed above regarding scale, palettes, and viewpoints likely presented a view to the plaza akin to that of a stage set. The Maya regularly engaged in a variety of rituals, and it is not difficult to envision actors in the gallery moving in its proscenium-like space. In contrast to the nearby, colossal Castillo, this walled area contained buildings that are more scaled to the human body, and plausibly helped to create a physically comfortable atmosphere for its residents. This small portion of "the least earth," with hierarchical seating in the Mercado that placed elites and rulers in close proximity to both k'an witz and a skyband could reinforce asymmetrical elite status and the privileged place of rulers in Maya society.

Significantly, landscape and the body intersect with some central tenets of the Yucatec Maya language. William Hanks' analysis of modern spoken Yucatecan focuses on the concept of deixis, a linguistic feature and cultural construct that Maya use to locate individuals and objects in space and time. As a relational practice, deixis assumes that a person, usually the speaker, is the center of space; communication orients space according to the speaker and her/his body; and speakers refer to the world via their body and surrounding space, perhaps by the span of an arm's reach. The deictic system that orders speech also organizes many other spheres of life including social organization, domestic space, rituals, agricultural practices, and ideas about the body (Hanks 1990: 5–6, 8, 14). According to Hanks (1990: 520–521), "Few things could be more obvious to a Maya speaker than his or her unreflective ways of occupying communicative spaces . . . language, lived space, and common sense are constructed in the lives of a group of Maya people [in the Yucatec village of Oxkutzcab, where Hanks did fieldwork]."

Spatial analysis is crucial for understanding visual culture. Features of Yucatecan Maya changed at pivotal historical moments such as European contact (Hanks 2010). Because Proto-Yucatecan is evident in ninth-century hieroglyphic inscriptions at Chichen Itza (Pérez de Heredia and Bíró, Chapter 3,

this volume) and some core features of Yucatec Maya society have remained fairly consistent through time, it is possible that the linguistic issues discussed here were understood in some way at Chichen Itza.[21]

Conclusion

Coming to terms with ancient spaces is not a straightforward exercise. To imply that actors and audience would have understood space, architecture, and imagery in lockstep is to oversimplify human experience and the power of landscape. While the designers of Chichen Itza, and specifically the Mercado and its dais/throne, may have attempted to incorporate some basic premises about Maya society, individuals would have reacted according to their individual experiences. A modern analysis cannot help but present an etic viewpoint regardless of attempts to understand and deploy emic constructs. Only in the last century have Western scholars attempted to derive consistent meaning out of visual programs from the past, regardless if they were intended this way (Elkins 1999). Nevertheless, it seems likely that the Mercado was intended to be a multiuse space for visual reference about social mores rather than for visual reverence. In a sequestered setting that echoed natural, cosmic, and royal themes for the upper echelons of Chichen Itza society, the Group of the Thousand Columns and its Mercado afforded a dwelling and stage for political theater that could have evocatively expressed conceptions about the natural and social worlds in a curated landscape that superseded "the least earth."

Acknowledgments

Mark Graham, Mary Pye, and my fellow *Landscapes of the Itza* editors offered comments on this paper. I am especially grateful to Susan Milbrath for reading an early draft and offering many suggestions about astronomy, and to John Justeson for suggesting clarification about the Yucatec and Ch'olan languages as they relate to imagery in the Mercado. Any errors are mine alone. Thank you to Annabeth Headrick for permission to use photographs of the Mercado gallery (Figures 8.3a-b) and to Nikolay Lyutskanov for permission to use his drawing of the Mercado plan (Figure 8.2b). I completed most of the research for this chapter during a 2012 Summer Fellowship at Dumbarton Oaks. The staff, especially Pre-Columbian librarian Bridget Gazzo, was—as always—extremely helpful. The Summer Fellows in Pre-Columbian, Garden and Landscape, and Byzantine Studies likewise provided camaraderie and helpful discussion and feedback.

Notes

1. I follow the chronology that Volta et al. propose in Chapter 2.

2. The 1582 *Motul Dictionary* defines popol nah as a community house where people gather to discuss political affairs and learn to dance for festivals (Barrera Vasquez et al. 1980: 228). *Pop* is part of the title *holpop*, a northern Maya title for "he/lord of the mat," a civic/lineage leader and caretaker or proprietor of the popol nah who led feasts. Guatemalan sources provide similar information for the title *ajpop* and the nimja ("big house"), a building equivalent to the popol nah.

3. These also have parallels to Aztec buildings, such as Tenochtitlan's House of the Eagles, which held elite rituals, including autosacrifice (Klein 1987), prayer, or penitence (López Luján 2006).

4. Dimensions are rounded up or down; dimensions not included here are in Ruppert (1943).

5. Schwarz (2013) discusses the evolution of Maya architecture with C-shaped benches.

6. Evidence for an earlier dais includes construction levels and pottery sherds inside the dais (Brainerd 1958: 37–38; Pérez de Heredia 2010: 398–408; Ruppert 1943: 249–250). Sandra Noble (1999: 55, 77) provides a glossary of Maya seats and thrones and prefers the term "Seat-of-Authority" for the latter. She notes that scholars are inconsistent when identifying benches, altars (E. H. Morris 1931: 71; Schele and Freidel 1990: 365), and thrones (Freidel et al. 1993: 159; Smith 1962: 37) at Chichen Itza.

7. The same is true of coeval benches at Tula (Kristan-Graham 1993, 2015). Instead of positing a Tula- or Chichen Itza–centric model of influence, shared traits of spatiality, architecture, writing, and sculpture are understood as indices of new Epiclassic–Early Postclassic interaction networks.

8. For example, Quirigua Zoomorph P is a mountain-shaped throne (Stone and Zender 2011: fig. 4).

9. Structure 66 North may have been a council house. Structures 66S and 22 may have been related; the latter may have been a council house by virtue of its central location and façade with inscriptions about the 16th Copanec ruler Yax Pas and seated figures that probably were once atop large sculpted glyphs. The figures may depict local ward/lineage leaders whose roles were akin to those of the later holpop, with the glyphs naming places or lineages. Late Classic community leaders with elevated status may have met with Copan rulers in Structure 22, perhaps as a strategy for political unity (Fash et al. 1992; Webster et al. 1998; cf. Wagner 2000).

10. Other Copan benches are embellished with skybands and serpents, for example the El Grillo seat (Noble 1999: 120).

11. A few stones remaining on the bench cornice—including crossed bands and kin glyphs—suggest that they once formed a skyband (Ruppert 1943: fig. 21a). Other skybands at the site are on a stairway near the Southeast Colonnade (Ruppert 1952: fig. 44b), on daises in the Northwest and Northeast Colonnades (Charlot 1931, vol. 1: figs. 255, 257), and on the Monjas façade (Bricker and Bricker 1992: 166).

12. A widespread version of the skyband is seen on parts of the Cosmic/Bicephalic Monster and ceremonial bars. Rulers are often portrayed holding the latter as a sign of their status and abilities, and like a skyband it usually includes a frame, crossed bands, and other celestial signs (Chinchilla 2005: 107, 131; Schele and Mathews 1998: 158–159, 416).

13. I use Yucatec Maya transliteration here for "sky-mountain." The Ch'olan spelling for both "sky" and "mountain" is *chaan* (Justeson 2015b).

14. Three radial pyramids on the Great Terrace are versions of Snake Mountain: the Castillo, the Venus Platform, and the Platform of the Eagles and Jaguars. The Castillo is aligned with the Sun, Venus, and the Pleiades, and the red jaguar throne atop the earlier Castillo-sub links the building with rulership (see Carlson 1993: 209; Coggins and Drucker 1988: 23; Milbrath 1999: 186 for Venus' astronomical aspects at the site, and Miller, Chapter 6, regarding the Castillo throne).

15. At Chichen Itza, images of plumed serpents with rattles also appear on buildings that are oriented toward the Pleiades setting at dusk. These include the Upper Temple of the Jaguars, the Temple of the Warriors, the Castillo, and the Caracol (Milbrath 1988: 70; 1999: 210). As Milbrath points out, these building orientations highlight the connection between Venus, the Pleiades, Kukulcan, and the time of year associated with the coming rains.

16. Interestingly, this definition, and not one related to quetzal, is in the early *Motul Dictionary*.

17. Paintings on the gallery walls, which can be understood as backdrops; above the dais/throne are four over–life-size standing males wearing elaborate costumes (Ruppert 1943: figs. 19–20). Ornate plumed serpents were painted on the wall above the benches. No trace of these paintings remains, and Tatiana Proskouriakoff's painted reconstruction includes few details (Figure 8.3).

18. This basic palette characterized other Maya sites, such as Copan's Acropolis (McVey 1998).

19. The smaller sculpture on the Great Terrace also features the Feathered Serpent, including the Venus Platform, the Upper Temple of the Jaguars, and the Temples of the Warriors and the Big Tables.

20. The word "frog" is part of some rulers' names from powerful sites such as Tikal and Copan.

21. Possibly hieroglyphic inscriptions at Chichen Itza were written in a Ch'olan language, and elites spoke Ch'olan languages. If this is the case, then the words inscribed for sky and snake—chaan for both—would "have been pronounced identically in the 'literary/textual' language . . . the terms could have been connected through something like punning even in Yucatecan, since they were pronounced similarly, but not identically" (Justeson 2015a).

References Cited

Aveni, Anthony F.
 2001 *Skywatchers*. University of Texas Press, Austin.
Bachand, Holly, Rosemary A. Joyce, and Julia A. Hendon
 2003 Bodies Moving in Space: Ancient Mesoamerican Human Sculpture and Embodiment. *Cambridge Archaeological Journal* 13: 238–247.
Barrera Vásquez, Alfredo, Juan Ramón Bastarrachea Manzano, William Brito Sansores, Refugio Vermont Salas, David Dzul Góngora, and Domingo Dzul Poot (editors)
 1980 *Diccionario Maya Cordemex: Maya-Español, Español-Maya*. Ediciones Cordemex, Merida, Yucatan.
Basso, Keith H.
 1996 *Wisdom Sits in Places: Landscape and Language among the Western Apache*. University of New Mexico Press, Albuquerque.
Bender, Barbara
 1993 Introduction: Landscape—Meaning and Action. In *Landscape: Politics and Perspectives*, edited by Barbara Bender, pp. 1–17. Berg, Providence, R.I.

Berlo, Janet Catherine

1989 Early Writing in Central Mexico: In *Tlilli*, In *Tlapalli* before A.D. 1000. In *Mesoamerica after the Decline of Teotihuacan, A.D. 700–900*, edited by Richard A. Diehl and Janet Catherine Berlo, pp. 19–47. Dumbarton Oaks, Washington, D.C.

Bey, George J., III, and Rossana May Ciau

2014 The Role and Realities of Popol Nahs in Northern Maya Archaeology. In *The Maya and Their Central American Neighbors: Settlement Patterns, Architecture, Hieroglyphic Texts and Ceramics*, edited by Geoffrey E. Braswell, pp. 335–355. Routledge, New York.

Bourdieu, Pierre

1977 *Outline of a Theory of Practice*, translated by Richard Nice. Cambridge University Press, Cambridge.

Brainerd, George W.

1958 *The Archaeological Ceramics of Yucatan*. Anthropological Records no. 19. University of California Press, Berkeley.

Braswell, Geoffrey, and Nancy Peniche May

2012 In the Shadow of the Pyramid: Excavations of the Great Platform of Chichen Itza. In *The Ancient Maya of Mexico: Reinterpreting the Past of the Northern Maya Lowlands*, edited by Geoffrey E. Braswell, pp. 227–258. Equinox, Sheffield, England.

Bricker, Victoria R., and Harvey M. Bricker

1992 Zodiacal References in the Maya Codices. In *The Sky and Mayan Literature*, edited by Anthony F. Aveni, pp. 148–183. Oxford University Press, Oxford.

1999 Astronomical Orientation of the Skyband Bench at Copán. *Journal of Field Archaeology* 26: 435–442.

Carlson, John

1993 Venus-regulated Warfare and Ritual Sacrifice in Mesoamerica. In *Astronomies and Cultures*, edited by Clive L. N. Ruggles and Nicholas J. Saunders, pp. 202–252. University of Colorado Press, Boulder.

Carlson, John, and Linda C. Landis

1985 Bands, Bicephalic Dragons, and Other Beasts: The Sky Band in Maya Art and Iconography. In *Fourth Palenque Round Table, 1980*, vol. 6, edited by Merle Greene Robertson and Elizabeth P. Benson, pp. 115–140. Pre-Columbian Art Research Institute, San Francisco.

Carrasco, Michael David, and Kerry Hull

2002 The Cosmogonic Symbolism of the Corbeled Vault in Maya Architecture. *Mexicon* 24: 26–32.

Chapman, John

2008 Object Fragmentation in Past Landscapes. In *Handbook of Landscape Archaeology*, edited by Bruno David and Julian Thomas, pp. 187–201. Left Coast Press, Walnut Creek, Calif.

Charlot, Jean

1931 Bas-Reliefs from the Temple of the Warriors Cluster. In *The Temple of the Warriors at Chichen Itza, Yucatan, vol. 1*, by Earl H. Morris, Jean Charlot, and Ann Axtell Morris, pp. 231–346. Publication 406. Carnegie Institution of Washington, Washington, D.C.

Chase, Arlen F., and Diane Z. Chase

2001 The Royal Court of Caracol, Belize: Its Palaces and People. In *Royal Courts of the Ancient Maya, vol. 1: Theory, Comparison, and Synthesis*, edited by Takeshi Inomata and Stephen D. Houston, pp. 130–167. Westview Press, Boulder, Colo.

Chinchilla Mazariegos, Oswaldo

2005 Cosmos and Warfare on a Classic Maya Vase. *RES: Anthropology and Aesthetics* 47: 107–134.

Chung, Heajoo

2008 Analysis and Interpretation of Chichen Itza Chronology Problem. *Asian Journal of Latin American Studies* 21(4): 113–37.

Coggins, Clemency Chase, and R. David Drucker

1988 The Observatory at Dzibilchaltun. In *New Directions in American Archaeoastronomy*, edited by Anthony F. Aveni, pp. 17–56. Proceedings of the 46th International Congress of Americanists. BAR International Series 454. British Archaeological Reports, Oxford.

David, Bruno, and Julian Thomas

2008 Landscape Archaeology: Introduction. In *Handbook of Landscape Archaeology,* edited by Bruno David and Julian Thomas, pp. 27–43. Left Coast Press, Walnut Creek, Calif.

Deleuze, Gilles

1993 *The Fold: Leibniz and the Baroque*, translated by Tom Conley. University of Minnesota Press, Minneapolis.

Elkins, James

1999 *Why Are Our Pictures Puzzles? On the Modern Origins of Pictorial Complexity.* Routledge, New York.

Fash, Barbara, William Fash, Sheree Lane, Rudy Larios, Linda Schele, Jeffrey Stomper, and David Stuart

1992 Investigations of a Classic Maya Council House at Copan, Honduras. *Journal of Field Archaeology* 19: 419–442.

Fowler, Chris

2008 Landscape and Personhood. In *Handbook of Landscape Archaeology,* edited by Bruno David and Julian Thomas, pp. 291–299. Left Coast Press, Walnut Creek, Calif.

Fox, John W.

1989 On the Rise and Fall of *Tuláns* and Mayan Segmentary States. *American Anthropologist* 91: 656–681.

Freidel, David

1981 Continuity and Disjunction: Late Postclassic Settlement Patterns in Northern Yucatan. In *Lowland Maya Settlement Patterns*, edited by Wendy Ashmore, pp. 311–332. School of American Research and University of New Mexico Press, Albuquerque.

Freidel, David A., Linda Schele, and Joy Parker

1993 *Maya Cosmos: Three Thousand Years on the Shaman's Path*. William Morrow, New York.

González de la Mata, Rocio, José F. Osorio, and Peter J. Schmidt

2004 The Divine Flow: Water Management at Chichén Itzá. In *XVIII Simposio de Investigaciones Arqueólogicas en Guatemala, 2004*, edited by Juan Pedro LaPorte, Bárbara Arroyo, and Héctor E. Mejía, pp. 1–12. Ministerio de Cultura y Deportes, Guatemala City.

Guevarra Chumacero, Miguel

2004 El Edificio 3 de Tula Historia de un Palacio? *Ciencia Ergo Sum* 11(2):1 64–170. Universidad Autónoma del Estado de Mexico, Toluca.

Hanks, William F.

1990 *Referential Practice: Language and Lived Space among the Maya.* University of Chicago Press, Chicago.

2010 *Converting Words: Maya in the Age of the Cross.* University of California Press, Berkeley.

Harrison, Peter

2001 Thrones and Throne Structures in the Central Acropolis of Tikal as an Expression of the Royal Court. In *Royal Courts of the Ancient Maya. Vol. 2: Data and Case Studies*, edited by Takeshi Inomata and Stephen D. Houston, pp. 74–101. Westview Press, Boulder, Colo.

Hendon, Julia A.

2010 *Houses in a Landscape: Memory and Everyday Life in Mesoamerica*. Duke University Press, Durham, N.C.

Hopkins, Nicholas A., and J. Kathryn Josserand

n.d. Directions and Partition in Maya World View. The Foundation Department, Independent Works, Foundation for the Advancement of Mesoamerican Studies. www.famsi. org/research/hopkins/DirectionalPartitions.pdf.

Houston, Stephen, Claudia Brittenham, Cassandra Mesick, Alexandre Tokovinine, and Christina Warinner

2009 *Veiled Brightness: A History of Ancient Maya Color*. University of Texas Press, Austin.

Hutson, Scott R.

2010 *Dwelling, Identity, and the Maya: Relational Archaeology at Chunchucmil*. AltaMira Press, Lanham, Md.

Ingold, Tim

2011 *Being Alive: Essays on Movement, Knowledge and Description*. Routledge, London.

Inomata, Takeshi

2006 Plazas, Performers, and Spectators: Political Theaters of the Classic Maya. *Current Anthropology* 47: 805–842.

Jackson, Sarah E.

2013 Writing as Material Technology: Orientation within Landscapes of the Classic Maya World. In *Writing as Material Practice: Substance, Surface and Medium*, edited by Kathryn E. Piquette and Ruth D. Whitehouse, pp. 45–63. Ubiquity Press, London.

Joyce, Rosemary A.

2003 Making Something of Herself: Embodiment in Life and Death at Playa de los Muertos, Honduras. *Cambridge Archaeological Journal* 13: 248–261.

2005 Archaeology of the Body. *Annual Review of Anthropology* 34: 139–158.

Justeson, John

2015a Personal e-mail, August 10.

2015b Personal e-mail, August 11.

Kaufman, Terrence S., and William Norman

1984 An Outline of Proto-Cholan Onology, Morphology, and Vocabulary. In *Phoneticism in Maya Hieroglyphic Writing*, edited by John S. Justeson and Lyle Campbell, pp. 77–166. Institute for Mesoamerican Studies Publication no. 9. State University of New York, Albany.

Keller, Angela H.

2009 A Road by Any Other Name: Trails, Paths, and Roads in Maya Language and Thought. In *Landscapes of Movement: Trails, Paths, and Roads in Anthropological Perspective*, edited by James E. Snead, Clark L. Ericson, and J. Andrew Darling, pp. 133–157. University of Pennsylvania Museum of Archaeology and Anthropology, Philadelphia.

Klein, Cecelia K.

1987 The Ideology of Autosacrifice at the Templo Mayor. *The Aztec Templo Mayor*, edited by Elizabeth Boone, pp. 293–370. Dumbarton Oaks, Washington, D.C.

Kowalski, Jeff Karl, and Cynthia Kristan-Graham (editors)

2011 *Twin Tollans: Chichén Itzá, Tula, and the Epiclassic to Early Postclassic Mesoamerican World*, rev. ed. Dumbarton Oaks, Washington, D.C.

Kristan-Graham, Cynthia

1993 The Business of Narrative at Tula: An Analysis of the Vestibule Frieze, Trade, and Ritual. *Latin American Antiquity* 4: 3–21.

2001 A Sense of Place at Chichen Itza. In *Landscape and Power in Ancient Mesoamerica*, edited by Rex Koontz, Kathryn Reese-Taylor, and Annabeth Headrick, pp. 317–369. Westview Press, Boulder, Colo.

2011 Structuring Identity at Tula: The Design and Symbolism of Colonnaded Halls and Sunken Spaces. In *Twin Tollans: Chichén Itzá, Tula, and the Epiclassic to Early Postclassic Mesoamerican World*, rev. ed., edited by Jeff Karl Kowalski and Cynthia Kristan-Graham, pp. 429–467. Dumbarton Oaks, Washington, D.C.

2014 The Frame and the Fold: Spatiality and Performance in the Group of the Thousand Columns, Chichén Itzá. Paper delivered at the 79th Annual Meeting of the Society for American Archaeology, Austin.

2015 Building Memories at Tula: Sacred Landscapes and Architectural Veneration. In *Memory Traces: Sacred Space at Five Mesoamerican Sites*, edited by Cynthia Kristan-Graham and Laura Amrhein, pp. 81–130. University Press of Colorado, Boulder.

Lesure, Richard G.

2005 Linking Theory and Evidence in an Archaeology of Human Agency: Iconography, Style, and Theories of Embodiment. *Journal of Archaeological Method and Theory* 12: 237–255.

Lincoln, Charles E.

1990 *Ethnicity and Social Organization at Chichen Itza, Yucatan, Mexico*. PhD diss., Department of Anthropology, Harvard University, Cambridge. University Microfilms, Ann Arbor, Mich.

López Luján, Leonardo

2006 *La casa de las águilas*. Fondo de Cultura Económica, México, Mexico City.

Lounsbury, Floyd

1974 The Inscription of the Sarcophagus Lid at Palenque. In *Primera Mesa Redonda de Palenque*, Part 2, edited by Merle Greene Robertson, pp. 5–21. Robert Louis Stevenson School, Pebble Beach, Calif.

Macri, Martha, J., and Matthew George Looper

2003 *The New Catalog of Maya Hieroglyphs: The Classic Period Inscriptions*. University of Oklahoma Press, Norman.

Martínez Hernández, Juan (editor)

1929 *Diccionario de Motul—Español. Atribuido a Fray Antonio de Ciudad Real y Arte de lengua Maya par Fray Juan Coronel*. Compañía Tiopgráfica Yucateca, S.A., Merida, Yucatan.

McDonald, J. Andrew, and Brian Stross

2012 Water Lily and Cosmic Serpent: Equivalent Conduits of the Maya Spirit Realm. *Journal of Ethnobiology* 32: 73–106.

McVey, Lorraine

1998 A Characterization and Analysis of the Floor Plasters from the Acropolis at Copán, Honduras. M.A. thesis. University of Pennsylvania, Philadelphia.

Milbrath, Susan

1988 Astronomical Images and Orientations in the Architecture of Chichen Itza. In *New Di-*

rections in American Archaeoastronomy, edited by Anthony F. Aveni, pp. 57–79. Proceedings of the 46th International Congress of Americanists. BAR International Series 454. British Archaeological Reports, Oxford.

1999 *Star Gods of the Maya: Astronomy in Art, Folklore, and Calendars*. University of Texas Press, Austin.

Montgomery, John

n.d. The John Montgomery Drawing Collection. Foundation for the Advancement of Mesoamerican Studies, Inc. www.famsi.org/research/montgomery/index.html.

Morris, Ann Axtell

1931 Murals from the Temple of the Warriors and Adjacent Structures. In *The Temple of the Warriors at Chichen Itza, Yucatan* by Earl H. Morris, Jean Charlot, and Ann Axtell Morris, vol. 1, pp. 347–485. Publication 406. Carnegie Institution of Washington, Washington, D.C.

Morris, Earl H.

1931 Description of the Temple of the Warriors and Edifices Related Thereto. In *The Temple of the Warriors at Chichen Itzá, Yucatan* by Earl H. Morris, Jean Charlot, and Ann Axtell Morris, vol. 1, pp. 11–227. Publication no. 406. Carnegie Institution of Washington, Washington, D.C.

Noble, Sandra Eleanor

1999 *Maya Seats and Maya Seats-of-Authority*. PhD diss., Department of Fine Arts, Art History, University of British Columbia, Vancouver. University Microfilms, Ann Arbor, Mich.

Normark, Johann

2006 Ethnicity and the Shared Quasi-Objects: Issues of Becoming Relating to Two Open-fronted Structures at Nohcacab, Quintana Roo, Mexico. In *Maya Ethnicity: The Construction of Ethnic Identity from the Preclassic to Modern Times*, edited by Frauke Sasche, pp. 61–81. Acta Mesoamericana, vol. 19. Verlag Anton Saurwein, Markt Schwaben.

O'Sullivan, Timothy

2011 *Walking in Roman Culture*. Cambridge University Press, Cambridge.

Pérez de Heredia Puente, Eduardo J.

2008 Chen K'u: La cerámica del cenote sagrado de Chichén Itzá. Foundation for the Advancement of Mesoamerican Studies.

2010 Ceramic Contexts and Chronology at Chichen Itza, Yucatan, Mexico. Unpublished PhD diss., Faculty of Humanities and Social Sciences, School of Historical and European Studies, Archaeology Program, La Trobe University, Melbourne.

2012 The Yabnal-Motul Ceramic Complex of the Late Classic Period at Chichen Itza. *Ancient Mesoamerica* 23: 379–402.

Pérez Ruiz, Francisco

2005 Recentos amirallados: Una interpretación sobre el sistema defensivo de Chichén Itzá, Yucatán. In *XVIII Simposio de Investigaciones Arqueológicas en Guatemala 2004*, no. 84, edited by Juan Pedro LaPorte, Bárbara Arroyo, and Héctor E. Mejía, pp. 917–926. Museo Nacional de Arqueología y Etnología, Guatemala City.

Piña Chan, Román

1970 *Informe preliminar de la reciente exploración del Cenote Sagrado de Chichen Itzá*. Instituto Nacional de Antropología e Historia, Mexico City.

Plank, Shannon
 2004 *Maya Dwellings in Hieroglyphs and Archaeology: An Integrated Approach to Ancient Architecture and Spatial Cognition*. BAR International Series 1324. British Archaeological Reports, Oxford.

Roys, Ralph
 1940 *Personal Names of the Maya of Yucatan*. Contributions to American Anthropology and History, no. 31. Publication 523. Carnegie Institution of Washington, Washington D.C.

Roys, Ralph L. (translator and editor)
 1933 *The Book of Chilam Balam of Chumayel*. Publication 438. Carnegie Institution of Washington, Washington D.C.

Ruppert, Karl
 1943 *The Mercado, Chichen Itza, Yucatan*. Contributions to American Archaeology and History, no. 43. Publication 596, pp. 223–260. Carnegie Institution of Washington, Washington, D.C.
 1950 Gallery-Patio Type Structures at Chichen Itza. In *For the Dean: Essays in Anthropology in Honor of Byron S. Cummings on His 89th Birthday*, edited by Erik K. Reed and Dale S. King, pp. 249–259. Hohokam Museum Association and Southwest Monuments Association, Tucson, Ariz., and Santa Fe, N.M.
 1952 *Chichen Itza Architectural Notes and Plans*. Publication 595. Carnegie Institution of Washington, Washington D.C.

Savage, Kurt
 2009 *Monument Wars: Washington, D.C., the National Mall, and the Transformation of the Memorial Landscape*. University of California Press, Berkeley.

Schele, Linda, and David A. Freidel
 1990 *A Forest of Kings: The Untold Story of the Ancient Maya*. William Morrow, New York.

Schele, Linda, and Peter Mathews
 1988 *The Code of Kings: The Language of Seven Sacred Maya Temples and Tombs*. Scribner's, New York.

Schele, Linda, and Khristaan D. Villela
 1996 Creation, Cosmos, and the Imagery of Palenque and Copan. In *Eighth Palenque Round Table, 1993*, edited by Martha J. Macri and Jan McHargue, pp. 15–30. Pre-Columbian Art Research Institute, San Francisco and Metropolitan Museum of Art, New York.

Schmidt, Peter
 2011 Birds, Ceramics, and Cacao. In *Twin Tollans: Chichén Itzá, Tula, and the Epiclassic to Early Postclassic Mesoamerican World*, rev. ed., edited by Jeff Karl Kowalski and Cynthia Kristan-Graham, pp. 113–155. Dumbarton Oaks, Washington, D.C.

Scholes, France V., and Ralph L. Roys
 1968 *The Maya Chontal Indians of Acalan-Tixchel: A Contribution to the History and Ethnography of the Yucatan Peninsula*. University of Oklahoma Press, Norman.

Schwarz, Kevin R.
 2013 Architecture, Materialization, and the Duality of Structure: A Maya Case Study of Structurally Shaped Innovation. *Cambridge Archaeological Journal* 23(2): 307–332.

Seamon, David
 2013 Lived Bodies, Place, and Phenomenology: Implications for Human Rights and Environmental Justice. *Journal of Human Rights and the Environment* 4: 143–166.

Shaw, Justine M.

2008 *White Roads of the Yucatán: Changing Social Landscapes of the Yucatec Maya.* University of Arizona Press, Tucson.

Smith, A. Ledyard

1962 Residential and Associated Structures at Mayapan. In *Mayapan, Yucatan, Mexico,* by H.E.D. Pollock, Ralph L. Roys, Tatiana Proskouriakoff, and A. Ledyard Smith, pp. 165–319. Publication no. 619. Carnegie Institution of Washington, Washington D.C.

Stomper, Jeffrey Alan

1996 *The Popol Na: A Model for Ancient Maya Community Structure at Copán, Honduras.* PhD diss., Department of Anthropology, Yale University. University Microfilms, Ann Arbor, Mich.

Stone, Andrea

1985 Variety and Transformation in the Cosmic Monster Theme at Quirigua, Guatemala. In *Fifth Palenque Round Table, 1983,* edited by Merle Greene Robertson and Virginia M. Fields, pp. 39–48. Pre-Columbian Art Research Institute, San Francisco.

1999 Architectural Innovation in the Temple of the Warriors at Chichén Itzá. In *Mesoamerican Architecture as a Cultural Symbol,* edited by Jeff Karl Kowalski, pp. 298–319. Oxford University Press, New York.

Stone, Andrea, and Marc Zender

2011 *Reading Maya Art: A Hieroglyphic Guide to Ancient Maya Painting and Sculpture.* Thames and Hudson, New York.

Stuart, David

2003 A Cosmological Throne at Palenque. Mesoweb: www.mesoweb.com/stuart/notes/Throne.pdf.

2014 A Possible Sign for Metate. Maya Decipherment: Ideas on Ancient Maya Writing and Iconography, Webblog, Feb. 14, https://decipherment.wordpress.com.

Thomas, Julian

1993 The Politics of Vision and the Archaeologies of Landscape. In *Landscape: Politics and Perspectives,* edited by Barbara Bender, pp. 19–48. Berg, Providence, R.I.

Thompson, J. Eric S.

1958 Symbols, Glyphs, and Divinatory Almanacs for Diseases in the Maya Dresden and Madrid Codices. *American Antiquity* 23: 297–308.

Tilley, Christopher

2008 *Body and Image: Explorations in Landscape Phenomenology 2.* Left Coast Press, Walnut Creek, Calif.

Tokovinine, Alexandre

2012 Writing Color: Words and Images of Color in Classic Maya Inscriptions. *RES: Anthropology and Aesthetics* 61/62: 283–299.

Tozzer, Alfred M. (editor and translator)

1941 *Landa's Relación de las cosas de Yucatán.* Papers of the Peabody Museum of American Archaeology and Ethnology, vol. 18. Harvard University, Cambridge, Mass.

Van Dyke, Ruth M.

2008 Memory, Place, and the Memorialization of Landscape. In *Handbook of Landscape Archaeology,* edited by Bruno David and Julian Thomas, pp. 277–284. Left Coast Press, Walnut Creek, Calif.

Volta, Beniamino, and Geoffrey E. Braswell
 2014 Alternative Narratives and Missing Data: Refining the Chronology of Chichen Itza. In *The Maya and Their Central American Neighbors: Settlement Patterns, Architecture, Hieroglyphic Texts, and Ceramics*, edited by Geoffrey E. Braswell, pp. 356–402. Routledge, New York.

Wagner, Elisabeth
 2000 An Alternative View on the Meaning and Function of Structure 10l-22a, Copan, Honduras. *The Sacred and the Profane: Architecture and Identity in the Maya Lowlands*. Acta Mesoamericana 10, edited by Pierre Robert Colas, Kai Delvendahl, Marcus Kuhnert, and Annette Schubart, pp. 25–49.

Webster, David L.
 2001 Spatial Dimensions of Maya Courtly Life. In *Royal Courts of the Ancient Maya. Vol. 1: Theory, Comparison, and Synthesis*, edited by Takeshi Inomata and Stephen D. Houston, pp. 130–167. Westview Press, Boulder, Colo.

Webster, David L., Barbara Fash, Randolph Widmer, and Scott Zeleznik
 1998 The Skyband Group: Investigations of a Classic Maya Elite Residential Complex at Copán, Honduras. *Journal of Field Archaeology* 25: 319–343.

9

To Face or to Flee from the Foe

Women in Warfare at Chichen Itza

LINNEA WREN, KAYLEE SPENCER, AND TRAVIS NYGARD

During the Terminal Classic and Early Postclassic periods (800–1100), Chichen Itza emerged as a regional capital in the Northern Maya Lowlands.[1] While its control over other polities undoubtedly rested on variable economic, political, religious, and coercive factors, its imagery celebrated the warrior culture as the fundamental factor that sustained the Itza state (for further discussion of Itza conquest and expansion, see Johnson, Chapter 4, and Smith and Bond-Freeman, Chapter 5; also see Headrick, Chapter 7, for a detailed description of the Osario as a monument dedicated to warriors).

The expansion of militaristic images at Chichen Itza in comparison to Classic period Maya sites might be understood in terms of changing patterns of warfare. According to the analysis presented by David Webster (1993, 2000), Maya elites of the Classic period devised ideological charters that defused the terror of war by conducting conflict as specialized and noncompetitive royal displays intended to maintain the balance of power and to legitimize rulership. However, in Webster's view, the environmental and political stresses in the Terminal Classic and Early Postclassic periods caused military constraints to loosen, with the result that warfare became more frequent, more intense, and more lethal.[2] Indeed, monumental art of the Great Terrace of Chichen Itza presents warfare in ways consistent with Webster's theory. Warfare is shown as pervasive involving not only extraordinary numbers of men, but also women who, if Itza, were valorized as warriors and, if not Itza, were sanctioned targets of orchestrated violence and forcible subjugation.[3] This chapter thus examines the representations of women in the art of Chichen Itza in terms of their roles, responsibilities, and responses to war.

Itza Women as Warriors

The inscriptions of Chichen Itza attest to the importance of matrilineal lines of descent. Located principally in the Terminal Classic elite residences and palaces, the inscriptions reverse the more common patrilineal preference found at other Maya sites and instead emphasize statements of maternal ancestry. Nicolai Grube and Ruth Krochock have proposed that the prominent place accorded to some women in the inscriptions was a means by which certain males were linked to the lineage associations and the political sanctions necessary to ascend to power and rule the state (Grube 1994: 326; Grube and Krochock 2011: 170–171; Krochock 2002: 169) (see Pérez and Bíró, Chapter 3, for an analysis of parentage statements of K'ak'upakal).

In contrast to the Terminal Classic residences and palaces, the Early Postclassic structures of the Great Terrace are almost devoid of inscriptions.[4] Instead, the paradigms of state consist of extensive visual programs spread over the architectural surfaces of public structures. These programs, which focus on military and ritual power, are overwhelmingly gendered as male.[5] Rosemary Joyce (2000: 97–117) has discussed the sociopolitical reorganization of Maya society in the Terminal Classic period and has considered the possible overall impact of militarism on the production and performance of gender at Chichen Itza and elsewhere. While earlier Maya societies may have organized gender identities in terms of balanced oppositions (Reilly 2002), complementarity (Joyce 1992, 1996), or fluidity (Looper 2002), the imagery of the Great Terrace suggests that a shift toward dominant and hegemonic masculinities occurred at Chichen Itza.

Masculinity has emerged as a pivotal area in gender studies. Dominant and hegemonic masculinities are terms that refer to idealized forms of masculinities in which elite male groups exercise power over women and subordinate males. These elite males are understood to have internalized a set of core values, often consisting of physical strength, aggression, violence, and courage, which form the basis of masculine scripts of behavior. Dominant masculinities are those forms of masculine behavior associated with male groups who use power in specific settings to control particular interactions and events and to secure compliance and control of other people (Coles 2008, 2009). Like the term "dominant masculinities," the term "hegemonic masculinity" describes a structure of power. However, in hegemonic masculinity ideological compliance plays a larger, more critical role. Cultural discourses are produced that encourage all to consent to and coalesce around unequal gender and social relations. Through ideological domination, hegemonic masculinity legitimates

the patriarchal structure of power and secures its perpetuation (Connell 1987, 1995; Messerschmidt 2010).

While now in widespread use, the concepts of dominant and hegemonic masculinities have been questioned in several key ways. One question centers on whether the concepts adequately account for men's subjectivity and agency or for the context-specific characteristics of social life (Connell and Messerschmidt 2005; Demetriou 2001). Another concern is that masculinity cannot automatically be conflated with male bodies and is therefore not automatically located in men; women can adopt orthodox masculine behaviors (Halberstam 1998). A third objection is that idealized constructions of masculinity do not necessarily correspond closely to the lives of any actual men (Coles 2008). Nonetheless, these concepts have been widely adopted as useful models to understand relations between genders and hierarchies of masculinities and to analyze the institutionalization of gender inequalities and cultural constructions (Messerschmidt 2012).

A large program of relief sculptures in the Lower Temple of the Jaguars (hereafter referred to as the LTJ) exhibits the paradigms of Itza masculinity that operated in Chichen Itza in the Early Postclassic (see Schele and Mathews 1998: fig. 6.14). The LTJ is a single-chambered, vaulted structure dated to the late tenth to early eleventh centuries, or Stage IX in the construction sequence recently proposed by Geoffrey Braswell and Nancy Peniche May (2012). Reliefs displaying rows of warriors, originally painted to enhance their visibility, spread across the interior walls and vault of the structure. The fusion of military power with political authority is indicated by the armed figure represented on a jaguar throne on the vertical axis of the reliefs and by the jaguar throne between the central entrance piers of the LTJ. The inclusion of male and female ancestral creation deities, Pawahtuns, the Maize Deity, and underworld or earth gods on the entrance piers amplifies state authority through the invocation of supernatural powers.[6]

The reliefs of the LTJ suggest that, for elite Itza women, ascendancy might have been achieved through the adoption of a form of femininity defined by its relationship to the prevailing mode of masculine militarism. Raewyn Connell (1987, 1995) has argued that to speak of masculinities is to speak about the practices by which both men and women address gender hierarchy. Kirsten Talbot and Michael Quayle (2010) have argued that the production of hegemonic masculinity requires some kind of "buy-in" from women who can thereby attain privilege and status. Although almost all the militaristic figures depicted in the relief of the LTJ are male, one exception is prominently included. A female, wearing a high-status feathered headdress and snake skirt

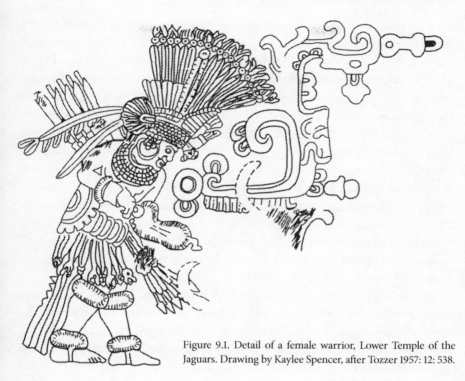

Figure 9.1. Detail of a female warrior, Lower Temple of the Jaguars. Drawing by Kaylee Spencer, after Tozzer 1957: 12: 538.

and carrying weapons typical of an Itza warrior, occupies a position of author-ity on the central axis. Clearly defined bare breasts signal that she is a woman (Wren et al. 2001: 269) (Figure 9.1).

The representation of breasts in Maya monumental art was rare. When shown they did more than simply record female anatomy; rather, they cued symbolic meanings (Houston et al. 2006: 42–43; Stone 2011: 168; Stone and Zender 2011). As Andrea Stone (2011: 168) has argued, the depiction of breasts purposefully "commemorate[d] power, competence, and social bonds associ-ated with women." In the case of the warrior woman represented in the LTJ, the associations of her gender, serpent skirt, and weaponry connect her identity to the Maya Goddess O and to the Central Mexican deity Cihuacoatl (Wren et al. 2001: 269–271), goddesses whose identities celebrate their leadership in warfare, ability to mete out death and destruction, and roles as genetrices in founding narratives. Behind the female warrior, an attendant (who also might be female) holds a bowl of sacrificial hearts and carries an *akbal* pot—a vessel form that references Goddess O's ability to bring forth floods and darkness.

The interrelationship of womanhood and war can be traced broadly in Meso-

american culture, and particularly in Late Postclassic Central Mexico. Cecilia Klein (1994) has noted that the ideal Aztec woman was described as a manly warrior even though the ideal behavior of Aztec women was supposed to be passive and domestic in comparison to Aztec men. Aztec ideology used militaristic terms to define the female roles of procreation. Childbirth was likened to battle—the parturient to an esteemed warrior of the highest eagle or ocelot orders, and her child to a captive (Klein 1994: 140). Women who died in childbirth were accorded an afterlife that approximated that of warriors who had died in battle or on the enemy's sacrificial stone (Klein 1994: 141). Similarly, Aztec ideology used militaristic tropes to describe women's tools of household production. Women's brooms were used ritually in mock battles with male warriors (Klein 1994: 137); women's weaving battens were compared to machetes (Sahagún 1950–1982 [1575–1580]: 29, 141); and women's spindle whorls at Cholula were painted with motifs seen on depictions of Aztec war shields (McCafferty and McCafferty 1999: 118; 2015: 100–101).[7]

As Klein (1994: 142) points out, women's militarism in Aztec culture was nearly always metaphorical. Among the Maya, warfare was also generally defined as a masculine activity. The depiction of the armed woman in the LTJ reliefs may have been the result of the ideological conception of Itza women as warriors in certain roles otherwise gendered as female. However, the relief also raises the possibility that some Maya women went to battle. Evidence from Classic period sites points to exceptional instances in which women were identified as active participants in battle, and sometimes even war leaders (Reese-Taylor et al. 2009). A panel from La Corona, for example, portrays queens traveling in battle palanquins—modes of transportation employed to deliver rulers to combat (Reese-Taylor et al. 2009: 41). Kathryn Reese-Taylor and her colleagues (2009) note that artists at Calakmul, Coba, Naachtun, and Naranjo deployed a well-known visual strategy generally reserved for men when they represented female sovereigns: stelae at these sites portray women as victorious conquerors who tread atop their captives, thus celebrating female military prowess. Two stelae from Naranjo (Stelae 24 and 25), for example, celebrate Ix Wak Chan Ajaw's role as a warrior queen (Reese-Taylor et al. 2009: 54–56). Named and designated as a *kalomte'* (a high-ranking title of authority) and as an impersonator of the Moon Goddess, Ix Wak Chan Ajaw appears on Stela 24 holding a platter containing symbols of bloodletting and wearing the trapeze and ray symbols in her headdress, both of which underscore her connections to warfare (Grube and Martin 2004: 2–46; Looper 2002: 183; Reese-Taylor et al. 2009: 54–44; Schele and Miller 1986: 213; Stuart et al. 1999: 55). The queen's hostage, whose name is inscribed on his torso, assumes a fetal position as the

triumphant queen stands on his back (Reese-Taylor et al. 2009: 55). A carved monument from Tonina more directly testifies to women's engagement with violence. A public altar presents a bare-breasted woman who clutches a man's hair with one hand while wielding an obsidian knife with the other (see Houston et al. 2006: fig. 6.4). Some researchers view the armed woman as Goddess O (or an impersonator of Goddess O), possessing attributes of a warrior (Ayala Falcón 2002: 108; Reese-Taylor et al. 2009: 61) while others see her as a captive in the process of being raped (Houston et al. 2006: 207–208). This interpretation is based on the presence of hieroglyphs marking the woman's thigh in a manner that typically labels captives' bodies, the exposure of the woman's breast, and the general degree of violence characterizing the scene. Both interpretations acknowledge that the woman is shown, at least in the moment depicted, actively participating in a violent exchange.

Women's direct involvement in martial activities is not limited to the Maya region. Parallels can be seen in precontact Mexico. At Teotihuacan the bodies of male warriors and young women were found in the Feathered Serpent Pyramid as part of a mass sacrifice, in which over 200 people perished (Cowgill 2002). The Mixtec codices from southern Mexico also reveal that women not only played pivotal roles in cementing political alliances through marriages, but also ruled kingdoms and waged wars in their own right. The picture writing comprising the Codex Selden/Añute portrays Lady Six Monkey of Jaltepec attacking enemy polities, sacrificing warriors whom she captured in battle, and receiving the chevroned *quechquemitl* (or "cape"), which celebrated and marked her "prowess as a warrior" (Pohl n.d.).

The Warrior Panels of the Upper Temple of the Jaguars

An important cycle of images depicting non-Itza women's experience of war is located on the interior walls of the eastern chamber of the Upper Temple of the Jaguars (hereafter referred to as the UTJ). These murals suggest that, while the militant masculinity of Chichen Itza opened avenues of social ascendancy for at least some Itza women, it also subjected non-Itza women to physical and possibly sexual assault. The murals further suggest that the subjugation of women was regarded by the Itza leaders as an essential outcome of war.[8]

Surviving sections of four scenes depicted in the temple's murals (North, Northwest, Southwest, and South panels) include depictions of women whose settlements are attacked by Itza armed forces and entered by Itza warriors (Figures 9.2, 9.3, 9.4, 9.5). Although not warriors themselves, women, in these scenes, are shown being accorded treatments that parallel those meted out by

Itza warriors to their male opponents on the battlefield. The women, like the warriors of their towns, had to be subdued, and their bodies had to be disciplined in order to assure their compliance to Itza overlords.

Located at the southern end of the east range of the Great Ball Court, almost directly above the LTJ, the UTJ consists of two tandem vaulted rooms connected by a central doorway. Like the rest of the Great Ball Court, the UTJ is

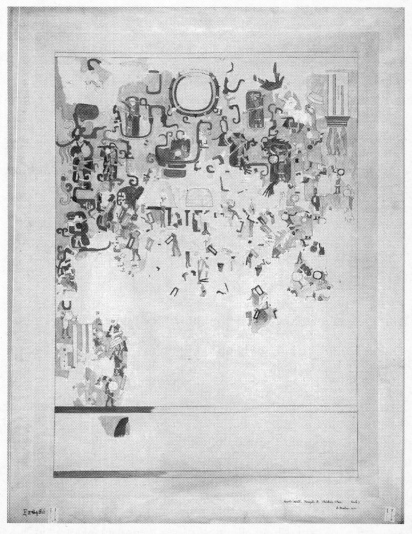

Figure 9.2. North panel, Upper Temple of the Jaguars; watercolor copy by Adela Breton, Ea 8486. By permission of Bristol Museums, Galleries and Archives.

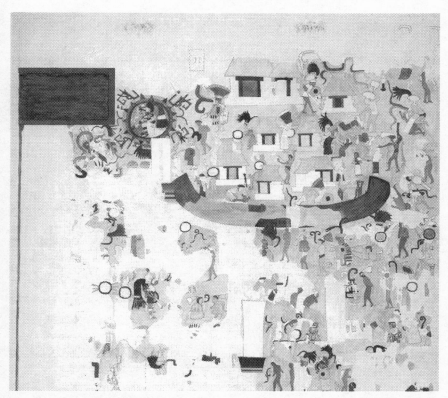

Figure 9.3. Northwest Panel, Upper Temple of the Jaguars; watercolor copy by Adela Breton, Ea 8487. By permission of Bristol Museums, Galleries and Archives.

considered by Braswell and Peniche May (2012: 249–250) to date to the later phase of Stage IX of the Great Terrace.[9] The temple interior is remarkable for the mural cycle of the inner chamber walls, which was documented between 1900 and 1906 by Adela Breton (1907). This cycle is divided into eight large panels. The West panel above the inner chamber entrance consists of a single supine figure in a long jade skirt with paired feather serpent figures rising from its abdomen (Coggins 1984: fig. 19).[10] The same figure reappears in the basal register beneath the double portrait of armed figures occupying the central, or East, panel opposite the entrance. These figures, identified by Arthur Miller (1977) as "Captain Sun-Disk" and "Captain Serpent," are closely related in iconography to the paired figures carved on the wooden faces of the inner doorway lintel, and on a table top, found in fragmentary condition, in the outer chamber.[11]

As many scholars have observed, the murals of the UTJ almost certainly

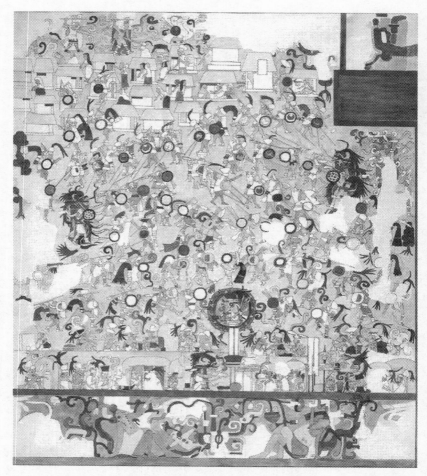

Figure 9.4. Southwest Panel, Upper Temple of the Jaguars; watercolor copy by Adela Breton, Ea 8481. By permission of Bristol Museums, Galleries and Archives.

represent semimythologized historical battles important to the Itza leadership at Chichen (Coggins 1984: 157; Finegold 2012: 176–191; Freidel et al. 1993: 377; Miller 1977; Ringle 2009: 21–22; Schele and Mathews 1998: 240; Tozzer 1957: vol. 11, 176, 181).[12] These scenes evidently represent a series of discrete conflicts fought in different terrains by Itza warriors against discrete enemies. In the conflicts of the Northeast (Coggins 1984: fig. 17), North (Figure 9.2), Southwest (Figure 9.4), and South (Figure 9.5) panels, the Itza opponents are distinguished from the Itza by distinct costumes and/or weapons. In the conflict in the Northwest panel (Figure 9.3), both warring armies wear the

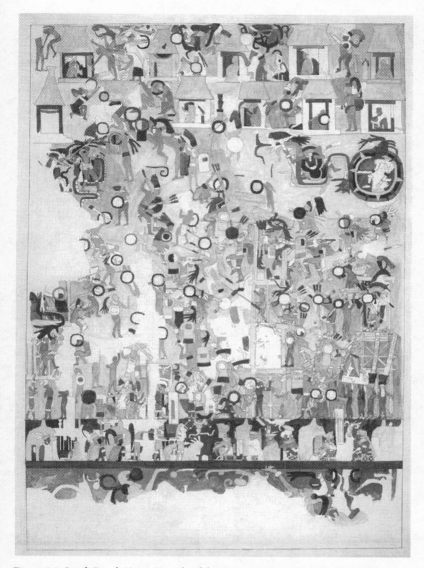

Figure 9.5. South Panel, Upper Temple of the Jaguars; watercolor copy by Adela Breton, Ea 8482. By permission of Bristol Museums, Galleries and Archives.

attributes characteristic of the Itza, an indication that conflict between Itza factions did occur. The remaining mural panel, the Southeast panel (Figure 9.6), does not directly represent a combat zone but does include several Itza warriors in bellicose postures. We will refer to these murals together as the Warrior Panels.

Figure 9.6. Southeast Panel, Upper Temple of the Jaguars; watercolor copy by Adela Breton, Ea 8483. By permission of Bristol Museums, Galleries and Archives.

The Warrior Panels are organized according to a narrative structure that condenses Itza warfare into a few key moments of conflict, conquest, and resolution.[13] These moments are shown within a multiscenic compositional format using a system of vertical oblique projection. Horizontal space is flattened into a single vertical plane, thereby allowing diachronic moments in time to be presented synchronically within a single pictorial field. With the exception of the Northeast and Southeast panels, the Warrior Panels each show three temporal events. A battle scene is placed in the central visual zone; a village conquest is placed above and an encampment scene of victorious Itza chiefs and their captives is placed below. All subjects are shown in the same scale regardless of their distance from the viewers.

Created in a specific Itza architectural setting that required elite Itza sponsorship, the Warrior Panels undoubtedly were intended to inculcate their view-

ers with Itza ideology of war and state. However, as active agents, viewers could be expected not only to respond passively to the murals, but also potentially to construct varying meanings according to time, circumstance, and individual experience. By coding meaning in visual structures of composition and culturally shared systems of signs, symbols, and narrative, the patrons of the Warrior Panels sought to constrain the range of meanings available to viewers and to reinforce their intended message.[14]

Viewers of the Warrior Panels

Who were those viewers? The small size of the interior chambers of the UTJ, as well as their elevated location on the east range of the Great Ball Court, indicates that access into the structure was restricted. The figural reliefs on the outer and inner jambs of the UTJ (Maudslay 1889–1902: vol. 3, plates 36–38) depict sixteen Itza warriors entering the structure. Their presence suggests that the viewers were likely to have been Itza warriors who entered singly or in small selective groups to acknowledge their allegiance to their rulers, who would have been seated on a table found in the outer chamber. The density of visual information in the Warrior Panels would have suggested the credibility and authenticity of the depictions to viewers. Although innumerable Itza warriors are depicted in the murals, each warrior is individualized by costume attributes including clothing types, headdresses, back racks, cloaks, and arm and leg bands. Some warriors wear body paint; others are paired with serpent forms or with military standards. Despite the level of detail in these representations, the murals should not be read as unmediated transcripts of events. Instead, these panels appear to be re-creations of story lines: their plots would have established expectations for how particular types of real-world events ought to unfold; their narratives would have enabled viewers who were themselves warriors to adapt the chaos of battle and the incongruities of events into coherence; their context would have encouraged viewers to connect individual psychological realities with cultural paradigms and to incorporate their personal memories into collective meanings; their thematic repetition would have instilled desires, goals, and behaviors for how their viewers should and must behave in future events; and their authority would have been reinforced by the cosmological framework of underworld and solar symbols in the lower band and the battle scenes.[15]

Simultaneously proclaiming the inevitability of Itza victory, the murals would also have recorded Itza perceptions of the identities of the populations, male and female, whom they conquered. In viewing the depictions of combatants in the murals, the Itza warriors would have been able to examine detailed depic-

tions of individualized warriors—non-Itza as well as Itza. The intense interest in costume and weaponry distinctions indicates that viewers were keenly interested in differentiations of military rank and in emblems of military success.

In contrast, viewers were presented with nonspecific depictions of women. While the costumes of their defending armies differ, and even the architectural styles of their settlements are distinct, the women are depicted as a universalized type. Women are distinguished from men by their long skirts, waist length *jipiles*, and head coverings over their hair and neck but they are shown without personal or communal distinctions in clothing. The color palette is restricted to blue, red, and white; attributes of individual identity and emblems of status and prestige, such as jewelry, body tattoos, and clothing elaborations, are absent. The mural templates of the UTJ present the identities of males and females in differing ways suggestive of the role of warfare in creating hierarchies of status and power.

Parallels for such hierarchies can be found elsewhere in Mesoamerica. In studying the Aztec state, June Nash (1978) has argued that male specialization in warfare and the resultant predatory conquest transformed a kinship-based society into a class-structured empire. Supported by an ideology of male dominance, the Aztecs defined hierarchies of privilege and wealth from which women were progressively excluded (Nash 1978: 350). The contrast between men and women, in Itza renderings, indicates that such a process was under way in the Itza state of Chichen and that it shaped the Itza perceptions of and models for the communities being brought under Itza influence. The differential treatment in male and female depictions in the Warrior Panels suggests that viewers regarded hierarchies among male warring classes, non-Itza as well as Itza, as critical markers of identity and role while simultaneously considering women in communities under Itza siege as undifferentiated.

The Warrior Panels would also have provided their viewers with generalized templates for sanctioned military actions on the battlefield toward combatants, and, in conquered settlements, toward noncombatant women. They may also have functioned to increase the willingness of their viewers to fight in future conflicts despite the terrifying memories that must have been ingrained in individual warriors.

Fought in intimate contact with their enemies, the battles of the Itza are represented as situations of extreme hazard. The weapons used by warring Itza groups in the UTJ included longer range weapons, such as *atlatls* and darts, and close-range weapons, such as knives and curved and spiked clubs. The close hand-to-hand combat represented in the UTJ would have resulted in the maiming and deaths of combatants. While it is impossible to gauge with any

certainty, we can speculate that the mayhem and bloodshed resultant from combat in such close quarters may have caused psychological trauma, as well as physical risk, to even the most successful of Itza warriors.

As we have learned from modern studies of combat veterans, war is deeply traumatic to most soldiers (Horgan 2012: 58). Approximately one-half of soldiers in modern wars urinate or defecate on the battlefield and a high proportion suffer emotional breakdowns after war. Although many soldiers report feeling exhilarated initially upon killing an enemy, they frequently experience profound revulsion and remorse later (Grossman 1996: 241–245). In battle situations, soldiers are more likely to inflict mortal injuries on opposing forces if they perceive their reputations to be at stake and if they have high regard for their comrades. In addition, they are most likely to obey commanders who are close at hand in battle, intense in their conduct, regarded as legitimately authoritative, and perceived as making socially sanctioned demands (Grossman 1996: 144–145). Nonetheless, polling of 400 companies of infantrymen who had fought in Europe and the Pacific during World War II revealed that the resistance to killing can be very great. This polling was conducted by Samuel Marshall, a World War I combat veteran in the U.S. Army and an official Army combat historian during and after World War II. Marshall reported that only 15 to 20 percent of the veterans fired their weapons directly at their enemies in combat even when ordered to do so; the majority chose to fire harmlessly into the air in a posturing mode; many took pride in never having deliberately aimed a lethal shot in battle (Grossman 1996: 15–16; Horgan 2012: 58–62).[16]

Documentation on warfare patterns in Western traditions dates as far back as ancient Greece and suggests that the reluctance to kill has been widespread and continual. To avoid causing death to their opponents, soldiers have preferred to use nonlethal tactics such as wearing intimidating military costumes, yelling or frightening their enemy out of their positions, and pushing, shoving, and otherwise driving the enemy into flight. The majority of casualties have traditionally been inflicted on enemy forces not in face-to-face encounters but in pursuit, after one side or the other has lost the battle (Grossman 1996: 5–28). The results compiled by Marshall from his polling led the U.S. Army to revamp its training in order to overcome the resistance to kill. Changes include greater reliance on long-range weapons, targets that have human shapes with hearts and heads, shooting drills with officers insistently shouting the command to kill, and propaganda that glorifies the soldier's cause and that dehumanizes the enemy (Grossman 1996: 249–261; Horgan 2012: 58–61).

Desensitization to slain opponents may have been a visual strategy in the mural programs of Chichen Itza. While the Warrior Panels do not exhibit

maimed or dead warriors, corpses are represented in the murals of the Temple of the Warriors (Morris et al. 1931: vol. 2, plate 144). Blood flows in three streams from a wound just below the left ear of one figure, shown sprawled on the ground, his death probably caused by the warrior shown to his left. The mutilated chest of another figure, a prone naked male, indicates that his death was caused by, or followed by, heart excision—the same means of inflicting death shown in a ritual depicted above the inner lintel. Forms of sacrifice depicted after warfare may have also been employed to overcome the reluctance to kill. The presence of a hemispherical heart excision stone at the Great Ball Court of Chichen Itza indicates that this form of sacrifice, as well as decapitation rituals, was practiced as part of ballgame rites (Wren 1991).

Non-Itza Women as Targets of State-Sanctioned Violence

The Warrior Panels in the UTJ are among the most informative sources in terms of strategies of battle employed by Itza warriors against enemy armies. In addition, they reveal that Itza strategies of battle included actions toward noncombatant women who inhabited the conquered settlements. Within the scenes of settlement conquest and pacification, space and architecture are condensed and stacked in nonnaturalistic ways that compressed many incidents—almost certainly occurring at different temporal moments and varied locations—into a single viewing panel.

The murals consistently link women with domestic settings by depicting them in or near constructed environments. The murals further represent some women as remaining within their residences as Itza warriors enter their villages.[17] Yet other women are shown in attempts of physical flight, sometimes acting in small groups of two or three, and sometimes gesturing in assistance to other women.[18] Dynamic body positions suggest their hasty departure, an interpretation supported by the presence of small bundles packed and tethered to the backs of four women. In the village scene in the Southwest panel (Figure 9.8), one blue-skirted woman signals the direction of escape to women behind her. Her extended arm and pointing hand indicate the direction that she is going and urges others to follow. A woman below her raises her hand to her forehead, expressing her dismay. Another woman shown in the same scene, wearing a blue jipil and white head covering, raises her hand to her face in an expression of grief. While rarely depicted in the imagery at Chichen Itza, the hand-to-forehead and hand-to-face poses are well documented in sculpture and ceramics in the southern lowlands during the Late Classic Period, where they can be seen in depictions of captives as they are presented as booty to an

elite lord or in contexts of imminent doom.[19] Nearby, a woman in blue head covering and red skirt twists her torso to look behind her. Her feet point to the left, and her head faces to the right. Such a dynamic pose suggests that she may have paused, perhaps in midflight, to gesture to a woman who is shown seated in her residence patio and who is seemingly unaware of an approaching warrior. A similar scene of a woman pausing and pointing to share information about danger, and by implication to direct another woman to safety, is depicted in the village scene in the Northwest panel (Figure 9.9). She is surrounded by warriors, but the direction of her feet suggests that she is trying to flee in the

Figure 9.7. Detail, South Panel, Upper Temple of the Jaguars; watercolor copy by Adela Breton, Ea 8482. By permission of Bristol Museums, Galleries and Archives.

Figure 9.8. Detail, Southwest Panel, Upper Temple of the Jaguars; watercolor copy by Adela Breton, Ea 8481. By permission of Bristol Museums, Galleries and Archives.

direction of fewer attackers. These gestures and extreme poses are not found in the ceremonial reliefs at Chichen Itza and are distinctive to scenes of women in warfare.

In studying everyday life among the farm families of Chan Noohol in Belize, Cynthia Robin has noted that domestic, as well as agricultural, activities were largely undertaken in outside spaces (2002: 256–259; 2003: 328; 2004: 163–164). Because spaces were not rigidly divided or enclosed, communication and interaction between persons working in these activities was facilitated, and working emphasized collaborative efforts between members of the community. In his excavations in the Monjas Complex at Chichen Itza, John Bolles (1977: 234) also found evidence of working spaces shared by women at Chichen for domestic activities, particularly of food preparation and textile weaving. Lynn Ruscheinsky (1996), in her more recent analysis of gendered spaces in the Monjas, has also pointed to the prevalence of artifacts associated with female occupations clustered in specific areas of the Monjas, particularly the East Court of the East Building.

The escape of women from the Itza warriors in the Warrior Panels is hindered by their gendered form of dress. Disadvantaged by their long skirts, the women cannot run. In contrast, the warriors in the UTJ are shown with little clothing around their lower torsos and legs. Their knees are bent and feet splayed, indicating forceful action. Such forcefulness was a necessity for a successful warrior, since the use of handheld weapons required kinetic energy as well as muscle force. A study of anatomy and physiology undertaken by Simon James (2010: 45–48) reveals that in some ways the human body is astonishingly resilient. While blunt-force assaults against the skull can cause incapacitating concussion or more serious brain injury without actual skull fracture, they require powerful impacts to be effective. Similarly, while a small piercing wound is enough to kill if in the right place, a sharp-force attack has first to pierce the skin. Because the deep elastic layer of the skin strongly resists weapon thrusts, sharp-force attacks require very sharp points and edges and/or sudden and powerful impacts to penetrate the skin. Thus, the same military clothing style that facilitated the kinetic force of Itza warriors against their combatants also advantaged them in hindering the flight of noncombatants.

The escape of women is further hindered in many instances by the burdens they carry on their backs, as previously mentioned. A blue-skirted woman in the upper section of the South panel (Figure 9.7) ties the cords on a white cloth bundle on the ground in front of her. In the Southwest panel (Figure 9.8), three women carry white cloth bundles strapped on their backs, and a fourth woman carries a blue bundle on her back.

Figure 9.9. Detail, Northwest Panel, Upper Temple of the Jaguars; watercolor copy by Adela Breton, Ea 8487. By permission of Bristol Museums, Galleries and Archives.

Although not revealed to viewers, bundles presumably would have held varied contents. As well as containing practical supplies for flight and valued economic commodities, the bundles might well have included the most important ritual objects associated with household authority and polity legitimacy.[20] At sites including Palenque and Yaxchilan, bundles are shown in Classic period monuments as symbols of authority in which implements of rulership and the regalia of patron deities were concealed. Ancestral remains were also bundled, a practice that cross-cut all levels of society and was conceptually linked to themes of lineage continuity and ancestor worship (Guernsey and Reilly 2006: vi–x). Functioning as legitimating devices within individual communities and between various lineage groups, bundled ritual objects would have been sources by which non-Itza populations might have resisted Itza ideology. A mural in the Temple of the Warriors (Morris et al. 1931: vol. 2, plate 159) includes a ritual building with an overarching feathered serpent as well as Itza warriors patrolling the village from canoes. Itza conquest may have included the imposition of Itza ideology in the form of the Feathered Serpent cult (Ringle 2004). If so, the survival of ritual objects, even in households ex-

iled from their communities, could have also been perceived as significant by the Itza as sources of significant threats to their authority.

In the Warrior Panels of the UTJ, the flight of women is halted by Itza warriors. In the South panel (Figure 9.7), an Itza warrior stands in a dominant position over a crouched woman and man. The woman indicates her submission to their new Itza overlord by raising her hand to her forehead. In the Northwest panel (Figure 9.9), women are the targets of extreme and deliberate violence. Itza warriors are shown raising their weapons to numerous struggling women. One woman, shown wearing a blue skirt, is held by the hair by a club-wielding warrior. Near her a woman, wearing a blue skirt and red jipil, is shown in a prone position, her knees bent and her arms stretched out to the ground as if she has struggled to protect herself from a sudden fall. She appears to be twisting her face away from her attacker as she is about to receive a blow from his club. Between these two women, a poorly preserved figure, shown prone on the ground with exposed, extended limbs and traces of blue and red fabric, may represent a woman.[21] Included in this group are at least two women who are shown being pushed to the ground by the Itza warriors behind them. Although their bodies have been stripped naked in a manner similar to male war captives, the women still wear the fabric head coverings distinctive to their gendered costumes. That violent death that could be meted out to women, as well as to men, is explicitly depicted in the Temple of the Warrior in the figure of a prone naked woman whose body is smeared with blue paint as a death symbol (Morris et al. 1931: vol. 2, plate 144).

Scenes in the Warrior Panels that depict women and their communities can be classified together as recurrent narrative units within the larger framework of Itza militaristic and hegemonic ideology.[22] Although particular details differ, each scene depicts both the problem posed to Itza warriors by recalcitrant populations and the resolution achieved through physical subjugation by Itza warriors of noncombatants. As a narrative unit within the mural cycle of the UTJ, the scenes insist that military conquest includes the forceful pacification of women in their communities. This raises the question of what benefits accrued to Itza warriors and to the Itza state through the treatment of women represented in the Warrior Panels. We propose that those benefits were multiple.

One benefit that accrued to the Itza state would have been the acknowledgment of Itza overlordship on the household level within defeated communities. Battles describe volatile times not only when political orders are restructured, but also when personal lives and social orders must be restructured. In recording the emotional nexus of women's responses, including fear, worry, and distress through the depiction of exclusively female hand and arm gestures,

one intent of these scenes might have been to reiterate for their Itza viewers that conflict and conquest had to be played out across personal and social, as well as political, boundaries. The settlement scenes seem to acknowledge that armies alone do not govern, that the defeat of opposing armies was necessary but insufficient, and that, to achieve Itza objectives, the population must be subdued. The Temple of the Warriors depicts a coastal settlement that is apparently under surveillance by Itza warriors who are traversing its shores in canoes (Morris et al. 1931: vol. 2, plate 159). The overall compliance apparently accorded by the populace to the Itza presence must have been an appreciable benefit. The banners in the upper left can perhaps be read as a list of tribute that the Itza state extracted from the village in this scene.

A second benefit that accrued to the Itza state would have been the acquisition by Itza elites of women's labor within defeated communities for food production. Women's labor was an essential asset in food production, a role referenced in the Southwest panel by the red-skirted woman who offers a bowl to the seated males in an adjacent domicile (Figure 9.8). Another woman involved in food preparation is shown in the Southwest panel within the Itza military camp (Figure 9.4). Her identity as a woman of the defeated settlement is indicated by the architectural style of the structure at which she works—a structure that is represented in the style of the distant conquered site rather than the style of the Itza encampment. The role of women in food production is further referenced in the Southeast panel by the kneeling woman shown in the curtained entrance of a domicile (Figure 9.10). She directs the attention of the standing male to a cacao vessel by pointing with her finger; a prominent blue bowl filled with *wah* bread is placed in front of her.

Women's labor was also an essential asset in textile production. Cloth was a source of social prestige and negotiable wealth in Mesoamerica (Hendon 1999, 2006). Landa (Tozzer 1941: 26) states that cloth was given to Maya lords as tribute in the Postclassic period. Cloth played an important role in the Aztec political economy and was a key item in the presentations of goods from the *tlatoani* to the elite lords and warriors (Brumfiel 1987, 1996). The abundance of cloth incorporated into the costumes of the warrior class, as represented across the reliefs of Chichen, attests to similar importance in the Itza capital.

A third benefit that accrued to the Itza state would have been the acquisition by Itza elites of local women as founders of new lineages. *The Book of Chilam Balam of Chumayel* narrates the migration of the Itza Maya from the east coast of Yucatan to Chichen Itza. At the town of Ppoole (Pole of Xcaret), the Itza reportedly took the local women "as their mothers," an action that increased their numbers and therefore has been interpreted as a reference to the formation of

Figure 9.10. Detail, Southeast Panel, Upper Temple of the Jaguars; watercolor copy by Adela Breton, Ea 8483. By permission of Bristol Museums, Galleries and Archives.

sexual unions (Folan 1969: 183; Roys 1933: 4). Sexual violence is also suggested in groupings of Itza warriors and women in a detail of the Northwest panel (Figure 9.9). Two figures, both identifiable as women by their white head coverings, are shown kneeling on the ground. One woman, stripped of her clothing, has been pushed forward to her knees by a warrior wearing a feathered headdress and cloak. He raises his knee to the small of her back as he bends toward her. Another kneeling woman, also stripped naked, turns her head toward the Itza warrior who pushes her shoulders to the ground. Three other naked figures, whose genders cannot be determined, are shown in close proximity to residences. These figures suggest that the unions between Itza men and local women may have been, in instances of warfare, coerced. According to complaints heard by the Spaniards, women of conquered cities were taken as seized captives and made available to sexual demands of Aztec warriors (Nash 1978: 358).

Several attempts have been made to read the order of the battle murals. In contrast to earlier scholars, we propose that the first mural in the sequence is the East mural (Coggins 1984: fig. 17) with its double portrait opposite the chamber entrance. Moving in the counterclockwise direction of Mesoamerican ritual, the battle murals would have begun with the Northeast mural (Cog-

gins 1984: fig. 17). The final mural would have been the Southeast mural (Figure 9.6).[23] We interpret the panel as representing a settlement pacified by Itza warriors and brought within the Itza influence sphere. One house includes a view of a woman, who again wears the standardized clothing of the village women in the battle murals. This woman bends deeply at the waist as one of two men behind her points to the ground (Figure 9.10). Her submissive pose in a noncombatant setting of an Itza settlement suggests that still another resource acquired by Itza men was women who were pacified as wives and who were now functioning as their new lineage founders.

Culturally important messages are often communicated in multiple media. Rather than being contradictory, messages conveyed through multimodality can be interpreted as complementary, none complete but each implying the other (Ashmore 1989; Preziosi 1979; Rapoport 1982). In the hieroglyphic texts of Chichen Itza, women are mentioned prominently as mothers and grandmothers of lineage leaders (Krochock 2002). In the relief imagery of the LTJ, an Itza woman is shown as an honored participant in an important military ceremony. This woman represented conceptualized ways in which females could achieve status within the militant masculinity of Chichen Itza. In the murals of the UTJ, the non-Itza women are shown as targets of conquest. We suggest that these women controlled resources of labor and ritual implements that Itza rulership sought to appropriate for the gain of elite warriors and for the advantage of the state. Because they controlled important resources of household production, ritual authority, and sexual reproduction, the control of non-Itza women was an acknowledged aim of Itza militarism. The open portrayal of coercion hints at the independent capacities of women to exercise noncompliance and possibly to maintain household authority and legitimacy in resistance to Itza control. As such, the combined imagery of the LTJ and UTJ functioned together to illustrate the varying ways by which the dominant masculinities of the Itza statehood constructed the lives, roles, and conceptual understanding of women.

Acknowledgments

We would like to thank Cynthia Kristan-Graham and Cecelia Klein for their helpful comments on our paper. We owe a debt of gratitude to Sue Giles, Senior World Cultures Curator at the Bristol Museum and Art Gallery, for generously sharing her time and expertise with us. We also thank our institutions, Gustavus Adolphus College, Ripon College, and the University of Wisconsin-River Falls, for their support.

Notes

1. See Chapter 2, Volta et al. for more information about the chronologies at Chichen Itza.

2. In analyzing the differences between Classic period Maya and Terminal Classic Itza weaponry, Ross Hassig notes that the greater diversity of the former suggests individuals owned their weapons and that the greater emphasis was on individual rather than group combat. In contrast, Itza weapons were more standardized. This has led Hassig to argue that Itza combat was state-organized (1992: 76, 114).

3. Cranial and projectile injuries consistent with warfare are noted for women throughout the Preclassic through Postclassic periods, although differences in the frequencies of such injuries indicate that men were engaged in violent activities more frequently than women (Serafin et al. 2014: 147).

4. An exception is the inscription on the Great Ball Court Stone (Wren 1991; Wren et al. 1989).

5. Alfred Tozzer (1957: vol. 11: 148–184) divided male soldiers into dualistic categories of Maya and Toltec. This division has been rejected by Linnea Wren (1984) and Edward Kurjack (1992), both of whom have noted that no set of costume attributes of Chichen warriors is clearly identifiable as a distinct marker of ethnicity. Instead, as Travis Stanton and Tomás Gallerta Negrón argue (2001), Chichen representations suggest social plasticity between multiple elite factions.

6. Joyce (2000: 102) points out that male-female complementarity between supernatural beings is evidenced in the reliefs flanking the central entrance of the LTJ.

7. However, as Klein (1994: 141) notes, the "ideological parallel between the domestic, reproductive woman and the militarily successful man was intrinsically asymmetrical and fictive." Similarly, June Nash (1978: 356) has observed that the tools and raw materials used by women in domestic tasks such as weaving were often metaphors for subordination and humility.

8. James C. Scott (1987) has studied commoners' resistance and has demonstrated how nonelites who are seemingly powerless can sabotage the policies of the elites in repressive societies and influence policy. Thus subjugation of noncombatants can be viewed by the victors as a necessary outcome of a successful war.

9. Marvin Cohodas (1978: 289) proposed a much earlier date for the Great Ball Court complex.

10. Clemency Coggins (1984: 164) identifies this figure as a "Mother Earth" motif while Linda Schele and Peter Mathews (1998: 236) identify this as the sacrificed Maize God.

11. A. G. Miller (1977) further proposed that the paired figures were emblems of the Maya/Toltec factions at Chichen Itza. William Ringle (2009) suggests that "Captain Serpent" represents the highest political office at Chichen Itza and that "Captain Sun" represents an initiate into political office.

12. Similar scenes evidently once covered the walls of the outer chamber, although the collapse of the front façade of the UTJ resulted in their loss prior to nineteenth-century documentation at Chichen Itza. Adela Breton (1907) reports that she could identify round shields on still-surviving painted fragments of the outer chamber walls.

13. Werner Wolf (2003) has discussed visual forms as nonverbal means to express narratives. In his view, visual narratives have the potential to enable viewers to relive and make sense of past experiences while simultaneously archiving them for future analysis.

14. The importance of the viewers as active agents whose responses are integral to the meaning of artworks is discussed by theorists such as Wolfgang Iser (1978) and Stanley Fish (1980).

15. Important aspects of narrative have been the focus of recent studies to which we are indebted. These include Roland Barthes (1990: 9) who has emphasized the omnipresence of narratives around us, conveyed in countless ways—stories, myths, histories, even gestures; and Tzvetan Todorov (1993: 30) who has argued that successful narrative has two basic principles, "succession" and "transformation," which are combined to form a coherent whole. According to David Herman (1997: 1046), narrative is effective when it triggers the audience's "experiential repertoires." Through this means, the narrative enables its audience to gain knowledge by relating to past experiences.

16. Not all combat historians have agreed with Marshall (Spiller 1988). Polling results can be skewed by many factors because respondents may choose to misrepresent themselves. It is possible that some soldiers may have minimized their combat actions in order to integrate more successfully into peacetime society, while others might have exaggerated their combat actions in order to reflect more fully the expectations of a soldier in battle.

17. Elderly noncombatant males are also depicted in village scenes. However, no children are shown in the settlement under attack. Scott Hutson (2006: 104) points out that, in most prehistoric populations, half of the living individuals are under the age of 20 and perhaps a third are under the age of 10.

18. Clemency Coggins (1984: 164) has noted the representation of women being forced by warriors to depart their village in the Southwest panel.

19. This gesture is clearly illustrated in a carved panel dating to the eighth century believed to be from the Yaxchilan region. The panel represents a noble lord presenting three captives to the Yaxchilan king, Shield Jaguar III. The second of the three bound prisoners holds his wrist to his forehead and sorrowfully hangs his head (Miller and Martin 2004: plate 2).

20. Joyce (2000: 115) suggests that children are being carried in some bundles. However, Breton's full-size tracings of the UTJ murals in the collection of Bristol Museum and Art Gallery have been closely examined by Wren, and children are not represented in these bundles.

21. Perimortem trauma to males and females suggests that conflict occurred both in the form of open combat between groups of combatants, mainly male, and surprise raids to settlements resulting in injury and death to women (Serafin et al. 2014: 147–149).

22. Vladimir Propp (1984), in his analysis of Russian folk tales, analyzed plots in terms of their simplest narrative units, often called narratemes. These units, considered by him to be irreducible, could be read either synchronically, as if all at once, or diachronically, as if going through the narrative over time, each reading resulting in a different set of information.

23. Miller (1977) and Coggins (1984) concur in seeing this panel as recording a settlement that is in a state of military readiness but not under attack. A divergent interpretation is offered by Ringle (2009), who argues that an attack is under way.

References Cited

Ashmore, Wendy
1989 Construction and Cosmology: Politics and Ideology in Lowland Maya Settlement Patterns. In *Word and Image in Maya Culture: Explorations in Language, Writing, and Representation*, edited by William F. Hanks and Don S. Rice, pp. 279–286. University of Utah Press, Salt Lake City.

Ayala Falcón, Maricela
 2002 Lady K'awil, Goddess O, and Maya Warfare. In *Ancient Maya Women*, edited by Traci Ardren, pp. 105–113. AltaMira Press, Walnut Creek, Calif.
Barthes, Roland
 1990 *Image, Music, Text*. Fontana Press, London.
Bolles, John S.
 1977 *Las Monjas: A Major Pre-Mexican Architectural Complex at Chichén Itzá*. University of Oklahoma Press, Norman.
Braswell, Geoffrey E., and Nancy Peniche May
 2012 In the Shadow of the Pyramid: Excavations of the Great Platform of Chichen Itza. In *The Ancient Maya of Mexico: Reinterpreting the Past of the Northern Maya Lowlands*, edited by Geoffrey E. Braswell, pp. 229–258. Equinox, Sheffield, England.
Breton, Adela C.
 1907 The Wall Paintings at Chichen Itza. *Proceedings, 15th International Congress of Americanists, Quebec, 1901*, vol. 2: 165–169.
Brumfiel, Elizabeth
 1987 Consumption and Politics at Aztec Huexotla. *American Anthropologist*, n.s. 89: 676–686.
 1996 The Quality of Tribute Cloth: The Place of Evidence in Archaeological Argument. *American Antiquity* 61: 453–462.
Coggins, Clemency Chase
 1984 Murals in the Upper Temple of the Jaguars, Chichén Itzá. In *Cenote of Sacrifice: Maya Treasures from the Sacred Well at Chichen Itza*, edited by Clemency Chase Coggins and Orrin C. Shane III, pp. 157–165. University of Texas Press, Austin.
Cohodas, Marvin
 1978 *The Great Ball Court of Chichen Itza, Yucatan, Mexico*. Garland, New York.
Coles, Tony
 2008 Finding Space in the Field of Masculinity: Lived Experiences of Men's Masculinities. *Journal of Sociology* 44: 233–248.
 2009 Negotiating the Field of Masculinity: The Production and Reproduction of Multiple Dominant Masculinities. *Men and Masculinities* 12: 30–44.
Connell, Raewyn W.
 1987 *Gender and Power: Society, the Person, and Sexual Politics*. Stanford University Press, Stanford.
 1995 *Masculinities*. University of California Press, Berkeley.
Connell, Raewyn W., and James W. Messerschmidt
 2005 Hegemonic Masculinity: Rethinking the Concept. *Gender & Society* 19: 829–859.
Cowgill, George L.
 2002 Ritual Sacrifice and the Feathered Serpent at Teotihuacán. Foundation for the Advancement of Mesoamerican Studies. www.famsi.org/reports/96036/.
Demetriou, Demetrakis Z.
 2001 Connell's Concept of Hegemonic Masculinity: A Critique. In *Theory and Society* 30: 337–361.
Finegold, Andrew
 2012 *Dramatic Renditions: Battle Murals and the Struggle for Elite Legitimacy in Epiclassic Mesoamerica*. PhD diss., Department of Art and Art History, Columbia University, New York. University Microfilms, Ann Arbor, Mich.

Fish, Stanley
1980 *Is There a Text in This Class? The Authority of Interpretive Communities.* Harvard University Press, Cambridge.
Folan, William J.
1969 Sacalum, Yucatan: A Pre-Hispanic and Contemporary Source of Attapulgite. *American Antiquity* 34: 182–183.
Freidel, David A., Linda Schele, and Joy Parker
1993 *Maya Cosmos: Three Thousand Years on the Shaman's Path.* William Morrow, New York.
Grossman, Dave
1996 *On Killing: The Psychological Cost of Learning to Kill in War and Society.* Little, Brown, Boston.
Grube, Nikolai
1994 Hieroglyphic Sources for the History of Northwest Yucatan. In *Hidden among the Hills: Maya Archaeology of the Northwest Yucatan Peninsula*, edited by Hanns J. Prem, 316–358. *Acta Mesoamericana* no. 7. Verlag von Flemming, Möckmühl, Germany.
Grube, Nikolai and Ruth J. Krochock
2011 Reading Between the Lines: Hieroglyphic Texts from Chichén Itzá and Its Neighbors. In *Twin Tollans: Chichén Itzá, Tula, and the Epiclassic to Early Postclassic Mesoamerican World*, rev. ed., edited by Jeff Karl Kowalski and Cynthia Kristan-Graham, pp. 157–193. Dumbarton Oaks, Washington, D.C.
Grube, Nikolai, and Simon Martin
2004 Patronage, Betrayal, and Revenge: Diplomacy and Politics in the Eastern Maya Lowlands. In *Notebook for the 28th Maya Hieroglyphic Forum at Texas, March, 2004*, edited by Nikolai Grube, pp. 1–95. Maya Workshop Foundation, University of Texas at Austin.
Guernsey, Julia, and F. Kent Reilly
2006 Introduction. In *Sacred Bundles: Ritual Acts of Wrapping and Binding in Mesoamerica*, edited by Julia Guernsey and F. Kent Reilly, pp. v–xviii. Boundary End Archaeological Research, Barnardsville, N.C.
Halberstam, Judith
1998 *Female Masculinity.* Duke University Press, Durham, N.C.
Hassig, Ross
1992 *War and Society in Ancient Mesoamerica.* University of California Press, Berkeley.
Hendon, Julia A.
1999 Spinning and Weaving in Pre-Hispanic Mesoamerica: The Technology and Social Relations of Textile Production. In *Mayan Clothing and Weaving through the Ages*, edited by Barbara Knoke de Arathoon, Nacie L. Gonzalez, and John M. Willemsen Devlin, pp. 7–16. Museo Ixchel del Traje Indígena, Guatemala City.
2006 Textile Production as Craft in Mesoamerica: Time, Labor and Knowledge. *Journal of Social Archaeology* 6: 354–378.
Herman, David
1997 Scripts, Sequences, and Stories: Elements of a Postmodern Narratology. *Publications of the Modern Language Association* 112: 1046–1059.
Horgan, John
2012 *The End of War.* McSweeney's Books, San Francisco.

Houston, Stephen D., David Stuart, and Karl Taube

2006 *Memory of Bones: Body, Being, and Experience among the Classic Maya*. University of Texas Press, Austin.

Hutson, Scott R.

2006 Children Not at Chunchucmil: A Relational Approach to Young Subjects. In *The Social Experience of Childhood in Ancient Mesoamerica*, edited by Traci Ardren and Scott R. Hutson, pp. 103–132. University Press of Colorado, Boulder.

Iser, Wolfgang

1978 *The Act of Reading: A Theory of Aesthetic Response*. John Hopkins University Press, Baltimore.

James, Simon

2010 The Point of the Sword: What Roman-era Weapons Could Do to Bodies-and Why They Often Didn't. In *Waffen in Aktion. Akten der 16. Internationalen Roman Military Equipment Conference (ROMEC). Xanetener Berichte*, edited by Alexandra W. Busch and Hans-Joachin Schalles, pp. 41–54. Philipp Von Zabern, Darmstadt, Germany.

Joyce, Rosemary A.

1992 Images of Gender and Labor Organization in Classic Maya Society. In *Exploring Gender through Archaeology: Selected Papers from the 1991 Boone Conference*, edited by Cheryl Claassen, pp. 63–70. Monographs in World Archaeology 11. Prehistory Press, Madison, Wisc.

1996 The Construction of Gender in Classic Maya Monuments. In *Gender and Archaeology: Essays in Research and Practice*, edited by Rita P. Wright, pp. 167–195. University of Pennsylvania Press, Philadelphia.

2000 *Gender and Power in Prehispanic Mesoamerica*. University of Texas Press, Austin.

Klein, Cecelia K.

1994 Fighting with Femininity: Gender and War in Aztec Mexico. In *Gendering Rhetorics: Postures of Dominance and Human History*, edited by Richard C. Trexler, pp. 107–146. Center for Early Medieval and Renaissance Studies, State University of New York at Binghamton.

Krochock, Ruth J.

2002 Women in the Hieroglyphic Inscriptions of Chichén Itzá. In *Ancient Maya Women*, edited by Traci Ardren, pp. 152–170. AltaMira Press, Walnut Creek, Calif.

Kurjack, Edward B.

1992 Conflicto en el arte de Chichén Itzá. *Mayab* 8: 88–96.

Looper, Matthew

2002 Women-Men (and Men-Women): Classic Maya Rulers and the Third Gender. In *Ancient Maya Women*, edited by Traci Ardren, pp. 171–202. AltaMira Press, Walnut Creek, Calif.

McCafferty, Geoffrey G., and Sharisse D. McCafferty

1999 The Metamorphosis of Xochiquetzal: A Window on Womanhood in Pre- and Post-Conquest Mexico. In *Manifesting Power: Gender and the Interpretation of Power in Archaeology*, edited by Tracy L. Sweely, pp. 103–125. Routledge, London.

2015 Mystery and Archaeology: Of Earth Goddesses, Weaving Tools, and Buccal Masks. In *Bridging the Gaps: Integrating Archaeology and History in Oaxaca, Mexico*, edited by Danny Zborover and Peter C. Kroefges, pp. 97–111. University of Colorado Press, Boulder.

Maudslay, Alfred P.
1889–1902. *Archaeology*. 6 vols. In *Biologia Centrali-Americana*, edited by F. Ducane Godman and Osbert Salvin. Porter and Dulau, London.

Messerschmidt, James W.
2010 *Hegemonic Masculinities and Camouflaged Politics: Unmasking the Bush Dynasty and Its War against Iraq*. Paradigm, Boulder, Colo.
2012 Engendering Gendered Knowledge: Assessing the Academic Appropriation of Hegemonic Masculinity. *Men and Masculinities* 15: 56–76.

Miller, Arthur G.
1977 "Captains of the Itza": Unpublished Mural Evidence from Chichén Itzá. In *Social Process in Maya Prehistory: Studies in Honour of Sir Eric Thompson,* edited by Norman Hammond, pp. 197–225. Academic Press, New York.

Miller, Mary Ellen, and Simon Martin
2004 *Courtly Art of the Ancient Maya*. Fine Arts Museums of San Francisco, San Francisco and New York.

Morris, Earl H., Jean Charlot and Ann Axtell Morris
1931 *The Temple of the Warriors at Chichén Itzá, Yucatán*. 2 vols. Publication 406. Carnegie Institution of Washington, Washington, D.C.

Nash, June
1978 The Aztecs and the Ideology of Male Dominance. *Signs* 4: 349–362.

Pohl, John M. D.
n.d. John Pohl's Mesoamerica, Ancient Books: Mixtec Group Codices, Codex Seldon/Codex Añute. Foundation for the Advancement of Mesoamerican Studies. www.famsi.org/research/pohl/jpcodices/selden/scene_by_scene.htm.

Preziosi, Donald
1979 *The Semiotics of the Built Environment: An Introduction of the Architectonic Analysis*. Indiana University Press, Bloomington.

Propp, Vladimir
1984 *Theory and History of Folklore*, edited by Anatoly Liberman. University of Minnesota Press, Minneapolis.

Rapoport, Amos
1982 *The Meaning of the Built Environment: A Nonverbal Communication Approach*. Sage, Beverly Hills, Calif.

Reese-Taylor, Kathryn, Peter Mathews, Julia Guernsey, and Marlene Fritzler
2009 Warrior Queens among the Ancient Maya. In *Blood and Beauty: Organized Violence in the Art and Archaeology of Mesoamerica and Central America*, edited by Heather Orr and R. Koontz, pp. 39–72. Cotsen Institute of Archaeology Press, Los Angeles.

Reilly, Kent F.
2002 Female and Male: The Ideology of Balance and Renewal in Elite Costuming among the Classic Period Maya. In *Ancient Maya Gender Identity and Relations*, edited by Lowell S. Gustafson and Amelia M. Trevelyan, pp. 319–328. Bergin and Garvey, Westport, Conn.

Ringle, William M.
2004 On the Political Organization of Chichen Itza. *Ancient Mesoamerica* 15: 167–218.
2009 The Art of War: Imagery of the Upper Temple of the Jaguars, Chichén Itzá. *Ancient Mesoamerica* 20: 15–44.

Robin, Cynthia

2002 Outside of Houses: The Practices of Everyday Life at Chan Noohol, Belize. *Journal of Social Archaeology* 2: 245–286.

2003 New Directions in Classic Maya Household Archaeology. *Journal of Archaeological Research* 11: 307–356

2004 Social Diversity and Everyday Life within Classic Maya Settlements. In *Mesoamerican Archaeology: Theory and Practice,* edited by Julia A. Hendon and Rosemary A. Joyce, pp. 148–168. Blackwell, Oxford.

Roys, Ralph L. (translator and editor)

1933 *The Book of Chilam Balam of Chumayel.* Publication 438. Carnegie Institution of Washington, Washington, D.C.

Ruscheinsky, Lynn

1996 The Monjas of Chichen Itza: The Construction and Reproduction of Gender Hierarchy. In *Debating Complexity: Proceedings of the 26th Annual Chacmool Conference,* edited by Daniel A. Meyer and Peter C. Dawson, pp. 629–634. The Chacmool Archaeological Association, Calgary.

Sahagún, Bernardino de

1950–1982 [1575–1580] *Florentine Codex: General History of the Things of New Spain.* Translated by Arthur J. O. Anderson and Charles E. Dibble. Book 2: The Ceremonies. Monographs of the School of American Research and the Museum of New Mexico. School of American Research and the University of Utah, Santa Fe, N.M.

Schele, Linda, and Peter Mathews

1998 *The Code of Kings: The Language of Seven Sacred Maya Temples and Tombs.* Scribner's, New York.

Schele, Linda, and Mary Ellen Miller

1986 *The Blood of Kings: Dynasty and Ritual in Maya Art.* George Braziller, New York; Kimbell Art Museum, Fort Worth, Tex.

Scott, James C.

1987 *Weapons of the Weak: Everyday Forms of Peasant Resistance.* Yale University Press, New Haven.

Serafin, Stanley, Carlos Peraza Lope, and Eunice Uc González

2014 Bioarchaeological Investigations of Ancient Maya Violence and Warfare in Inland Northwest Yucatan, Mexico. *American Journal of Physical Anthropology* 154: 140–151.

Spiller, Roger J.

1988 SLA Marshall and the Ratio of Fire. *RUSI Journal* 133 (4): 63–71.

Stanton, Travis W., and Tomás Gallerta Negrón

2001 Warfare, Ceramic Economy, and the Itza: A Reconsideration of the Itza Polity in Ancient Yucatan. *Ancient Mesoamerica* 12: 229–245.

Stone, Andrea

2011 Keeping Abreast of the Maya: A Study of the Female Body in Maya Art. *Ancient Mesoamerica* 22: 167–183.

Stone, Andrea, and Marc Zender

2011 *Reading Maya Art: A Hieroglyphic Guide to Ancient Maya Painting and Sculpture.* Thames and Hudson, New York.

Stuart, David, Stephen D. Houston, and John Robertson

1999 Recovering the Past: Classic Maya Language and Classic Maya Gods. In *Notebook for the 23rd Maya Hieroglyphic Forum at Texas*, Part 2, pp. 1–96. Maya Workshop Foundation, University of Texas at Austin.

Talbot, Kirsten, and Michael Quayle

2010 The Perils of Being a Nice Guy: Contextual Variation in Five Young Women's Constructions of Acceptable Hegemonic and Alternative Masculinities. *Men and Masculinities* 13: 255–278.

Todorov, Tzvetan

1993 *Genres in Discourse*. Cambridge University Press, Cambridge.

Tozzer, Alfred M.

1957 *Chichen Itza and Its Cenote of Sacrifice: A Comparative Study of Contemporaneous Maya and Toltec*. Memoirs of the Peabody Museum of Archaeology and Ethnology, vols. 11 and 12. Harvard University, Cambridge.

Tozzer, Alfred M. (editor and translator)

1941 *Landa's Relación de las cosas de Yucatán*. Papers of the Peabody Museum of American Archaeology and Ethnology, vol. 18. Harvard University, Cambridge, Mass.

Webster, David L.

1993 The Study of Maya Warfare: What It Tells Us about the Maya and What It Tells Us about Maya Archaeology. In *Lowland Maya Civilization in the Eighth Century A.D.*, edited by Jeremy A. Sabloff and John S. Henderson, pp. 355–414. Dumbarton Oaks, Washington, D.C.

2000 The Not So Peaceful Civilization: A Review of Maya War. *Journal of World Prehistory* 14: 65–119.

Wolf, Werner

2003 Narrative and Narrativity: A Narratological Reconceptualization and Its Applicability to the Visual Arts. *Word and Image* 19: 180–197.

Wren, Linnea

1984 Chichén Itzá: The Site and Its People. In *Cenote of Sacrifice: Maya Treasures from the Sacred Well at Chichen Itza*, edited by Clemency Chase Coggins and Orrin Shane III, pp. 13–21. University of Texas Press, Austin.

1991 The Great Ballcourt Stone at Chichén Itzá. In *Sixth Palenque Round Table, 1986*, vol. 8, edited by Virginia M. Fields and Merle Greene Robertson, pp. 51–58. University of Oklahoma Press, Norman.

Wren, Linnea, Peter J. Schmidt, and Ruth Krochock

1989 The Great Ball Court Stone of Chichen Itza. *Research Reports in Ancient Maya Writing* 25. Center for Maya Research, Washington, D.C.

Wren, Linnea, Kaylee Spencer, and Krysta Hochstetler

2001 Rhetoric and the Unification of Natural Geography, Cosmic Space, and Gender Spheres. In *Landscape and Power in Ancient Mesoamerica*, edited by Rex Koontz, Katherine Reese-Taylor, and Annabeth Headrick, pp. 257–277. Westview Press, Boulder, Colo.

Contributors

Péter Bíró received his doctorate from the Department of Archaeology at La Trobe University, Melbourne. He is currently a researcher at the University of Bonn, Abteilung fur Altamerikanistik. His research focuses on Maya writing and historiography.

Tara M. Bond-Freeman received her PhD from Southern Methodist University. Her research focus is centered on the archaeology of Mesoamerica, including ceramic analysis, with an emphasis on the northern Maya lowlands.

Geoffrey E. Braswell received his doctorate from Tulane University and is professor of anthropology at the University of California, San Diego. He currently serves as coeditor of *Latin American Antiquity*. Braswell's research interests include settlement pattern studies, lithic studies, geoarchaeology, and the emergence of complex society and economic systems. Dr. Braswell has worked at numerous Mesoamerican sites from Mexico to Nicaragua, including Chichen Itza, Kaminaljuyu, Copan, Teotihuacan, and Pusilha.

Annabeth Headrick is associate professor of art history at the University of Denver. She received her PhD in art history from the University of Texas, Austin. Her geographic area of specialization is Mesoamerica. Dr. Headrick's research, particularly at Teotihuacan and Chichen Itza, incorporates art, architecture, anthropology, and archaeology through a synthetic and comprehensive methodology.

Scott A. J. Johnson received his doctorate from the Department of Anthropology at Tulane University and is an honorary research associate at Washington University in St. Louis. He is director of the Low Technology Institute. His interests include experimental archaeology, writing systems, science and math in archaeology, environmental archaeology, ethnoarchaeology, coastal ecology, linguistics, and field methods.

Cynthia Kristan-Graham earned her PhD in art history from the University of California, Los Angeles. She was associate professor of art history at the Atlanta College of Art, which closed in 2006, and instructor of art history at Auburn University. Now an independent researcher, her work focuses on the visual culture of Epiclassic and Early Postclassic Mesoamerica, particularly Tula and Chichen Itza.

Virginia E. Miller completed her PhD in art history at the University of Texas, Austin. She is associate professor emerita in the Department of Art History at the University of Illinois at Chicago. Dr. Miller is the author of *The Frieze of the Palace of the Stuccoes, Acanceh, Yucatan, Mexico* and the editor of *The Role of Gender in Precolumbian Art and Architecture*, as well as of numerous articles about ancient Maya art, particularly in Yucatan.

Travis Nygard earned his PhD in art history from the University of Pittsburgh. He is associate professor of art at Ripon College. His scholarship focuses on indigenous art and visual culture of the Americas. Dr. Nygard is particularly interested in the art from the Maya sites Yo'okop, Chichen Itza, Palenque, and Tonina, as well as the art of the Lakota and Ojibwa peoples.

Nancy Peniche May earned her PhD in anthropology from the University of California, San Diego. Her scholarship focuses on the political economy of early complex societies in Yucatan and the Belize Valley, in the context of gender studies, household archaeology, lithic studies, and the relationship between power and architecture.

Eduardo Pérez de Heredia is honorary associate professor in the Department of Archaeology at La Trobe University in Melbourne. He has worked as a ceramicist on the Proyecto Arqueológico Chichen Itza–Instituto Nacional de Antropología y Historia. His interests focus on Maya ceramics and complex society systems.

J. Gregory Smith earned his PhD from the University of Pittsburgh and is associate professor of anthropology at Northwest College in Powell, Wyoming. Although he has worked in Mongolia, Ecuador, and across the United States, the bulk of his archaeological research has been carried out in the highlands and lowlands of Mexico.

Kaylee Spencer earned her PhD in art history from the University of Texas, Austin. She is associate professor of art at the University of Wisconsin, River Falls. Her scholarship focuses on the visual culture of the Late Classic and Early Postclassic Maya and particularly on portraiture and viewership.

Beniamino Volta is a PhD candidate in anthropology at the University of California, San Diego. His dissertation uses agent-based computational modeling to study settlement patterns in the Maya region. Other research interests include ancient exchange and archaeological chronology building. He has done fieldwork in Mexico, Belize, and Jordan.

Linnea Wren earned her PhD in art history from the University of Minnesota, Minneapolis. She is professor emerita of art history at Gustavus Adolphus College in St. Peter, Minnesota. Her scholarship focuses on the art and architecture of Late Classic Maya culture in Quintana Roo and Yucatan.

Index

The letter *f* following a page number denotes a figure; the letter *t* following a page number denotes a table.